Thomas Gainsborough
1727–1788

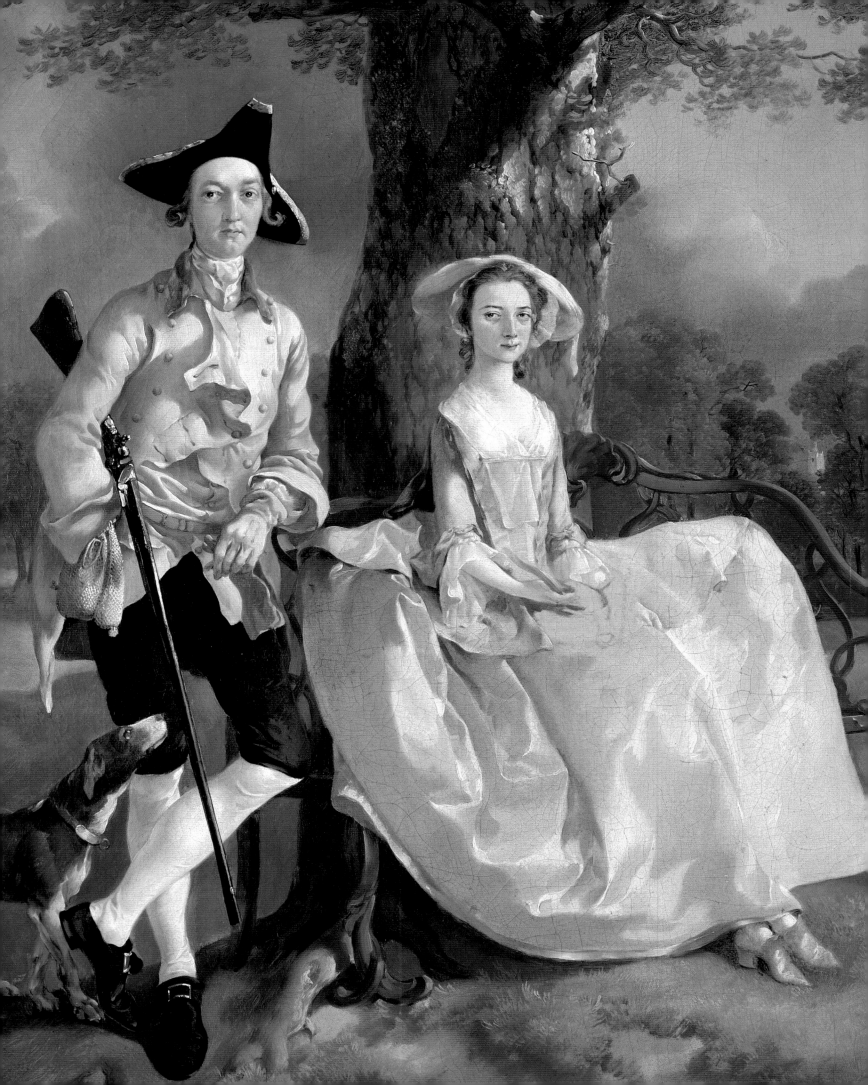

Thomas Gainsborough
1727–1788

Edited by Michael Rosenthal and Martin Myrone

With contributions by Rica Jones, Martin Postle
Diane Perkins, Christine Riding, and Louise Hayward

Harry N. Abrams, Inc., Publishers

Published by order of the Tate Trustees
on the occasion of the exhibition at
Tate Britain, London
24 October 2002–19 January 2003
and touring to
National Gallery of Art, Washington
9 February–11 May 2003
and
Museum of Fine Arts, Boston
9 June–14 September 2003

First published in 2002
by Tate Publishing, London

© Tate 2002

Library of Congress Control Number:
2002112084
ISBN 0-8109-4440-5

Published in 2002 by Harry N. Abrams,
Incorporated, New York

Designed by Paul Barnes
Printed and bound in Italy by Conti Tipocolor
10 9 8 7 6 5 4 3 2 1

A list of abbreviations used in the catalogue is
given on page 288.

Measurements of works of art are given in
centimetres, height before width, followed by
inches in brackets.

Authorship of catalogue entries
is indicated by initials
MM Martin Myrone
MP Martin Postle
DP Diane Perkins
CR Christine Riding
MR Michael Rosenthal

Frontispiece: Detail from *Mr and Mrs Andrews*
*c.*1750 (cat.18)

 Harry N. Abrams, Inc.
100 Fifth Avenue
New York, N.Y. 10011
www.abramsbooks.com

Abrams is a subsidiary of

Contents

Foreword

This is the third Tate survey of the work of Thomas Gainsborough, successor to the 1953 and 1980 exhibitions. The galleries at Millbank have thus given successive generations the opportunity to become acquainted at first hand with the work of one of Britain's best-known and best-loved painters, one among that relatively select band whose international reputation is also well established. Of course the exact nature of Gainsborough's reputation at home and abroad has changed over the years. His landscapes, for example, though largely overlooked in his lifetime, were to become the cornerstone of his posthumous celebrity in the early nineteenth century, their evident spontaneity and naturalism striking particular chords in the Romantic era. Later in the nineteenth century his glamorous portraiture took centre stage, a taste that became especially keen in early twentieth-century America (evidenced by the many loans to this exhibition from American collections). By mid-century his prowess as a draughtsman began to attract particular notice. And so the process of shifting preference and appreciation continues, the present exhibition allowing early twenty-first-century art historians, critics and the wider public on both sides of the Atlantic to assess, and I hope celebrate, the quality and interest of Gainsborough's work according to the criteria of our own times.

Gainsborough scholarship in Britain has certainly been very fertile over the past fifty or so years, with the extensive research and publications of Mary Woodall, Ellis Waterhouse and John Hayes being especially influential. We now have authoritative *catalogues raisonnés* of his drawings and landscape paintings, a newly-edited collection of his letters, and, thanks to ongoing archival research published regularly, for example in *Gainsborough's House Review* (edited by

Hugh Belsey), an ever more detailed picture of his family, his life and his practice. In parallel, especially over the last two decades, historians of British culture and society including John Barrell, John Brewer and the late Roy Porter have cast new and sometimes dazzling light on the broader social and political world in which Gainsborough existed, revealing the eighteenth century to be a much more 'modern' and mobile place than earlier histories had proposed. We now know more about the upheavals in technology, science, politics and the intellectual advances of the Enlightenment, but we also have come to understand that the very fabric of most people's lives began to change quite profoundly in this period. In the cultural sphere, Gainsborough himself participated personally in these shifts – for example by moving to Bath (a centre of entertainment), by being a friend of popular musicians and actors, and by showing in the new annual public exhibitions – but also by responding directly through his art to the sometimes worrying changes in the agricultural economy that affected the way of life of ordinary working people.

In his recent major book *The Art of Thomas Gainsborough*, Michael Rosenthal undertook the first significant fusion of these two distinctive areas of scholarship by re-investigating Gainsborough's art, in detail, in the light of the newly-enhanced understanding of his milieu. Indeed in many respects Rosenthal's book prompted our decision at Tate Britain to organise a new Gainsborough exhibition, one which might bring together a wider range of his art than had been attempted before, in an effort to reappraise the artist, his work and his world. We have been fortunate to secure so many paintings that are not only key milestones in the artist's career but are amongst the most

famous works in the whole history of British art –*Mr and Mrs Andrews* and *The Watering Place* from the National Gallery, London, *Carl Friedrich Abel* from the Huntington Library and Art Collections, San Marino, *Ann Ford* from the Cincinnati Art Museum, *Mrs Sheridan* from Washington, *Countess Howe* from Kenwood. Such is the fame and apparent familiarity of these as images, even though many have not travelled to Tate before, that they may seem more like old friends than new acquaintances. But one of the purposes of this exhibition is to revitalise our appreciation of them and to suggest ways in which we might re-discover them as works of even greater quality, complexity and interest than once thought, with the power moreover to illuminate aspects of eighteenth-century culture in new and various ways. It is a great privilege to be able to bring them into the company of a number of very fine if lesser-known works, some of which are now being exhibited for the first time in many generations–for example the exceptional full-length portraits of Lord and Lady Ligonier from the Huntington–and others, such as the self-portrait executed at the age of thirteen, providing an invigorating freshness to our understanding of particular phases of Gainsborough's career.

I am very grateful to Professor Rosenthal for accepting our invitation to take on this show as its lead curator, for allowing a wide public to share the fruits of his research and analysis, and for lending the project his great flair and commitment. He has collaborated closely from the outset with Tate curator Martin Myrone, who, through his simultaneous work on a series of other exhibitions and publications, has in his relatively short time at Tate established himself as a leading scholar in his field, bringing to curatorship an enviable combination of great art historical sophistication with an effortless common touch. Michael and Martin's project has, of course, also relied on the direct input of many other scholars, here and elsewhere. Their own acknowledgments detail these and other debts, but I would like to record my own warm thanks to John Hayes, curator of the 1980 Tate exhibition, for so generously sharing his unrivalled knowledge of Gainsborough with us, and for advising closely and acutely on our selection of works for the show; to Hugh Belsey of Gainsborough's House for a myriad of favours; and to Tate's Martin Postle and Rica Jones both for contributing their extremely illuminating essay in this catalogue on Gainsborough's techniques and practice as an artist and for their provision of help throughout the project. The Tate team–and here I must mention the leadership of Judith Nesbitt, Head of Exhibitions and Display at Tate Britain, and the vital contribution of exhibitions registrar Sionaigh Durrant and curators Carolyn Kerr,

Christine Riding, Diane Perkins, Louise Hayward and Ben Tufnell–has worked very successfully with colleagues at the National Gallery in Washington, notably Franklin Kelly, Dodge Thompson and Jennifer Cipriano, and the Museum of Fine Arts in Boston, notably George Shackelford, Frederick Ilchman, Kathleen Drea and Jennifer Bose, and I think it is due to their most apparent professionalism that so many museums and collectors around the world responded so positively to our often taxing loan requests. To all our lenders go our profound thanks; but to Her Majesty The Queen, to the Trustees of the National Gallery, London, to the Huntington, to Cincinatti, to the Morgan Library, and to English Heritage (notably Julius Bryant and Simon Thurley) I would like to emphasise our particular gratitude for their consent to loans that involved notable difficulty or sacrifice.

The exhibition installation in London was designed with great flair by Liza Fior and Cathy Hawley of muf architecture with Una Designers. The catalogue, designed by Paul Barnes, was skilfully seen to press by John Jervis of Tate Publishing, working alongside Tim Holton and Fran Matheson. In all, this has been an exhilarating project from conception through to execution and its launch is a proud moment for Tate Britain and our partners in Washington and Boston. Sponsorship, without which of course no project on such a scale could be contemplated these days, has been magnificently provided in London by British Land.

Stephen Deuchar
Director
Tate Britain

Acknowledgments

At the risk of unforgivable oversights, we would like to identify some of the very many individuals who have contributed their time, energy and expertise to making this exhibition possible.

We owe a particular debt to John Hayes, whose authoritative publications on Gainsborough provide the essential foundation for any serious consideration of the artist, as the bibliography of this catalogue alone must inevitably testify. The exhibition has benefited enormously from his personal input. Great debts are owed to Susan Sloman, whose research has uncovered important new material about Gainsborough's time and practice in Bath, and to Hugh Belsey, who has built up a superb collection at Gainsborough's House. Further recent scholarship, particularly that of Amal Asfour and Paul Williamson, has provided an invaluable stimulus.

Within Tate, Rica Jones, Martin Postle, Christine Riding and Diane Perkins have contributed in ways that go far beyond the already substantial contributions apparent in the pages of the present catalogue. Each has been the source of advice, direction, information and support throughout the life of this project, and has had a decisive influence in shaping the show. Their knowledge and insight have been essential, and their abiding enthusiasm for the project is deeply appreciated. Sarah Hyde, with the assistance of Heather Birchall, created the wonderful interpretative materials for the exhibition, and made significant contributions to the curatorial formation of the show. Registrar Sionaigh Durrant managed the transportation of loans, undertaken by Momart and Martinspeed, and Andy Shiel and Ken Graham led the teams who installed the exhibition. Many further individuals across Tate have become involved, including staff from Conservation, Registrars, Visitor Services, Photography, Tate Britain Exhibitions and Display, Communications and Development, and also David Dance and Mark Edwards from AMEC facilities. Claire Eva, Ben Luke and Sioban Ketelaar have dedicated themselves to the press and publicity surrounding the show with their characteristic verve. Louise Hayward has contributed the chronology to the present catalogue but this is only the visible tip of a veritable iceberg: her dedication, judgement and boundless enthusiasm have been essential to the realisation of this exhibition. Above all, Stephen Deuchar is to be thanked for his vision and unfailing acuity in every matter.

Many other individuals have been generous in many different ways. We might single out: Antony Griffiths and his staff at The British Museum, notably Don Esposito and Sheila O'Connell, Mark Evans and his colleagues at the Victoria and Albert Museum, Oriole Cullen of the Museum of London, Shelley Bennett of the Huntington, Susan Foister of the National Gallery, London, Betsy Wiesman of Cincinatti Art Museum, Cara Denison of the Morgan Library, Cathy Power of English Heritage, Andrew Middleton of DCMS, and Neil Claridge and his colleagues at the British Library; also Clare Baxter, Elizabeth Barker, Ian Dunlop, David Edmond, David Fawkes, Ted Gott, Richard Green, Charles Hatherall, James Holloway, Alan Hobart, Lee Hendrix, Rhian Harris, Alastair Laing, Anthony Mould, Philip Mould, Susan Morris, Andrew Moore, Angus Neill, Mark Pomeroy, Anne Puetz, Viola Pemberton-Pigott, Lucy Peltz, Christopher Ridgway, Tessa Sidey, Helen Smailes, John Stainton, Ernst Vegelin, Katharine Wall, Ian Woodcock, Malcolm Warner, Christopher Woodward and Amina Wright. Michael Rosenthal would additionally like to thank Hilary Rosenthal, Alice Rosenthal, Gordon Bull, Richard Read, Louise Campbell, and Kate Retford.

Michael Rosenthal and Martin Myrone

Thomas Gainsborough: Art, Society, Sociability

Michael Rosenthal and Martin Myrone

This Gentleman, in all his work, pleases by his vivacity, genteelness, and ingenuity. He totally neglects all the mechanical arts of Painting, and never attempts, by nicety and smoothness, to make his works be mistaken for the identical personages they represent. His pieces are masterly and well-chosen imitations of Nature; but we never mistake his Paintings for real flesh and blood, and never find more upon his canvas than ideas … all is soft, yet forcible. There is no distinct flatness on which the eye is compelled to rest; but it is kept in constant motion.

Thus wrote a 'Roger Shanhagan, *Gent.'* of Gainsborough in *The Exhibition, Or a Second Anticipation, Being Remarks on the principal Works to be Exhibited next Month at the Royal Academy*, apparently published immediately prior to the opening of the annual Royal Academy exhibition for 1779.[1] Pretending to be a sneak preview of the show, the pamphlet was a knowing hoax, actually commenting on an invented selection of exhibits attributed to the leading artists of the day, and written by the young architect William Porden, the painter Robert Smirke and the would-be artist Robert Watson.[2] By turns gently ironic, fiercely sarcastic and politically charged, its witty 'anticipation' of artists' performances was also perceptive and sophisticated: it is highly revealing of the very great complexity surrounding painting and its reception at this period.

Shanhagan's text attests to the delicate play of artifice and authenticity that characterises the social world of Gainsborough's time and which was fundamental to his art. Shanhagan claims that one would never take Gainsborough's works for anything other than paintings, yet Gainsborough's own intimates were anxious to stress how far only he was able to produce portraits which one might perceive

as surrogates for their sitters. His friend, Philip Thicknesse (1719–1792), wrote in 1770 how, on looking at these works, one might 'form the same judgement from the person as from the life', and it was probably Thicknesse again, writing in 1772 in the *Town and Country Magazine*, who claimed that these 'pictures may not be said so properly to be *like* the originals as to *be* the people themselves'.[3] And if Shanhagan understood likeness to reside in a 'licked' (that is, a smooth and apparently unambiguous) surface, as far as Gainsborough's obituarist in the *Gentleman's Magazine* was concerned, it was precisely because Gainsborough's handling demanded an active way of looking that he gave 'not merely the map of the face, but the character, the soul of the original':

His portraits are calculated to give effect at a distance; and that effect in so eminent a degree, that the picture may almost be mistaken for the original: but closely inspected, we wonder at the delusion, and find scumbling scratches that have no appearance of eye-brows or nostrils.[4]

These early commentaries on Gainsborough provide highly attuned formal analysis in which the painted surface is recognised as having a mutable quality, existing both as physical marks and substance and, viewed under the proper conditions, resolving into an image. We might not readily associate this kind of analysis with the eighteenth century and the more familiar intellectualised abstraction of the 'Enlightenment'. Gainsborough's works appear to have forced his commentators to undertake a formal consideration of the mechanisms of representation, of, quite simply, *how* his paintings *work*. Even the spokesman of academic abstraction and Gainsborough's great rival (even 'defining other'), Sir Joshua Reynolds (1723–1792), had to get his hands dirty with a

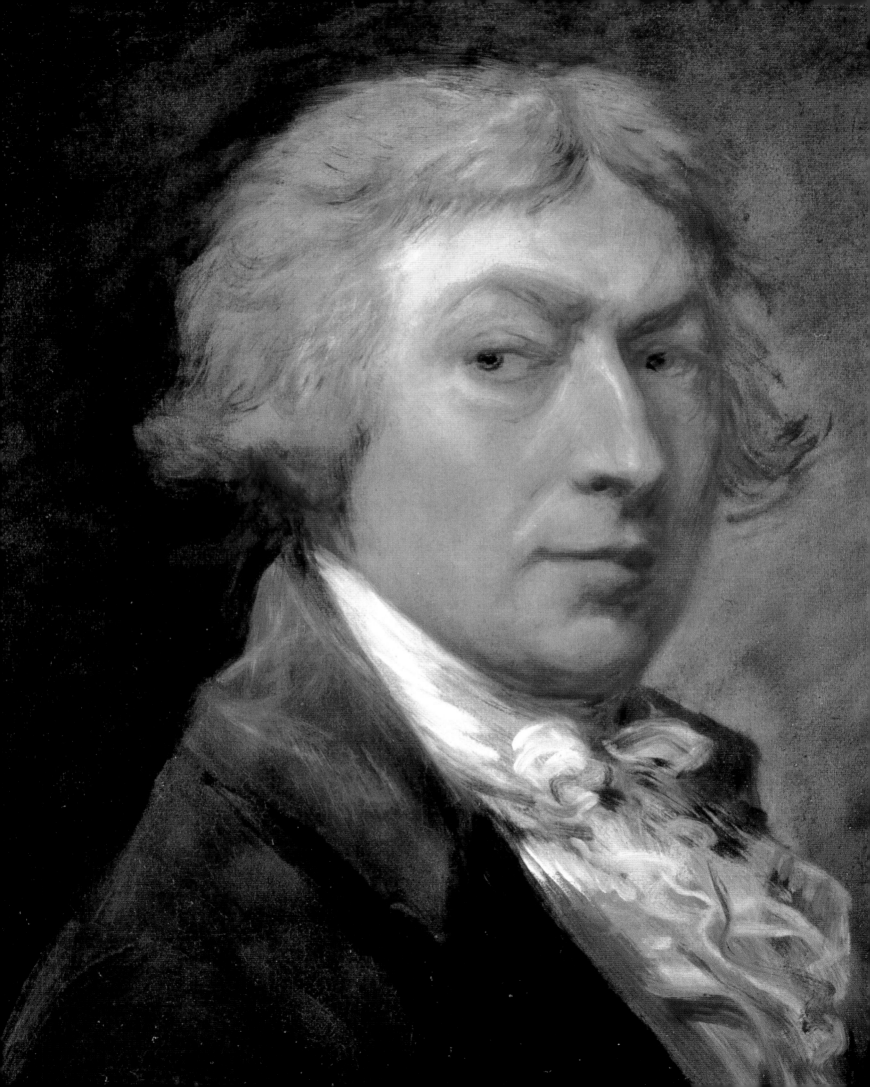

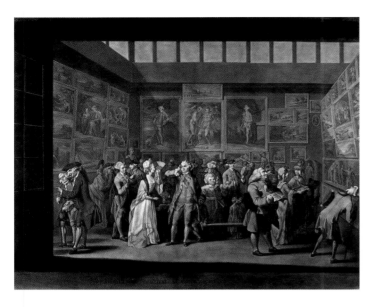
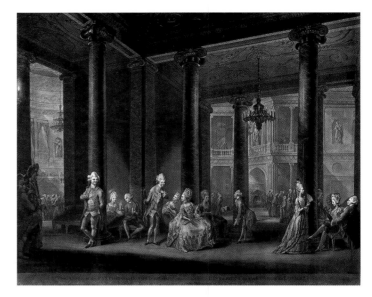

Figure 1
Richard Earlom after Michel-Vincent Brandoin
The Exhibition of the Royal Academy 1772
Mezzotint on paper, 48 x 57 (18⅞ x 22⁷⁄₁₆)
Guildhall Library, Corporation of London

Figure 2
Richard Earlom after Michel-Vincent Brandoin
Interior of the Pantheon on Oxford Street 1772
Mezzotint on paper, 48 x 57 (18⅞ x 22⁷⁄₁₆)
Guildhall Library, Corporation of London

discussion of the mechanical processes of making a painting when he discussed his work, making his oft-quoted remarks about

all those odd scratches and marks, which, on close examination, are so observable in Gainsborough's pictures, and which even to experienced painters appear rather the effect of accident than design; this chaos, this uncouth and shapeless appearance, by a kind of magick, at a certain distance assumes form, and all the parts seem to drop into their proper places.[5]

Reynolds is here certainly looking back, casting Gainsborough in terms taken from Giorgio Vasari (1511–1574) in his account of Titian, and so positing him as painterly sensualist to complement his own self-proclaimed role as a latter-day Michelangelo. But it may also be said to look forward. In the analysis of the formal effects of Gainsborough's painted surfaces we might claim to find the emergence of a particular kind of aesthetic modernity, a recognition that the relationship between the physical mark and the resulting image was not simply natural, but a form of 'magick' which could be disturbing.

Yet this modernity was rooted in the social and political experiences of the time. Shanhagan's pamphlet reveals the extent to which writings on art at this period were a medium by which a wide range of ideas and themes were circulated. Its praise of the 'vivacity, genteelness, and ingenuity' of the painter's works points up the contiguity between notions of social decorum and the qualities of painting. It affirms that the artist was a social actor. While a claim to his superiority in his profession could be based on a commitment to 'ideas', just as the gentleman's claim to status might lie with his capacity to form a generalising vision of the

world, the effortlessness of the painter's art could equally be matched to the effortless demeanour of the genteel. In terms of social spaces, those for looking at art and those intended for other kinds of entertainment may not have been that different. There are many parallels, for instance, between Brandoin's images of one of the earliest public art exhibitions at the Royal Academy (fig.1) and the interior of the Pantheon, a popular entertainment venue on Oxford Street (fig.2). These were both venues for personal display; if anything, the elegant young crowd at the Pantheon is made to appear more self-assured than the visitors at the Academy, where a variegated cast of types seems a little uncertain how to behave, examining each other as much as the art. These were both new kinds of social spaces, heterogeneous and unpredictable, sometimes unruly, sometimes precious, sometimes politely studious.

In the new and reinvigorated social spaces of the eighteenth century – the theatres and clubrooms, coffee-houses and exhibitions – novel kinds of critical writing and commentary gained authority. Art criticism, which emerged as a genre (and then as a generally ill-defined genre) only with the inception of public art exhibitions in the 1760s, could connect the identity of the individual, the physical character of a work of art and a broader context of social activities and exchanges in manifold ways. We have noticed the tricky issue of likeness. In addition, Shanhagan's text touches on the relationship between the mechanical and the intellectual, and on the character of the pleasures to be gained from looking – spatial, sensual, perhaps even political: Shanhagan notes the absence in Gainsborough's paintings of 'a bold and determined outline' that would 'chain the eye to the canvas, and prevents the imagination from ranging and deceiving

Thomas Gainsborough: Art, Society, Sociability

itself'.[6] The commentary invites us to think about Gainsborough in relation to some of the key issues that emerged in later eighteenth-century thought, issues that appeared with the birth in that era of a distinctly modern art world.

This may not be immediately obvious. We are most familiar with a Gainsborough who has been presented–partly by himself, as he survives in his correspondence–as an artist unconcerned with ideas and the realities of cultural modernity. His virtuosity of technique has been understood as an expression of his personality, as the variations in both engagement and quality in portraits are taken to indicate the degree to which he related personally with his various sitters. His landscapes have likewise often been understood as having been driven exclusively by his personal love of nature, which is part, but not the whole, of the story. Thomas Gainsborough has been characterised as straightforward, compassionate, lacking in pretension and so completely absorbed in the art of painting that he was bound to come into friction with such ultra-worldly peers as Sir Joshua Reynolds. His art is exceptional not only in quality but also in not quite fitting neatly into art-historical schemes. Where art historians have endeavoured to articulate the longer-term historical impact of his paintings, they have tended to claim for them a prefiguration of the emotionalism and virtuosity of 'Romanticism', which was in itself expressive of alienation from industrial and commercial modernity.

If Gainsborough's art occupies a special place in the canon of British painting, that canon was in the process of getting established during his lifetime. As Reynolds observed in his fourteenth *Discourse*, which, in December 1788, he devoted to the assessment of his recently deceased rival: 'If ever this nation should produce genius sufficient to acquire to us the honourable distinction of an English School, the name of Gainsborough will be transmitted to posterity, in the history of the Art, among the very first of that rising name.'[7] As David Brenneman was the first to observe, Reynolds was, by means of this *Discourse*, able to reinstate Thomas Gainsborough within a Royal Academy with which relations had verged from semi-detached to hostile.[8] Founded in 1768, the Academy was intended to promote a British school of art that could rival the 'schools' of Renaissance Italy and seventeenth-century France, by emulating them in the production of 'Grand Style' pictures on historical, literary and sacred themes. In reality, British patrons of art had little interest in these subjects unless validated (and given literal economic value) by the aura attached to the established Old Masters. As the idea of a British school

gained force in the early nineteenth century, it tended now to focus on 'low' subjects–landscape, rural life–and the issue of spontaneous naturalism. The recovery of Gainsborough's reputation in this period saw him cast into a coherent and naturalised national school of art, where painting could be considered as an instinctive form of expression rooted in a supposedly common heritage.[9] If this was a nostalgic image of Gainsborough well-suited to the emerging bourgeois culture, it was necessarily insensitive to the social subtleties of his art.

Seeing Gainsborough's paintings as social products–as objects that not only depict his society but express in their form certain kinds of social ideas–proved troublesome to some later commentators. John Ruskin (1819–1900) told Kate Greenaway, 'He is inimitable–and yet a bad master... you may try a Gainsborough every now and then for play', casting his works as the object of a leisurely rather than studied form of attention.[10] So while Ruskin's Gainsborough was a great artist, he was not part of that heritage of great art from which the student might properly learn. The Victorian painter Edward Burne-Jones was more aggressive, reportedly saying:

> *I can't stand the humbug of Gainsborough any more. Reynolds is all right, he's got no ideas but he can paint – Gainsborough's simply an impostor. He just scratches on the canvas over loose flimsy stains and puts markings in black around them. The only thing he paints solidly are the scarlet coats, and they're just simply crude vermilion.*[11]

The artifice of Gainsborough's art, recognised in his portraits but more rarely in his landscapes, made him a slightly uncomfortable figure in the canon. His uneasy position might be explained in dramatic terms. In the opinion of the great art critic Clive Bell (1881–1964), Gainsborough was 'one of the two best English painters' (for Ruskin, he had been in the top five), but Bell called his career a 'tragedy', because, although his true calling was for an art where 'the emotion was personal and faithfully expressed' and 'honest', he was dragged down by the demands of shallow society portraiture.[12]

Gainsborough was always recognised as an artist of facility which in itself was, or nearly was, the foundation of greatness. Gainsborough's achievement was in part his ability to equate the social graces and pretensions of his day with the graces and pretensions of his art: to make Gainsborough a truly great artist, one whose qualities could be appreciated in the modern age, meant casting his career as tragic, as Bell did, or more often insisting that he be, in a sense, 'dumbed-down'. The dominant perception of Gainsborough has been as the great 'natural'

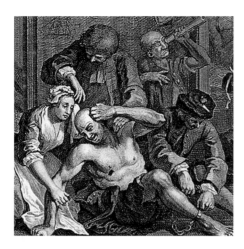

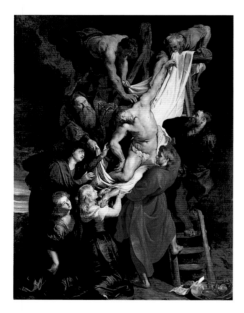

Figure 3
William Hogarth
Detail from **A Rake's Progress** (Plate 8) 1735,
retouched 1763
Etching and engraving on paper, image 31.8 × 38.7 (12½ × 15¼)
Tate

Figure 4
Peter Paul Rubens
The Descent from the Cross 1611–14
Oil on panel, 420 × 310 (165 × 122)
Antwerp Cathedral

Figure 5
Detail from **The Harvest Wagon** 1767 (cat.43)

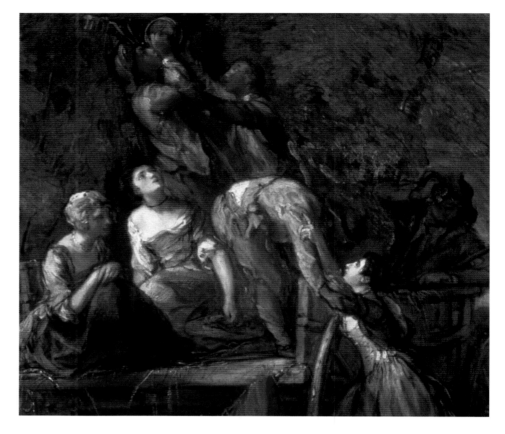

painter, someone who did not think or worry too much: 'Abstract ideas did not exist for Gainsborough; he loved the particular, and loved others to share his pleasure' and 'although so gifted in many ways, [he] was not at all of a literary turn of mind.'[13] In his poem, 'Gainsborough' (1863), Charles Swain imagined the young artist pleading with his mother to allow him to pursue art and had him proclaiming precociously: 'I will work out the poetry of Art | Make painting read as easily as a book' (apparently unaware of the irony of having these words uttered in a largely illiterate era).[14]

As W.T. Whitley wrote, in his unsurpassed biography of 1915: 'There is no painter of English birth more widely appreciated than Gainsborough, whose art touches every observer, great and simple, learned and unlearned … Gainsborough charms us all.'[15] Gainsborough's works had and continue to have an immediate and even demotic appeal. He is that rarity, a historic British artist with a secure international reputation, a reputation gained in no small part by the vogue for his work among the great American collectors of the late nineteenth and early twentieth centuries (a vogue for which there is telling evidence in this exhibition). But of course if Gainsborough's work was acknowledged to have a striking aesthetic immediacy in its own time, and if the facility of his painting has been central to the appreciation (and sometimes derogation) of his art, the complexities of

Shanhagan's exhibition preview point to the necessity of caution in taking this as any straightforward matter. And this must extend, too, to any unquestioning assessment of the artist's personality as spontaneous and uncalculated.

This was a persona that Gainsborough cultivated. Surviving letters (some were so licentious that their recipients destroyed them) communicate a witty, sprightly personality, someone who was instinctively generous but who did not suffer fools gladly. He wrote frequently to his friend, the Exeter musician and composer, William Jackson, and, despite the latter's half of the correspondence not having survived, we can still sense the edge generated between the capricious artist and his more cautious friend. In 1767 for instance it is evident that Jackson had been counselling Gainsborough to attempt more serious landscape subjects. The painter's response was to write:

I admire your notions of most things and do agree with you that there might be exceeding pretty Pictures painted of the kind you mention But are you sure you don't mean instead of the flight into Egypt, my flight out of Bath! do you consider my dear Maggotty Sir, what a deal of work history Pictures require to what little dirty subjects of Coal horses & Jack asses and such figures as I fill up with … do you really think that a regular Composition in the Landskip way should ever be fill'd with History, or any figures but

Thomas Gainsborough: Art, Society, Sociability

such as fill a place (I won't say stop a Gap) or to create a little business for the Eye to be drawn from the Trees in order to return to them with more glee.[16]

Jackson wrote of his friend that 'the swallow in her airy course, never skimmed a surface so light as Gainsborough touched all subjects' and he was keen to emphasise the painter's aversion to books and literature.[17] Yet Gainsborough knew men of letters, and his extraordinary verbal dexterity was hardly the attribute of an illiterate. So while he might write to Jackson 'I question if you could splice all my Letters together whether you would find more connection & sense in them than in many Landskips join'd where half a Tree was to meet half a Church to make a principal Object', he would also warn him not to be 'in a hurry to determine anything about *me*, if you are, ten to one you are wrong'.[18]

As John Hayes's work on Gainsborough reminds us, the painter's warning is well taken.[19] At the time of writing to Jackson about 'history pictures', Gainsborough was painting his celebrated *Harvest Wagon* (cat.43). The central pyramid of figures (fig.5) has traditionally been seen as paraphrasing Rubens's *Deposition of Christ* (fig.4), from which Gainsborough had made an incomplete copy (via a print or other painted copy), but the connection is not exact, and one can trace the figure handing the woman (who can be identified by comparison with portraits as

Gainsborough's daughter, Margaret) into the cart back to Raphael's *Fire in the Borgo* (1514; Vatican). The referencing of such elevated antecedents was meant to be restricted to worthy, 'historical' subjects, taken from the Bible or mythology, ancient history or serious literature. This was the ideal art promulgated by the high-minded artists of Gainsborough's time, the artists who led the moves to create a Royal Academy of art in the late 1760s. The incongruity of such references in so academically 'low' a subject is reinforced by the figure of the youth restraining the lead horse with no apparent effort, for this group is based on the monumental classical statues of the horse-tamers on the Quirinal Hill in Rome. If we further recognise that the man in shade, mopping his brow, previously played the part of Hogarth's insane rake in Bedlam (fig.3), we are invited to ponder on the rationale behind all this pictorial quotation.

Gainsborough, the ironist, referred to historical landscapes as 'tragi-comic' pictures, which point he may be demonstrating here. The figures in his landscapes usually have some narrative rationale. In *Gainsborough's Forest* (cat.4) they work the forest common — digging sand, keeping a cow, gathering timber — or they pass through; and they continued to have this kind of symbiotic relationship with their habitats (fig.6). *The Harvest Wagon* conversely asks how we square elevated pictorial quotation with a representation of a harvest cart passing through woodland and a fashionably dressed woman hitching a lift, and perhaps supplies its own answer in the figure modelled on the demented rake. The composition implicitly questions how a modern might radically relate to historical painting. Gainsborough maintained that figures should 'fill a place', or fit their surroundings, and his jokey remonstration to Jackson alongside the painted demonstration of the incongruity of historical landscape serves, if nothing else, to indicate that in fact he was taking these issues very seriously indeed. It could be that, with pressure continuing among the artists to form themselves into a Royal Academy, whose exclusive principles of membership would eventually press out of existence the more democratic artists' groups that had existed, Thomas Gainsborough wished to stake out his own oppositional position. What may be most telling is that, with the ultimate dominance of the Academy over the British art scene, the increasingly inflexible definition of 'artist', and the pretentious flavour of the art of his most successful rivals, his opposition was given most effective form as humour. Gainsborough's wry radicalism might be the only response he could formulate to the changing times.

Gainsborough's active life as an artist, stretching over almost half a century,

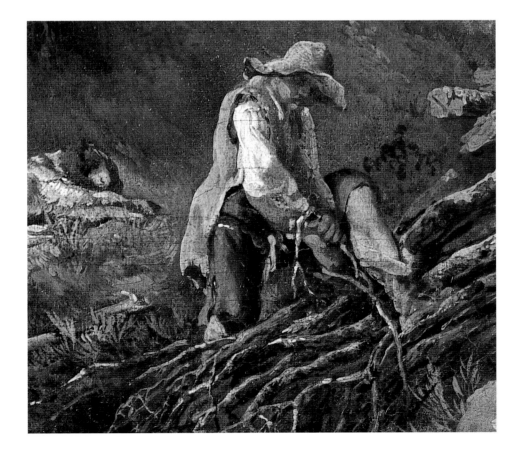

Figure 6
Detail from **Gainsborough's Forest ('Cornard Wood')**
c.1746–8 (cat.4)

was a rather more eccentric figure; known as 'scheming Jack' he came up with invention after invention, which were as ridiculous as they were useless. Thomas himself experimented with all the latest techniques of reproductive printing such as aquatints and soft-ground etching, and painted landscape subjects on to glass slides to be lit from behind in an especially constructed box (see cats.159–62 and 152–6).

Fuelled by empire and advancing technology, the expanding economy was creating an increasingly large class with the money to finance leisure, and the incentive to acquire culture. Art was no longer the strict preserve of an exclusive elite, but a territory of contested values, shared by the social establishment, newly wealthy professional classes, and the producers and disseminators of culture themselves. Moreover, the terms in which culture was appreciated changed. In place of the rigorous and ultimately self-referential terms formed by aristocratic philosophers, music, art and literature could be re-cast as primarily emotional in their effects, in line with new public morality that placed unprecedented emphasis on affection and the intuitive bonds of feeling. In compliance with the ideals of 'sensibility', social values were reworked to encompass men and women whose claim to status lay not in the traditional forms of authority founded on the ownership of land, but could be based on less tangible wealth derived from business and professional activities. Sensibility, the capacity to be moved by nature or art, and be impelled to do good in the world, was meant to be innate in every man and woman (although tellingly it was most commonly manifested by men and women who existed in reasonably comfortable circumstances). Sensibility could, it was proposed, tie society together into an orderly state following a structure determined by the superior emotional capacities of the literate class.

The particular significance of Gainsborough's paintings and drawings lies in the way that developments within them register the transformation of British culture at large, from the awkward but charming provincialism of his earliest works through to the cosmopolitan sophistication and technical daring of his last portraits. Thus his handling of landscapes develops from a manner learned from close observation of Dutch artists into something more wide-ranging, adapting the lessons of Sir Peter Paul Rubens (1577–1640), and even Titian (*c.*1485–1576), as William Jackson was to summarise: 'There are three different æras in his landscapes – his first manner was an imitation of Ruysdael, with more various colouring – the second, was an extravagant looseness of pencilling; which, though reprehensible, none but a great master

encompassed a period of extraordinary and dramatic change in British culture and society. It saw the unstable evolution of a great empire, with Canada and India purged of other European interests, America lost, and, in the last year of Gainsborough's life, the establishment of a penal colony in New South Wales. The unprecedented widening of national horizons – from the late 1760s Captain James Cook had undertaken legendary voyages throughout the South Pacific – was a corollary of technological advance, for such feats of navigation would have been impossible without accurate instrumentation, notably chronometers, and this was as manifest in the domestic sphere. New industrial processes and marketing methods transformed the economy. This was the age of Josiah Wedgwood and Matthew Boulton, of James Watt and Benjamin Franklin, of innovation in agriculture, science and industry and in advertising and retailing.[20] Gainsborough's clerical brother, Humphry, won premiums for, among other things, inventing a tide-mill and for a drill plough from the Society for the Encouragement of Arts, Manufactures and Commerce, itself only in existence since 1754, and in 1775 was involved in an acrimonious dispute with James Watt over their relative patents for a steam engine with a separate condenser. Another brother, John,

Thomas Gainsborough: Art, Society, Sociability

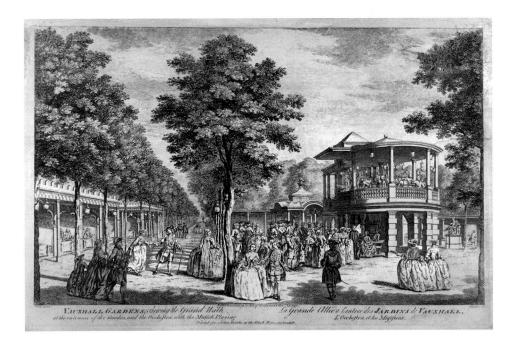

can possess – his third manner, was a solid, firm style of touch.'[21] Painting is thus judged in terms of social decorum, for Gainsborough's second manner is 'extravagant', 'reprehensible' and, it is implied, effeminate, where the third manner is properly 'solid' and 'firm'. Jackson's very language underlines the remoteness and complexity of an art which retains a more striking immediacy of appeal than that of some of Gainsborough's contemporaries. We can clarify some of these issues by setting the scene with an outline of the artist's career.

Gainsborough was born in 1727 in Sudbury in Suffolk, a town, according to one contemporary report, 'Populous and Wealthy, being enrich'd by the Clothing-Trade' but about which Defoe remarked: 'I know nothing for which this town is remarkable, except for being very populous and very poor.'[22] His family was engaged in Sudbury's prime industry, the wool trade, but the young Gainsborough is supposed to have shown himself so talented an artist at so early an age that his father consented to his going to London to study, initially as a silversmith. The little self-portrait (cat.1), done, very probably, after arriving in the city around 1739, demonstrates both his precocity and the fact that his outlook was closely tied into that avant-garde collection of painters centred around the figure of William Hogarth (1697–1764), and the Academy at St Martin's Lane. These were artists who defined themselves through their practical expertise and who looked with a wry and comic eye for subject matter to modern life. Their positions

were summed up in Hogarth's later self-portrait, painting the comic muse (fig.7). Here we have an artist proudly displaying the tools of his art, rather than hiding behind the appearance of conventional gentility. The young Gainsborough displayed himself with comparable vocational frankness.

The artists whom the young Gainsborough mixed with in London were bohemian and cosmopolitan. Besides Hogarth, they included the French sculptor, Louis-François Roubiliac (c.1705–1762), and, more saliently, his co-patriot, the engraver and draughtsman Hubert-François Gravelot (1699–1773), as well as the bucolic Francis Hayman (1707/8–1776), both of whom appear to have taught the young painter. It is not hard to imagine that the dominating presence of the opinionated William Hogarth would have inculcated into an impressionable rustic teenager a commitment to a modern art and a detached relationship with the Old Masters who were conventionally presented as the standard to which any painting had to aspire. But life in London did not involve a total commitment to work. Taking a retrospective view in 1773 Gainsborough wrote to his younger friend, the actor John Henderson: 'pray my boy, take care of yourself this hot weather, and don't run about London streets, fancying you are catching strokes of *nature*, at the hazard of your constitution – It was my first school, and deeply read in petticoats I am, therefore you may allow me to caution you.'[23]

The young Gainsborough belonged to a set of artists who displayed a real sense of corporate identity, not just in individual collaborations, but in larger-scale projects to create public art. While Gainsborough was in London, a team led by Hayman provided decorations for Vauxhall Gardens, a pleasure park just south of the Thames (fig.8). Here, London society could gather to dine, gossip, flirt, listen to music and, with these high-quality and eminently modern decorations, indulge themselves in the belief that they were part of a 'polite society' that was detached from the old world of court and country-house manners. Under the direction of the entrepreneur Jonathan Tyers (see cat.19) Vauxhall Gardens was a progressive, modern place, which made a point of using progressive, modern British art to set the scene. If visitors to Vauxhall may have been disinclined to bestow any close attention on the pictures set in the back of their supper-boxes, Hogarth led another programme of decoration, at the Foundling Hospital, that was a rather more serious proposition. The Hospital was an establishment dedicated to taking in abandoned babies and turning them into useful members of society. Gainsborough was among the artists who contributed round paintings of hospitals for the decoration of the

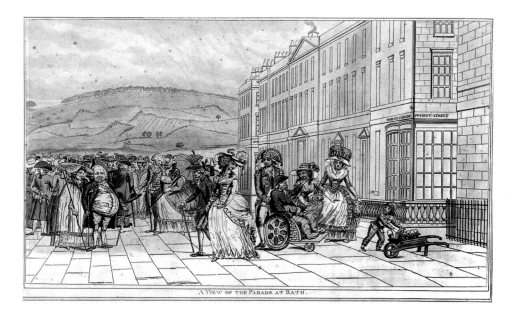

Figure 9
Robert Dighton
A View of the Parade at Bath *c.*1780
Engraving, 23.6 × 39.8 (9¼ × 15⅝)
Print Collection, The Lewis Walpole Library, Yale University

Court Room (cat.6). With this scheme, the artists of St Martin's Lane could claim to be momentarily playing a real role in modern British society.[24]

By the mid-1740s Gainsborough was evidently well thought of by his peers, but was not selling work. Despite his marrying Margaret Burr, who as the illegitimate daughter of the Duke of Beaufort came with an annuity of £200, he was not earning his living. He consequently returned to Sudbury in 1748 or early 1749, getting commissions where he could, including the portrait of Mr and Mrs Andrews (cat.18). Sudbury was never going to keep a painter going, even one who maintained his London contacts, and in 1752, now with two daughters, Mary and Margaret, the Gainsboroughs moved to the county town, Ipswich. At the time a flourishing port handling British coastal trade as well as vessels from Scandinavia and the Low Countries, the town supplied a cultured environment. Gainsborough was able to socialise with musicians – a keen instrumentalist himself, he often preferred to keep the company of performers and composers – and to exploit further contacts in building up his practice. Commissions grew in significance, including landscapes for the Duke of Bedford, and a portrait of Admiral Vernon (cat.25). None the less, letters to landladies promising to pay rent belatedly, alongside, as Susan Sloman has shown, Gainsborough's borrowing considerable sums (whether his wife knew or not) against the annuity, indicate that Ipswich, with all its charms, was not going to supply a living.[25] In consequence, having made an exploratory trip in the early autumn of 1758, the Gainsboroughs repaired to Bath in 1759.

This was a calculated move. There was little in the way of artistic competition in Bath,

and Gainsborough made sure he would impress potential patrons with his newly-developing cosmopolitan sophistication. Gainsborough had evidently been alert to the possibilities of the more suggestive style of handling that the portraitist Allan Ramsay (1713–1784) had been developing from a study of French pastel technique, learning how a hatched manner would oblige the spectator perceptually to complete painted imagery, which, in turn, would involve more direct involvement with the paint surface than with the far harder and 'licked' portraiture of Reynolds and others (see cats.62 and 106). In 1758 he was painting the convivial Colchester attorney William Mayhew (Art Gallery of Western Australia) in this manner, and that March wrote:

> *You please me much by saying that no other fault is found in your picture than the roughness of the surface, for that part being of use in giving force to the effect at a proper distance, and what a judge of painting knows an original from a copy by; in short the touch of the pencil, which is harder to preserve than smoothness, I am much better pleas'd that they should spy out things of that kind, than to see an eye half an inch out of its place, or a nose out of drawing … I hope, Sir, you'll pardon this dissertation upon pencil and touch, for if I gain no better point than to make you and Mr. Clubb laugh when you next meet at the sign of the Tankard, I shall be very well contented.[26]*

And by the time that Gainsborough had arrived in Bath later in 1758, his tactics were bearing fruit. The Poet Laureate, William Whitehead, noted: 'We have a painter here who takes the most exact likenesses I ever yet saw, his painting is coarse and slight, but has ease and spirit.'[27]

Gainsborough's years in Bath, from 1759 to 1774, saw his artistic maturation, as he mastered his medium and became increasingly experimental in his imagery and techniques. Within relatively easy reach of the city were such country seats as Wilton, with its famous collection of portraits by Sir Anthony Van Dyck (1599–1641), and Gainsborough accordingly embarked on a concentrated study of that artist's work. The lessons learnt were apparent as early as 1760 in the portrait of Ann Ford (cat.35). The significance of these years in the artist's personal development can hardly be overstated; they also saw him at the very heart of Britain's burgeoning luxury culture.[28]

The imperial and mercantile advances of mid-century were consolidated by Britain's victory in the Seven Years' War (1756–63), which created an empire of unprecedented proportions. Through the 1760s and early

Thomas Gainsborough: Art, Society, Sociability

1770s the moral condition of this newly wealthy and powerful empire became the subject of increasing concern. Fashion, fripperies and fun seemed to be consuming the nation, and the old social order appeared to be falling apart: 'The constitution of this country, from the effeminacy of our manners, and from the luxury of our entertainments, seems not to rest on a permanent foundation. True nobility *now* consists in splendid titles, gay equipage, and princely palaces', while a rampant 'middle class' sought 'to acquire respect and esteem from the vulgar'.[29] A writer in 1773 noted that just five years previously tea, coffee and chocolate were luxuries available to only the wealthiest, but were now consumed by everyone: 'We send to the East and West Indies to furnish our poor with their breakfasts.'[30]

Bath, second only to London as a centre for music, theatre and socialising, and benefiting from its famous health-giving baths and rural setting, was attracting tourists from the upper reaches of society: elderly peers with their mistresses, actresses, musicians, socially aspirant businessmen, young gents with time and money to spare – a cast of types gently satirised by Robert Dighton (fig.9). What they sought there was, as this poet of the time wryly notes, a short-cut to fashionable gentility:

> Bath demands, and Bath deserves my praise!
> Bath! the divine Hygeia's favoured child,
> Where Pigs were once, and Princes now are boil'd;
> Where Arts and Elegance have fix'd their seat,
> And Graces ply – like chairman – in the street;
> Where free from lingr'ing Education's plan,
> By which the Brute is polish'd into Man,
> We learn a shorter and more pleasing road
> And grow (like beef) by stewing – Alamode.[31]

The very mix of types in the city engaged in these pursuits was sometimes viewed with misgivings. The poet continues to note the presence of peers, 'nabobs' (British businessmen and adventurers returned from colonial India where they made their fortune) 'rich in ev'ry thing but sense' and beaux 'to teach us graces, and to kick our shins'.[32] Tobias Smollett in his novel *Humphrey Clinker* (1771) described the 'Clerks and factors from the East Indies, loaded with the spoil of plundered provinces; planters, negro-drivers, and hucksters, from our American plantations … agents, commissaries, and contractors … usurers, brokers and jobbers of every', men of 'low birth' who had become engorged by the wealth created in imperial expansion and who 'hurry to Bath because here, without any further qualification, they can mingle with the princes and nobles of the land'.[33]

In Bath Gainsborough was able to paint high society at its most fashionable and celebrated, and he was able to socialise with, as well as depict, his favoured company of musicians and theatrical types. Here he painted the famed actor James Quin in his retirement; David Garrick, the most famous actor of the day; the musically talented Linley family; and a range of gentlemen and ladies in all their finery (see cats.39, 49 and 80). The suspect qualities of fashionable living are effectively submerged into an image of high glamour, although we should note the difficulties in painting Ann Ford (cat.35), whose musical performances were considered as going beyond the bounds of good taste, and the presence of a jokey culture of masculine conviviality apparent in his portrait of, for instance, Lord Vernon (cat.41). Moreover, we should bear in mind that such families as the Tudways, whom Gainsborough painted on a number of occasions during his years at Bath, derived their wealth in part from plantations in the West Indies (see cat.66).

William Whitehead's judgement of Gainsborough highlights the implicitly social risks the artist was taking, having to balance out coarseness and slightness with ease and spirit, and thus becoming obliged to infuse his work with rather more finesse and elegance. Mr Booby in Richard Graves's comic novel, *The Spiritual Quixote* (1773), gave a critical account of Bath that highlights the delicate nature of living in high society there:

> The pleasures of Bath *indeed! … It is a tedious circle of unmeaning hurry, anxiety and fatigue: of fancied enjoyments and real chagrins: – to-day one is in vogue, and Lord knows why; tomorrow deserted, and equally without reason. In the former case, one is pestered and distracted with variety of enjoyments; in the latter, left prey to melancholy, and the disagreeable reflections on the slights we meet with. Such indeed is the spirit of public places.*[34]

Gainsborough appears to have adapted to this environment with the greatest success, and remained 'pestered and distracted' with work throughout his years in the city. In 1761 he began to send work to the exhibition of the Society of Artists, and this he selected with much care. *Robert Craggs* (cat.36) was a prominent political figure displayed in a pose of relaxed insouciance that would itself have attracted notice as Gainsborough's own invention. In 1763 *James Quin* (cat.39) represented a famous sitter and was appreciated widely for the extraordinary likeness. Indeed, the inception of public exhibitions meant that artists had to be thoroughly strategic in selecting exhibits, and Gainsborough preferred to be represented by striking full-length portraits, preferably of well-known personalities. As we know from prints of early exhibitions, conditions therein were inimical to those who painted on the smaller scale, or whose manner would not stand up to being surrounded by harder and brighter works, and for Gainsborough there were tensions from

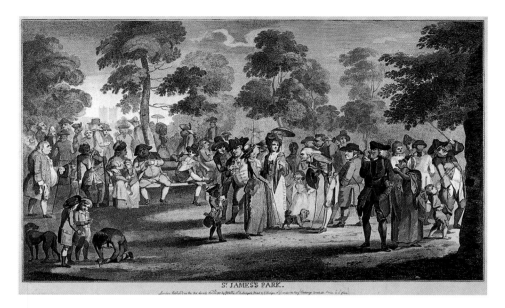

ST JAMESS PARK.

Figure 10
Henry William Bunbury
St James's Park 1783
Engraving on paper, 40 × 64 (15¾ × 25¼)
Guildhall Library, Corporation of London

1770 poem, *The Deserted Village* (see cat.131). The paintings in which the dispossessed poor are represented as always on the move, and where, in the decline of the moral economy, charity is denied, share this ethos. Gainsborough's improvising on these themes in drawings as much as in paintings indicates both his real concern with what was going on and the unique role that drawing played in his art. Normally drawing was used for preparation and held to be inferior to the finished painting, although writers such as the French theorist Roger de Piles or Sir Joshua Reynolds maintained that, to the practised eye, the slightest of drawings could inspire enormous pleasures of the imagination. With Gainsborough – and it is important to notice this – there is parity between painting and drawing. Or there is in all genres save for the portrait, for there he tended to paint straight on to canvas and make and amend mistakes as he went.

By the late 1760s Gainsborough's reputation was such that he was invited to be a founder member of the Royal Academy. That he accepted, knowing that this would alienate his old friend Joshua Kirby (1716–1794), the then president of the Society of Artists, from whom the new Academicians had seceded, indicates his awareness that it would be professional suicide not to be associated with the new institution. Although he exhibited with them at their first exhibition in 1769 (including a glamorous portrait of Isabella, Viscountess Molyneaux, cat.44), and for the three years following sent in a parade of fine portraits and more experimental landscapes, the association was not easy. Art criticism as a genre was now beginning to emerge, and no artist could be guaranteed a positive reception. Moreover, as his comments to Stratford in 1771 showed, he was acutely aware of the unfavourable hanging conditions that prevailed at the Academy. The experimental drawings in imitation of paintings he showed in 1772 were, in effect, a challenge to the Academy's hierarchy, which would rank finished paintings above drawings or watercolours which could be 'only' studies or sketches (cat.132). In 1773 he stopped exhibiting with them.

the start. The annual exhibitions, from 1760 onwards, caused a revolution in British artistic practice. From attracting private clients and building up networks as had previously been usual, painters now were able to show competitively in conditions that made their chances of being well received something of a lottery.[35] Gainsborough preferred to exhibit larger portraits for the simple reason that they were big enough to be seen. In 1771 he complained to the Hon. Edward Stratford, who had just commissioned half-length portraits from the artist, that 'I wish that yours and Mrs Stratfords Portraits had been whole lengths that I might have Exhibited you, & have got Credit; but half lengths are overlook'd in such a Monstrous large Room and at a Miles Distance'.[36] What he did exhibit that year was a large and extraordinarily striking pair of portraits, of the Ligoniers (cats.46–7). If they were then going through a spectacular trial for 'criminal conversation' – she had been carrying on a liaison with the Italian dramatist, Vittorio Alfieri – then so much the better for attracting attention.

So central was portraiture to his practice at Bath that, until the later 1760s, Gainsborough seems to have let his landscape practice slip. His landscapes from the end of the 1750s had shown him advancing in his abilities and in his ambitions (see cats.31–3). When he returned to this subject matter in force in the late 1760s, it was with a reinvigorated desire to experiment and a new attention to the widely reported changes in rural life. The easy actualities of early landscapes, where such events as we might imagine to have typified the common economy of the Suffolk woodland were represented within localised scenery, gained an edge in the later 1760s, as the debate over the enclosure movement inspired such statements oppositional to the incipient cash economy as Oliver Goldsmith's

The following year the Gainsboroughs removed to London, very possibly because he would get regular access to potential clients (Joseph Wright, who moved to Bath to fill his shoes, reported that business had become very slack). It is interesting that, in this respect, he confirmed his detachment from his fellow artists, who lived mainly around Leicester Square and Soho, by establishing himself in Schomberg House, Pall Mall. Taking a house in Pall Mall was well established as a means of marking one's social ascendancy. Convenient for St James's Palace, and the

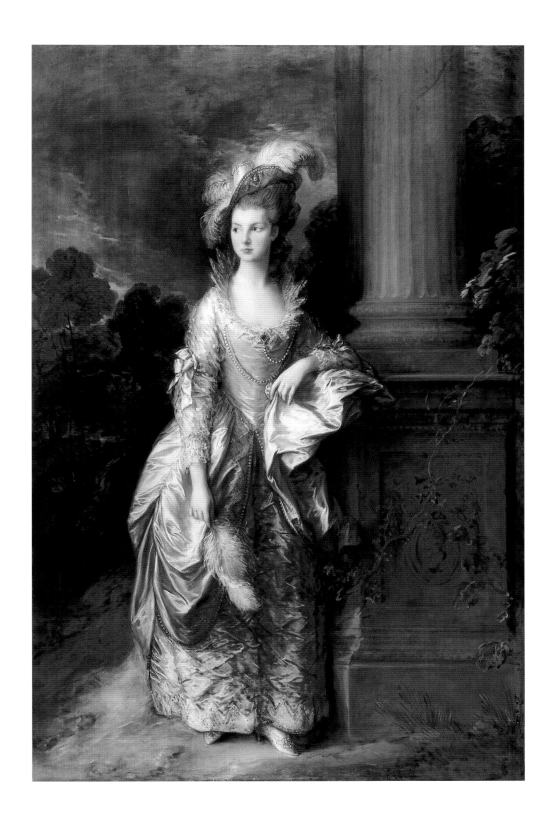

shops, clubs and entertainments of the West End, it was closely associated with both the court and fashionable life. Furthermore, St James's Park offered a setting that was, surprisingly for anyone familiar with the area now, noted for its 'rustic simplicity'; indeed, 'Cows feed on the turf, and you may buy their milk quite freshly drawn from the animal' for a penny a cup.[37] Here gathered a 'pretty pleasing fascinating throng', the social mix of predatory women, silly old men and effete young fops satirised by Bunbury (fig.10).[38] High life and low morality mixed freely at St James's, as Gainsborough must have been only too aware: from 1780 his neighbour at Schomberg House was the sex therapist Dr Graham, whose dubious practices and supposedly health-giving 'Grand Celestial State Bed' were dismissed by Horace Walpole as 'the most impudent puppet-show of imposition I ever saw'.[39]

When, in 1777, Gainsborough did return to the Academy exhibitions, he orchestrated the event with some care. He ensured that he was represented by works which showed him at his most inventive and spectacular. *Mrs Graham* (fig.11) was a full-length portrait of one of the most glamorous celebrities of the day, and *Carl Friedrich Abel* (cat.50), musician and personal friend, a brilliant exercise in colourism. Contemporaries such as Horace Walpole recognised the Rubensian in *The Watering Place* (cat.51). And in addition to these were full lengths of the Duke and Duchess of Cumberland, to show that he was attracting patronage from the royal family. If this were not enough, Gainsborough now had guaranteed support in the press, from his friend, the journalist and editor the Revd Henry Bate (later Bate-Dudley). The fact that he only re-exhibited once he had guaranteed journalistic support points to the extremely competitive nature of the art world. Painters would use journalists to write partisan reviews, alerting their readers to what was worth looking at on the crowded walls of the exhibition rooms or which artists surpassed their peers, and supplying in effect an alternative exhibition, one that would predispose people to share their own, sometimes self-serving, judgements.[40]

Relations with the Royal Academy continued to be relatively smooth for some six years. The range of Gainsborough's exhibits widened, including more elaborate landscapes and seascapes to exemplify his invention. He enjoyed an intimacy with George III and began to get further commissions from members of the royal family, most notably the grand full lengths of the king and queen exhibited in 1781. In 1783, by when he was perceived as *de facto* court painter, he had to remind the Hanging Committee of the exhibition that they might

not wish to displease the king when dictating the place in which his extraordinary composite portrait of fifteen oval heads of the monarchs and their offspring should go. This he thought necessary because it was the rule that full-length works (and larger) should be hung 'above the line'; that is, with the bottoms of their frames level with the cornice that ran along the rooms of Chambers's Great Room at Somerset House. For paintings that relied on their effect for delicacy and finesse this was death, and Gainsborough knew it. The following year he attempted again to dictate where a portrait of the three eldest princesses should go, one that had been calculated to hang five feet from the ground. This time the commission came from the Prince of Wales, and the demands were confidently ignored. So, where in 1783 he had written to Francis Milner Newton, Secretary to the Royal Academy, 'hang my Dogs & my Landskips in the great Room. The sea Piece you may fill the small Room with', in 1784 he was to write to the Hanging Committee that he had

> painted this Picture of the Princesses in so tender a light, that notwithstanding he approves very much of the established Line for Strong Effects, he cannot possibly consent to have it placed higher than five feet & a half, because the likeness & Work of the Picture will not be seen any higher; therefore at a Word, he will not trouble the Gentlemen against their Inclination, but will beg the rest of his Pictures back again.[41]

This time he was not to exhibit at the Academy again, preferring to display his works under favourable conditions in his own painting room. And, to add insult to injury, on the death of Allan Ramsay, the King's Painter, in August 1784, Reynolds moved heaven and earth to get the post, to Gainsborough's very great chagrin. As Reynolds was President of the Royal Academy (fig.12) and the most prolific and famous painter of the day (Gainsborough only excepted), the king must have felt obliged to grant him the honour. But his artistic programme was quite different from Gainsborough's, and out of keeping with George III's personal preferences.

Reynolds understood his brief to be the promotion of a serious national art. Developing his theories within the context of an aesthetic debate that had been carrying on since the Renaissance and had been concerned to establish the fine arts as liberal— that is, as liberated from the stigma of un-intellectual craftsmanship—he took it as axiomatic that intellectualised line had to be privileged over sensual colour and that the subjects to be preferred were those that addressed the mind with elevated ideas. These last were quintessentially to be had

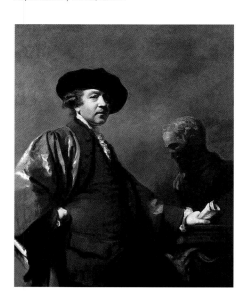

Figure 12
Joshua Reynolds
Self-Portrait in Doctoral Robes 1780
Oil on panel, 127 × 101.6 (50 × 40)
Royal Academy of Arts, London

Thomas Gainsborough: Art, Society, Sociability

from great historical subjects, for it was these that addressed the major moral issues. He understood, too, that it would be essential for British artists to learn a great deal if they were ever to produce work that would get anywhere near rivalling the great art of Raphael and Michelangelo. His academic lectures – the *Discourses* – were concerned to stress the imperative of learning from pre-existing art, assimilating the canon, as a prerequisite to developing the capacity to supply a great imperial nation with the public art it was so obviously lacking. In this scheme of things Reynolds proposed the idea of the 'hierarchy of the genres', in which landscapes, or representations of rustic figures could only occupy a low rank, and he was keen to stress that ostentatious craftsmanship or over-attention to the representations of particularities militated against the capacity of painting to stimulate important and abstracted ideas because it was too materially distracting.

Thus, in the third *Discourse*, delivered in December 1770, Reynolds spoke out against the draping of figures in modern fashions, articulated his theory of the various ranks of the genres of art, and decried 'a careless or indetermined manner of painting'.[42] The following year he stated that it 'is the inferior stile that marks the variety of stuffs. With [the historical painter], the cloathing is neither woollen, nor linen, nor silk, sattin, or velvet: it is drapery', and, towards the end of this fourth *Discourse*, described how portrait painting might benefit from borrowing from the Grand Style (fig.13):

> if a portrait-painter is desirous to raise and improve his subject, he has no other means than by approaching it to a general idea. He leaves out all the minute breaks and peculiarities in the face, and changes the dress from a temporary fashion to one more permanent, which has annexed to it no ideas of meanness from its being familiar to us. But if an exact resemblance of an individual be considered as the sole object to be aimed at, the portrait-painter will be apt to lose more than he gains by the acquired dignity taken from general nature. It is very difficult to ennoble the character of a countenance but at the expense of the likeness.[43]

While Reynolds may have claimed that his were disinterested sentiments grounded in authoritative theory such as were proper to deliver to rising artists, an artist such as Thomas Gainsborough would have been forgiven for interpreting them as aimed precisely as belittling the kind of art he professed. He was brilliantly skilful in the painting of clothing (generally painting it himself, rather than use a drapery painter as

was the practice of Reynolds and others), his handling of paint was uniquely distinctive, and he prided himself on his capacity to take a likeness. In 1773 William Hoare (*c*.1707–1792), the Bath-based pastel portraitist with whom Gainsborough appears to have been on genial terms, teasingly sent him a copy of the fifth *Discourse*. Gainsborough's response was that it was 'amazingly clever', but that it was 'all adapted to form the History Painter, which he must know there is no call for in this country … Therefore he had better come <u>down</u> to <u>Watteau</u> at once'.[44]

If Gainsborough's years in Bath had seen the ascendance of British imperial might, his time in London coincided with the wars with colonial America and its European allies (1775–82) that saw that empire challenged and in large part dismantled. The fundamentally fratricidal nature of the war with the Americans was the source of enormous anxiety, and the miserable years of conflict led to financial crisis and social disturbance on an unprecedented scale. The new empire that rose now was to be focused less on the settlement of English-speaking colonies, than on the exploitation of natural and human resources in lands brought under British rule by whatever means necessary. Things were hardly happier in the art world. The removal of the Academy to prestigious new premises at Somerset House in 1780 signalled its absolute supremacy, and heralded the decline and ultimate death of the other artists' groups, even though it was all too evident that the high hopes for British culture which had accompanied its foundation in 1768 (and which even drew Gainsborough in, perhaps reluctantly) were not to be realised in these straitened times. In politics (imperial and domestic) and in culture (itself, of course, political) the era after the loss of America was one of entrenchment.

One of the last works shown by Gainsborough at the Academy, *Shepherd Boys with Dogs Fighting* (cat.60), can be interpreted as offering an oblique comment on the American wars as well as a deliberate challenge to Academic hierarchies. It is an experimental painting, raising a 'low' rustic subject to the monumental scale and encompassing a range of knowing references to the Old Masters to create a work intended to show that a modern subject could also be profound, despite what the Academy taught. As such, it is exemplary of his later art. His landscapes from the 1770s and 1780s show a restless experimentation quite in defiance of academic distinctions between drawing and painting, finish and unfinished, sketch and completed work, and, in the form of his transparencies, an acute sense of the importance of lighting and optics (which could not be respected in the public exhibitions; see

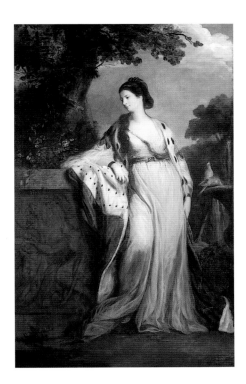

Figure 13
Joshua Reynolds
Elizabeth Gunning, Duchess of Hamilton and Duchess of Argyll 1758–9
Oil on canvas, 236 × 146 (92⅞ × 57½)
Lady Lever Art Gallery, Port Sunlight

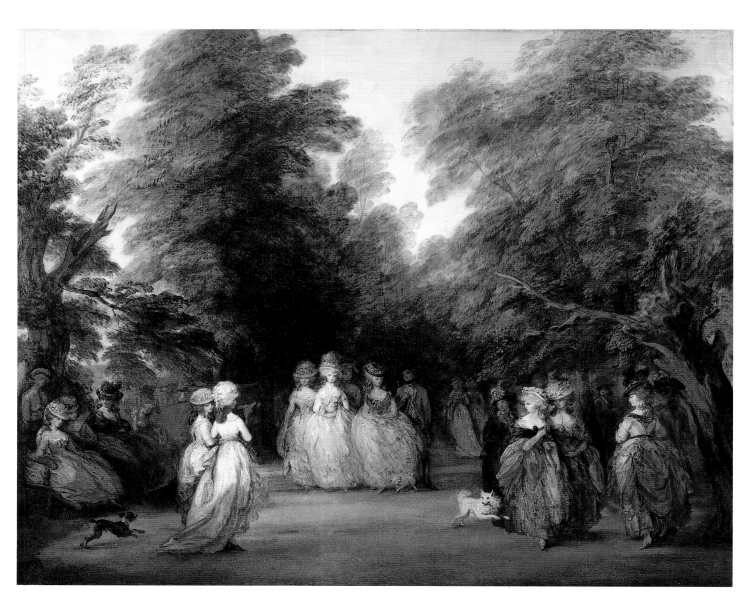

Figure 14
The Mall 1783
Oil on canvas, 120.6 × 147 (47½ × 57⅞)
The Frick Collection, New York

cats.152–6). And even if he was continuing to do rather run-of-the-mill portrait commissions on occasion, his greatest works from this era, such as the *Mrs Sheridan* (cat.166) and *Wolfran Cornwall* (cat.167), convey a profound sense of monumentality that is none the less still rooted in the Hogarthian naturalism of his youthful experience and the desire to convey a living likeness.

Gainsborough's subject pictures take on especial importance when viewed from the perspective of his continuing effort to create a viable modern art. His one classical mythology, the *Diana and Actaeon* (cat.173), took his ironic view of the staid conventions of the 'Grand Style' to its highest pitch. And two late park-scenes, *The Mall* (fig.14) and the planned 'Richmond Water-walk' (cats.90–1 and 94), represented his picturing of fashionable life taken to near-visionary levels. These may share a basic thematic vocabulary with satirical and fashionable engravings of the time (fig.10, cats.92–3) but they also convey

a sense of pictorial complexity that goes far beyond these models and becomes, nearly, an end in itself. Evoking the dreamy visions of courtly grace of Jean-Antoine Watteau (1684–1721), they show Gainsborough coming 'down' to that artist as he had ironically recommended Reynolds to do, and building a vision of the world in which perceptual and social instabilities are not denied or interrogated, but celebrated. Still bearing the traces of Hogarth's ideals, Gainsborough's last works demonstrate his desire to produce a viable modern art that was sensual as well as intellectual, pleasing as well as challenging, ingenious and well-crafted, and which, most of all, recognised and was able to represent something of the reality of the desires and dreams of modern living, however unstable these may have been. Indeed, the most significant trait of Gainsborough's art may be its finding a perceptual unfixedness that could register effectively the fluidity of the social world of his time, one that acknowledged the

Thomas Gainsborough: Art, Society, Sociability

central importance of individual subjectivity in a 'public' increasingly defined as an aggregation of private individuals rather than an elite of patricians. Moreover, these instabilities – of technique, of subject matter, of identity – at least held the promise of change, even in a society where the division between the rich and the poor could be appalling.

It was this that underpinned his painting, not the detached theories of Reynolds and the Academy. The central project of Gainsborough's art was to bring a sense of pleasure and joy into the realm of public culture while forging something that could equal and even surpass the Old Masters. That Gainsborough had recourse to irony so often in his art and in his letters reveals that he knew that these ideals would not have an easy ride. He witnessed the creation of a public for art, the confirmation that visual art could and should have an important role in Britain. How it fulfilled that role, and how its public defined itself, is another question, and Gainsborough's ideals were, by and large, disavowed. Perhaps they were unrealisable. His dynamic engagement with the techniques of his art and the possibilities of modern-life subjects was taken up by caricaturists and satirists like Thomas Rowlandson with greater conviction than the number of artists who continued literally to pastiche him into the nineteenth century. His vision of the landscape was subjected to dreamy sentimentalism and romantic anecdote, rather than being acknowledged for its experimentalism and social content. The qualities of his painting ultimately came to be seen as reflecting all too literally the caprices and whims of a long-lost world, coming at the extreme to border on kitsch, rather than forming the possible foundation of a meaningful modern art that could function in the new spaces of culture. But, as Mr Booby said of Bath, 'Such indeed is the spirit of public places.' If we recognise that, it may be that we recognise also that Gainsborough's art deserves more than nostalgia.

1 'Roger Shanhagan, *Gent.*', *The Exhibition, Or a Second Anticipation, Being Remarks on the principal Works to be Exhibited next Month at the Royal Academy*, London 1779, pp.49, 51.
2 The authors are identified in *Farington Diary*, vol.3, p.655 (1 September 1796).
3 Philip Thicknesse, *Sketches and Characters of the Most Eminent and Most Singular Persons now living*, Bristol 1770, p.96; *Town and Country Magazine*, vol.4, 1772, p.486.
4 *Gentleman's Magazine*, vol.58, July–Dec. 1788, p.754; Thicknesse considered this passage about Gainsborough's techniques so perceptive he quoted it at length (*A Sketch of the Life and Paintings of Thomas Gainsborough, Esq.*, London 1788, pp.52–4).
5 Wark, pp.257–8.
6 Shanhagan, *Anticipation*, pp.50–1.
7 Wark, p.248.
8 David Brenneman, *The Critical Response to Thomas Gainsborough's Painting: A Study of the Contemporary Perception and Materiality of Gainsborough's Art*, Ph.D. Brown University, published Ann Arbor 1995.
9 See Kay Dian Kriz, *The Idea of the English Landscape Painter: Genius as Alibi in the Early Nineteenth Century*, New Haven and London 1997.
10 Letter of 4 January 1885 in *The Works of John Ruskin*, ed. E.T. Cook and Alexander Wedderburn, 39 vols, London 1903–12, vol.37, p.507.
11 Mary Lago (ed.), *Burne-Jones Talking: His Conversations 1895–1898 preserved by his studio assistant Thomas Rooke*, London 1982, p.101.
12 Clive Bell, 'The Tragedy of Gainsborough', in R.S. Lambert (ed.), *Art in England*, Harmondsworth 1938, p.32–5.
13 John Piper, 'British Romantic Artists', in W.J. Turner (ed.), *Aspects of British Art*, London 1947, p.138; Emily Baker, *Peggy Gainsborough: The Great Painter's Daughter*, London 1909, p.57.
14 Charles Swain, *Art and Fashion: With Other Sketches, Songs and Poems*, London 1863, p.36.
15 Whitley, p.vii.
16 *Letters*, pp.39–40.
17 William Jackson, *The Four Ages: Together with Essays on Various Subjects*, London 1798, p.183.
18 *Letters*, pp.43, 72.
19 See Hayes 1982 and his introduction to *Letters*.
20 Neil McKendrick, John Brewer and J.H. Plumb, *The Birth of A Consumer Society: The Commercialisation of Leisure in Eighteenth-Century England*, London 1983.
21 Jackson, *Four Ages*, p.155.
22 Thomas Cox, *Magna Britannia*, 6 vols., London 1738; Daniel Defoe, *A Tour Through the Whole Island of Great Britain* (3 vols., 1724–6), Pat Rogers (ed.), Harmondsworth 1971, p.73.
23 *Letters*, p.116.
24 On the significance of Vauxhall and the Foundling Hospital see David Solkin, *Painting for Money: The Visual Arts and the Public Sphere in Eighteenth-Century England*, New Haven and London 1992.
25 Susan Sloman, *Gainsborough in Bath*, New Haven and London 2002, p.28.
26 *Letters*, pp.10–11.
27 William Whitehead to Viscount Nuneham, 6 December 1758, quoted in Sloman, p.38.
28 Gainsborough's period in Bath is the subject of Susan Sloman's major study, *Gainsborough in Bath*. See also Dulwich Picture Gallery, *A Nest of Nightingales: Thomas Gainsborough 'The Linley Sisters'*, exh. cat., London 1988, and Michael Rosenthal, *The Art of Thomas Gainsborough: 'a little business for the Eye'*, New Haven and London 1999, pp.23–51.
29 'Modern Manners', *London Magazine*, vol.42, 1773, p.30.
30 'Lively Portrait of the Fashion Luxuries', *London Magazine*, vol.42, 1773, pp.68–71.
31 George Ellis, *Bath: Its Beauties and Amusements*, Bath 1777, p.3.
32 Ellis, *Bath*, p.6.
33 Tobias Smollett, *Humphry Clinker* (1771), Angus Ross (ed.), Harmondsworth 1967, pp.65–6.
34 Richard Graves, *The Spiritual Quixote*, 3 vols., London 1773, vol.1, pp.301–2.
35 On the old networks, see Louise Lippincott, *Selling Art in Georgian London: The Rise of Arthur Pond*, New Haven and London 1983.
36 *Letters*, p.83.
37 Pierre Jean Grosley, *A Tour to London*, trans. Thomas Nugent, 2 vols., London 1772, vol.1, p.80; Carl Philip Moritz, *Journeys of a German in England in 1782*, trans. Reginald Nettel, London 1965, p.29.
38 John Wolcot, 'Ode to A Margate Hoy', in *The Works of Peter Pindar*, 4 vols., London 1816.
39 Letter to the Countess of Ossory, 23 August 1780, in W.S. Lewis (ed.), *The Yale Edition of Horace Walpole's Correspondence*, 48 vols., Oxford and New Haven 1937–83, vol.33, p.217.
40 On the exhibitions and art criticism see the essays in David Solkin (ed.), *Art on the Line: The Royal Academy Exhibitions at Somerset House, 1780–1836*, New Haven and London 2001. For a detailed account of the reception of Gainsborough's landscapes see Brenneman.
41 *Letters*, pp.148, 160.
42 Wark, p.52.
43 Wark, pp.62, 72.
44 *Letters*, p.112.

Gainsborough in his Painting Room

Rica Jones and Martin Postle

Thomas Gainsborough's career was marked by a series of decisive geographical re-locations – from Sudbury to London, to Sudbury and Ipswich, then to Bath and finally back to London. These geographical shifts were accompanied by significant changes in his technique and in his painting environment. Gainsborough's own letters, and a number of early accounts, provide many useful clues about his working methods, as well as revealing his concern with the lighting and space of his painting rooms. In recent years a number of important studies on Gainsborough's painting technique and on the location and layout of his different painting rooms have allowed us to form a much fuller picture than ever before.

Gainsborough began to attain some sort of artistic proficiency at an early age. Before he left for London at the age of thirteen he was practised in making sketches in pencil from nature, and had apparently some experience of painting in oils. Henry Bate maintained that he painted 'several landscapes from the age of ten to twelve'.[1] He also made portraits. To date the only evidence of this practice is a small portrait on paper of a boy, aged twelve to thirteen years old, holding a brush and palette, which may plausibly stand as the artist's earliest self-portrait (cat.1). The role played by Gainsborough's early portraits in determining his choice of career was later noted by the artist's niece, who recalled that 'an intimate friend of his mother's being on a visit was so struck by the merit of several heads he had taken, that he prevailed on his father to allow him to return with him to London, promising that he should remain with him and that he would procure him the best instruction he could obtain'.[2]

London in the 1740s provided a most fertile climate for a young artist of talent. Several factors had helped create this situation.

Encouraged by a royal court that favoured foreign painters, London had long since thrown off any restraints that might be imposed by a guild. The rule of the Company of Painter-Stainers was confined to the City of London and even there it was restricted by this time largely to the trades of painting.[3] As a consequence no young person was obliged to undergo a long, formal apprenticeship in order to be able to practise as a painter; and few of them did. Undoubtedly this undermined the studio tradition, which had imparted such profound knowledge of methods and materials, but it did not kill it off. In diminished form the tradition continued under other guises, giving the student sufficient knowledge to produce a largely durable picture, while allowing him the freedom from restraint to develop his own personal style and technique, if he wanted. In default of studio training or a formal academy, the practice of painting was now underpinned by artists' colourmen, evening academies, manuals of painting and word of mouth. By the 1740s colourmen could and often did provide the painter with everything he required – primed canvases, stretchers, brushes, colours ready-ground, varnishes in bottles.[4] Manuals of painting appeared throughout the eighteenth century. Evening academies taught drawing from the model, and at the same time the student probably picked up a wealth of technical information from informal discussion among the participants. Finally, the newly established auction rooms and access to private collections opened the students' eyes to the traditions of painting on the Continent. In response to this free and stimulating environment, the techniques underlying any particular style of painting could become personal. By the 1740s no two major British portrait painters were using the same

technique to produce a face.[5] Moreover a unique technical device, such as Allan Ramsay painting the face bright red before applying more naturalistic colour, could engage fickle public attention and hold it at least for a while until it strayed elsewhere.[6] Nothing of this opportunity and variety was to be lost on the young Gainsborough.

In London Gainsborough initially lodged with a silversmith, a man 'of some taste', from whom he 'was ever ready to confess he derived great assistance'.[7] He may also have introduced Gainsborough to his master, the designer and illustrator Hubert-François Gravelot. Under Gravelot Gainsborough studied alongside the engraver Charles Grignion (1721–1810) 'and several others, at his house in James Street, Covent Garden, where he had all the means of study that period could afford him'.[8] Here Gainsborough would have honed his drawing skills by assisting with decorative book illustrations and related design projects. He may also have learnt the rudiments of engraving from Grignion, since Gravelot was apparently not skilled in this particular art form.[9] Nor is there any evidence that Gravelot was involved in teaching Gainsborough how to paint.[10] Gravelot's business was located at the sign of the Pestle and Mortar, immediately to the north of Covent Garden and a stone's throw from the St Martin's Lane Academy (fig.15), where Gravelot gave instruction in life drawing, alongside Francis Hayman, Louis-François Roubiliac and William Hogarth. According to Henry Bate, Gravelot, 'who was also his patron', introduced Gainsborough to the St Martin's Lane Academy, where, as Philip

Thicknesse stated, Gainsborough 'greatly improved his natural talents'.[11] Even so, Gainsborough is not mentioned among the lists of subscribers to the St Martin's Lane Academy, and it is quite possible, as William Whitley first surmised, that he spent comparatively little time studying there.[12]

At some point in the early 1740s Gravelot introduced Gainsborough to Francis Hayman, from whom the younger man clearly learned much about painting. In the nineteenth century Hayman's influence upon Gainsborough was dismissed as slight. 'From such a man,' concluded his biographer, 'Gainsborough could learn little of painting and less of morality.'[13] The association between the two artists was, however, of vital importance, even though it did not take the form of a traditional master–pupil relationship. At that time Hayman's painting practice was based in Drury Lane, not far from Gravelot. His reputation was far greater than it is today, not so much as a portraitist but as a painter of literary and historical subjects, and as a mover and shaker in the capital's artistic community.[14] Hayman offered Gainsborough varied opportunities: they collaborated on portrait commissions and very probably on his various decorative schemes, including the large series of 'supper box' paintings for Vauxhall Gardens.[15] A number of Hayman's paintings of the 1740s are thought to contain figures by Gainsborough, including his *Children Building Houses with Cards* of *c.*1743 (Hamsterley Hall, Durham). He also painted the landscape background in at least one of Hayman's portraits, *Elizabeth and Charles Bedford* of 1746–7 (fig.16).[16] Given the fact that

Gainsborough modelled his early portrait style upon Hayman, and the collaborative nature of their relationship, it is especially important to consider not only the technical similarities between these two painters but the aspects of his painting method that set Gainsborough apart from even his closest contemporaries.

The characteristic technical features of Gainsborough's early landscapes and conversation pieces can be illustrated in the case studies described below.[17] The canvas supports are all primed with grounds toned in shades of grey, pink or orange. These primings are composed of lead white and chalk with varying amounts of black and ochres, all bound together in oil. The high proportion of chalk would have given a slightly absorbent surface once dry. The priming mixture was applied in two or sometimes three coats, the final layer usually having a finely striated surface – two or three grooves per millimetre – caused by the brush or trowel used to apply it. A close-up detail (fig.17) of Ann Gravenor from *The Gravenor Family* of 1752–4 (cat.20) shows the ridges running horizontally. This ridged, absorbent surface would have given useful purchase to a swiftly moving brush. The paint is sometimes only a brushstroke thick; there are rarely more than two superimposed strokes.[18] At Ann's shoulders and in the ribbon there are traces of the initial drawing; it was the merest sketch of a few outlines made with a fine brush and brown paint, but, where they were left visible, the lines play their part in our reading of the figure because Gainsborough's whole conception of form is graphic.

Analysis of the paint reveals that Gainsborough favoured translucent pigments over opaque and composed his colours from very complex mixtures of different pigments. A shade of green in foliage, for example, may contain black, terre verte, Prussian blue, yellow, red or brown ochres, Naples yellow, yellow lakes (translucent yellows made from plant dyes) and occasionally orpiment. Some of the pigments are so coarsely ground that large particles or clumps of them may be seen on the surface of the painting with the unaided eye, as in fig.18, a detail from *Wooded Landscape with a Cottage, Sheep and a Reclining Shepherd* of c.1746–7 (Paul Mellon Collection, Yale Center for British Art, New Haven). At very high magnification a noticeable feature of the paint is a large proportion of colourless, transparent filler in the mixture. This is usually ground glass or very pale smalt, which is itself a blue glass finely ground. The transparent filler ensures maximum access of light into the paint-film, giving a bright effect. Another effect may have been to hasten the drying of the oil without imparting to it the yellow colouring of other drying agents or siccatives.[19] Gainsborough

mainly used untreated linseed and poppy oils in these paintings.[20] The attraction of each would have been that they are virtually colourless and remain so as time passes, but both are very slow driers. Furthermore, most of the translucent pigments are also slow driers in oil.

In some ways Gainsborough was working well within contemporary practice. From the 1730s to the 1750s the grounds in British paintings were usually grey with ridged surfaces; they were probably the products of colourmen.[21] Most artists in this period used

Figure 18
Detail from **Wooded Landscape with a Cottage, Sheep and a Reclining Shepherd** c.1746–7
Paul Mellon Collection, Yale Center for British Art, New Haven
The dotted highlights in the foliage are large particles of orpiment in the green paint mixture.

complex mixtures of different pigments. The old-established method of applying an opaque body-colour, and glazing it once dry with a translucent colour to enrich, alter or deepen its tone, was largely giving way to more simple applications composed of opaque and translucent pigments mixed up together. Two features of Gainsborough's work, however, stand out as significant departures from the norm, the first being his use of orange grounds. To date there is no precedent in British painting for these. The earliest dated one we know of is Gainsborough's *The Charterhouse* of 1748 (cat.6).[22] That this was a deliberate choice on his part is evident when it is compared with the other seven roundels from the Court Room at the Foundling Hospital. These are all on an identical pale grey ground and the canvases were cut from the same roll. By contrast, *The Charterhouse*, though its original stretcher is exactly the same as all the others, is on a finer canvas primed with a pinkish-orange ground (fig.19). The inspiration for the colour of the ground, along with the style of the composition, probably came from an awareness of seventeenth-century Dutch paintings, many of which were being sold on the London art market.[23] Gainsborough is recorded as having repaired one and added figures to another.[24] He would not have needed magnifying aids to see orange grounds in some Dutch landscapes – they were often left visible here and there in the

Figure 17
Detail of Ann Gravenor from **The Gravenor Family** c.1752–4 (cat.20)

Figure 19
Detail from **The Charterhouse** 1748 (cat.6), showing the orange ground deliberately left visible around the tree trunk.

Figure 20
Fragment of green paint from **The Revd John Chafy Playing the Violoncello in a Landscape** *c.*1750–2 (cat.22)
Photographed through the microscope at ×240 magnification.

Figure 21
Fragment of green paint from *Francis Hayman* **Wrestling Scene from 'As You Like It'** *c.*1740–2
Tate
Photographed through the microscope at ×240 magnification.

composition and were the source of the underlying warm glow in the thinly painted brickwork. Both these features are visible in *The Charterhouse*. Grey or orange were Gainsborough's choice until about 1752–3, after which orange, dark pink, tan or red became his standard grounds more or less until he left Bath. His contemporaries did not follow suit, with one exception: Hogarth, who employed dark or beigey greys throughout his career, chose an orange ground very similar to that of *The Charterhouse* for *O The Roast Beef of Old England* (Tate), also done in 1748 but later in the year.[25] It has been confidently assumed that Hogarth invited the young painter to participate in the Foundling Hospital scheme, and Gainsborough's pictorial debts to Hogarth have been extensively explored.[26] Perhaps *The Roast Beef*'s ground indicates how deeply impressed Hogarth was with the work of the twenty-year-old painter.

The second unusual feature is the translucency of his paint, best illustrated by comparison with Hayman, whose work does not share this characteristic. Fig.20 is a highly magnified fragment of paint from green foliage in Gainsborough's *Revd John Chafy Playing the Violoncello* (cat.22), and fig.21 a fragment of green foliage from Hayman's *Wrestling Scene from 'As You Like It'*. Both contain a very similar range of pigments, but the Hayman sample contains less transparent filler, the pigment particles are generally smaller and there is a much larger proportion of white lead in the mixture. As can be seen in the illustration, this helps form an opaque body in which individual coloured pigments are not so accessible to light. The resulting overall colour, therefore, is less intense and a whole palette made up in this way would be unvaried in terms of translucency and opacity.

In these paintings Gainsborough exploited the optical as well as colouristic values of his pigments. We can be sure that the comparatively small amount of white lead in the paint was of his own choosing, as an increased amount would have made it visibly more opaque; but, in spite of the advantages of increased brightness and reduced drying time, we do not know whether he was also aware of the significant amounts of glassy material in his paint. He may have been buying dry pigment adulterated with it or an inexpensive ready-made paint extended with it. At this period only one manual of painting in English made reference to ground glass and it does not appear to have been in wide circulation.[27] On the Continent, however – particularly in the Netherlands – the use of glassy filler seems to have been part of the studio tradition, and there is a possibility that the knowledge was brought to England by itinerant Netherlandish painters or artists' colourmen.[28] It has been suggested that as a

child Gainsborough worked in Suffolk with immigrant Dutch artists, though there is incomplete documentary evidence for this.[29] It is not impossible, however, that sometime in his training days he came into contact with artists who knew about this tradition at first- or second-hand, and passed on the knowledge. It is certain, however, that the working properties of this type of paint gave the effects that Gainsborough required within the small scale of his canvases, and that with it he honed his personal style and skills to a fine degree. The light touch, glowing colours, graphic brushwork and varied surface of *The Gravenor Family* (cat.20) and *Mr and Mrs Andrews* (cat.18) became the hallmarks of his style at all periods, whatever the type or scale of picture.

Gainsborough's independence as a painter, demonstrated by his innovative technique, is also confirmed by the pattern of his professional life during the 1740s. In the nineteenth century it was stated that 'after a short and unprofitable residence with Hayman he hired rooms with a Mr Jorden'. Recently, David Tyler has confirmed that from 1743 or 1744 Gainsborough lodged with a certain John Jorden of Little Kirby Street, off Hatton Garden.[30] Since Gainsborough probably occupied only a couple of rooms in Jorden's house, there must have been limited space in which to paint and little opportunity to display his work. Following his marriage in July 1746, with consequent access to his wife's sizeable annuity, Gainsborough sought more spacious accommodation; and in the spring of 1747 the couple moved into a house in nearby Hatton Garden. By this time his wife Margaret had probably already given birth to their first child, a daughter who evidently died in early childhood.[31] The house at no.67 Hatton Garden was comparatively spacious, with a reasonably sized garden. Gainsborough would have been able to set up a modest painting room; he may even have used one of the rooms to display his pictures. It is more likely, however, that he advertised his work principally through dealers, notably the Suffolk-born Panton Betew (d.1799), whose premises in Old Compton Street, Soho, acted as Gainsborough's shop window.

By the later 1740s Gainsborough was evidently spending extended periods in Suffolk, as is suggested by Hayman's comment to a portrait client that he would 'have an opportunity of getting the landscape done by Gainsborough whilst he is in Town'.[32] Early in 1749 Gainsborough gave up the house in Hatton Garden and returned with his wife to Sudbury.[33] It was common for young artists, having gained experience in the capital, to return home in order to exploit their local connections. As the artist's friend Philip Thicknesse stated, Gainsborough at this point

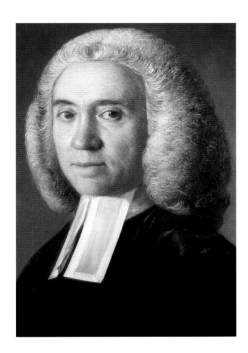

Figure 22
Detail from **Portrait of Reverend Richard Canning** 1757
Oil on canvas 74 × 62 (29⅛ × 24⅜)
Ipswich Borough Council Museums and Galleries. Acquired
with the assistance of the National Art Collections Fund

probably considered himself as no more than 'one, among a crowd of young Artists, who might be able in a country town (by turning his hand to every kind of painting) [to] pick up a decent livelihood'.[34] Sudbury, however, was not a mine of artistic patronage, and the three years Gainsborough spent living in Friar's Street proved among the most unprofitable of his entire career. Even so, it was in Sudbury that his two daughters were born: Mary in February 1750 and Margaret in August 1751. In November 1751 Gainsborough sought a loan of £400 on his wife's annuity, and the following summer they moved to Ipswich.

In Ipswich Gainsborough rented a spacious house with a garden and stabling, situated in Foundation Street, opposite the Shire Hall, near the harbour. Previously the home of a clergyman, it was well appointed with 'a Hall, and two Parlours, a Kitchen, Wash-house, with a Garden and Stable, good cellars, and well supply'd with Cock-Water, five Chambers and Garrets, with other Conveniences'.[35] One of these two parlours presumably served as Gainsborough's painting room. Something of its atmosphere can be gleaned from the following description by Philip Thicknesse: 'Mr. Gainsborough received me in his painting room, in which stood several portraits, truly drawn, perfectly like, but stiffly painted, and worse colored, among them was the late Admiral Vernon's … but when I turned my eyes to the little landscapes and his drawings, I was charmed'.[36] The life-size portrait of Admiral Edward Vernon of Nacton, Suffolk (cat.25), painted in 1753, was among Gainsborough's most prestigious commissions to date. It did not, however, signal an upturn in business, since the money he received was used merely to stave off mounting debts.[37] Despite the prosperity enjoyed by Ipswich and its environs, Gainsborough found it hard to make ends meet: at this time, it has been calculated, he produced no more than seven or eight portraits a year.[38] By contrast, in 1755 Reynolds painted over 130 portraits in his London studio.[39] With so few commissions Gainsborough, even if he had wanted to, did not have the opportunity to operate the 'production-line' portrait business that Reynolds ran so successfully, with his growing entourage of pupils, assistants and drapery painters. During his time in Ipswich Gainsborough worked entirely on his own, although in 1759 he took on a pupil, William Kirby (c.1743–1771), the son of his close friend, Joshua Kirby.[40] The relationship was short-lived: Kirby disliked Gainsborough as a master and soon moved on.[41]

The Ipswich clientele, though in short supply, demanded portraiture on a larger scale than was general among Gainsborough's connections in London or Sudbury. Here he produced mainly half and three-quarter lengths, in both of which the head approaches life-size. Clearly the succinctly accomplished brushwork of Ann Gravenor's head, which measures about four centimetres (1⅝in) long on the canvas, could not be scaled up to life-size without significant loss of subtlety and legibility. In Ipswich Gainsborough's brush at first searches hesitantly for new ways of applying paint to create a likeness, and the method he settled on in the mid- to late 1750s can be seen in a detail from his late 1750s portrait of Richard Canning (fig.22). The paint was applied in strong hatching strokes, many following the contours of the face, and it has been suggested that Ramsay's portraits were the inspiration for this approach.[42] Since Ramsay was so successful in London during Gainsborough's years there, this is the most probable explanation, though it is not impossible that Gainsborough also had the work of Sir Godfrey Kneller (1646–1723) in mind when evolving this technique. Some of the portraits of the Kit-cat Club, for example, display a vigorous hatching technique in the flesh tones, and it is interesting that Gainsborough, writing in 1758, cites Kneller to justify 'the roughness of the surface' of his own paint at close quarters: 'Sir Godfrey Kneller used to tell them that pictures were not made to smell of; and what made his pictures more valuable than others with the connoisseurs was his pencil or touch.'[43]

Through a nineteenth-century descendant of Gainsborough's great friend, Joshua Kirby, we have a glimpse of how his landscapes were created during these years. The painting under discussion, *Landscape with Gypsies* of about 1753 (fig.23), was commissioned by an Ipswich gentleman. 'When about two-thirds of it were finished – for Gainsborough in his early works, owing to his great execution, finished as he went on', the gentleman called by to see the picture and criticised it, whereupon Gainsborough slashed it with his pen-knife. Kirby asked if he could have the painting as it was, had the tear mended and kept it till his death.[44] The right side of the painting is more or less finished and Gainsborough must have been working on the half-finished middle of the composition when the gentleman called. On the left side we see the very little Gainsborough needed for the first painting, or 'dead colouring' as it was generally known: the rocks, pond and goat grazing have been delineated with the very sketchiest brushwork in naturalistic but subdued tones.

Although Gainsborough's practice was based in Ipswich during the 1750s he did not lead a sedentary life. Road communications with the capital were particularly good, and London was only a day's journey away by coach. Gainsborough evidently visited London

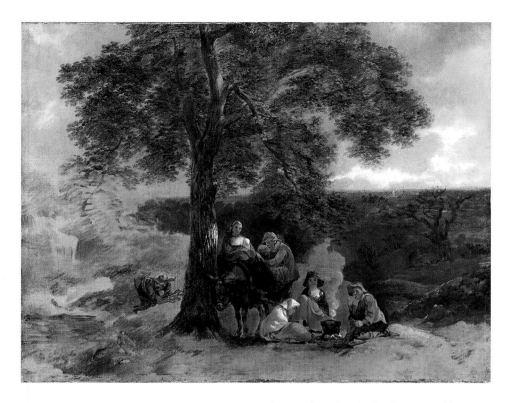

Figure 23
Landscape with Gypsies c.1753–4
Oil on canvas, 48.3 × 62.2 (19 × 24½)
Tate

Figure 24
Attributed to John Wood the Elder
Elevation of Gainsborough's house, Abbey Street, Bath
British Architectural Library, RIBA, London

Figure 25
Attributed to John Wood the Elder
First floor ground plan of Gainsborough's house, Abbey Street, Bath
British Architectural Library, RIBA, London

frequently and maintained contact with colleagues such as Hayman: the artist Nathaniel Dance (1735–1811) stated that he first met Gainsborough in London during the early 1750s when he was himself a pupil of Hayman.[45] During this time Gainsborough continued to sell his landscapes through Panton Betew, who recalled: 'I have had many and many a drawing of his in my shop-window before he went to Bath; ay, and he has often been glad to receive seven or eight shillings from me for what I have sold.'[46] Whether Gainsborough continued to paint portraits in London on a regular basis is uncertain, although it is clear that he was quite prepared to travel if commissions were forthcoming. Early in 1758, for example, he was intent upon travelling to nearby Colchester, where he hoped to have 'a few Heads to paint'.[47] It was a town he probably visited frequently on business. On 9 October his name was included among the 'Arrivals' in the *Bath Journal*.[48] During this visit he may have stayed with his elder sister, Mary Gibbon, who ran a milliners and lodging-house business near Bath Abbey. Gainsborough came to Bath to assess long-term possibilities for establishing his artistic practice, and evidently set up a temporary painting room there.[49] He was still there in early December, when his presence was remarked upon by the poet William Whitehead.[50]

The following year, in October 1759, Gainsborough sold the contents of his house in Ipswich and moved to Bath. There, he was accompanied in his search for suitable accommodation by Philip Thicknesse, who recorded his need for 'a good painting room as

to light, a proper access, &c.'[51] In the event Gainsborough signed a seven-year lease in May 1760 on a house in Abbey Street, one of the most expensive residences in Bath, at a rental value of £150 per year.[52] Gainsborough's house, designed by Bath's leading architect, John Wood the Elder, was probably built for the Duke of Kingston, who owned the property, and whose coat of arms was displayed on the pediment. Although the house was demolished in the nineteenth century, drawings of its elevation and ground plans have survived (figs.24–5). On the ground floor, to the left of the entrance, was a parlour, which probably served as the artist's show room–a spacious apartment with easy access from the street. Gainsborough's painting room was probably located on the first floor, at the north end of the house. It gave him the opportunity to work on larger, more ambitious canvases, works such as the double portrait of the Byam Family (fig.26), commenced in 1762, and his large equestrian portrait of General Honywood (Ringling Museum, Sarasota), which he exhibited at the Society of Artists in 1765. Gainsborough's Abbey Street painting room features in a number of his Bath portraits –for instance that of Robert Craggs (cat.36)– each of which depicts an imaginary landscape beyond a window, which in reality looked onto the crowded streets surrounding Bath Abbey. Gainsborough's sister's millinery shop probably occupied premises directly below his painting room, and directly across the hall from the entrance to his show room–an arrangement that must have both complemented and provided mutual support for their respective businesses.

In 1763 Gainsborough, who had recently suffered a near fatal illness, went to live with his family in a house away, as he said, from the 'Smoake'.[53] This house was situated on Lansdown, on the northern slopes of the city, and appears to have been used solely as a domestic residence: he continued to paint and display his work in Abbey Street, and let out the remaining rooms as lodgings.[54] Towards the end of 1766, tired perhaps of commuting between his home and business, Gainsborough transferred his family and his painting practice to a newly built house at no.17 King's Circus, a highly prestigious address. He remained there until his departure for London in 1774. He did not, however, give up the house in Abbey Street, and in 1767 took out a further seven-year lease on the property, a sure sign of his increasing prosperity and business acumen.

Gainsborough's painting rooms in Abbey Street and at the Circus were both north facing –traditionally an important consideration for artists who wished to ensure an even source of daylight, excluding the glare of direct sunlight and transient shadows. The window

Gainsborough in his Painting Room

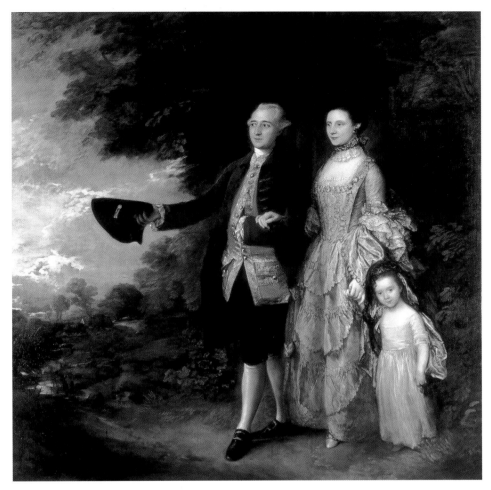

Figure 26
George Byam with his wife Louisa and their daughter Selina c. 1762 and before 1766
Oil on canvas, 249 × 238.8 (98 × 94)
The Andrew Brownsword Arts Foundation, on loan to the Holburne Museum of Art, Bath

Figure 27
The first-floor windows to Gainsborough's painting room at no.17 The Circus, Bath. This is a private property – the rear elevation cannot be seen from any street.

in Gainsborough's painting room in the Circus still exists (fig.27). Although it has been altered since, its original tripartite form, with an extended central light, is still visible. Because Gainsborough was already living in Bath when the houses in the Circus were being constructed, he was able, as Susan Sloman observes, to 'select a house perfectly suited to his needs and, presumably, to have the unconventional window built in to his own specification'.[55] The purpose of the extended central window, Sloman notes, was to control lighting. A number of similar windows still exist in west London houses, purpose-built for artists only a few years after Gainsborough installed his painting room window at the Circus. These 'shot up' windows were used to provide focused light from a high angle, and diffused light from a lower level, by using blinds or fabric draped across the lower parts of the window. The tripartite window at the Circus was not, however, an innovation for Gainsborough, who had already installed a similar triple window at Abbey Street.[56]

There has been much speculation on what inspired the wonderful confidence and painterly bravura that emerged so soon after Gainsborough's removal to Bath. Accepting that a principal factor was the opportunity he

had to study the work of Van Dyck in the great collections of the west of England, how did he go about achieving this splendour? We are fortunate that several of the Bath-period portraits have been the subjects of analytical study, and also that two contemporary witnesses of Gainsborough at work were minded to write down some notes. Ozias Humphry (1742–1810), then an aspiring young painter staying at Bath around 1762–4, recollected that for the early stages of his portraits Gainsborough worked in 'a kind of darkened Twilight', shutting out most of the natural light entering the room and replacing some part of it with candlelight. This prevented him from being distracted by too much detail at this vital stage when the all-important likeness and general form of the portrait were being established.[57] The candles may have been placed so as to cast directional light on the sitter's face, thereby accentuating the contours of the features.[58] In this moderated gloom, 'when neither … [the subjects] or their pictures were scarcely discernible' at times, Gainsborough devised a complicated procedure in order to do some of the work within very close range of the sitter. He would have the canvas attached to the stretcher with pieces of thin cord tied together round the back. Then, having marked out the position of the face, he would reposition the canvas so that the central portion was further towards one edge of the stretcher, fixing it there temporarily with reknotted cords, so as to be able to bring it on an easel right next to the sitter's head.[59] With life-size, head-and-shoulders portraits this would of course not have been necessary, as the face is only a short distance from the edge of the stretcher. It would seem that Gainsborough preferred to keep the canvas slack even once it was back in its proper alignment on the stretcher. In her technical examination of *The Linley Sisters* (cat.49), Helen Glanville found linear build-ups of paint parallel to the edges of the picture, where the loaded brush had pressed the pliant canvas against the inside edges of the stretcher-bars.[60] Similar features can be seen in the unfinished *Portrait of an Unknown Boy* (fig.28), where the thinly applied russet paint of the curtain has formed a build-up against the inside edge of the bar at the lower right corner.[61]

This painting, left unfinished for unknown reasons, allows us a fascinating insight into what a Bath-period portrait looked like at the end of the first sitting, or dead colouring. All the structure of the figure and the space around him have been established in fluid paint, applied in a minimum of tones with bold, graphic brushwork. We are in no doubt about the solidity of the boy's body, the exact space between himself and the curtain, or the

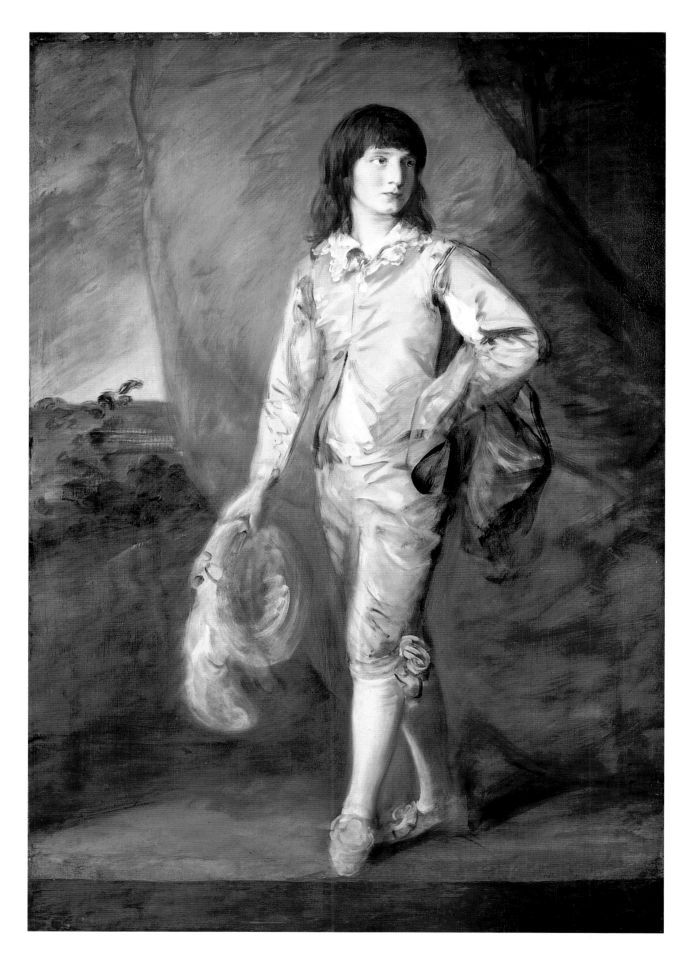

Gainsborough in his Painting Room

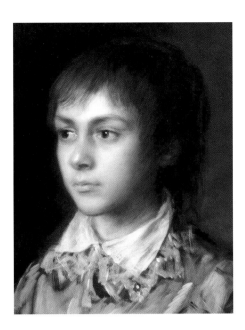

Figure 29
Detail from **Edward Richard Gardiner** *c.*1760–8
Oil on canvas, 62.2 × 50.2 (24½ × 19¾)
Tate

Figure 28
Portrait of an Unknown Boy *c.*1770
Oil on canvas, 165.5 × 113 (65 × 44½)
Private Collection

fact that his suit is made of satin. It looks as if the bristle brushes used for the figure and background were up to an inch (2.54 cm) wide, but for the face and hair they were softer and smaller.[62] In keeping with Humphry's account of the lighting, the head has been conceived broadly in sharply contrasted light and shade, the overall shape of the features at this stage being more important than detail, though, for all that, this face is immediately recognisable as an individual likeness. The hatching strokes of Ipswich days have been replaced by a less mechanistic method of scumbling a few opaque flesh tones thinly onto the ground, leaving the shadows thin but building up the lights with a variety of small strokes and tones to establish the features. For the far side of the face Gainsborough appears to have rubbed on some of the orange paint of the curtain, then scumbled into it with a thin, semi-opaque brown. The ground is light pink and forms the mid-tone of the costume.

An underpainting to establish the form followed by brightly coloured paint to create the surface effects became the technical pattern for Bath portraits, and with this Gainsborough was reviving in a personal way one of the principles of seventeenth-century portraiture – an interesting development in the light of the impact of Van Dyck's work on him. We know that Gainsborough made copies of Van Dyck portraits in such collections as Wilton (see cat.84), so it is probable that he looked at them closely enough to work out how some of the effects had been obtained.[63] He may also have dipped into some of the manuals of painting in which the fundamental principles of seventeenth-century painting techniques were described. They were not hard to come by: *Art's Masterpiece* by 'KC', for example, was in its fifth edition by about 1710 and was itself plagiarised in 1747 in George Bickham's *The Oeconomy of the Arts or a Companion for the Ingenious of Either Sex* (both published in London). In books like these the effects of using translucent glazes or bright opaque scumbles on top of either opaque or highly reflective underpainting are described simply. So Gainsborough, with his profound feeling for the optical values of pigments, with an adequate understanding of seventeenth-century methods and a discerning eye for quality, was well equipped to respond to Van Dyck's silvery surfaces and it is perhaps not so surprising that he took so little time to elaborate his techniques in order to produce comparable effects of his own.

We can try to envisage how *Portrait of an Unknown Boy* might have looked, had he gone on to finish it. Humphry describes how Gainsborough, once satisfied with the likeness and overall laying-in of the composition, would let in more light for the later stages of finishing. The head would have required

another sitting: 'I cannot (without taking away the likeness) touch it unless from the life', he wrote of another portrait in 1771, expressing a fundamental of his work.[64] The dead colouring, which would have needed to be touch dry by this stage, would have been incorporated into rather than obscured by this second painting. *Unknown Boy*'s face would probably have ended up similar to that of *Edward Richard Gardiner* (fig.29). How long Gainsborough needed for faces is not recorded in any account- or sitter-books, but two references exist to suggest that he worked remarkably swiftly. Thicknesse claimed that the painting of the head at the first sitting for his own portrait took 'not above fifteen minutes'.[65] Since Gainsborough had known Thicknesse's face for years, this might account for the brevity of the session, but the evidence that the whole portrait of Ignatius Sancho (cat.112) was completed within an hour and forty minutes may indicate that this pace was normal for Gainsborough. The artist would not necessarily have needed the sitter's presence to complete the costume and background, as he is known to have owned jointed dolls or lay figures, on which a costume could be arrayed at any time.[66] Moreover it looks as if Gainsborough owned this particular Vandyke costume, as it appears again in *The Blue Boy* (fig.45) and in *Edward Richard Gardiner*.

It is probable that the costume of *Unknown Boy* would have ended up similar to that of *The Blue Boy* – a blue glaze on top of elaborate dead colouring that contains large proportions of white lead to give maximum reflection of light.[67] Glanville describes the blue paint of Elizabeth Linley's dress (cat.49) as applied 'unbelievably thinly, almost as a water-colour wash … over the broad white strokes of Gainsborough's initial under-painting'.[68] *Countess Howe*'s (cat.64) pink and white costume, by contrast, was worked up mainly with more opaque mixtures of pink, white and grey on top of the grey and white dead colouring and red ground.[69] 'Through many overlaid brushstrokes a sumptuous effect was increasingly built up', as one writer described a similar effect.[70] Gainsborough's daughter recalled how 'his colours were very liquid and if he did not hold the palette right would run over'.[71] Thinning the paint with turpentine alone, though it would have reduced the drying time, would have left a weak paint film; for the finishing layers of his paintings it is probable that he would have added extra oil as well to ensure stability.[72]

The blue of the costume would probably have been Prussian blue, the principal choice of Gainsborough and all his British contemporaries, though we know that Gainsborough also valued indigo.[73] Gainsborough's pigments in the Bath and

London periods were effectively the same as in earlier times: a strong preference for translucent over opaque and bright over dull.[74] The glassy filler is no longer a major feature – on the ambitious scale of his portraits since the full lengths in Ipswich, the type of paint used in the early works would have looked insubstantial. Powdered chalk has been found in Bath-period work, which would have been a way of thickening some of the paint on this scale without significantly increasing its opacity.[75] Analysis of the binding media in the Bath portraits shows that they were still chosen mainly for their stability and resistance to yellowing.[76]

Gainsborough's concern for stability did not prevent his inventive spirit from exploring new methods of making art. Ozias Humphry's comments, cited above (p.33), were principally directed towards his portrait practice, but he also remarked that Gainsborough's landscapes were 'frequently wrought by candlelight'. It may therefore be significant that it was also probably in Bath that Gainsborough first began to make small three-dimensional models of landscapes. According to one eyewitness, Gainsborough kept a small folding oak table for this express purpose. 'This table', noted the observer, 'he would order to be brought to his parlour, and thereupon compose his designs. He would place cork or coal for his foregrounds; make middle grounds of sand and clay, bushes of mosses and lichens, and set up distant woods of broccoli.'[77] Although doubt has been cast upon the relevance of such models to his practice, they may well have been conceived as more than a form of parlour entertainment.[78] They were significant enough to merit a notice in Reynolds's fourteenth *Discourse*, where he notes how they were 'magnified and improved into rocks, trees and water'.[79] Made in the evening and designed to be viewed by candlelight, they may have helped Gainsborough to establish the compositional balance and tonal harmonies in his painted landscapes (see for instance cat.135). Later, further inventiveness went into devising an entirely original process for producing varnished drawings (see cats.130, 132, 136 and 140), and for making paintings on glass, which were to be viewed via transmitted candlelight in a specially constructed peepshow box (cats.152–6).

In the summer of 1774 Gainsborough left Bath. According to Philip Thicknesse this departure was wholly unexpected, occasioned by a quarrel between the two men. In fact, Gainsborough may have been planning the move for at least a year, since he had signalled his intention of giving up the tenancy of his property in Abbey Street the previous summer.[80] In midsummer 1774 Gainsborough moved into no.80 Pall Mall, London, part of Schomberg House (fig.31), named after the third Duke of Schomberg, who had reconstructed the property in 1698. More recently, in 1769, the artist and fortune-hunter John Astley purchased the lease of Schomberg House from the Earl of Holdernesse for £5000. Astley spent a further £5000 on enhancing the property, and divided it into three separate houses, retaining the central house as his own residence.[81] Gainsborough, who paid an annual rent of £150 (subsequently reduced to £112), occupied the west wing of Schomberg House. The east wing operated as a fashionable textile store – an arrangement reminiscent of his situation in Abbey Street, Bath. Immediately to the east of Schomberg House was the auction house of James Christie, to which Gainsborough was a frequent visitor.[82] In his own house Astley appears to have constructed the elaborate painting room at the top of the house lit by a large tripartite window, with views over St James's Park and Buckingham House. Following his departure in 1777, the house was occupied in 1781 by Dr James Graham's notorious 'Temple of Health and Hymen', and subsequently by the artists Maria (1759–1838) and Richard Cosway (1742–1821), who lived there between 1784 and 1791. In the nineteenth century the east wing of Schomberg House was demolished: the central and western blocks, including Gainsborough's house, survived until the 1950s, when they too were destroyed, except for the facade which was reconstructed. With the help of the original ground plan (fig.30), some photographs and a number of descriptive accounts of the interior, it is still possible to gain a mental picture of the house's appearance during Gainsborough's tenancy and how it functioned as the base for his artistic practice.

The entrance of Gainsborough's house led into a small square hall, then to a larger inner hall, almost the width of the house, lit by a large roof-light. In the hall was a grand staircase, which, it has been suggested, may have been made specifically for Gainsborough.[83] The top-lit hall area, as a visitor noted in 1787, was hung with 'a large landscape', while there were 'in the small room three or four landscapes, all lately painted by Gainsborough'. The small room, suggested Whitley, probably adjoined the outer hall, and faced onto Pall Mall.[84] In addition to the paintings on display, Gainsborough painted four landscape murals for Schomberg House, apparently in the manner of architectural decoration: they included two mountainscapes and a pastoral scene. The fourth mural was destroyed in 1784, when a window was blocked up following the imposition of the window tax.[85] None of the rooms in the main part of

Gainsborough in his Painting Room

Figure 30
Ground plan of the ground floor, Schomberg House, London
National Monuments Record

Figure 31
View of Schomberg House, London, in 1907
London Metropolitan Archives

Gainsborough's house appears to have been large enough to accommodate the artist's painting room, which was almost certainly situated in an extension built over the garden and connected to the main house by a long timber-framed passage. This extension was probably very similar to the 'spacious and lofty' auction room constructed around the same time by Christie to the rear of his nearby property.[86] According to the artist William Beechey (1753–1839), 'Gainsborough's landscapes stood ranged in long lines from his hall to his painting room; and they who came to sit for him for their portraits … rarely deigned to honor them with a look as they passed them'.[87] The painting room was apparently quite spacious; William Whitley, who inspected the interior of Gainsborough's house in the early years of the twentieth century, noted that the garden room on the ground floor was about 35 feet (10.7 metres) long and 25 feet (7.6 metres) wide and 'proportionately high'. As far as Whitley could see, a south-east-facing window afforded the only available natural light.[88] Above this room was a salon of similar proportions (but possibly also with top lighting), which may have served as Gainsborough's show room or gallery – although this too may have functioned as a painting room.

Visitors presumably approached Gainsborough's painting room from the main entrance to the house on Pall Mall. There may also have been a garden entrance to facilitate the introduction of the various animals – including donkeys, horses and pigs – that appear in his work. As the musician William Parke recalled, with reference to Gainsborough's *Girl with Pigs* (cat.59): 'I have seen at his house in Pall Mall the three little pigs (who did not, in the common phrase, sit for their likenesses) gambolling about his painting room, whilst he was catching an attitude or a leer from them at his easel.'[89] The most revealing first-hand account was provided by the antiquarian and biographer,

John Thomas Smith (1766–1833), who, as a young man, visited Gainsborough on several occasions at Schomberg House. Smith noted the subdued lighting in the artist's painting room. 'I was much surprised', he also noted, 'to see him sometimes paint portraits with pencils on sticks full six feet in length, and his method of using them was this: he placed himself and his canvass [sic] at a right angle with the sitter, so that he stood still, and touched the features of his picture exactly at the same distance at which he viewed his sitter.'[90] Another contemporary confirmed this, noting that Gainsborough 'usually painted with a very long and very broad brush, stood very far from his canvas, and in a room with very little light'.[91] Reynolds gives the most succinct, if not wholly supportive, description of the effect of this distancing of the artist from the subject and canvas, referring to 'all those odd scratches and marks', and remarking that 'this chaos, this uncouth and shapeless appearance, by a kind of magic at a certain distance assumes form'. He goes on to appreciate how the artist's pride in this increasingly abstract brushwork might make him insistent that his work should be seen close up as well as at a distance, indirectly referring to Gainsborough's split with the Royal Academy in 1783.[92] In 1772 Gainsborough had taken on his nephew, Gainsborough Dupont (1754–1797), as his pupil and studio assistant. Reynolds's pupil, James Northcote (1746–1831), recalled how Gainsborough and Gainsborough Dupont had painted the drapery of a portrait of Queen Charlotte together by candlelight at night, giving us an eloquent account of how the fluid, linear brushwork was built up: ''Tis actual motion, and done with such light airy facility. Oh! It delighted me when I saw it.'[93]

He introduced a few technical changes in his last two decades. His grounds ceased to be warm toned and became cooler in colour – white, off-white, cream, pale buff and dull, lilac-pink have been identified.[94] In this he was following contemporary taste; the consistent greys of the first half of the century lost popularity during the late 1750s and early 1760s and gave way to a wide variety of pale colours; few artists shared Gainsborough's preference for the russet tones of his Bath period. His dead colouring probably varied greatly in colour and extent: *Mrs Siddons* (cat.165) appears to have a very complex system of underpainting in many bright colours, whereas the unfinished *Housemaid* of c.1782–6 (Tate) has been started off entirely in shades of brown.[95] It may be that many portraits and fancy pictures were begun in brown, others more chromatically. With such an intuitive and innovative artist as Gainsborough one would not expect an unvarying approach.

In London Gainsborough's binding media became more complex. *The Watering Place* (cat.51) appears to have oleo-resinous underpainting in some areas, and there are references to his use of 'asphaltum', a term describing a range of tarry, bituminous substances that impart mellow translucency to dark colours when fresh but which are not always durable without cracking or darkening.[96] He is said to have claimed that with asphaltum he 'could have painted a pit as deep as the infernal regions'.[97] As yet we have no analytical studies to confirm asphaltum in his work, though the patterns of cracking in some late paintings suggest its presence. In this usage his preference for durable, non-yellowing materials must have been unable to withstand the combined force of his own instinctive need for translucent paint, and the ever-present example of Reynolds, whose newly finished work, often full of such substances, must have looked so bewitching before the colours faded or their surfaces shrivelled.

Following his final appearance at the Royal Academy exhibition of 1783, Gainsborough's house assumed a far greater importance in terms of the public reception of his work. Towards the end of July 1784 he held an inaugural exhibition at Schomberg House. Here, as Michael Rosenthal has commented, Gainsborough had absolute control over display conditions, the height at which the pictures were viewed and the lighting.[98] The exhibition was timed, perhaps, to coincide with the closure of the Academy exhibition at Somerset House. The *Morning Herald* – the only newspaper to carry a review of the exhibition – noted that the pictures were to be displayed in Gainsborough's 'saloon'. The first exhibition included ten full-length portraits, twelve half or three-quarter lengths, plus a number of subject pictures and landscapes. The only rooms in the artist's house that could have accommodated such a display of grand full-length portraits were those built over the garden, although it is quite likely that the exhibition extended through several apartments.

As he had done in Bath, Gainsborough admitted visitors to his gallery throughout the year. On a Sunday in the early autumn of 1786 a young German woman named Sophie von La Roche paid a visit. She saw several royal portraits as well as the fancy picture *A Cottage Girl with a Bowl of Milk* (South African National Gallery, Capetown). She also noted that Gainsborough's colours were supposed to last better than Reynolds but that his pictures were not visible in 'such a quantity' as his rival in Leicester Square.[99] The same morning she inspected the galleries of Reynolds, Gilbert Stuart, Benjamin West and the engraver Valentine Green. By the time Sophie von La Roche made her peregrination, visits to artists' show rooms had long been established as fixtures in the capital's social calendar, attracting a *mélange* of potential patrons, casual visitors and critics alike. Artists regarded their residences as spaces where the public could congregate and commune, not merely to discuss the merits of their work but to appreciate their material success. In this respect Schomberg House, a world away from Gainsborough's humble beginnings in Hatton Garden, was the jewel in the crown.

Gainsborough in his Painting Room

1 Henry Bate, *Morning Herald*, 4 August 1788.

2 It has been suggested that this may have been a local clothier named William Carter. See John Bensusan-Butt, *Thomas Gainsborough in his Twenties: A Memorandum based on Contemporary Sources*, 3rd ed., Colchester 1993, p.36.

3 W.A.D. Englefield, *The History of the Painter-Stainers Company of London*, London 1923, reprinted 1950, p.161.

4 W. Whitley, *Artists and their Friends in England, 1700–1799*, 2 vols., London 1928, vol.1, p.331.

5 R. Jones, 'The Artist's Training and Techniques', in Elizabeth Einberg (ed.), *Manners and Morals: Hogarth and British Painting 1700–1760*, exh.cat., Tate, London 1987, pp.19–28.

6 George Vertue, 'Notebooks III', *The Walpole Society*, vol.22, 1933–4, p.54.

7 Henry Bate, *Morning Herald*, 4 August 1788. It has been suggested that the silversmith may have been George Coyte (d.1782). See Elaine Barr, 'Gainsborough and the Silversmith', *Burlington Magazine*, February 1977, p.113.

8 E.W. Brayley (ed.), *The Works of the Late Edward Dayes*, London 1805, p.329. See also *Farington Diary*, vol.6, p.2435. Although 1716 or 1717 are often given as the year of Grignion's birth, he told Farington that he was born on 25 October 1721 (see *Farington Diary*, vol.8, p.2800).

9 *Farington Diary*, vol.8, p.2800.

10 R. Jones, 'Gainsborough's Methods and Materials: A "remarkable ability to make paint sparkle"', *Young Gainsborough*, London 1997, p.25 (reprinted in *Apollo*, August 1997, p.25).

11 Henry Bate, *Morning Herald*, 4 August 1788. Philip Thicknesse, *A Sketch of the Life and Paintings of Thomas Gainsborough, Esq.*, London 1788, p.4.

12 Whitley, pp.5–7.

13 George Williams Fulcher, *Life of Thomas Gainsborough, R.A.*, London 1856, p.29.

14 For Hayman's relationship with Gainsborough see Brian Allen, *Francis Hayman*, New Haven and London 1987, pp.39–43.

15 See Allen, *Hayman*, pp.107ff.

16 Allen, *Hayman*, pp.92–3.

17 Jones, 'Methods and Materials', pp.19–26. Also R. Jones, 'The Rev. John Chafy playing the Violoncello in a Landscape', in *Paint and Purpose: A Study of Technique in British Art*, London 1999, pp.48–53.

18 Exceptions occur with alterations to the composition, not infrequent in this period of his work, and in instances where he repainted areas that had cracked.

19 M. Smith, *The Art of Painting According to the Theory and Practice of the Best Italian, French and German Masters*, 1692, p.73.

20 Jones, 'Methods and Materials', p.24 and n., and J. Egerton, *The British School*, London 1998, p.66. The medium of most areas of *Portrait of the Artist with his Wife and Daughter*, as tested, is walnut oil, but the tree trunk in the background contains heat-bodied oil (oil thickened by heating) with some copal resin.

21 Comparative information on English grounds comes from an unpublished survey in the Tate Gallery begun by R. Jones and A. Southall in 1986.

22 The first mention of this orange ground is in V. Pemberton-Pigott, 'The Development of the Portrait of Countess Howe', in A. French (ed.), *The Earl and Countess Howe by Gainsborough*, London 1988, p.43. Comparative information on English grounds as in n.21.

23 Pemberton-Pigott, 'Portrait of Countess Howe', p.41, suggests he may have seen red grounds in Italian paintings or in Watteau's work.

24 Hayes 1982, vol.1, p.60. See also Egerton, *British School*, for discussion of the influence of Dutch painting.

25 For the dating of *The Roast Beef...*, see E. Einberg and J. Egerton, *The Age of Hogarth*, London 1988, pp.127–31.

26 Hayes 1982, vol.1, p.53.

27 Smith, *Art of Painting*, discussed in M.K. Talley, *Portrait Painting in England: Studies in the Technical Literature before 1700*, London 1981, pp.375–96.

28 Jones, *Paint and Purpose*, pp.51–3.

29 A. Corri, 'Gainsborough's Early Career: New Documents and Two Portraits', *Burlington Magazine*, vol.125, 1983, pp.212–16.

30 See David Tyler, 'Thomas Gainsborough's days in Hatton Garden', *Gainsborough's House Review*, 1992/93, pp.27–32.

31 See David Tyler, 'The Gainsborough family: births, marriages, and deaths re-examined', *Gainsborough's House Review*, 1992/93, pp.41, 50 n.24; see also Egerton, *British School*, pp.66–7.

32 See Allen, *Hayman*, pp.92–3. Allen suggests that this undated letter was written sometime between 1746 and 1747.

33 It has been speculated that Gainsborough delayed his homecoming until after the death of his father in October 1748, on the grounds that he may not have approved of his daughter-in-law's illegitimacy. See Tyler, 'Hatton Garden', p.29.

34 Thicknesse, *Sketch*, p.8, quoted in Hayes 1982, vol.1, p.61.

35 Hayes 1982, vol.1, p.61.

36 Quoted in Fulcher, *Life*, p.45.

37 *Letters*, p.5.

38 Michael Rosenthal, *The Art of Thomas Gainsborough*, New Haven and London 1999, p.20.

39 Ellis K. Waterhouse, 'Sir Joshua Reynolds's Sitter-Book for 1755', *The Walpole Society*, vol.41, 1968, pp.112–64.

40 See Felicity Owen, 'Joshua Kirby (1716–74): a biographical sketch', *Gainsborough's House Review*, 1995/6, pp.65–7. See also John Ingamells, *A Dictionary of British and Irish Travellers in Italy, 1701–1800*, New Haven and London 1997, p.580, and Whitley, p.19.

41 See Walter Thornbury, *The Life of J.M.W. Turner RA*, 2 vols., London 1862, vol.2, p.61.

42 Hayes, *Gainsborough: Paintings and Drawings*, London 1975, p.37.

43 *Letters*, pp.10–11.

44 Thornbury, *Life*, vol.2, pp.59–60.

45 *Farington Diary*, vol.9, p.3192.

46 John Thomas Smith, *Nollekens and his Times*, 2 vols., London 1828, vol.1, pp.189–90.

47 *Letters*, p.9.

48 See Ann Sumner, *Gainsborough in Bath*, exh. cat., Holburne Museum, Bath, 1988, p.10.

49 See Susan Sloman, 'Gainsborough in Bath in 1758–59', *Burlington Magazine*, August 1995, pp.509–12; Michael Rosenthal, 'Testing the water. Gainsborough in Bath in 1758', *Apollo*, September 1995, pp.49–54.

50 See Sloman, 'Gainsborough in Bath', pp.509–10.

51 Thicknesse, *Sketch*, pp.15–16.

52 Susan Sloman, 'Gainsborough and "the lodging-house way"', *Gainsborough's House Review*, 1991/92, p.23. The following discussion of Gainsborough's houses and studios in Bath is based upon material contained in Sloman's article.

53 See *Letters*, p.23.

54 Sloman, 'Gainsborough and "the lodging-house way"', pp.33–4 and notes 56–8.

55 Ibid., p.30.

56 The aforementioned points were kindly communicated in correspondence with Susan Sloman. They are discussed at further length in her book, *Gainsborough in Bath*, New Haven and London 2002. The London houses in question are situated in Percy Street, off Tottenham Court Road. For further information on these houses see Giles Walkley, *Artists' Houses in London 1764–1914*, Aldershot 1994, pp.28–9.

57 Ozias Humphry, MS, Royal Academy, London.

58 D. Bomford, A. Roy and D. Saunders, 'Gainsborough's "Dr Ralph Schomberg"', *National Gallery Technical Bulletin*, vol.12, 1988, p.44. The high-contrast, directional lighting of Schomberg's face is noted as being due more to studio artifice than to the broad daylight of his painted surroundings.

59 Humphry MS; Bomford et al., 'Gainsborough's "Dr Ralph Schomberg"', p.44; and H. Glanville, 'Gainsborough as Artist and Artisan', in *A Nest of Nightingales*, exh. cat., Dulwich Picture Gallery, London 1988, p.16.

60 Glanville, 'Artist and Artisan', pp.16–17 plus note, which cites other instances including *The Housemaid*.

61 We are grateful to Henrietta Pattinson of Sotheby's for arranging for the reproduction of this painting.

62 Gainsborough Dupont inherited some of the contents of his uncle's studio. After his own early death in 1797, Dupont left hog brushes and 'twelve bundles of camel's hair pencils' (Whitley, p.247).

63 Rosenthal, *The Art of Thomas Gainsborough*, p.41.

64 *Letters*, p.88.

65 Thicknesse, *Sketch*, p.17.

66 R. Simon, *The Portrait in Britain and America*, Oxford, 1987, p.107. Two lay figures were sold in the Gainsborough sale of 1792.

67 R. Aselson and S.M. Bennett, *British Paintings at The Huntington*, San Marino 2001, p.104.

68 Glanville, 'Artist and Artisan', p.24.

69 Pemberton-Pigott, 'Portrait of Countess Howe', p.39.

70 T. Green, 'Pomeranian Bitch and Puppy', in *Completing the Picture*, London 1982, p.24.

71 J. Hayes, *Thomas Gainsborough*, London 1980, p.39. From Trimmer in Thornbury, *Life*, vol.2, p.62.

72 Green, 'Pomeranian Bitch', pp.23–4. But most of the shrinkage cracking described in Egerton, *British School*, is attributed to the use of turpentine to thin the paint.

73 *Letters*, p.71.

74 Trimmer, Kirby's descendant who described the slashed landscape, also recollected Gainsborough's pigments from information given to him by Briggs, the young painter who befriended Gainsborough's daughters in their old age: yellow ochre, Naples yellow, yellow lake, orpiment, raw sienna, vermilion, light red venetian, the lakes, burnt sienna, Cologne earth, brown pink, terre verte, ultramarine and Cremona white, which last he got from Scott in the Strand. Thornbury, *Life*, vol.2, pp.63–4. All these have been found by analysis of his paintings. Bomford *et al.*, 'Gainsborough's "Dr Ralph Schomberg"', p.51, and Glanville, 'Artist and Artisan', pp.23–4, discuss Cremona white. Glanville also notes the presence in *The Linley Sisters* of bright, translucent Indian yellow, newly available.

75 Bomford et al., 'Gainsborough's "Dr Ralph Schomberg"', p.48.

76 J. Mills and R. White, 'Analyses of Paint Media', *National Gallery Technical Bulletin*, vol.11, 1987, p.94. See Glanville, 'Artist and Artisan', for similar usage.

77 Whitley, p.369.

78 See Wendy Gascoin Norris, 'The reconstruction of Gainsborough's Countess Howe', *Gainsborough's House Review*, 1994/95, p.58.

79 See Wark, p.25.

80 *Letters*, p.116.

81 See F.H.W. Sheppard, *Survey of London*, London 1960, vol.29, pp.368ff. See also Mary Webster, 'John Astley, artist and beau', *Connoisseur*, December 1969, p.259.

82 Sheppard, *Survey*, pp.374 and 368. Christie did not, as it is often stated, live in Schomberg House, but in a property adjacent to it. He occupied the easternmost house and sub-let the other.

83 Sheppard, *Survey*, p.376.

84 See Whitley, p.110.

85 See Hayes 1982, vol.1, pp.131 and 157 n.39.

86 Sheppard, *Survey*, p.368 and pl.50b.

87 Fulcher, *Life*, pp.113–14.

88 Whitley, p.110. See also Walkley, *Artists' Houses*, pp.16–17.

89 W.T. Parke, *Musical Memoirs; comprising an account of the general state of music in England, from the first commemoration of Handel, in 1784, to the year 1830*, 2 vols., London 1830, vol.2, p.108.

90 Smith, *Nollekens*, vol.1, p.186.

91 *Morning Chronicle*, 8 August 1788.

92 Wark, pp.257–8.

93 Ernest Fletcher (ed.), *Conversations of James Northcote R.A. with James Ward*, London 1901, pp.160–1. Cited in Glanville, 'Artist and Artisan', p.27 n.65.

94 Egerton, *British School*, pp.108, 114, 120; Aselson and Bennett, *British Paintings*, pp.142, 146, 154.

95 Egerton, *British School*, p.114.

96 Ibid., p.108.

97 Whitley, p.247, and *Art Union*, 1 September 1841, p.147.

98 See Rosenthal, *The Art Of Thomas Gainsborough*, pp.113–16.

99 *Sophie in London 1786, being the Diary of Sophie von La Roche*, trans. Clare Williams, London 1933, p.152.

Beginnings: The Early Years

Thomas Gainsborough was one of those artists who, legend has it, displayed such early artistic precocity that his family was prevailed upon to allow him to become a painter. As Philip Thicknesse put it:

> Mr Gainsborough like the best Poets, was born a Painter, for he told me, that during his Boy-hood, *though he had no idea of becoming a Painter then, yet there was not a Picturesque clump of Trees, nor even a single Tree of beauty, no, nor hedge row, stone, or post, at the Corner of the Lanes, for some miles around about the place of his nativity, that he had not so perfectly in his* mind's eye, *that had he known he could use a pencil, he could have perfectly delineated. I say had he* known he could use a pencil, *for he could, and did use one the* first time *he took it up, that the first effort he made with one … of a group of Trees … would not be unworthy a place, at this day, in one of his best landscapes.*

Born into a prosperous family in Sudbury in Suffolk, one long involved in that staple of the East Anglian economy, the wool trade, young Gainsborough is said to have preferred to spend his days making sketches in the local woods and fields, rather than in sitting behind his desk in the schoolroom. His schoolmaster was kept in the dark by meticulously forged notes that, according to the truant, were written by his father. When the truth came out, the latter was so impressed with the evident quality of his son's drawings that he consented to his going down to London to be apprenticed to a silversmith, where his aptitude and dexterity could be turned to material profit in practising fine engraving.

The attachment to the landscape that Gainsborough expressed in his art may, as Amal Asfour and Paul Williamson have proposed in an elaborate and intriguing argument, have been fuelled by the religious Nonconformity prevalent in his native East Anglia. The meticulous vision of the landscape apparent in his very earliest works certainly conveys a feeling of spiritual engagement, of finding the divine through nature. Whatever the precise stimulus, it appears that in London, rather than pursue an apprenticeship in silversmithing, the young Gainsborough soon fell among artists, specifically the French designer and painter Hubert-François Gravelot. According to Henry Bate (who would have heard this from the artist himself) Gravelot 'got him introduced at the Old Academy of Arts in St Martin's Lane'. Emphatically democratic in its organisation, the Academy provided drawing classes and, more importantly, formed a focus for artistic debate in this era. Flamboyant and opinionated, William Hogarth dominated the Academy. He had first discovered success as a painter of conversation pieces (small-scale group portraits), introducing a new sense of informality and wit into the genre. He went on to found a fortune on engravings of series of scenes from modern life. Dealing with contemporary urban themes in a style packed with literary and visual humour, these 'modern moral subjects' provided a vital alternative to the moribund traditions of mythological and classical art, supported in theory (but more rarely in practice) by the social elite. Moreover, Hogarth had showed how a native-born artist might profit in the developing world of urban consumer society, using press advertisements, publishing prints by subscription, and responding to changing market conditions. Underlying all these practical concerns was a distinct aesthetic that Hogarth later formulated in his book *The Analysis of Beauty* of 1753 (fig.32). Here he proclaimed the superiority of the natural over the conventional, the contemporary over the historic, and a preference for demotic visual pleasures over the dryly intellectual and elitist.

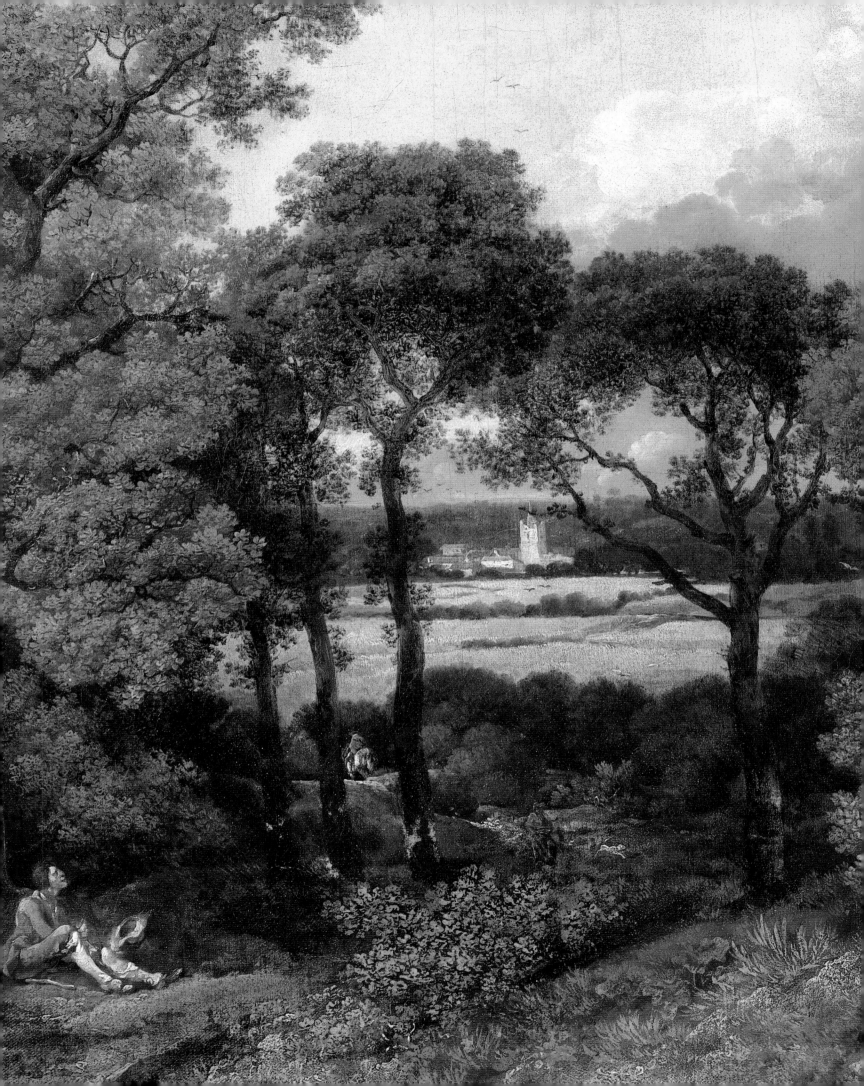

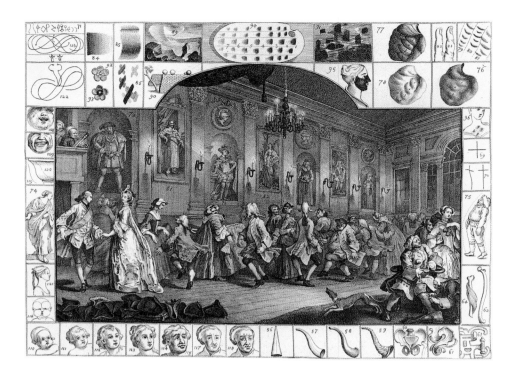

Figure 32
William Hogarth
The Analysis of Beauty (Plate 2) 1753
Etching and engraving, 42.3 × 53 (16⅝ × 20⅞)
The British Museum, London

Hogarth's ideas exerted a powerful influence on his contemporaries and were of crucial and abiding importance to Gainsborough, but his hegemony over matters of taste was not undisputed. Artists such as Allan Ramsay, the Scots portrait painter whose extensive experience travelling and studying on the Continent provided him with a much more cosmopolitan outlook, contributed to what must have been lively discussions at the Academy. Also in London in the early 1740s was another young student of art up from the provinces, Joshua (later Sir Joshua) Reynolds, who was to become Gainsborough's greatest professional rival and the spokesman for the more authoritarian and exclusive artistic ideals that (much to his chagrin) gained dominance in Gainsborough's lifetime.

This environment must have seemed both extraordinary and stimulating to a thirteen-year-old boy up from the country. If Hogarth and his colleagues wanted to create an art that appealed to contemporary audiences on their own terms, Gainsborough was in London when these desires were given their fullest expression. In 1741–2 the artists of St Martin's Lane became involved in the decorations of the supper boxes at Vauxhall Gardens, a fashionable pleasure garden just south of the Thames. The painter Francis Hayman, with whom Gainsborough was studying at the time, oversaw the decorations. The paintings dealt with themes drawn from popular literature and scenes of rustic pleasure and fancy that were calculated to appeal to an urban audience. As a student of Hayman, Gainsborough must have been involved in this scheme.

By the mid-1740s, however, Gainsborough was establishing himself as an independent talent. He set up his own studio in 1745 and John Boydell (1719–1804) published the first engravings after his drawings in 1747. Hayman thought so highly of him that in 1746–7 he had him paint in the landscape background to a portrait he was doing of the children of Grosvenor Bedford (fig.16). According to a letter written by Hayman to Bedford, this was painted by Gainsborough 'whilst he is in Town', so it is evident that he must have had to come to town from somewhere. This was probably Sudbury, to which he returned permanently late in 1748. Despite his wife's annuity, the Gainsboroughs were living beyond their means, for, as Susan Sloman points out, this annuity was being used as security for significant loans as early as 1751. Business was not that good. A contemporary wrote that in London Gainsborough was 'only a landscape painter, and merely as such must have starved – he did not sell six pictures a year'. A 1762 sale catalogue which included such items as 'a Dutch landscape, prepared by Mr. Gainsborough' or 'Wynants, a landscape, the figures by Mr. Gainsborough' points to the lengths to which he would go to make money from painting. The birth of a daughter, Mary, in 1750 (their second child, as a first daughter had died in infancy by 1748) must have focused the need to earn a living.

In Sudbury Gainsborough was getting orders from the local gentry for the small-scale portraits – 'portraits in little' – in landscape settings. These allowed the artist to combine what he always said he loved with what he was obliged, through necessity, to paint, for

Beginnings: The Early Years

he was never unreservedly enthusiastic about face-painting. The most famous of these, *Mr and Mrs Andrews* (cat.18), with its depiction of a working landscape, is really an oddity, for normally the artist would paint rather 'Dutch'-looking scenes confected from the terrain of woodland and sandbanks characteristic of his native countryside, and often populated by idling members of the labouring poor. The often doll-like figures can sit uncomfortably in their natural surroundings, in comparison with the sheer elegance with which Gainsborough handled these motifs later in his career, but already we can see in these works how a vision of the landscape, only rarely relating to a specific place, was being used to fabricate a sense of identity for those who are shown inhabiting it.

Gainsborough's earliest works show him developing a reasonable consistency of approach and quality, and in 1752 he took the decision to move to Ipswich, then a prosperous port and market town, a centre that would supply sources of patronage that the artist might profitably exploit. The birth of a further daughter, Margaret, in 1751 might also have motivated the move. In Ipswich he formed a fast friendship with Joshua Kirby, author, printseller and friend of Hogarth who on his own removal to London in 1755 would have been able to keep Gainsborough up to date on the machinations to form a more formal art academy and to instigate exhibitions of modern art. Gainsborough himself fitted easily into local society and was able to capitalise on networks of friendship and connection to get commissions of increasing ambition. His handling of paint was gaining in sophistication, and in his landscape subjects he was beginning to engage with a more inventive rural subject matter. Portraiture was generally for faces only, but the three-quarter length of William Wollaston (cat.34) pausing while playing the flute, demonstrates something of his developing sophistication as a colourist by the end of the decade. As other portraits in this section show, Gainsborough, passionately keen on music himself, was also a painter of musicians, often personal friends: the artist always preferred the company of musical and theatrical performers over that of fellow artists.

By now, however, Gainsborough was aware that, if he was to make a living from painting, it would not be in Ipswich. He consequently went on a reconnaissance trip to Bath in autumn 1758, discovered that a fashionable holiday resort with its constant flow of potential, wealthy patrons might be just the location for an artist aiming to make a good living through portraiture, and removed himself and his family there in 1759. His portrait of Ann Ford and his landscapes created at that time show how far he had come, or rather, what he wanted to show off to the fashionable society of Bath (cats.33 and 35). These works reveal Gainsborough as a painter who was beginning to define himself by his virtuosity and invention, turning away from the rather parochial models provided by London artists to the examples of Van Dyck and Rubens. This was the artist who was to use the new public art exhibitions to re-launch himself for a metropolitan spectatorship in the next decade, addressing a public for art that was of a scale and social variety that had never been seen before. MR/MM

1

Self-Portrait

*c.*1739–40
Oil on paper laid on canvas, 22.9 x 19.7 (9 x 7¾)
Private Collection, London

This little painting was brought to light by Adrienne Corri and first published as a Gainsborough as the frontispiece to an issue of the *Burlington Magazine* in 1983. In the accompanying article, Corri argued that it was a self-portrait by Gainsborough aged no more than eleven years old. This view did not go unchallenged. However, the techniques deployed in the painting are entirely appropriate to Gainsborough, although it may be more convincing to date it to the time that he arrived in London at the age of thirteen when he would have readier access to materials and better reason to create such a precociously assertive self-image. If nothing else, it would be extremely difficult to come up with alternative candidates for such a youthful painter of a self-portrait of this quality from this date. It is now generally accepted that this is a self-portrait by the artist, and was sold as a Gainsborough to the present owner by Felder Fine Art in 2000. Corri's more recent researches have indicated a provenance for the picture that would connect it with the painter. Until 1974 the picture was in the estate of Ernest Albert Butcher, who is believed to have descended from the Butcher family, stewards to the Dukes of Bedford. An ancestor, Robert Butcher, is said to have acted as an agent between the 4th Duke and Gainsborough.

If hardly a virtuoso performance, this is none the less a remarkably sound product for such a young man just embarking on his professional training and a demonstration of the precocity attributed to him by contemporaries. Furthermore, it asserts a particular kind of identity for the painter. His direct, almost confrontational look and the prominence given to his palette and paintbrush introduce him as a keen apprentice proudly displaying the emblems of his trade. While a few native-born artists, notably William Kent (1685–1748) and Sir James Thornhill (1675/6–1734), had risen to the highest social status, British artists were generally perceived as downtrodden. The artists of St Martin's Lane whom Gainsborough associated with in London staked a claim to social value on their mastery of their trade and the contributions they could make to the developing urban culture. Gainsborough, presenting himself here as a combative and knowing youth, seems to be suggesting that he would be ready to take up that cause. MM

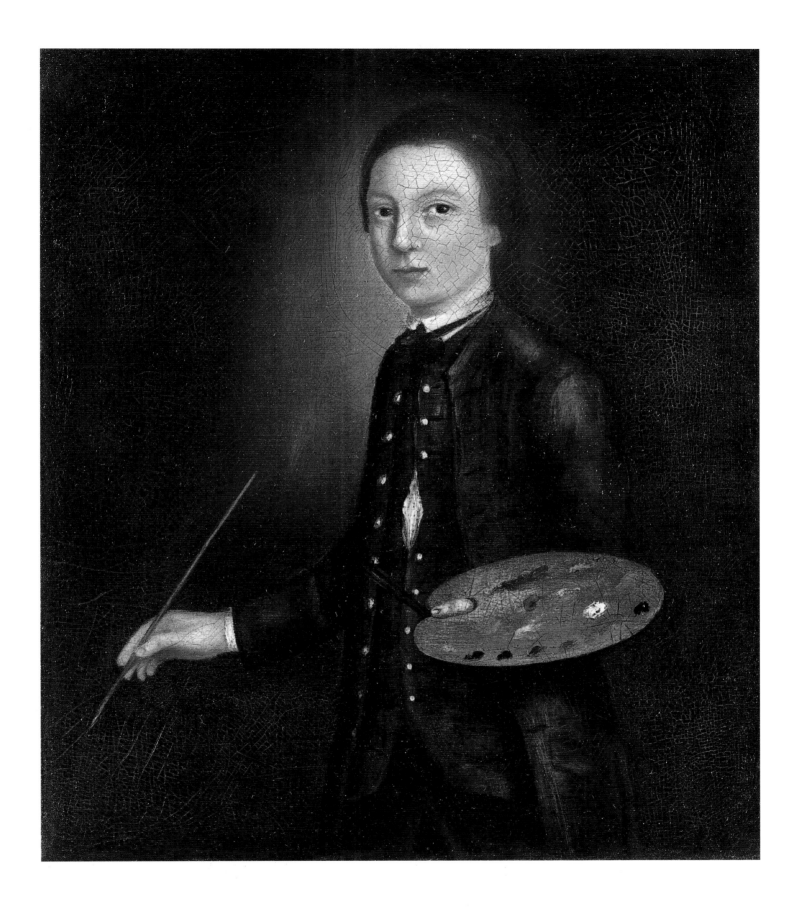

2

Open Landscape with Cottage at the Edge of a Wood

c.1744–5
Oil on canvas, 29.8 × 34.9 (11¾ × 13¾)
The Royal Pavilion, Libraries & Museums,
Brighton & Hove
Presented from the Herbert Powell Collection
through the National Art Collections Fund,
1955

Hayes 1982, no.3

This small oil sketch is one of the earliest known landscapes by Gainsborough, executed at around the time that he established his own studio in London. It is largely unfinished with much of the composition, such as the trees on the right, no more than laid in. The absence of any figures or other staffage also points to it being abandoned at an early stage. It may be an attempt to paint directly from nature, given up when the challenge proved too great. The resulting design is none the less highly contrived: the rather stiff framing tree on the left is a device familiar from Gaspard Dughet (1615–1675) or Claude (1600–1682), while the carefully placed logs are derived from Jacob van Ruisdael (1628/9–1682).

The simplicity of the composition, with the broadly arching shapes of the two banks to suggest receding planes and the generalised treatment of the foliage and sky, is typical of the artist's first attempts at landscape painting. The sweeping, repetitive curves are likewise common to most of his very early works. The subject of a cottage at the edge of

a wood was one that was to be repeated many times throughout Gainsborough's career, although here the cottage tucked behind the tree in the centre is barely discernible.

Unusually for a picture that was not finished, there are two known copies of this subject. The first was possibly by George Frost (d.1821), a collector, largely of Gainsborough drawings, and the original owner of this canvas, while the other was by J.C. Ibbetson (1759–1817), whose style as a landscape and genre painter was closely imitative of Gainsborough's work. DP

3
Copy after Ruisdael's 'La Forêt' *c.*1747
Drawing black and white chalks on buff paper,
40.8 × 42.2 (16⅟₁₆ × 16⅝)
The Whitworth Art Gallery, The University of
Manchester

Hayes 1970, no.80

Figure 33
Jacob van Ruisdael
La Forêt (Wooded Landscape with a Flooded Road) 1660–70
Oil on canvas, 171 × 194 (67⅜ × 76⅜)
Louvre, Paris, on extended loan to Douai, Musée de la Chartreuse

Gainsborough's use of the examples set by
Dutch seventeenth-century landscape
painters is nowhere more apparent than in
this direct copy in chalks of a painting by
Ruisdael. It is the only surviving example by
Gainsborough of a drawn copy of a specific
Dutch landscape, although others may have
been executed and since lost. It is a repetition
of Ruisdael's *La Forêt* (fig.33), several versions
of which are known to exist. The original
would probably have been unfamiliar to
Gainsborough and the drawing was more
likely to have been based on a replica of the
subject. Although Gainsborough adopted
many of the compositional devices and the
motifs, as well as the naturalistic style, of the
Dutch masters, particularly those of Jan
Wijnants (d.1684) and Meindert Hobbema
(1638–1709), the deepest and most enduring
influence on his early work was exerted
by Ruisdael.

This is Gainsborough's largest drawing of
the period and its painstaking and elaborate
manner suggests the importance it must have
held for him. It is executed in black and white
chalks, rather than the more usual pencil,
probably because they were better suited to
capturing the tonal qualities of a painting.
Gainsborough's earliest drawings tended to
be very precise but rather weak in suggesting
depth and space. It was perhaps to try and
overcome these problems of composition and
recession that he made this exact replica after
Ruisdael, for in *La Forêt* there is a strong
emphasis on depth, with the shallow river
leading into the distance, and the overlapping
trees and the winding sunlit path disappearing
through the woods.

The subject was used as the basic
pattern for three large, ambitious oils
painted at this time: the landscapes in the
São Paulo Museum of Art, Brazil, that in the
Philadelphia Museum of Art, and, with more
freedom, *Gainsborough's Forest ('Cornard
Wood')* (cat.4). DP

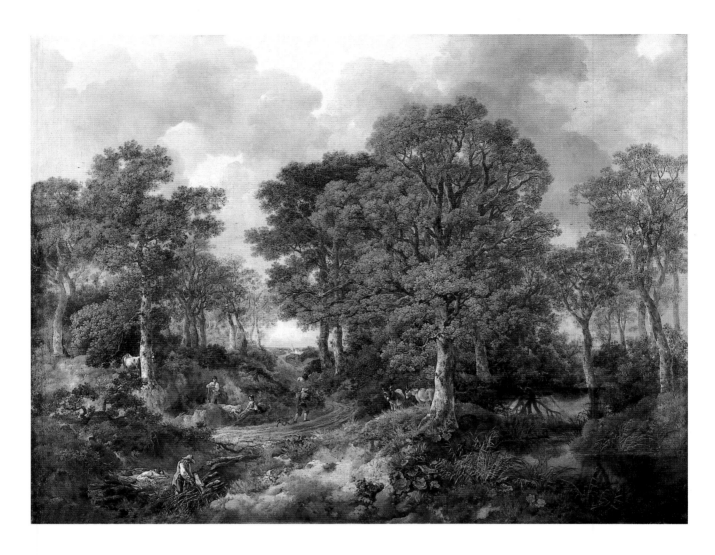

4

Gainsborough's Forest ('Cornard Wood')
*c.*1746–8
Oil on canvas, 121.9 × 154.9 (48 × 61)
National Gallery, London

Hayes 1982, no.17

Gainsborough's Forest is the artist's most celebrated early landscape. It clearly held an important place for him for he referred to the painting in a letter written towards the end of his life:

> *It is in some respects a little in the Schoolboy stile – but I do not reflect on this without a secret gratification; for – as an early instance how strong my inclination stood for LANDSKIP, this picture was actually painted at SUDBURY in the year 1748; it was begun before I left school; – and was the means of my Father's sending me to London. (Letters, p.168)*

Gainsborough's reminiscences concerning the dating of the painting are not altogether credible. Since the canvas itself was evidently not begun as early as 1740, it may be that the idea for the composition was present when he was still a boy and that he had perhaps made some preparatory sketches for it. On stylistic grounds the painting appears to date from slightly earlier than 1748.

Large in scale and ambition, the picture encompasses all that the young artist had learnt and achieved in London. In the same letter Gainsborough commented that 'though there is very little idea of composition in the picture, the touch and closeness to nature in the study of the parts and *minutiae*, are equal to any of my latter productions'. The complexity of design here, encompassing numerous unrelated figures and incidents, is certainly far removed from the breadth and unified mood of his later landscapes, while the sensitivity and descriptive accuracy of the figures, animals and foliage fit with Gainsborough's own estimate of this youthful performance.

The composition is modelled on Ruisdael, which is confirmed by Gainsborough's drawn copy of Ruisdael's *La Forêt* (see cat.3) of around the same date, which is closely related to this both in design and subject matter. However, Gainsborough's detailed portrayal of the activities and freedom of the country people – the woodman, travellers and courting couple – on the common woodland creates a persuasive image of the contemporary way of life of the 'forest commoners'. Their livelihood was to become increasingly threatened with the onset of enclosures and engrossing, which removed such ground from communal usage. DP

Beginnings: The Early Years

5

Wooded Landscape with Peasant Resting

*c.*1746–7
Oil on canvas, 62.5 × 78.1 (24⅝ × 30¾)
Tate; Purchased 1889

Hayes 1982, no.19

Gainsborough painted this landscape when he was about twenty years old, towards the end of his apprentice years in London. Although he was absent from his native county (to which he returned late in 1748), the painting is clearly a vision of the Suffolk landscape, characterised by its flatness, open fields, wooded copses and rutted roads. The brightly illuminated church tower in the background, glimpsed between the trees, has not been identified as one in an actual village, but could conceivably stand as a symbolic reminder of the path to salvation. It is typical of Gainsborough's early landscapes in its obvious debt to earlier Dutch painters, especially Ruisdael and Wijnants. The Dutch influence is apparent in the ordered composition and the detailed observation of nature, in particular the foliage, where Gainsborough has recorded an astonishing variety of different greens, or the equally careful observation of light and shade in the landscape and how this corresponds to the pattern of light and cloud in the sky. Despite this apparent naturalism, the composition is highly contrived, with a central path between two balanced masses of trees leading the eye

to the sunlit landscape beyond, a device clearly derived from Ruisdael, and one that he used in other landscapes of this date, such as *Gainsborough's Forest* (cat.4).

Like many of Gainsborough's early works, the handling of *Wooded Landscape* is fresh and fluent, with a crisp touch that gives a lively sparkle to the canvas more akin to contemporary French painters than the earlier Dutch masters. The painting is innovative in fusing Dutch compositional devices and detailed observation with this decorative handling of paint, and stands as an early example of Gainsborough's wholly individual feeling for the light and atmosphere of the English countryside. A mood of lazy contentment is established by the reclining figure, resting by the wayside under the shade of a tree. This is a motif that proliferated in contemporary and historical landscape painting, and was continually employed by Gainsborough. DP

6

The Charterhouse
1748
Oil on canvas, diameter 55.9 (22)
Coram Family in the Care of the Foundling
Museum

Hayes 1982, no.23

In 1748 Gainsborough became involved in the most significant collaborative artistic project of the time: the decoration of the General Court Room of the Foundling Hospital in London. The Hospital was set up by Captain Thomas Coram in 1739 to care for abandoned children. This was a controversial issue, as the morality of the mothers of these foundlings was much in question. Led by Hogarth (who was appointed a governor of the hospital in 1739), during the 1740s a group of artists associated with St Martin's Lane contributed decorations and works of art to the Hospital. Hogarth, Hayman, Joseph Highmore (1692–1780) and James Wills (active c.1740–1777) gave large religious pictures in 1746–7. Gainsborough was among the artists who presented small round paintings showing hospitals (including the Foundling itself) that were set into the walls of the Court Room alongside these larger pictures. This scheme served to give the Hospital greater public profile and, with the focus on the theme of charity (both in the large paintings depicting biblical precedents and in the small roundels showing the Foundling on a par with more

established hospitals), helped to legitimise its cause. For the artists involved, this was a quite unprecedented opportunity to show that painters could have a meaningful role in public life and demonstrate that they were at least equal to their foreign competitors.

This painting was given by Gainsborough to the Hospital on 11 May 1748. Like the other roundels it shows a well-established and respected charitable institution: the Charterhouse was set up in 1611 for the education of the poor. In striking contrast to the more starkly topographical views presented by the other artists, Edward Haytley (active 1740–1761), Richard Wilson (1713/14–1782) and Samuel Wale (1721–1786), Gainsborough has created a compact composition that negotiates the formal problems created by the round format with astonishing facility, while demonstrating his supreme mastery of chiaroscuro and perspective. Technically, and formally, the artist is looking back to seventeenth-century Dutch precedents rather than his London contemporaries. MM

Beginnings: The Early Years

7

Holywells Park, Ipswich

*c.*1748–50
Oil on canvas, 48.5 × 65 (19⅛ × 25⅝)
Ipswich Borough Council Museums and
Galleries. Acquired with the assistance of the
National Art Collections Fund, the Museums
and Galleries Commission (via the Victoria and
Albert Museum Grant-in-Aid Fund), Pilgrim
Trust and the National Heritage Memorial Fund

Hayes 1982, no.26

Although still in his early twenties,
Gainsborough's work after his return to
Sudbury in 1748 demonstrates that he had
developed from being an outstanding student
to an accomplished master. In spite of his
acute talents (demonstrated so well at the
Foundling Hospital), at this early stage of his
career Gainsborough seems to have been
willing to accept a wide range of
commissions.

This distinctive landscape of the
interlocking reservoirs of Holywells Park in
Ipswich was commissioned by the Ipswich
brewer John Cobbold, who had sunk the
series of ponds in the park to provide spring
water for his brewery. It is unusual in
representing an identifiable view and even
more unusual in depicting an industrialised
landscape. It is one of only a handful of
topographical landscapes by Gainsborough,
which includes *St Mary's Church, Hadleigh*
(*c.*1748–50; Gainsborough's House, Sudbury)
and *Landguard Fort* (destroyed, but engraved
in 1754), commissioned by Philip Thicknesse.
Gainsborough's aversion to painting strictly
topographical views was given expression in

a letter, probably of the mid-1760s, from him
to the Earl of Hardwicke, where he stated 'if
his Lordship wishes to have anything
tollerable [sic] of the name of G. the Subject
altogether, as well as figures &c must be of his
own Brain' (*Letters*, p.30). Aside from these
early examples, the artist stuck by these
principles and declined to paint specific views
to commission.

Gainsborough's treatment of the park here
is quite different from topographical views by
his contemporaries, such as Samuel Scott
(1702–1772) or Canaletto (1697–1768). While he
has carefully described the series of
reservoirs, with the three larger ponds on the
left linked via the sluice gatehouse to the five
smaller ones, he has imbued the scene with a
characteristic light, and the threatening grey
clouds impart a somewhat melancholy air.
Despite the obvious constraints of
representing an actual view and his
disinclination for such work, he has
nevertheless devised an imaginative and
atmospheric composition. DP

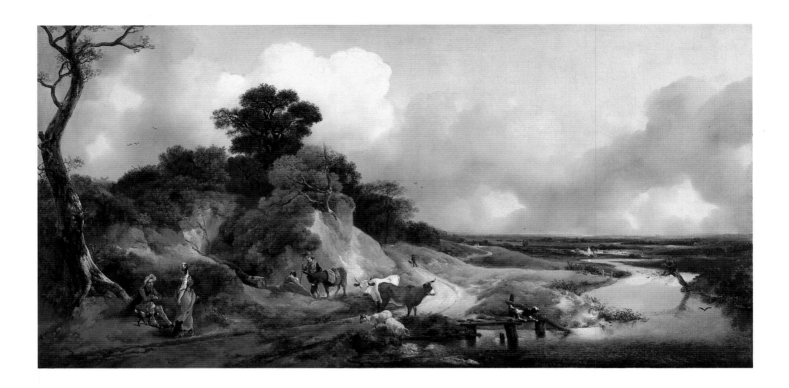

8

Landscape with a View of a Distant Village
c.1750
Oil on canvas, 75 × 151 (29½ × 59½)
National Gallery of Scotland, Edinburgh

Hayes 1982, no.29

This landscape may have been painted to
commission, for the large panoramic view seems to
have been designed to occupy a particular space,
such as an overmantel. This might account for the
picture's fundamentally decorative quality, for it is
rich in texture, colour and incident. The artifice of the
design is apparent in the serpentine lines of the path
and meandering river, the rolling clouds, and
particularly in the figure of the peasant girl in her
billowing skirt, standing on the left.

The artist makes the most of the wide format of
this composition by leading the viewer's eye across
the sweep of the canvas, from the girl conversing
with the seated wayfarer on the left via the low
horizon to the dog barking at a swallow, which is
flying towards the right bank of the river. At the same
time the receding river and path lead us into the
picture towards the open landscape in the distance.
The sophistication of the carefully constructed
composition stands out amongst the artist's early
Suffolk landscapes, although in other respects it has
much in common with similar subjects of around
this date, especially in its wide variety of scattered
figures and animals and their various activities,
a tendency also apparent in *Gainsborough's
Forest* (cat.4).

An extensive river landscape had been the
subject of one of Gainsborough's first landscape
compositions of c.1744–5 (National Trust, Upton
House), but although it was a theme that he turned
to on other occasions throughout his career, river
scenes were not commonplace in his oeuvre. This
majestic river landscape is inspired by a view in the
Stour Valley. Some of the details, such as the brightly
illuminated church tower and bridge in the distance,
seem to indicate local topography, although the
scene remains fundamentally a confection. DP

9

**Landscape with a
Decayed Willow over a Pool**

c.1754–6
Pencil on paper, 28.6 × 34.3 (11¼ × 13½)
The Pierpont Morgan Library, New York

Hayes 1970, no.150

10

Drover with Calves in a Country Cart

c.1754–6
Pencil and grey wash on paper,
24 × 29.1 (9⁷⁄₁₆ × 11⁷⁄₁₆)
National Gallery of Art, Washington, Gift of
Howard Sturges, 1956.9.25

Hayes 1970, no.152

Like several other pencil drawings made in Suffolk, these detailed and sensitive landscape sketches have been brought to a high degree of finish. The careful drawing is especially apparent in the ploughman straining against the heavy work-load with his plough drawn by two horses in cat.9. The withered tree stump that dominates the composition is equally closely observed and, in its darker tonality, adds a sombre note to the scene, perhaps to symbolise the futility of man's labour in the face of inevitable death. In the distance, sketched in a more cursory way, is a cottage with a milkmaid milking a cow, and a herdsman leaning against a tree, supervising his cattle.

The subject matter of many of Gainsborough's Suffolk landscape drawings was fairly repetitive, consisting largely of woodland scenes, with pools or streams, sandy or chalky banks, or cottages nestling among trees, and peopled by shepherd boys or ploughmen. The withered or pollarded tree was also a common feature. Having established this repertoire he went on to deploy it repeatedly, so these drawings are thus something of a summary of many of his familiar motifs. Some of his more elaborate early Suffolk drawings seem more concerned with detail than with the overall design of the composition. In both there are obvious disparities in scale, as if the vignettes are treated as separate elements, combined rather unsuccessfully on each sheet of paper.

It is not generally known exactly how Gainsborough sold his drawings but in the 1750s the London dealer Panton Betew stocked them and the artist presumably attempted to sell finished drawings, such as these, through him. Cat.9 and its companion (now missing) were owned early on by Philip, 2nd Earl of Hardwicke, and may have been purchased from the dealer. DP

11

The Suffolk Plough

*c.*1753–4
Etching on laid paper, image 33.2 × 38.8
(13 1/16 × 15 1/4)
Lent by the Trustees of Gainsborough's
House, Sudbury (Gift of Cavendish Morton,
October 1987)

Hayes 1971, no.21

Gainsborough was unusual for an artist of his generation in being unsystematic about having his works reproduced. Although he made a few etchings such as this in the early part of his career, he did not become closely involved with printmaking until the 1770s.

The Suffolk Plough was, until fairly recently, known only from a description in Edward Edwards's *Anecdotes of Painters* of 1808. According to Edwards, Gainsborough was impatient with the process of biting the etched plate and, against the advice of his friend the engraver Charles Grignion (1721–1810), impetuously went ahead on his own and irreparably damaged the copper plate. This could explain why the etching was never worked up into a fully realised image with the addition of engraved lines. This is the only known impression of the plate. The unsuccessful outcome of this large plate and that of the unfinished *Gypsies* (cat.28) reveal Gainsborough's early frustrations with the delicate processes of intaglio printing. It was

not until later in his career, with the availability of the new techniques of soft-ground etching and aquatint – more suited to his drawing style – that he began to excel as a printmaker.

The design for *The Suffolk Plough* comes from a painting rediscovered in the 1980s (Private Collection, USA; Hayes 1982, no.39). However, Gainsborough's initial attempt at the subject was in a slightly earlier and simplified version of around 1750–3 (Private Collection, England; Hayes 1982, no.36). The composition, with its windmill perched on a sandy bank, dominating the human activity below, is very similar to Rembrandt's *The Mill* (1645/48; National Gallery of Art, Washington), which Gainsborough may have known through a copy. DP

Beginnings: The Early Years

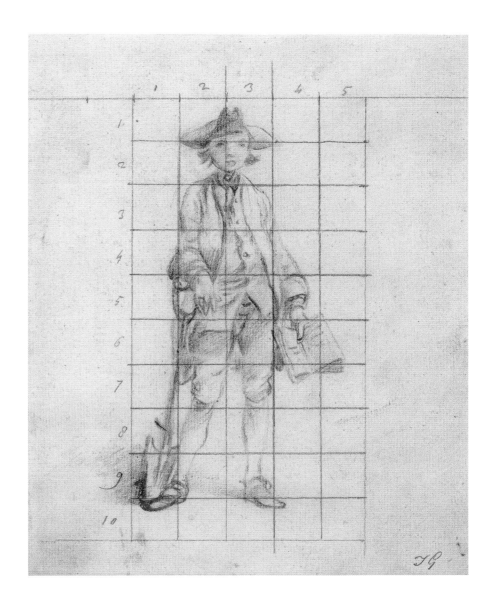

12

Study of a Standing Youth (Boy with a Book and Spade)

c.1744–6
Pencil, squared up for enlargement, 18.9 × 14.9
(7⁷⁄₁₆ × 5⅞)
The Pierpont Morgan Library, New York

Hayes 1970, no.813

Gainsborough made many youthful studies from nature, whether of the Suffolk countryside, plants and animals, or of country folk. Some of these were given by the artist to Philip Thicknesse, who described them as 'sketches of Trees, Rocks, Shepherds, Plough-men, and pastoral scenes, drawn on slips of paper, or old dirty letters, which he called *his riding School*'. Although the studies he gave to Thicknesse cannot be identified or have now disappeared, others, such as this, seem to have shared a similar purpose as details or staffage to be included in his landscape paintings. Although this study of a rather jaunty boy in a tricorne hat does not seem to relate to any such figure in a finished oil, other early figure drawings can be directly linked to paintings.

The drawing is squared up, presumably with the intention of enlarging it for use in a picture, although the actual size of the drawing is very similar to the average size of the little figures in his early landscapes.

A further puzzling aspect of the drawing is the unusual combination of the open book, which the boy holds in one hand, with the spade, on which he leans with his other arm.

This is one of the drawings originally bought by Charles Fairfax Murray (1849–1919), one of the greatest nineteenth-century collectors of Gainsborough drawings. Fairfax Murray was an artist who had studied under Sir Edward Burne-Jones (1833–1898) and who, later in his career, began collecting Old Master drawings. His collection, which included about twenty-five fine Gainsborough drawings, was bought by Pierpont Morgan in 1910 and forms the nucleus of the present Pierpont Morgan Library collection. Other works in the exhibition bought by Fairfax Murray include *Landscape with a Decayed Willow over a Pool* (cat.9) and *Study of Mallows* (cat.13), although the latter did not join the Pierpont Morgan holdings. DP

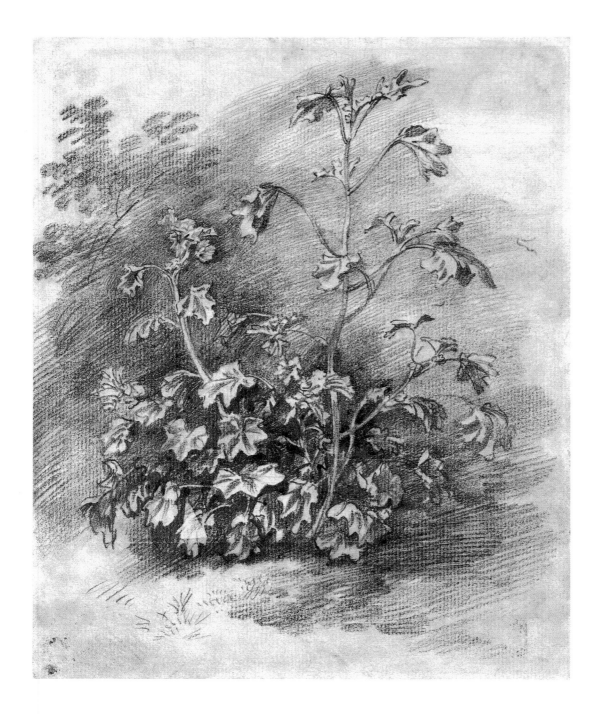

13
Study of Mallows
c.1755–60
Pencil on laid paper, 19 × 15.6 (7¼ × 6¼)
Sir Edwin Manton

Hayes 1970, no.177

This detailed and sensitive drawing is one of the few surviving studies by Gainsborough that appears to be an attempt to take an accurate transcription from nature. Only a few other precise drawings of specific motifs are known, including the *Study of Burdock Leaves* (later 1740s; British Museum) or the *Study of an Old Hurdle* (c.1755–60; Courtauld Institute of Art, London). Gainsborough's landscape drawings of his Suffolk period tended to be more generalised in character. They were primarily notations of ideas for compositions, or were finished drawings in their own right. Nearly all of Gainsborough's paintings include some carefully delineated natural features, whether plants, reeds, tufts of grass or fallen tree-trunks. However, the present motif cannot be identified closely with any known painting.

This study is almost certainly originally a sheet from a sketchbook. Ten of Gainsborough's sketchbooks descended to his daughter Margaret, who auctioned them in 1799, after which all of them were broken up. Indeed some of the purchasers of these sketchbooks, such as Sir George Beaumont, are recorded as buying them with the purpose of dividing them up. One of the sketchbooks that belonged to Richard Payne Knight (British Museum) contains a similar nature study of thistles on a mossy bank. DP

Beginnings: The Early Years

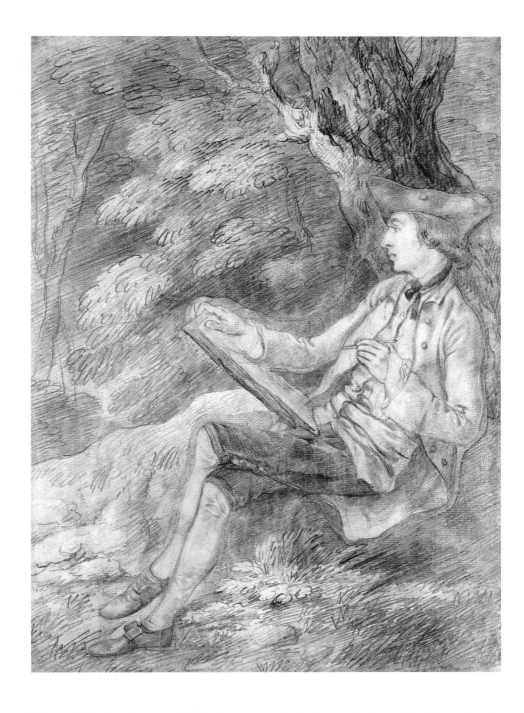

14
Self-Portrait Sketching
*c.*1754–9
Pencil on paper, 35.9 × 25.8 (14⅛ × 10⅛)
British Museum, London

This pencil drawing of a man sketching from nature is believed to be a self-portrait. It bears a likeness to others in oil, such as *Portrait of the Artist with his Wife and Daughter* (cat.17), although it is the only known drawing of Gainsborough. As a self-portrait, showing himself in his familiar tricorne hat, absorbed by nature and poised with a large sketchbook and pencil in hand, it seems to confirm the accounts of Gainsborough sketching outdoors, which were recorded by his friends Philip Thicknesse and, later, Uvedale Price (1747–1829), who went on sketching excursions with the artist around Bath.

The figure of the artist in this drawing has been cut out of a separate sheet and glued on to a landscape background, which may be of a slightly later date. As he is shown sketching with his left hand rather than his right, it might have been intended for engraving, which would have produced the reverse image. The composite nature of the drawing perhaps makes it unlikely to be a record of an actual event. It may indicate that the artist wanted to imply that he was an avid sketcher from nature, at a time when careful observation and 'truthfulness' were attributes that were much admired. DP

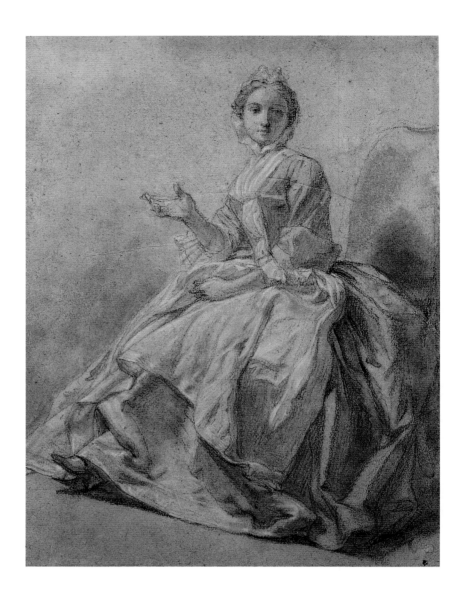

15
Hubert-François Gravelot (1699–1773)
A Young Woman Seated on a Chair
*c.*1744
Black chalk heightened with white,
32.5 × 25.5 (12¾ × 10)
Lent by the Trustees of Gainsborough's
House, Sudbury (purchased with a
contribution from the MGC/V&A Purchase
Grant Fund, May 1993)

16
Study of a Young Girl Walking
*c.*1745–50
Black chalk and pencil, heightened with white
chalk on brown paper, 38.3 × 23.8 (15 × 9¼)
National Gallery of Scotland, Edinburgh

Hayes 1970, no.815

These two drawings demonstrate
Gainsborough's profound debt to the French
engraver and draughtsman Hubert-François
Gravelot, with whom he studied in London
from 1739. Gravelot had come to England in
1732, and was closely associated with the St
Martin's Lane Academy, teaching life-drawing
there and working with Hayman on the
designs for the Vauxhall Garden decorations.
With these activities and through his
paintings, drawings and illustrations, he
played an important role in bringing over the
latest ideas from France. The elegant and
sophisticated style of French art and design –
which we might now call 'Rococo' but which
at the time was known (more tellingly) as
'modern' – was tremendously popular in
England. The artists and craftsmen of St
Martin's Lane knew that, if they were to
compete with the imported French products,
they would have to incorporate those qualities
into their own creations.

Gainsborough's use of black chalk in
combination with white highlights, and the
management of the neutral ground to create a
sense of volume by the most economical and
graceful means, are distinctly French in origin,
comparing closely to Gravelot's technique.
What characterised the approach of the artists
associated with St Martin's Lane was their
deployment of these elegant French
techniques in the creation of an imagery that
engaged with contemporary British life in a
more robust fashion. In this, Hogarth, with his
painted and printed explorations of themes of
urban morality – and more to the point,
immorality – was exemplary. Here, if Gravelot's
young girl is the very picture of modesty, the
sly look and revealing pose and costume of
Gainsborough's may indicate that her virtues
are more in question. Themes of prostitution
were certainly prevalent in Hogarth's art; the
woman who sold her charms in the city
served well as a symbol of both the pleasures
and corruption of modern life. MM

Beginnings: The Early Years

17

Portrait of the Artist with his Wife and Daughter

*c.*1748
Oil on canvas, 92.1 × 70.5 (36¼ × 27¾)
National Gallery, London

Waterhouse, no.296

This picture was painted towards the end of Gainsborough's time in London, before he returned to Sudbury in 1748–9. The small girl has been identified as their first child, Mary, who appears to have died in infancy early in 1748.

Gainsborough had married young, and, arguably, for money. When he and Margaret entered wedlock at Dr Keith's Mayfair Chapel on 15 July 1746 he was only eighteen, she, nineteen. However she did come with an annuity and it is fair to assume that this was as much an attraction as her evident good looks. Certainly, when compared to the solidly affectionate union that the artist showed the Gravenor family enjoying around the same date (see cat.20), Gainsborough's depiction of his own family might appear relatively chilly and distant. The physical separation between Gainsborough and his wife, and the way the child seems to shrink away and the dog ignores his master and drinks from the pool, create the impression of emotional disconnection.

Created very much in the idiom of Francis Hayman, the portrait presents an image of down-to-earth gentility. He holds a sheet of paper, which perhaps once bore the indications of a drawing, which have since faded or worn away. She holds a flower, a conventional motif in feminine portraiture. In each case these motifs allude to the interior emotional or intellectual life of the sitter; they are visible signs for the social and aesthetic capacities of these individuals. Painted in London, the landscape background is of the most generalised kind and is thus testament less to the sitters' attachment to any particular area than to their genteel capacity to appreciate the natural world. MM/MR

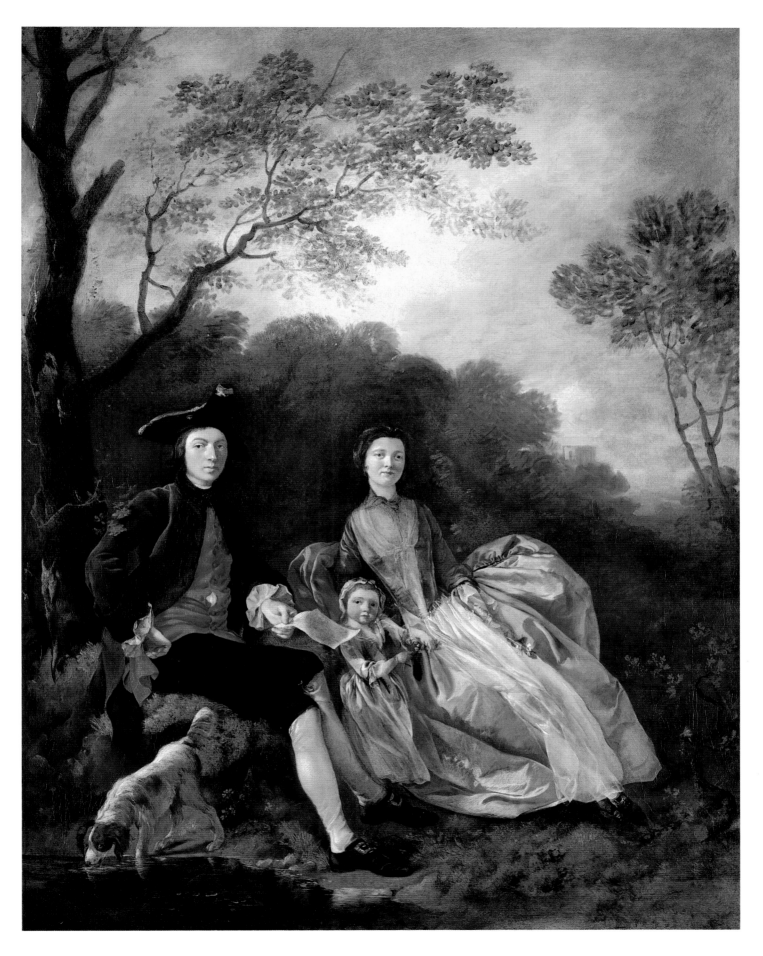

18

Mr and Mrs Andrews

*c.*1750
Oil on canvas, 69.8 × 119.4 (27½ × 47)
National Gallery, London

Waterhouse, no.18

This, one of Gainsborough's most famous paintings, shows Robert Andrews and his wife Frances on their estate in Essex. They had been married on 10 November 1748, when he was twenty-three and she was only sixteen. Robert Andrews had grown up in Bulmer, 2 miles (3 km) from Sudbury, and is said to have attended the Grammar School there at the same time as Gainsborough. He had inherited half of the estate in Essex from his father in 1735 and the other half from his wife's father, William Carter, in 1750. Although the painting is not, strictly speaking, a formal wedding portrait, as it was probably not painted until after Gainsborough had returned to Sudbury, it is none the less a celebration of their union and of the extensive property now owned by Andrews. What is unusual, in the context of Gainsborough's art, is that this property appears so carefully delineated, presumably in response to Mr Andrews's specific commands. Whereas the landscape settings for his portraits tended to be of a generalised character this was a depiction of a specific landscape, taken from an identifiable location. It has even been possible to relocate the very tree under which the Andrews sit.

Still, there is much artifice in this painting. The garden seat on which Mrs Andrews is positioned so primly is in the latest fashion, and is more likely to be an invention of the artist than an actual piece of furniture. More notably, there is the mysterious patch of unfinished painting on Mrs Andrews's lap, which is usually understood as being intended to represent a game bird but has prompted various speculative explanations. It is possible that the artist simply never completed the picture, although the lack of finish seems so deliberate that it is tempting to interpret it as some sort of private joke. But most important of all is the way that the artist has negotiated the potentially tricky problem of depicting an economically productive landscape alongside sitters who, as Mrs Andrews's fine costume and Mr Andrews's dog and gun suggest, wanted to present themselves as genteel. Most of Gainsborough's landscapes present an idyllic and deliberately artistic vision in which ordinary country people have as much time to rest and play as to work, their lives determined by the rhythms of nature rather than identifiable employers. Here the wheat field and grazing sheep have been described in exacting detail. The regular lines of stubble indicate the innovative use of a seed-drill, rather than more arbitrary hand sowing, and the sheep are shown in an enclosure that would ensure that they do not crossbreed with neighbouring and potentially inferior stock. These details draw attention to how Andrews had introduced the latest agricultural principles onto the estate. Rather than show labourers at work, which in juxtaposition with

the Andrews would have revealed the economic and social inequities that allowed them the leisure to pose for an artist, it would seem to be the neat sheaves of wheat that in themselves symbolise the economic fruitfulness of the land. The men and women who made that economic fruitfulness possible through their labour are displaced from the picture.

From John Berger's politically critical account of the picture in his landmark TV series and book *Ways of Seeing* (1972) through to the many political and social satirists who have re-worked the image, the picture has served as a potent emblem of wealth and privilege. Yet, despite its present-day fame, the picture remained with the Andrews family until 1960, and was virtually unknown until it was lent to an exhibition at Ipswich in 1927. MM

Beginnings: The Early Years

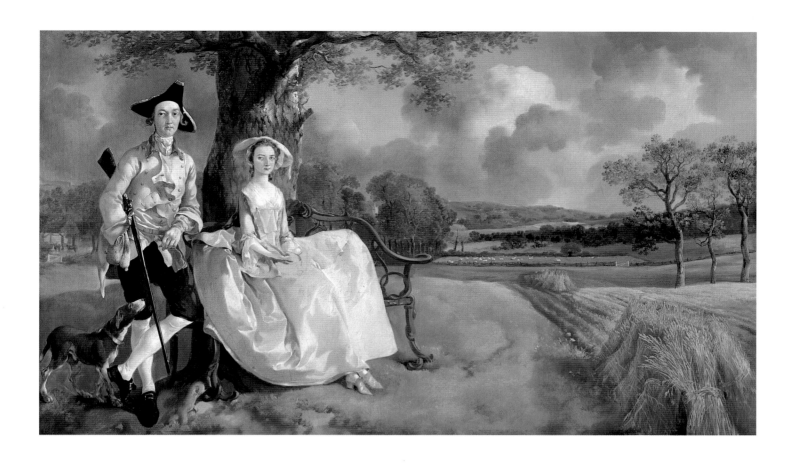

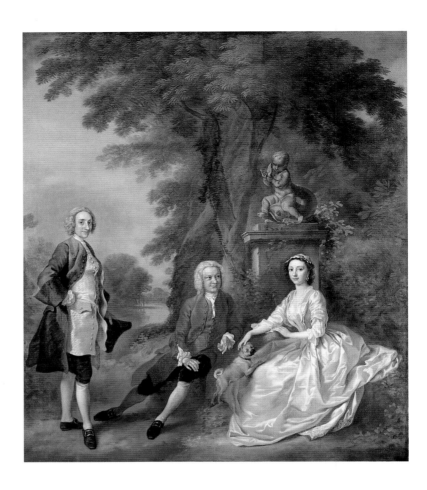

19

Francis Hayman (1708–1776)

Jonathan Tyers with his daughter Elizabeth, and her husband John Wood

*c.*1750–2

Oil on canvas, 99.1 × 86.4 (39 × 34)

Yale Center for British Art, Paul Mellon Collection

20

The Gravenor Family

*c.*1752–4

Oil on canvas, 90.2 × 90.2 (35½ × 35½)

Yale Center for British Art, Paul Mellon Collection

Francis Hayman was, with Gravelot and Hogarth, the most important artistic influence on the young Gainsborough. Gainsborough studied with Hayman in the early 1740s. These two pictures show how closely Gainsborough followed his model in the style and imagery of his own early portraits, although, as Rica Jones and Martin Postle point out (pp.29–30), this closeness did not extend to the exact techniques of their paintings.

Hayman's sitters are Jonathan Tyers (1702–1767), the owner of Vauxhall Gardens, with his recently married daughter Elizabeth and her husband John Wood. Tyers is shown seated at the centre of the image, his daughter and new son-in-law at either side. In his employment of the best artists available for the decorations at Vauxhall, Tyers had sought to create a place of public entertainment that was distinguished by a refined and fashionable taste that his visitors could aspire to. Hayman represents him as the head of a polite and elegant family in this portrait. The attention to the rich textures and colours of costume, the studied nonchalance of the poses, and the parkland setting combined with the relatively small scale of the figures communicate a sense of graceful informality and ease, rather than grandeur and pretension. This kind of portraiture was able to represent the values of the 'middle rank' of

society without dutiful reference to the grander and more specifically aristocratic traditions of the genre.

Gainsborough's picture depicts John Gravenor with his second wife and their two daughters. Gravenor was an apothecary at Ipswich, and so one of the professional men who were Gainsborough's most frequent patrons in the 1750s. As had Hayman, he creates an image of a family at once conscious of their elegance and refinement, and convincingly bound together into a unit by affection. Likewise, there is an element of symbolic artifice. Where Hayman had used the garden sculpture (with the dove, cherub and dolphin representing love and peace) and the lapdog (symbol of fidelity) to comment on the relationship between the sitters, Gainsborough depicts crossed tree-trunks behind Mr and Mrs Gravenor to represent the bond of marriage, while the corn may refer to the theme of fertility. MM

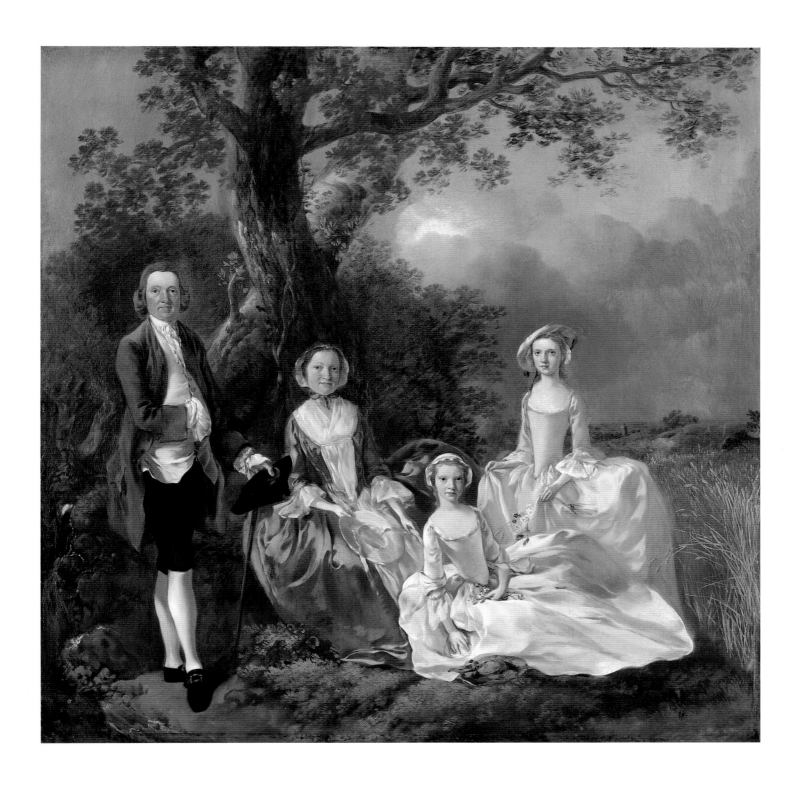

21

**Peter Darnell Muilman, Charles Crokatt and
William Keable in a Landscape**

*c.*1750
Oil on canvas, 76.5 × 64.2 (30⅛ × 25¼)
Tate; Purchased jointly with Gainsborough's
House, Sudbury, with assistance from the
National Heritage Memorial Fund, the
National Art Collections Fund and the Friends
of the Tate Gallery 1993

Waterhouse, no.747

The sitters can probably be identified as (from
left to right): Charles Crokatt (died 1769),
William Keable (?1714–1774) playing the flute,
and Peter Darnell Muilman (*c.*1725–1766). The
two seated figures to the left are posed in a
relaxed way in the spirit of a conversation
piece, whereas the young man standing on
the right, slightly set apart from his comrades,
is characterised by an air of distinction. Since
it is believed that the picture was
commissioned by his father, Henry Muilman,
it would be appropriate that Peter Darnell
Muilman is the most prominent figure.

Peter Darnell Muilman's father, Henry (died
1772), was a prosperous merchant who had
emigrated with his brother Peter (1713–1790)
from Amsterdam and retired to the Essex
countryside in 1749. It seems likely that Henry
Muilman commissioned the picture from
Gainsborough to include both his son and his
future son-in-law, for his daughter Anna was
to marry Charles Crokatt on 16 April 1752.
Charles Crokatt was also the son of a wealthy
merchant, from Charleston, South Carolina,
who in 1749 acquired Luxborough Hall near
Chigwell, Essex, not far from the newly
acquired Muilman estate at Dagenhams,
Romford. It is tempting to assume that the
two families had business associations, since
they were all successful immigrant
merchants, although their connection may
have been solely a marital one.

In the centre is William Keable, who was
a moderately successful portrait painter. He
was also an amateur musician and his role as
the flautist suggests that he served Crokatt
and Muilman as a music master. Keable may
have become acquainted with Gainsborough
through artistic circles in Suffolk or musical
ones, such as the Ipswich Musical Club. DP

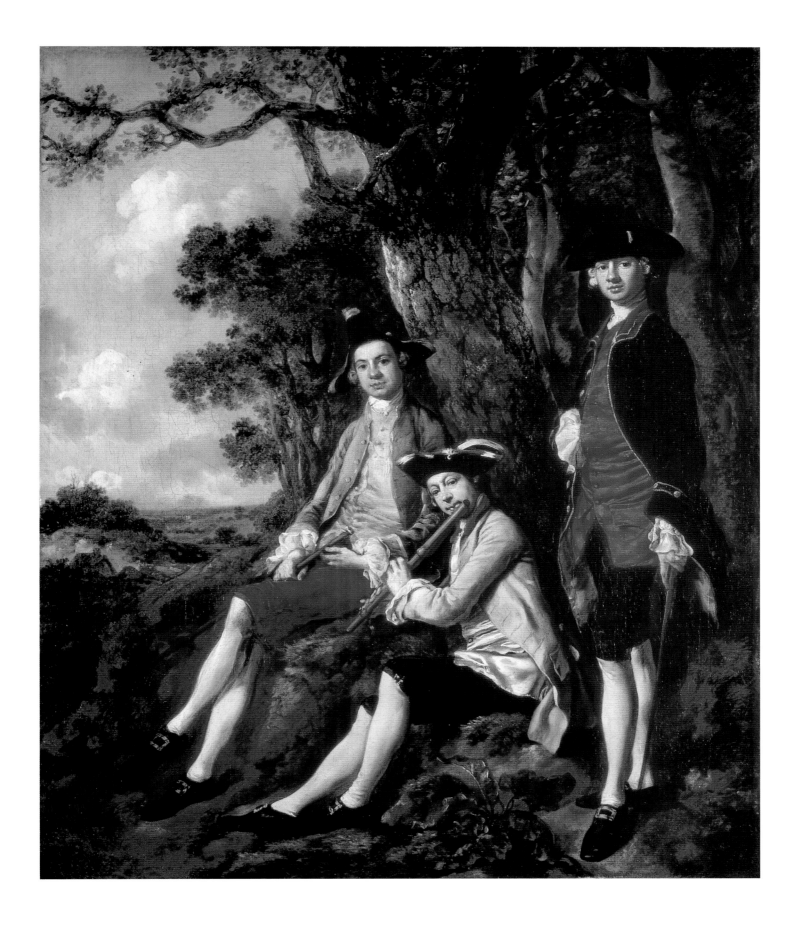

22

The Revd John Chafy Playing the Violoncello in a Landscape

*c.*1750–2
Oil on canvas, 74.9 × 60.9 (29½ × 24)
Tate; Purchased with assistance from the Friends of the Tate Gallery, the National Heritage Memorial Fund and the National Art Collections Fund 1984

Waterhouse, no.127

The Reverend John Chafy (1719–1782) was the vicar at Great Bricett, between Sudbury and Ipswich, for the period from 1749 to 1752. This portrait was probably commissioned by the sitter towards the end of his time in Suffolk. Gainsborough shows him in the unlikely circumstance of playing a cello whilst seated on a grassy knoll beside a river. Chafy was known to be a highly accomplished musician, and the way he holds down the bow can be identified with the 'Italian manner' described in Michael Corette's *Méthode … pour appendre le violoncello* (1741). To the left we see a classical urn and a temple containing the sculpture of a figure holding a lyre, a presumably rather non-specific reference to the ancient gods concerned with music and poetry.

The idea of posing a male sitter so casually in a landscape setting is one that appears in a number of portraits in the 1740s and 1750s by Hayman and Gainsborough. The most important source for such images was Watteau. Gainsborough here seems to be referring to a print reproducing, or perhaps only interpreting, Watteau's self-portrait with his patron Julienne in a park. There, the painter is shown at an easel next to Julienne, who is playing a viola, the painter and the musician each finding their own ways to be in harmony with their natural surroundings. This was a theme explored by Gainsborough in a number of paintings, and in his letters, where music and art are considered as sharing principles of natural harmony. Appealing as the resulting image is, it is worth remembering its serenity was predicated upon the social status and gender of the sitter. The Revd Chafy might appropriately be shown out in the country playing his instrument between his knees, but when a few years later Gainsborough came to paint a female player of the viola da gamba, the results were quite different (see cat.35). MM

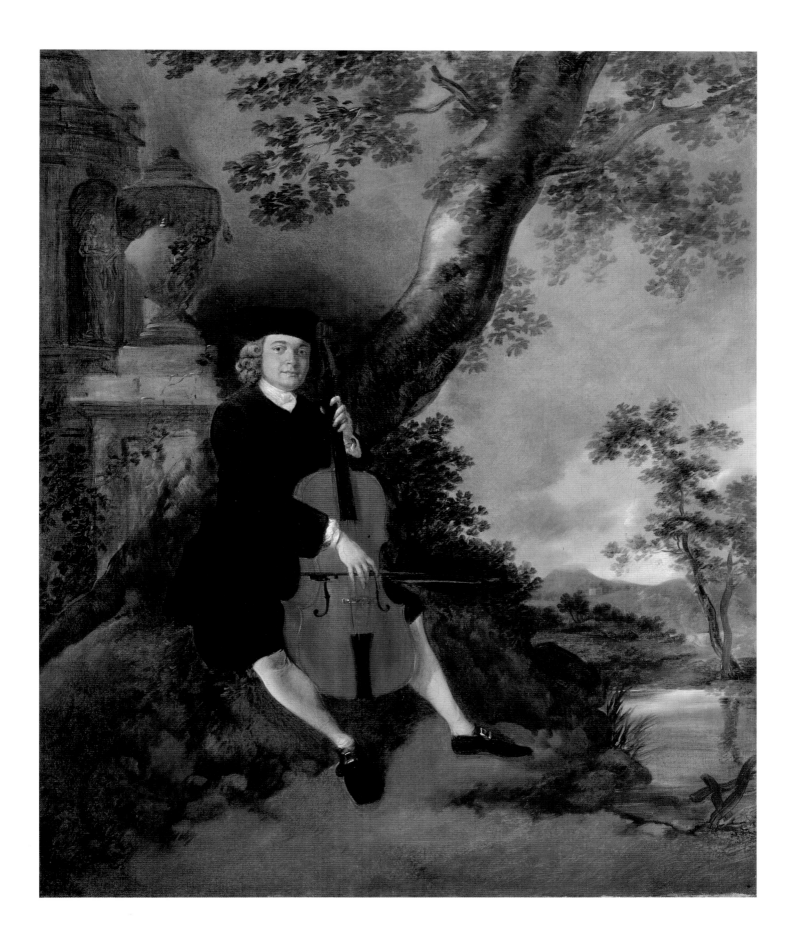

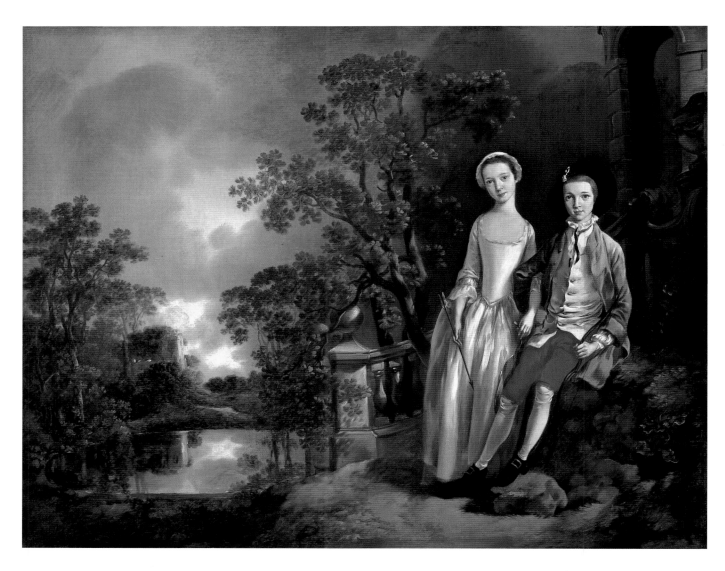

23

Heneage Lloyd and his Sister

c.1752
Oil on canvas, 64.1 × 81 (25¼ × 31⅞)
The Syndics of the Fitzwilliam Museum,
Cambridge

Waterhouse, no.452

One of the most deliberately fanciful-looking of Gainsborough's portraits of the 1750s, this picture represents Heneage and Lucy Lloyd, the children of Sir Richard Lloyd of Hintlesham Hall near Ipswich, arm-in-arm in a parkland setting. Richard Lloyd was a prominent figure in local life, and Gainsborough painted a number of portraits of the Lloyd family at the beginning of the 1750s. Sir Richard is depicted in a portrait in the National Museum of Wales, and a double portrait of Richard Savage Lloyd with his mother is in the Yale Center for British Art, New Haven.

Amal Asfour and Paul Williamson have ingeniously connected this portrait to a specific emblem in Van Veen's *Amorum Emblemata*, published in Antwerp in 1608. That represents two embracing cupids as emblematic of innocent love within a corrupted and ruinous world. This would help explain the otherwise mystifying presence of the arrow held by Lucy Lloyd and the bows held by both children, and the prominent place given to the ruin in the background. Though we might doubt whether, by the

middle of the eighteenth century, these emblems could carry the full intellectual and spiritual weight that Asfour and Williamson propose, it would certainly seem right to consider the picture in relation to the traditions of emblematic imagery, if only in a more generalised way. Certainly, Gainsborough was always ingenious in employing his landscape settings to convey something about his sitters, and was willing to use symbolic devices (see cat.20). MM

Beginnings: The Early Years

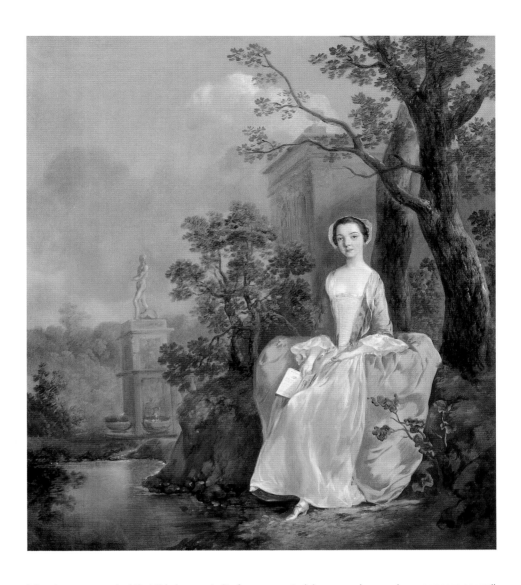

24
Portrait of a Woman
c.1750
Oil on canvas, 75.8 × 66.7 (29⅞ × 26¼)
Yale Center for British Art, Paul Mellon
Collection

Waterhouse, no.754

It has been suggested that this is a portrait of a member of the Lloyd family of Ipswich, on the basis of resemblances between this picture and a painting by Gainsborough known as 'Miss Lloyd' (c.1750; Kimbell Art Museum, Texas) and the similarities in the parkland setting that appears in his portrait of Heneage and Lucy Lloyd (cat.23). The identification has not been firmly established.

Like other portraits by Gainsborough of this period, the painting appears to employ a degree of symbolic artifice. The classical pavilion rising over the trees on the right and the large fountain with its sculpture are suggestive elements, setting the scene as an elegant park and intimating some kind of emblematic significance. What these additional meanings might be are mysterious, although the use of sculpture to add a layer of meaning to a portrait was well established, being used by Hayman (see cat.19) and deriving, in turn, from the works of Watteau. The motif of a young girl with a book can be explored in a more general way. The massive escalation in the production of printed materials – magazines and newspapers as well as books – and the emergence of novels as a popular form of entertainment created a readily accessible culture of reading in the early eighteenth century, in which news and ideas could circulate in an informal and unregulated way. The concomitant emphasis on private contemplation meant that the more severe ideals of citizenship, which equated knowledge, power and property and were exclusive to men, receded before the advance of new ideals of personal virtue, based around emotional sensitivity and imagination. The figure of the girl with a book was a prime symbol of this new kind of experience, and featured as a theme in both portraiture and in invented scenes – 'fancy pieces' – celebratory of the pleasures of privacy. In common with such images, Gainsborough's sitter is not shown as engaged in serious study. The book is the object of leisure and pleasure rather than a means of acquiring serious knowledge – still generally considered the province of men. MM

25
Admiral Vernon

1753

Oil on canvas, 124 × 99.5 (48¾ × 39)

Private Collection of Robert Stephen Holdings plc

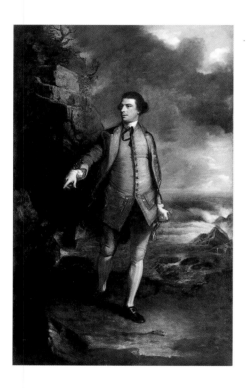

Figure 34
Joshua Reynolds
Commodore the Hon. Admiral Keppel 1752–3
Oil on canvas 239 × 147.5 (94⅛ × 58⅛)
National Maritime Museum, Greenwich

During the 1750s Gainsborough rarely had opportunities to create portraits on a larger scale. But such works were crucial if a portrait painter was to establish a reputation among the best kinds of patrons. The commissioning of this portrait, shortly after Gainsborough had moved to Ipswich in 1752, gave such an opportunity. It was also a financial necessity, as is revealed in a letter from the artist to Elizabeth Rasse, the wife of his landlord in Ipswich, in which he promises that he will be able to pay his debt to her once he had finished 'the Admirals picture' (*Letters*, p.5).

The sitter is Admiral Edward Vernon (1684–1757), a naval hero whose performance in the War of Jenkins's Ear (1739) had established him as a national figure, consolidating the growing sense of patriotism that accompanied the aggressive imperial and mercantile expansion of the mid-century. Serving as Member of Parliament for Ipswich from 1741 until his death, Vernon was a controversial figure and his political enemies threw his naval achievements into doubt. Significantly, it is his role as a naval commander that is celebrated here, with Vernon's capture of the Spanish town of Porto Bello on the coast of Panama in 1739 represented to the right (in a painted detail probably added by a marine specialist). The dignified pose, prominent canon and the dramatic background were conventional elements of naval portraiture. But where Reynolds, in his famous *Commodore Keppel* of 1752 (fig.34), had revitalised the genre with his knowing use of a classical pose for his naval officer and a self-consciously grandiose composition, Gainsborough here develops an image of Hogarthian robustness. Given Vernon's reputation for being bluff and outspoken, this would have suited him well. However, the slightly uneasy composition indicates that Gainsborough was not yet fully in command of his art. Philip Thicknesse recalled seeing this work in the artist's studio, and referred to it as 'truly drawn, perfectly like, but stiffly painted, and worse coloured'.

The version of the portrait in the National Portrait Gallery (Waterhouse, no.692) was long considered the original, but is now generally agreed to be an inferior version of this painting. The present picture was engraved in mezzotint by the leading printmaker James McArdell in 1753, showing that Gainsborough was trying to get the most publicity he could from the chance to paint a nationally famous sitter. MM

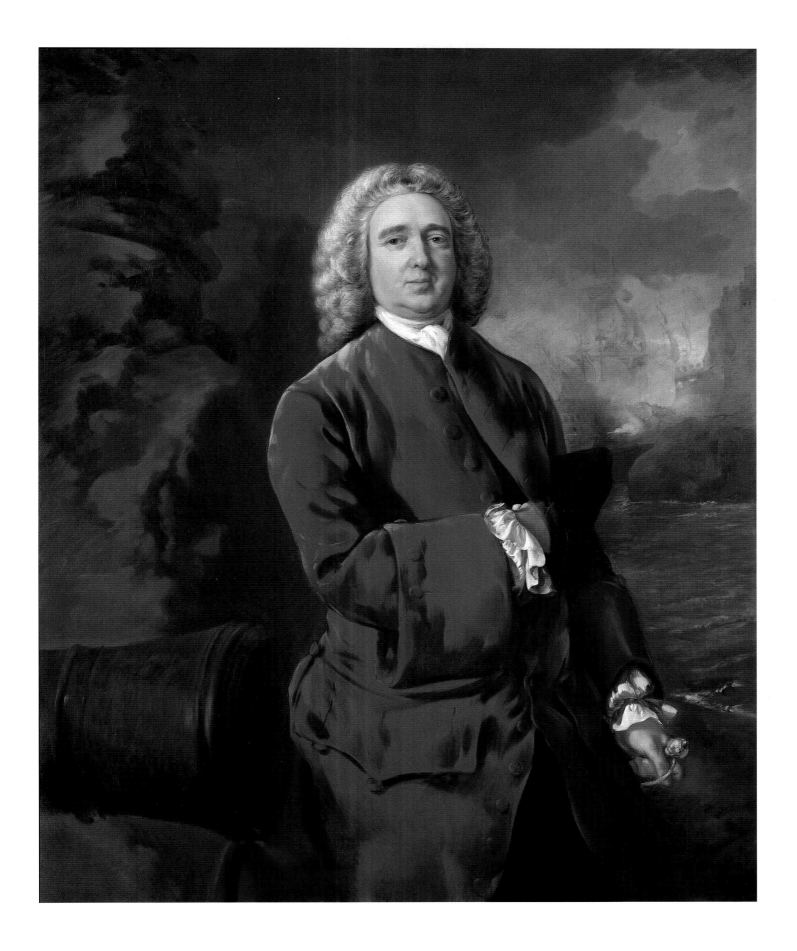

Self-Portrait

*c.*1758–9
Oil on canvas, 76.2 × 63.5 (29¾ × 24½)
National Portrait Gallery, London

Waterhouse, no.291

Painted on the eve of his move to Bath, in its scale and confidence this portrait marks the growing ambitions of Gainsborough's art. As in his very first self-portrait (cat.1), Gainsborough shows himself gazing directly out of the picture, and is soberly dressed. But now his left hand is tucked into his jacket – the conventional posture of the gentleman – and the tools of his trade are absent. Instead, the tumbling foliage that frames his features and concentrates our attention on his face indicates an outdoor setting. This suggestion of a landscape context was more fully explored in the curiously constructed drawing of the same decade showing the artist sketching in the landscape (cat.14), and later in his portraits of, notably, Joshua Grigby (cat.105). The painter is, here, a man of nature and a man of sensibility. His features are subtly animated, and even the upward flick of his hair suggests a man of lively wit.

By the time of this self-portrait the London art scene in which Gainsborough had been schooled was transforming. The democratic principles of the old Academy at St Martin's Lane were being challenged by a new generation of artists. In three essays published in the *Idler* late in 1759 Reynolds set out to define a more academic programme of artistic expertise, which involved the denigration of the wit, naturalism and informality that had characterised the art of St Martin's Lane in favour of ponderous idealisation. His advice to his contemporaries was as follows: 'I have only one word to say to the Painters, – that however excellent they may be in Painting naturally, they would not flatter themselves very much upon it'. This self-portrait, where Gainsborough flatters himself as a 'natural painter', may show even at this early stage how their artistic paths were inevitably to diverge. MM

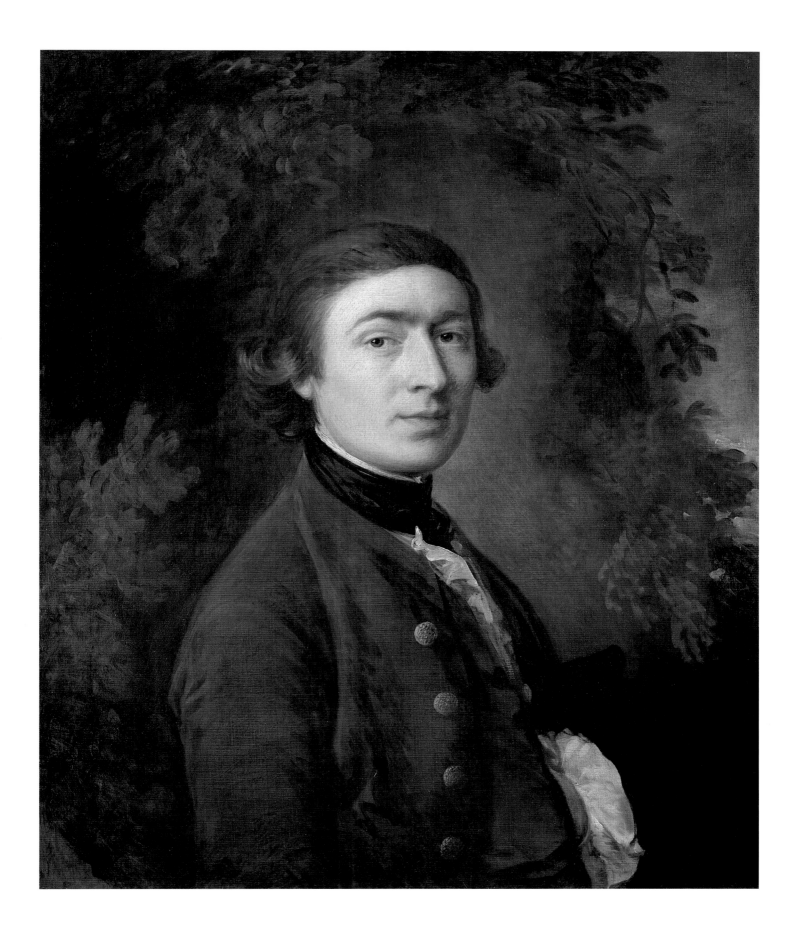

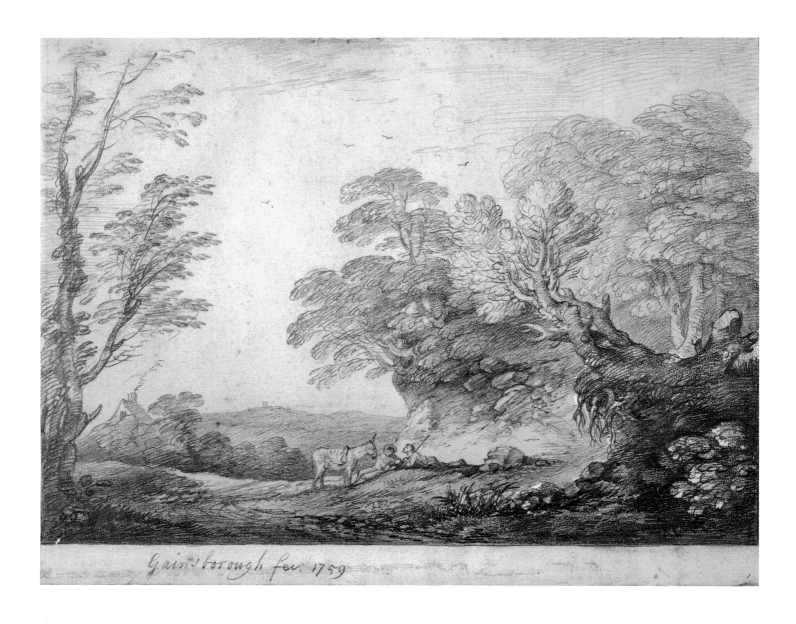

Gainsborough fec 1759

27

Wooded Landscape with Peasants, Donkey and Cottage

1759
Pencil on paper, 30.5 × 38.7 (12 × 15¼)
Courtauld Gallery, Courtauld Institute of Art

Hayes 1970, no.238

This landscape drawing is inscribed below 'Gainsborough fec. 1759' in the way that might appear on a print, indicating that it was intended as the model for an engraving, although this did not come to fruition. Some of his Suffolk landscapes were published by Panton Betew, between 1760 and 1782, and this may have been one that Gainsborough planned to send to London for such a purpose.

As well as this composition, there are a number of the artist's finished landscape drawings of around 1758–9 that seem to have been intended for engraving, one of which bears a similar inscription. Since they are also drawn on a large scale and are close to this in design, they may have formed a group that the artist hoped to publish as a series. Like his plate for *The Gypsies* (cat.28), which was published in 1759, the proposed engraving of this subject or others may have been part of

his scheme to promote his abilities as a landscape painter. Such a desire was perhaps exacerbated, after his arrival in Bath that year, by the increasing demands on him for portraits.

With his move to Bath, the artist's landscape sketches became more generalised and schematic, with fewer specific details. For instance, the trees here are difficult to identify as individual species. The handling of these drawings became broader, with a more tonal use of pencil or chalk. The free, looped lines and the twisting tree-trunks growing out of the bank on the right of this drawing give the impression of the landscape being alive with movement. The emphasis in this composition, and others from the period, is more on the overall effect, rather than on observable nature. DP

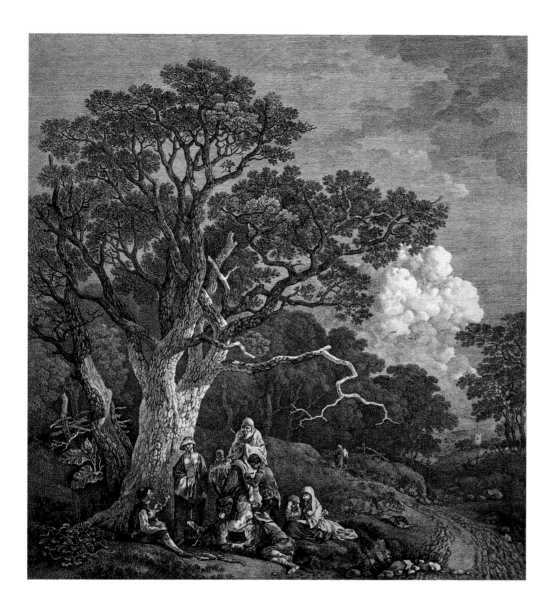

28
Thomas Gainsborough and Joseph Wood
Wooded Landscape with Gypsies round a Camp Fire (The Gypsies)
published 1759
Engraving, with initial etching by
Gainsborough, image 47.2 × 42.1 (18⅝ × 16⁹⁄₁₆)
Lent by the Trustees of Gainsborough's
House, Sudbury

Hayes 1971, no.2

The design for the print of *The Gypsies* seems
to have caused Gainsborough considerable
trouble. His first ideas for the composition
appeared in an unfinished oil of around 1753–4
(fig.23) but the artist must have felt that the
result was unsatisfactory for he slashed the
canvas. The idea was not abandoned and
another canvas (whereabouts unknown;
Hayes 1982, no.44), painted shortly
afterwards, provided the final design for the
print. Gainsborough made an etching of the
subject, probably at around the same time as
the paintings.

However, his impatience during this period
with the complexities of the printmaking
process, apparent too with his etching of *The
Suffolk Plough* (cat.11), seems to have had a
detrimental effect on his attempts to
complete this print. For although the etching
was technically accomplished, he never went
beyond the initial stage and the plate was

eventually finished by Joseph Wood, who
worked up the final design by means of
engraving. Wood himself published the print
in 1759, and John Boydell republished the
engraving in 1764 along with Richard Wilson's
Lake Nemi, which was also engraved by
Wood. This impression is the fourth state of
the print, as published by Wood. The early
etching by Gainsborough, before the addition
of Wood's engraved lines, is similar in its
degree of finish to *The Suffolk Plough*. DP

29

Beech Trees in the Woods at Foxley, with Yazor Church in the Distance

1760

Brown chalk, watercolour and bodycolour over pencil, 28.7 × 38.9 (11⁵⁄₁₆ × 15³⁄₁₆)

The Whitworth Art Gallery, The University of Manchester

Hayes 1970, no.248

This elaborate finished watercolour, signed and dated by Gainsborough, was made for Sir Robert Price (1717–1761) and was probably a gift from the artist. Gainsborough became friends with Sir Robert and his son Uvedale Price after his arrival in Bath, probably through artistic or musical circles there, for the father was a talented amateur artist and musician (see cat.30).

Gainsborough must have visited the family seat at Foxley in Herefordshire, for a nineteenth-century label on the back of the frame reads 'A water colour Landscape by … Gainsborough …while on a visit at Foxley, A study from nature of some famous beech trees in the woods … with a view of Yazor Church in the distance … Originally in the collection of the late Sir Robert Price Bart., M.P.' The inscription is not wholly reliable, for the baronetcy was conferred on Uvedale in 1828. Moreover, the implication that this highly wrought watercolour was painted directly from nature is unlikely to be true. Gainsborough probably made pencil sketches of the scene which he later worked up into a finished composition in his studio.

Sir Robert Price died the year after this watercolour was made but Gainsborough maintained his connection with the family and is known to have gone on sketching excursions with Uvedale Price around Bath. Gainsborough's approach to nature was undoubtedly influential on the young theorist, whose *Essay on the Picturesque* was published in 1794. Sir Robert and Uvedale Price both made great improvements in the estate and gardens at Foxley. Uvedale's garden designs strove for a natural and picturesque beauty. He endeavoured to show that the fashionable style of laying out grounds was 'at variance with all the principles of landscape painting, and with the practice of all the most eminent masters'. Gainsborough's view of the Foxley Woods here, with remote paths and rickety fences, dominated by the majestic old trees, seems to anticipate Uvedale Price's later theories on the Picturesque. DP

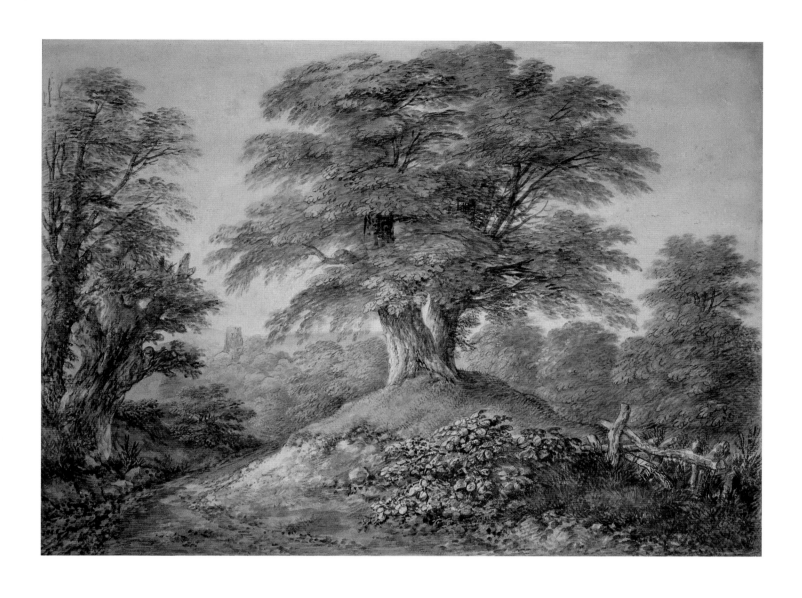

30

Uvedale Tomkyns Price

*c.*1760–1

Oil on canvas, 124.5 × 99.1 (49 × 39)

Bayerische Staatsgemäldesammlungen,
Münich, Neue Pinakothek

Waterhouse, no.556

The sitter is a member of the Price family of Foxley, Herefordshire. Gainsborough also painted Sir Robert Price, with whom he was most closely associated, and this portrait has sometimes been identified as showing him. However the appearance and age of the sitter (surely older than his early forties) suggests otherwise, and it is known that a portrait of Uvedale Tomkyns was in the family as well. So it is assumed that the sitter is Uvedale Tomkyns Price (1685–1764), the father of Robert Price, and thus grandfather to Uvedale Price.

He is shown holding in his left hand a drawing, in a distinctly Gainsborough-esque style. With the *porte-crayon* (a double-ended drawing instrument) in his right hand, the suggestion must be that it has been created by the sitter. On the wall behind him is a further framed drawing. Price's stern, concentrated gaze suggests a man of firm intellect, seriousness and innate good taste.

While Gainsborough cultivated the idea that his creation of landscape images was the consequence of his pure enjoyment of the countryside, this portrait reminds us that they were also objects that could embody complex social meanings. The landscape drawings and the portfolio, presumably containing more drawings, leaning against the wall serve to underscore the impression of Price being a man of culture: looking over such portfolios of drawings was an exemplary social amusement at this time. Furthermore, given the importance of Picturesque theory in later interpretations of Gainsborough's art, his relations with the amateur artists of the Price family, and the young Uvedale Price, demonstrate that the development of this aesthetic was not an abstract intellectual exercise, but was created from the active dialogue between amateur and professional artists. MM

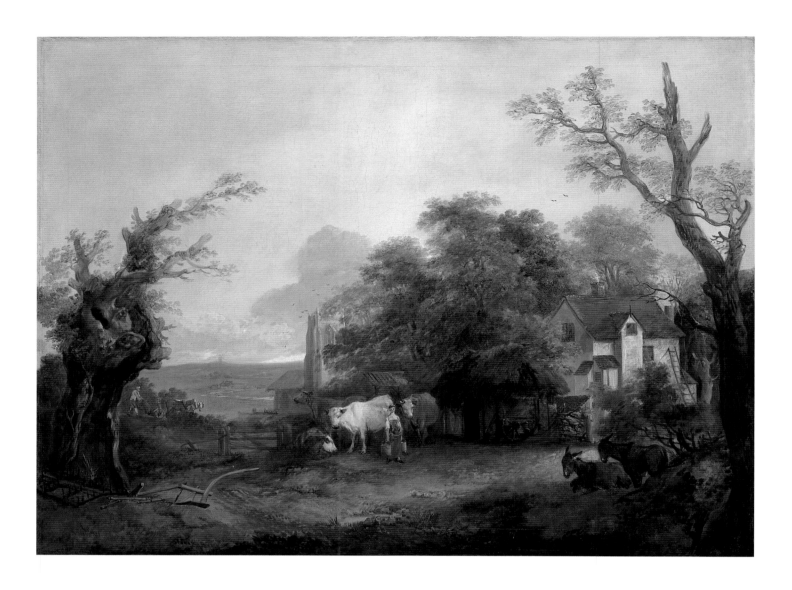

31
Landscape with Cows
*c.*1757–9
Oil on canvas, 94 × 124.7 (37 × 49⅛)
Lord de Saumarez (on loan to Norwich Castle
Museum and Art Gallery)

Hayes 1982, no.72

This farmyard scene was executed towards the end of Gainsborough's residence in Ipswich. It was probably painted for the Lee-Acton family of Livermere Park, near Thetford, Suffolk, one of only a handful of East Anglian families who commissioned landscape compositions from the artist. Here, the buildings – the large farmhouse on the right and the church in the centre – are more dominant than was usual in the artist's landscapes of this time. Similarly, there is more of an emphasis on human presence, with the milkmaid carrying her pails, the ploughman in the distance and the farm equipment in the foreground, which goes beyond Gainsborough's more usual use of figures as staffage within the context of nature. It may be that the patron demanded something more akin to a rustic genre scene than a pure landscape. The farm implements beside the hollow gnarled tree-trunk on the left are a crab harrow and a swing plough. They are painted accurately, although the crab harrow is larger than it should be and has

been left around (somewhat dangerously) facing the wrong side up. The Suffolk-type wheel plough in use in the distance, normally about nine feet (2.7 metres) long, has been considerably condensed to fit better within the design. DP

Beginnings: The Early Years

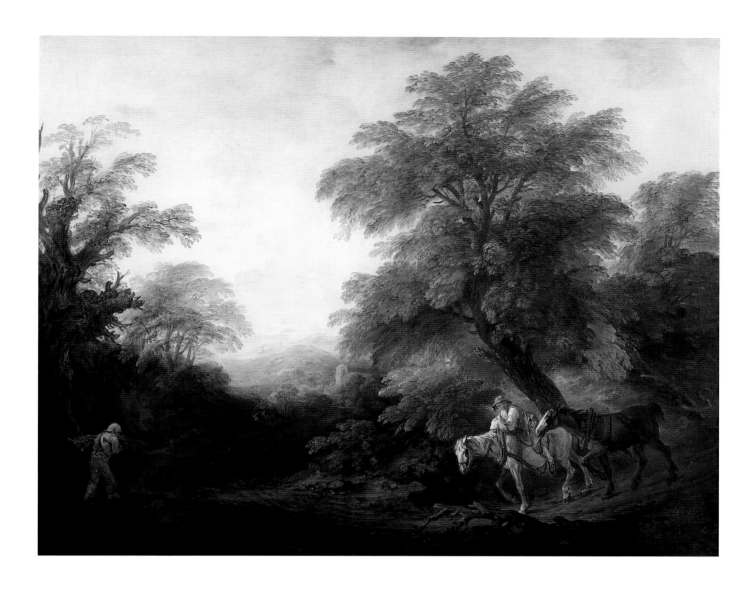

32
Woody Landscape
c.1759–60
Oil on canvas, 101.6 × 127.6 (40 × 50¼)
Private Collection

Hayes 1982, no.74

This is the earliest of the landscapes Gainsborough painted in Bath. It was commissioned by the Ipswich attorney and Town Clerk, Samuel Kilderbee (1725–1813), a life-long friend of the artist, whose portrait he had painted in c.1755 (Fine Arts Museums of San Francisco). The mounted peasant boy in this painting, slumped awkwardly on his grey horse while leading another, has been adapted from Gainsborough's earlier *Landscape with Peasant Boy and Two Horses*, painted for the Duke of Bedford in 1755 (Woburn Abbey), although the horses here are shown in movement. The woodman trudging home with his bundle of sticks marks the first appearance of what was to become a favourite motif in his work. Gainsborough claimed that his use of figures in his landscapes was often merely 'to create a little business for the Eye to be drawn from the Trees in order to return to them with more glee' (letter to William Jackson, 23 August 1767; *Letters,* p.40). However, the figures in his Bath landscapes, such as this, began to take on a more prominent role and appear to have had a greater purpose and symbolic significance.

This is one of the few large-scale landscape compositions he made in his early years at Bath and demonstrates the assimilation of his Ipswich style into a grander conception of the landscape. It reveals his rapid development of new techniques and a complete transformation of the mood and ambition of his art. DP

33

Sunset: Carthorses Drinking at a Stream

*c.*1760

Oil on canvas, 143.5 × 153.7 (56½ × 60½)

Tate; Presented by Robert Vernon 1847

Hayes 1982, no.75

The theme of peasants going to or from market was first explored by Gainsborough while still in Ipswich, in *Landscape with Peasants in a Country Wagon* of *c.*1756–7 (Newcastle, Australia) and remained a popular subject for him for the remainder of his career. The family here are travelling home in a country wagon and are shown in a moment of repose after the labours of the day; the drover on the footbridge halts by a stream to allow the horses to quench their thirst. The landscape is bathed in a warm, golden light and the glowing sunset adds a suitably poetic note to the tranquil scene.

This painting is typical of Gainsborough's early Bath period landscapes. The Dutch influence has been replaced by the freer, more dramatic and imaginative style of Rubens, apparent in a broader handling of paint and richer colouring. In addition to the more Flemish approach, Gainsborough has also borrowed something of the structure and poetry of Claude. At Bath the artist had access to outstanding collections of these artists' works at nearby Wilton, Corsham, Longford Castle and Stourhead.

The contrived nature of the composition is most apparent in its curving, almost circular design, created by the sweeping arch of the pollarded tree on the right and the downward movement of the wagon and horses towards the stream. This pronounced circular structure gives a 'peephole' effect to the composition, which offers the viewer an intimate glimpse of an enclosed and idyllic world. DP

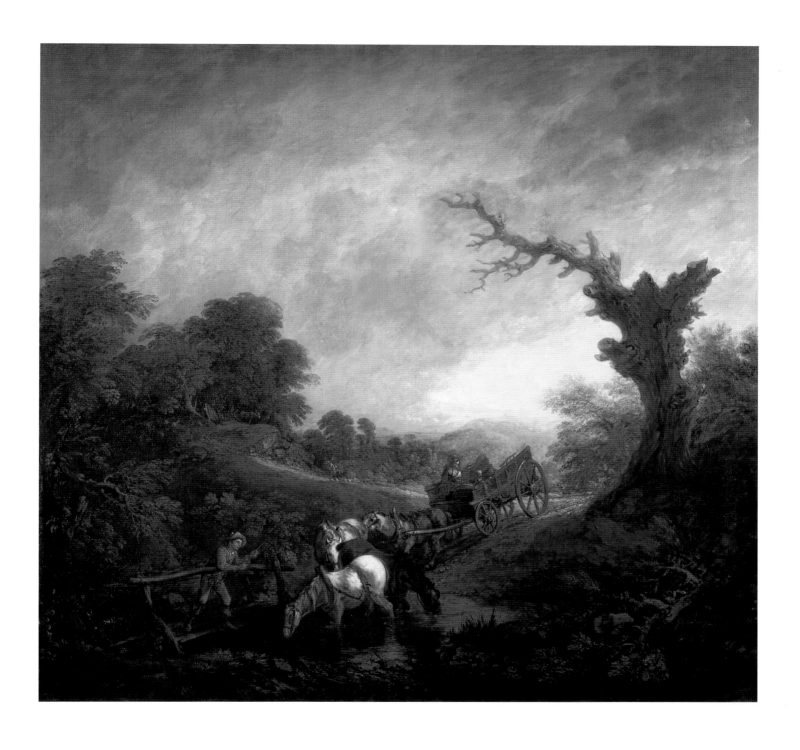

34
William Wollaston
c.1759
Oil on canvas, 124.5 × 99 (49 × 39)
Ipswich Borough Council Museums and
Galleries

Waterhouse, no.733

William Wollaston (1730–1797) of Finborough Hall, Ipswich, was a local landowner and later a Member of Parliament. Gainsborough also painted him in full-length around this date, accompanied by his dog and leaning on a stile in his estate, his house visible in the distance (Private Collection; Waterhouse, no.734). Where that portrait was a relatively conventional celebration of the sitter as a landowner and gentleman, this innovative image presents him in an entirely informal manner, caught as if in a moment distracted from his flute. As both amateur musicians, Gainsborough and Wollaston may well have known each other socially from the musical circles of Suffolk. This is certainly an image of masculine conviviality, sharing something of the spirit of the earlier portraits of the Revd Chafy (cat.22) and the Muilman group (cat.21) but taken to a higher artistic pitch. From the hatchings that describe the sitter's face through to the overall twist of his body, this is an image exceptionally expressive of motion both graceful and casual. If the ideals of genteel society put great stress on personal deportment, Gainsborough by the end of the 1750s had mastered a pictorial language that could convey gentility with an easy persuasiveness hardly rivalled by any contemporary.

As Richard Leppert has explored, the social codes surrounding amateur music-making in the eighteenth century were complex and highly gendered. The flute held here by Wollaston was emphatically an instrument considered appropriate only to men, for obvious reasons. It would certainly not require the full apparatus of Freudian analysis to recognise the phallic associations of the flute, as the wide use of inanimate objects of all sorts as substitutes for the male member in eighteenth-century graphic satire and written pornography makes evident. If there is no suggestion of impropriety in this portrait, it is none the less an image of a specifically masculine culture of leisure: it would have been impossible to depict a woman in the same fashion. MM

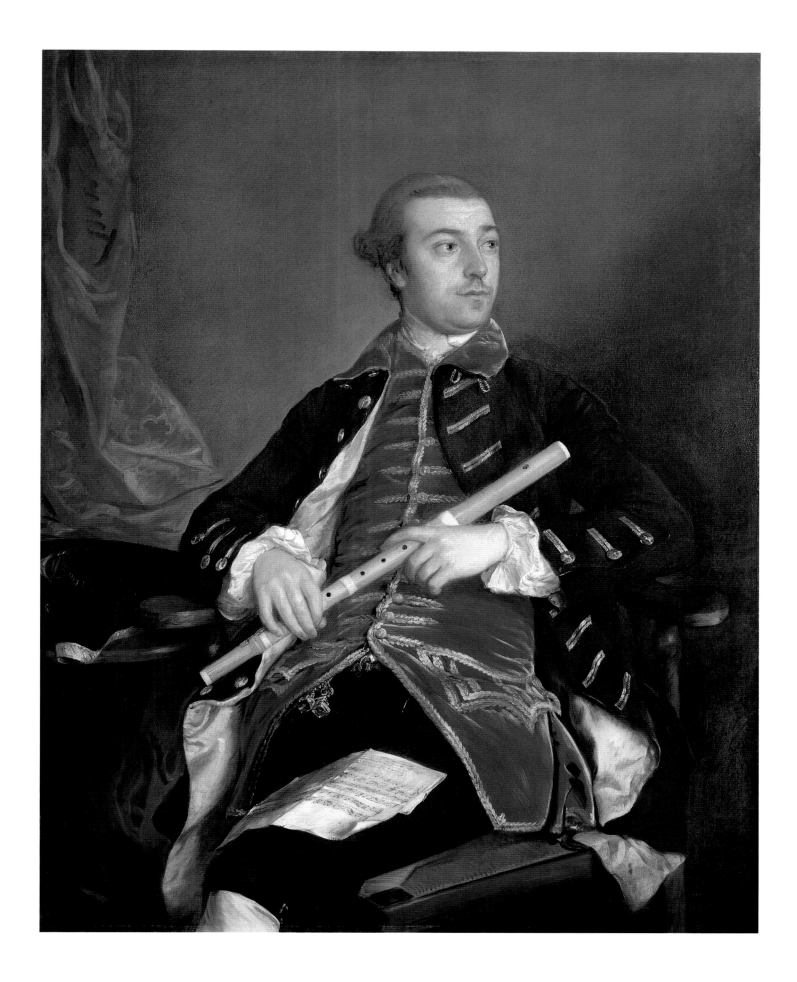

35
Ann Ford, Later Mrs Philip Thicknesse
1760
Oil on canvas, 196.9 × 134.6 (77½ × 53)
Cincinnati Art Museum, Bequest of Mary
M. Emery

Waterhouse, no.660

Ann Ford (1732–1824), a virtuoso on the English Guitar, viola da gamba and musical glasses, and additionally a fine singer, had been one of the sensations of the amateur music scene in Bath from 1758. Wishing to perform publicly, she had advertised subscription concerts in London in March and April 1760 and October 1761, probably returning to Bath, where she was living under the protection of Mrs Thicknesse, in the interim. In thus advertising her talents she was taking a large risk, for, although women were welcome to perform in private, their going on to the public stage carried the threats of scandal and ignominy – Richard Brinsley Sheridan forbade Elizabeth Linley to sing to an audience after their marriage (see cat.166). Of the various people who attempted to thwart Ford's London performances, the most notable was the aged Earl of Jersey who had become infatuated with her, offering her £800 per annum to come into his keeping. Her refusal might have provoked him into arranging an alternative concert to which he invited many of those who had subscribed to her first performance, which lack of gallantry led to a short pamphlet war between the two. None the less, she still made the very large sum of £1500 from this first concert (the historian Simon McVeigh observes that hers were the only such between 1756–63) although the consequence of her bravado appears to have been, as Gainsborough would later put it, to make her 'partly admired & partly laugh'd at at every Tea Table' (*Letters*, p.26).

Gainsborough built some of these tensions into his portrait. He based Ford's pose on a combination of that of Roubiliac's famous statue of Handel at Vauxhall Gardens and the pose Hogarth's aristocratic woman assumes as she weighs up the pros and cons of surrendering her virtue to recoup her gambling debts in *The Lady's Last Stake* (1758–9; Albright-Knox Art Gallery, Buffalo, New York). Thus Gainsborough pointed up how Ford's invading a masculine realm (emphasised through the positioning of her English Guitar, and the crossed legs which, according to a contemporary conduct book, constituted a 'masculine freedom') courted scandal. To this wit he added a bravura performance of painting, the draperies managed with virtuoso insouciance, and the harmonious counterpoint between the silver of the dress and red of the curtain demanding that we notice to what extent he had been learning from a study of Van Dyck's portraits. To marry this brilliantly painted invention with the representation of a person perhaps regrettably prominent in the public eye was to invite more than usual notice from visitors to his painting room (it is important to notice that he did not risk exhibiting this work). Mrs Mary Delany reacted appropriately, describing Ford's as 'a most extraordinary figure, handsome and bold; but I should be very sorry to have any one I loved set forth in such a manner'. MR

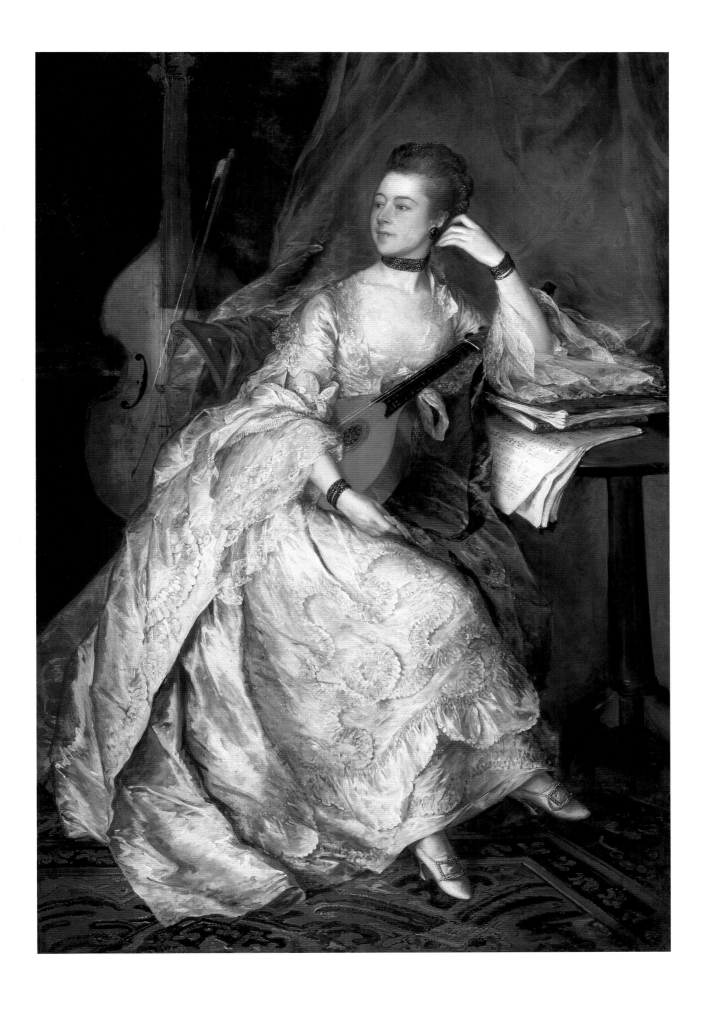

Gainsborough in the Public Eye: The Exhibition Works

All the works in this section were selected by Thomas Gainsborough for display at one of the annual exhibitions that were held in London from 1760 onwards. The inception of public exhibitions was arguably the most important innovation in the British art world during this period. It was ever more apparent that they could make or break careers, and their character as places to see art transformed the ways artists worked.

During the 1740s and 1750s the artists associated with St Martin's Lane were increasingly conscious that if they were to gain the recognition they wanted as professionals, and if their art was to play a meaningful role in public life, they needed somewhere to display their talents. The decorations for Vauxhall Gardens and the production of paintings for the charitable Foundling Hospital provided two novel (and very different) outlets, and Gainsborough had been involved in both. By the mid-1750s the desire to create a more formal setting for the display of modern art was growing. The Seven Years' War (1756–63), which saw Britain in ultimately victorious conflict with the old enemy, France, stimulated an upsurge of patriotic feeling and focused the desire for change and improvement. The first show was organised in London in 1760 by a group calling itself the Society of Artists, and was hosted by the patriotic Society for the Encouragement of Arts, Manufactures and Commerce. These new displays of modern art demonstrated that British artists were developing a sense of corporate identity and served to deny their oft-mooted inferiority to Continental peers. Now, as Britain triumphed in war, so, it was hoped, the nation could triumph in culture. As one commentator in 1763 put it:

As we have already carried the fame of our Arms to the most distant shores, and convinced the astonished world of our importance, as a war-like and commercial people, so we hope to be found no less capable of distinguishing ourselves, by a noble and generous attachment to the milder arts of peace.

Where once the visual arts had been the preserve of the few, and could generally only be found in exclusive private settings, now they were seen as having a major role in defining a public, national culture.

Gainsborough knew the power of publicity. Although he did not show any works at the first London exhibition of 1760, his daring portrait of Ann Ford (cat.35) was on display in his house at Abbey Steet, Bath, from October that year, and he had prepared his portrait of Robert Craggs (cat.36), who arrived in Bath only in September, in time for the next show. When the original Society of Artists argued with their hosts about entrance fees, a split occurred. A 'Free Society of Artists' remained faithful to the Society for the Encouragement of Arts for a few years. A group maintaining the name 'The Society of Artists' now exhibited in Spring Gardens. It was with the latter group that Gainsborough exhibited from 1761. A further schism led to the creation of the Royal Academy in the winter of 1768–9, a body founded on much more rigorous and exclusive principles than the earlier groups. Gainsborough was invited to become a founder member of the Academy, and exhibited in their first annual show in 1769. The Academy quickly established itself as the leading artists' group. As the inveterate traveller Mrs Lybbe Powys wrote as early as 1770: 'The Royal Academy is always stil'd the only one worth seeing, at least 'tis unfashionable to say you had been to any other.' In 1780 it moved to a magnificent new home at Somerset House on the Strand (fig.35), which had a specially designed 'Great Room' for exhibitions, affirming its status as the

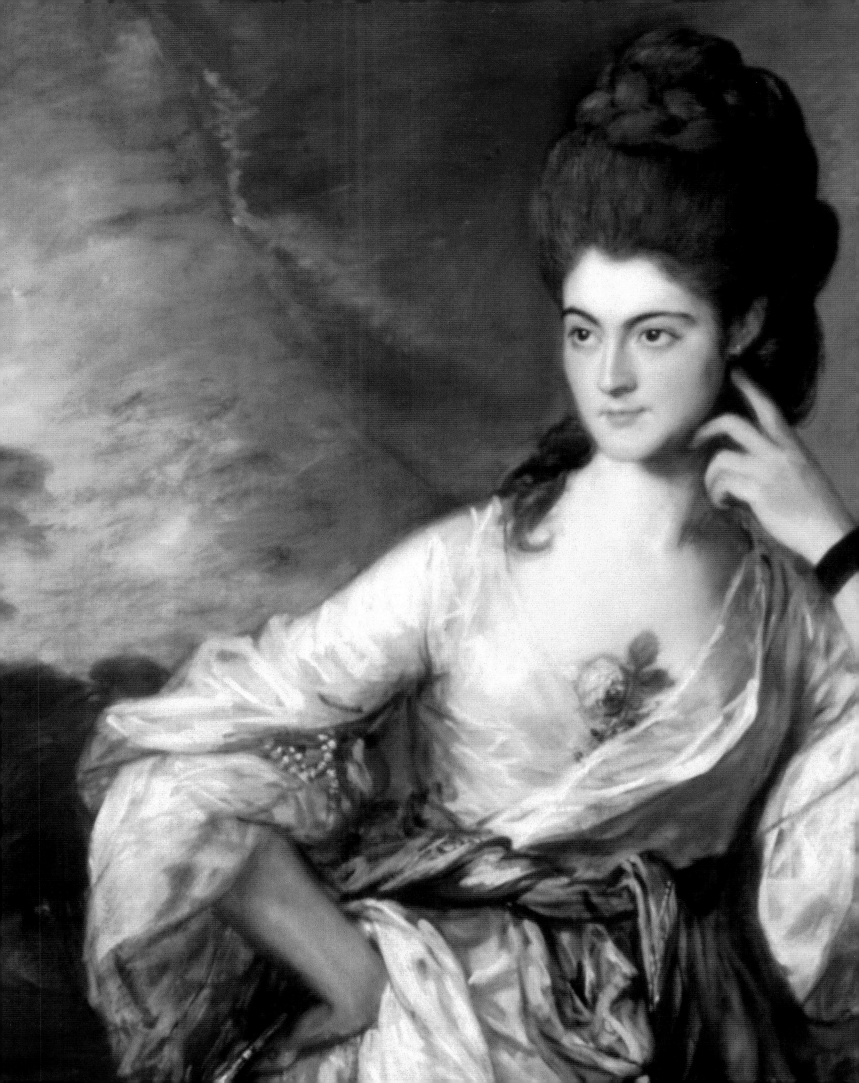

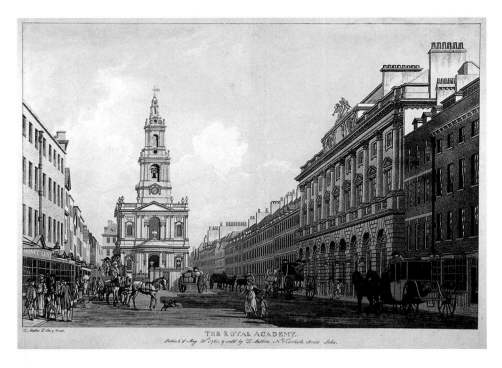

gratified at the moderate Expence of a Shilling a Visit. I mean the different Exhibitions of the Works of English Artists ... To these Places of Publick Resort, do People Flock in a forenoon to saunter about gazing at each other as at any other kind of Route, and now and then perhaps look with admiration on an Outré *Piece, that on account of its staring Colours and sharp unnatural Angles would* attrappe *their Notice.*

In other words, during their earlier days, the status of these exhibitions was highly ambivalent. Moreover, as contemporary representations of the annual shows reveal only too clearly, the public exhibition was hardly the ideal venue for an artist to display work to best personal advantage, if that artist was expecting a reflective, contemplative viewer (fig.36). They were noisy, crowded places, where people went to chat and show themselves off as much as to look at art, with dogs and children supplying added distractions. The hanging of the works themselves was often far from propitious. At the Academy this was overseen by a committee of Academicians, bringing into play personal rivalries and institutional politics. In the worst cases paintings would be placed so that they could not be seen. Artists developed a range of strategies for making sure their pictures would look their best, and get attention. The new spaces for looking at pictures created a novel set of expectations about what a painting should look like, how it should 'address' the viewer, quite separate from the abstract intellectual principles proposed by Reynolds.

It is clear that Gainsborough took very great care in representing himself to the public through the exhibitions. Portraits were often of his more famous contemporaries, from royalty and high society, to the actor James Quin (cat.39) or the well-known auctioneer James Christie (cat.54), as well of those whose celebrity rested on more shaky foundations–mistresses and theatrical types (cat.57). This was one way of getting the critics to take notice of your pictures. The size of a work, and the way it was painted, could make a difference as well. Pictures might be 'painted up' more brightly for the exhibition, and then toned down afterwards before being sent to the domestic interiors for which they were intended. Gainsborough, master of extraordinarily refined effects in oil paint, was acutely sensitive to the eventual lighting of his paintings (as when he told Garrick that his portrait 'was calculated for breast high & will never have its Effect or likeness otherwise', *Letters*, p.108), and could find the annual exhibition a nightmare. And he was said to be 'much affected by any newspaper criticism that remarked unfavourably on any of his works' (*Farington Diary*, vol.5, p.1784). Like some peers, notably Joseph Wright of Derby and George Stubbs, his relationship with the Academy was inconstant and sometimes fraught. In 1773 he

premier art establishment. Gainsborough's relationship with this body, which could be authoritarian as well as authoritative, was not, however, easy.

The Royal Academy was set up as a pedagogic institution along high-minded principles. These were laid out by Sir Joshua Reynolds in his *Discourses*, delivered on the occasion of the student prize-givings. Reynolds's lectures, and the rigorous teaching system at the Academy's schools, expressed the idea that young artists should abase themselves before the Antique and Old Masters, and should strive for perfection by emulating their examples. Art was meant to be an onerous, slow, intellectually demanding occupation; looking at art was meant to be hardly less arduous. In theory, the Academy's exhibitions would be a forum for the best examples of painting being created by high-minded youngsters and by the wise artistic elders of the Academy (whose works were guaranteed a place on the wall, while outsiders had to compete for inclusion). Such ideals were anathema to Gainsborough, with his thoroughly Hogarthian sense that visual pleasure was itself intellectually stimulating, and his comprehension of a more sensual Old Master tradition that could be the foundation of personal creativity rather than an object of slavish imitation.

In reality, the exhibitions could be transformed into arenas for the manifestation of violent rivalries, where artists had the chance to show off to the widest possible public. Against this, they were perceived as little different from other places of fashionable socialising, as one critical letter-writer of 1783 pointed out:

there is a fashionable Rage which seems to prevail here for some late years, which is

failed to show, and when he did return in 1777 the event was carefully managed.

The earliest exhibitions had received only slight notices in the press. During the 1770s the floodgates opened, with a mass of reviews and commentaries and the appearance of identifiable art critics. Published commentaries could act as guides through the jungle of the massed works, suggesting where the visitor might bestow attention, and on which paintings she or he might pause to contemplate. By 1777 Gainsborough had Henry Bate, then editor of the *Morning Post*, as his mouthpiece, thus guaranteeing a rhapsodic reception of the parade of highly significant works that he had selected for exhibition. These included portraits of the Duke and of the Duchess of Cumberland (whom Reynolds had painted the previous year), Mrs Graham, then celebrated for her great beauty (fig.11), and the composer Carl Friedrich Abel (cat.50), as well as the major landscape, *The Watering Place* (cat.51). The last was recognised as throwing down the gauntlet to the seventeenth-century masters, and succeeding, while *Carl Friedrich Abel* was a colouristically brilliant rendering of a musical star, shown pausing in composing as the light of inspiration shines down on him. Gainsborough's success in 1777 was such that Reynolds was prompted to show his huge, ambitious and vastly impressive *Marlborough Family* (Blenheim Palace, Oxfordshire) the following year.

If in 1777 some kind of reconciliation had been forged between Gainsborough and the Academy, the peace was not to last. The removal of the Academy to grandiose new premises at Somerset House brought new problems. Sir William Chambers's Great Room there was designed for the annual exhibitions, and included in its design a 'line', in fact a cornice at eight feet, enforcing a greater degree of regulation on the hanging schemes. Large paintings, including full-lengths, had to be hung high, above the line, and so would be seen at a distance. By 1781 press reports were complaining about the poor hanging afforded some of Gainsborough's exhibits, suggesting that with his reputation (for by now he was enjoying royal patronage) he should get preferential treatment. When in 1783 the Hanging Committee acceded to the artist's demands regarding the display of the series of fifteen canvases of royal heads *en bloc*, this was only because he had threatened them, and because no Royal Academy would wish to offend a royal patron. By now his art, particularly with the fancy pictures representing shepherds, or girls with pigs, had begun to move in challenging new directions, summed up in the daring marriage of Titian and Hogarth in *Shepherd Boys with Dogs Fighting* (cat.60), shown in 1783, a picture that confounded Reynolds's distinctions between 'high' and 'low' subjects, pleasure and intellect, the Old Masters and the moderns. This was the last time Gainsborough was to show at public exhibition. From then on he displayed his works, coincidentally with the Royal Academy, in his own house.

The works Gainsborough chose to exhibit in public are among the most flamboyant and ambitious of his paintings, by turns charming or magnificent, seductive or bold, and various in their subjects. This must have been the impression made on his public; the critics who recorded their responses suggest as much. But if these pictures have a remarkable immediacy, they also reveal how complex and troubled relations between artists, markets, patrons and the public in general were during the later eighteenth century. MR/MM

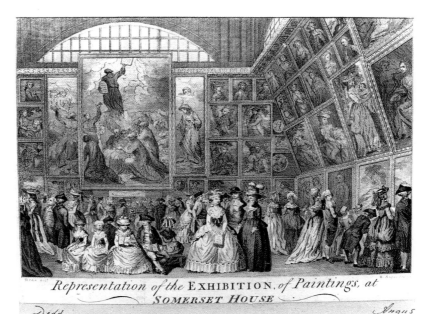

Figure 36
William Angus after Daniel Dodd
Representation of the Exhibition of Paintings, at Somerset House 1784
Engraving
Photograph: Witt Library, Courtauld Institute, London

36
Robert Craggs
Exhibited at the Society of Artists in 1761,
no.34: 'Whole length of a gentleman'
Oil on canvas, 235 × 150 (92½ × 59)
Private Collection, on long-term loan to the
Holburne Museum, Bath

Waterhouse, no.523

As this picture demonstrates, Gainsborough obtained commissions from important members of Bath society very soon after his arrival in the autumn of 1759. Robert Craggs (1702–1788), later Earl Nugent, was the Member of Parliament for Bristol (1754–74), a prominent public figure and the owner of an estate at Gosfield Hall in Essex. Not surprisingly, Gainsborough launched his exhibition career with this full-length portrait, as a signal of his growing confidence and status as an artist. It was the only work he submitted that year. With cat.36 Gainsborough was building on his more ambitious life-size portraits from the mid-1750s, culminating in *Ann Ford* (cat.35). In the present portrait, however, Gainsborough seems less preoccupied with the sparkling, attenuated elegance of Van Dyck than with the type of dignified society portraiture popularised by artists including Allan Ramsay, William Hoare (*c*.1707–1792), and Thomas Hudson (1701–1779).

In contrast to the majority of Gainsborough's early work, his portrait of Craggs is remarkable for the sharp-edged solidity of the figure, which owes much to the example of Hudson. Gainsborough softens the overall effect of grandeur by introducing a sense of informality and character derived from Hogarth and the other artists of St Martin's Lane. The room is an actual interior (Gainsborough's own painting room) rather than a contrived stage set, and Craggs himself is placed off-centre, seated casually as if relaxing during a sitting, his look and half-smile establishing an intimacy with the viewer, or indeed the artist. It may be that Gainsborough wished to infer a level of ease and intimacy between himself and his wealthy patron. Gainsborough used Craggs's pose and the setting in his later portrait of Matthew Hale (*c*.1770–5; Birmingham City Art Gallery). Thus Gainsborough's strategy in this first exhibition appears to have been that of establishing himself as a cosmopolitan artist of the first rank, demonstrated through his technical brilliance, his talent for capturing a likeness and his ability to compose, with informality, on a large scale. CR

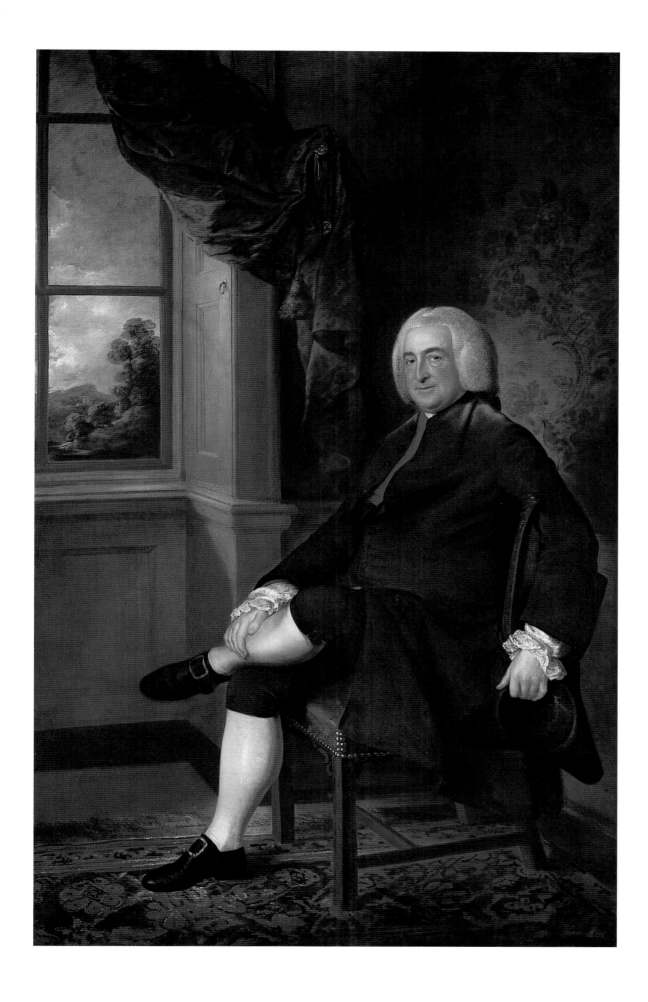

37

William Poyntz

Exhibited at the Society of Artists in 1762, no.30: 'A whole length of a gentleman with a gun'

Oil on canvas, 234.9 × 152.4 (92½ × 60)

Althorp

Waterhouse, no.554

This portrait of William Stephen Poyntz (1734–1819), son of the Rt Hon. Stephen Poyntz, was painted for the sitter's younger sister, Georgiana. She had married John Spencer who became Viscount Spencer in 1761. Portraits of gentlemen engaged in countryside pursuits, sporting or otherwise, were popular among the landed gentry. Hunting in particular was thought to be an ennobling and heroic pursuit, which by law separated the rural elite from their urban counterparts: only those who possessed land worth £100 or more per annum could take part. A country gentleman could thus flaunt his social status, in the field and in painted form, through a leisure activity that suggested action, daring and physical fitness. The hall at Althorp, as with other large country houses, was decorated with large-scale rural (including hunting) scenes executed by John Wootton (c. 1682–1764). In the early 1760s the social exclusivity of hunting was actively challenged by city dwellers as a violation of their civil liberty. Thus this picture, Gainsborough's only submission that year, would have been topical if not contentious while on public view in London.

Poyntz's hair is unpowdered and his outfit uses the neutral colours adopted by men in a rural environment. The frock coat, traditionally a sporting or country coat, is of plain brown, woollen cloth. Poyntz's legs are crossed at the ankles, a stock pose employed throughout the eighteenth century to denote gentlemanly ease, whether in an urban or rural context. Here Gainsborough innovates by showing Poyntz leaning his whole body backwards against the gnarled tree, the angle causing a series of diagonals with the trunk and the upward-pointing gun held casually against his stomach. This, with the looser, flickering brushwork of the foliage and sky, creates a restless mood, in keeping with the turn of Poyntz's head and his intense, upward stare. Guns, when not in use, were habitually shown resting in the crook of the arm, often pointing downwards or sometimes held with the butt on the ground in the manner of a staff. Poyntz, however, holds his gun by his groin, a blatant reference to virility and the sexual connotations of 'hunting'. Such a lewd, almost Hogarthian joke would have been positively audacious in a public exhibition. Gainsborough thus mediates between the liberties that could be taken with the private, personalised conversation piece and the formality and grandeur of the conventional full length, to produce an innovative portrait that is at once imposing and intimate.

This picture elicited what appears to be Gainsborough's earliest newspaper criticism, in the *St. James's Chronicle*: 'Mr. Gainsborough. No. 30. A whole length of a Gentleman with a Gun. A good portrait and a Pleasing Likeness of Mr. Poyntz. The Dog well done.' CR

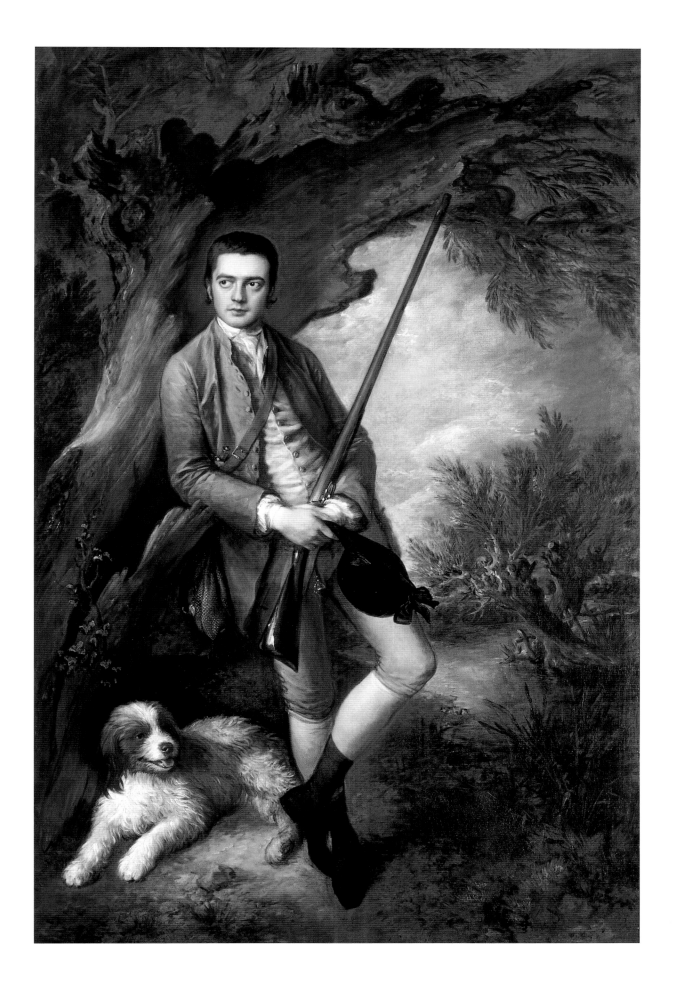

38

A Grand Landscape
Probably exhibited at the Society of Artists in
1763, no.43: 'A large landskip'
Oil on canvas, 146 × 157.5 (57½ × 62)
Worcester Art Museum, Worcester,
Massachusetts, Museum purchase

Hayes 1982, no.80

This dramatic work is generally accepted as being
the 'large landskip' submitted for exhibition in 1763,
on the basis that it was Gainsborough's most
ambitious to date, both in terms of scale and
treatment. Despite Gainsborough's well-
documented preference for this genre he only
exhibited three landscapes at the Society of
Artists, in 1763, 1766 and 1767 (the most likely
candidates are shown here), as opposed to sixteen
portraits over the 1761–8 period. This balance
reflects the demands of the art market on British
painters at that time. Gainsborough had
comparatively little problem gaining commissions
for portraits, whereas he struggled to find a
lucrative market for his landscapes. The present
picture, for example, was a speculative venture,
which remained unsold throughout his life. This
situation was due in part to his reluctance to
accept topographical commissions, which
remained popular with art patrons throughout the
eighteenth century. However, Gainsborough's
successful portrait practice allowed him to pick
and choose his exhibits. In fact all his exhibited
landscapes were speculative rather than
commissioned.

That Gainsborough decided to submit a
landscape in 1763 may have been in response to
the encouragement that artists appeared to be
receiving to develop a national school of
landscape. Horace Walpole, for example, in his
Anecdotes on Painting (published 1762–71) opined
that 'enough has been done to establish such a
landscape school, as cannot be found on the rest
of the globe'. He added: 'If we have the seeds of a
Claude or Gaspar amongst us, he must come
forth.' Gainsborough may also have been buoyed
up by the positive critical responses at the Society
of Artists to the work of Richard Wilson, whose
'grand manner' ambitions in landscape have been
compared to Reynolds's in portraiture. Wilson was
at this time attempting to raise the intellectual
status of native landscape painting and carve a
niche in an exclusive market that preferred Old
Masters. His reputation for the Grand Style
was established at the first Society of Artists
exhibition in 1760 with the classical *Destruction
of the Children of Niobe* (Yale Center for British
Art, New Haven).

The composition of cat.38, as with a number of
Gainsborough's landscapes in the early 1760s, is
generally in the manner of Claude, as is the warm
glow of the sunlight. Rubens may have inspired the
inclusion of animals moving downwards towards
the water's edge, and Ruisdael the dark, moody
dominance of the trees and the sharp contrast of
light and shadow. However the aesthetic of his
early years still lingers in the trembling, vortex-like
movement caused by the curve of the sky and
trees (upper left) and the descending ground
(lower right). Far from resulting in a multiple
pastiche Gainsborough fused these sources with
his own ideas and observations on nature to create
a highly singular vision of a British rural idyll. CR

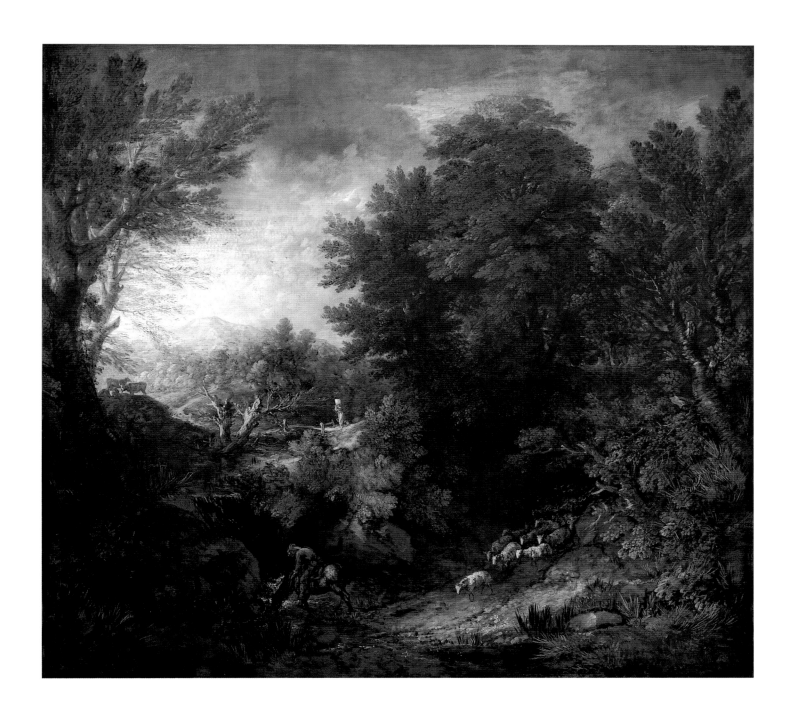

39
James Quin
Exhibited at the Society of Artists in 1763,
no.41: 'Mr. Quin; whole length'
Oil on canvas, 233.7 × 152.4 (92 × 60)
National Gallery of Ireland

Waterhouse, no.567

Figure 37
Joshua Reynolds
David Garrick between the Muses of Tragedy and Comedy
1761
Oil on canvas, 147.3 × 181.6 (58 × 71½)
Waddesdon, The Rothschild Collection
(Rothschild Family Trust)

Gainsborough's portrait of the famous actor James Quin (1693–1766) was one of three works submitted by the artist in 1763. The others were a full-length of Thomas John Medlicott (no.42; Private Collection), and 'A large landskip' (no.43; cat.38). Whether cat.39 was commissioned or not is unclear. It may have been ordered by the actor himself and then reverted back to Gainsborough after he died. It is also possible that Gainsborough, capitalising on Quin's fame, painted this portrait as a speculative venture.

Although the majority of theatrical players in the eighteenth century remained on the fringe of polite society, some achieved celebrity and occasionally respectability. Over and above the draw of a well-known sitter among the crowded walls of the exhibition rooms, the very nature of the acting profession allowed artists to extend 'mere face painting' into a new genre, the theatrical conversation piece, and into history painting. Hogarth, Hayman, Zoffany, Reynolds and others depicted actors in role or allegorical guise. Hayman's *Garrick as Richard III* (1759; Somerset Maugham Collection, Royal National Theatre) and Reynolds's *Garrick between Tragedy and Comedy* (fig.37), exhibited at the Society of Artists in 1760 and 1762 respectively, were among a small group of works singled out for comment by critics. Gainsborough resisted portraying actors in character. Indeed his portrait of Quin, possibly conceived as a riposte to Hayman and certainly to Reynolds, underlines exactly how far Gainsborough was prepared to go down this route; only the bust of Shakespeare and the book of plays the actor holds in one hand represent his former profession (Gainsborough's portrait of Garrick, exhibited at the Society of Artists in 1766, shows the actor likewise with a bust of Shakepeare; see cat.80). Thus the character of 'Quin the actor' must be evoked through subtler means.

Gainsborough's starting point appears to have been Hogarth's large-scale portraits from the late 1730s of middle-class sitters. A specific model may be found in that artist's print of the Jacobite rebel, Simon, Lord Lovat. Gainsborough may have known Hogarth's own portrait of Quin which has the same turn of the head and upward glance (fig.43). In the present portrait the actor's figure is animated by the gesture he makes with his left hand, the turn of the body and the lips parted as if in conversation. Cat.39 goes beyond the simple expression of informality to make apparent Quin's creativity and intellect, as indicated by the focus of light on his forehead, which likewise falls on the face of Shakespeare. Reynolds used a similar strategy in his early portraits of men of letters; Gainsborough probably saw, for example, his portrait of Laurence Sterne, exhibited at the Society of Artists in 1761 (see cat.81). Thus we can imagine that Quin is interpreting a Shakespearean text or participating in high-minded discussion.

That the portrait was generally well received, much to the chagrin of the portrait painter Thomas Hudson, was noted by Garrick in a letter to Quin:

> *It was hinted to me that the much, and deservedly admired picture of you by Gainsborough has piqued him [Hudson] not a little, and hinc illæ lacrimæ! If it is so I sincerely pity him, for there is merit sufficient in that portrait to warm the most stoical painter, and what must it do when it works among the combustibles of our friend Hudson.*

Later, in the obituary of Gainsborough published in the *Gentleman's Magazine* in August 1788, the author opined that the present picture 'will be ever considered as a wonderful effort in the portrait line'. CR

Gainsborough in the Public Eye: The Exhibition Works

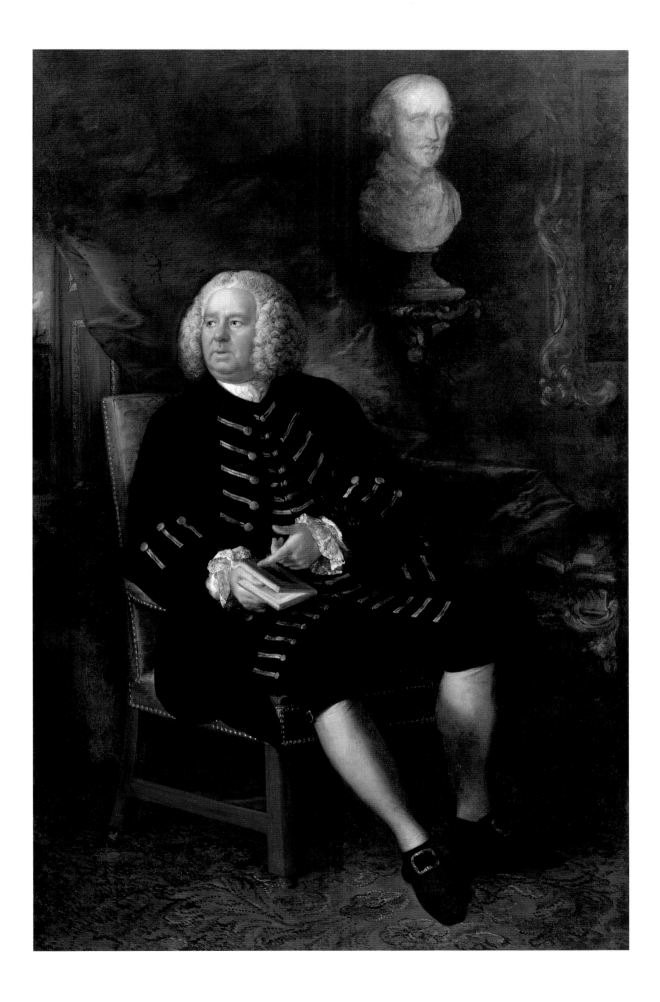

40

Wooded Landscape with Country Wagon, Milkmaid and Drover

Probably exhibited at the Society of Artists in 1766, no.53: 'A large landscape with figures'
Oil on canvas, 152 × 127 (59⅞ × 50)
Private Collection

Hayes 1982, no.87

In 1766 Gainsborough showed three full-length portraits and one landscape. Cat.40 has been accepted as the 'large landscape with figures' primarily through the evidence of contemporary descriptions. Indicating the competitiveness of this public forum, Gainsborough wrote to Garrick in May that the exhibition 'is conducted at present, to be calculated so much to bring out good Painters as bad ones' and that 'a false taste and impudent stile [sic]' prevailed, which he characterised as 'a Glare', perhaps an early reference to the heightened colours that artists (including Gainsborough) were accused of employing in order to give visual prominence to their works (*Letters*, p.38). His additional assertion that 'Nature is modest, and the Artist should be so in his addresses to her' is almost a mission statement for his decorous approach to landscape.

In the 1760s Gainsborough clearly sought to demonstrate through exhibited landscapes, as much as through his portraits, that he had become a cosmopolitan artist with the ability to absorb and refer to Old Masters without mimicry, and perhaps more significantly without having studied abroad. Thus both cat.43 and the present landscape underline his move towards a broader, more generalised aesthetic in reference to Flemish and Italianate Old Masters, such as Rubens and Claude. However, he did not divorce himself completely from his earlier practice: the scene of rustic lovers – shown here as a drover abandoning his cart to flirt with a milkmaid – was an established theme in his Suffolk landscapes and would be repeated. Equally the dramatic chiaroscuro and the weighty, overpowering presence of the wood illustrate his admiration for Ruisdael, and the general movement of the composition, accentuated by the light falling on the ground in a gentle 'S' curve, is Hogarthian.

Horace Walpole noted in his exhibition catalogue that the figures were of a 'milkmaid and clown' ('clown' being the conventional term for male rustics in eighteenth-century pastoral poetry). In the inclusion of this rustic vignette Gainsborough may have been parodying the work of Wilson, who included classical narratives in many of his landscapes. The following year, for example, in a letter to his friend William Jackson, he described the union of 'a regular Composition in the Landskip way' with 'History' as 'tragi-comic' (*Letters*, p.40). In fact, Gainsborough's vision was no less ambitious than Wilson's, but was clearly conceived as an alternative aesthetic to the classical tradition, and both were on display at the same exhibition.

That Gainsborough was gaining some critical recognition (if not financial gain) as a landscape painter is underlined by the opinion of an anonymous reviewer of the exhibition, who wrote: 'In this picture there is much to be commended, the figures are in a fine taste, the cart-horses, and fore-ground are extremely fine, and well painted, but the trees are too blue and hard'. CR

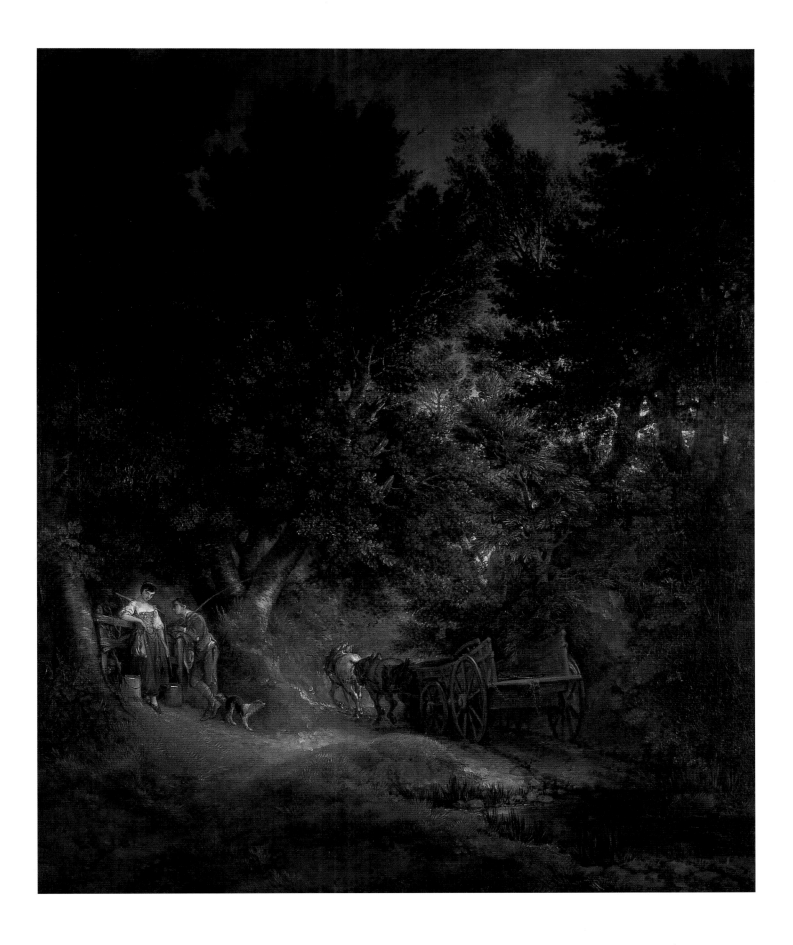

41
George, Lord Vernon

Exhibited at the Society of Artists in 1767,
no.60: 'Portrait of a gentleman; whole length'
Oil on canvas, 246.3 × 150.4 (97 × 59¼)
Southampton City Art Gallery

Waterhouse, no.693

As in the previous year, in 1767 Gainsborough submitted four works for exhibition. These were a full-length of Lady Grosvenor (cat.42), the only single female portrait he showed at the Society of Artists, *The Harvest Wagon* (cat.43), a full-length portrait of John, 4th Duke of Argyll (no.59; Scottish National Portrait Gallery) and the present portrait of George, Lord Vernon (1735–1813). With the last two works Gainsborough sought to demonstrate his artistic range by juxtaposing two contrasting representations of the aristocratic gentleman, of public and private virtue. Against an architectural backdrop, Argyll is shown as a statesman in full ceremonial robes, Vernon as a country gentleman taking a stroll in a generalised landscape with his dog.

The majority of Gainsborough's full-length portraits, in particular of his male sitters, were characterised by their informality and outdoor setting, as he sought to advertise himself to the exhibition-going public as a specialist in such rural representations. Examples would include the portraits of William Poyntz (cat.37) and of David Garrick leaning on a bust of Shakespeare (see cat.80). The portrait of Vernon exemplifies this greater freedom of dress and informality of manner that was deemed appropriate in the countryside; Vernon wears a wool frock coat and waistcoat in brown and green respectively, his hair unpowdered as befits his informal attire, and he leans on the broken branch of a tree.

Here, Vernon's dog has jumped up, perhaps to interrupt his master's reverie. Rather than chastise the animal Vernon lays an affectionate hand on the dog's shoulder which emphasises the companionship, rather than straightforward ownership, that exists between master and animal, and, in general terms, Vernon's ease with nature. The Arcadian mood is heightened by the flickering brushwork of the idealised landscape and the warm Claudean glow of the sunset. Vernon is thus presented as the quintessential 'man of feeling': his sober, practical clothes, his contemplative frame of mind and his good-naturedness are all indicative of this. Judging from the volume of commissions, this type of rural sensibility portrait was a highly attractive form of self-imagery to art patrons. The motif of the friendly dog figured again and again not only in portraits but in Gainsborough's fancy pictures from the 1770s and 1780s. CR

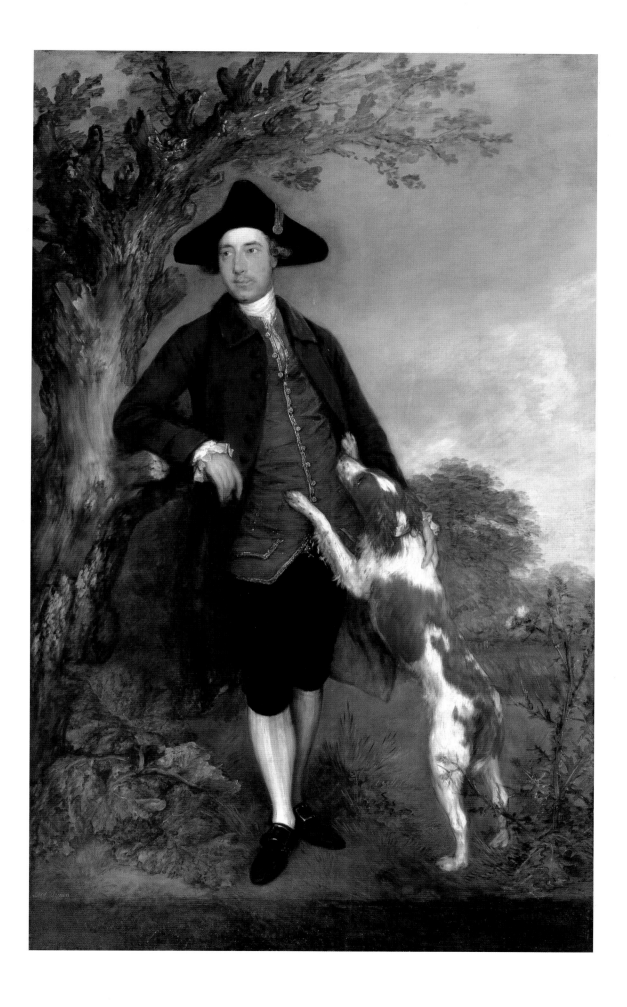

42
Henrietta Vernon, Countess Grosvenor
Exhibited at the Society of Artists in 1767,
no.58: 'Portrait of a lady; whole length'
Oil on canvas, cut down to 75 × 63 (29½ × 24¾)
By kind permission of His Grace the Duke of
Westminster O.B.E., T.D., D.L. on behalf of
himself and his Trustees

Waterhouse, no.332

This was the only full-length portrait of a female
sitter exhibited by Gainsborough at the Society
of Artists. At some point afterwards it was cut
down to a head and shoulder format. The full
impact of the painting can however be imagined
from other portraits from the early to mid-1760s
of a similar scale and ambition: for example, the
treatment of the costume from Countess Howe
(cat.64), and of the landscape (it seems safe to
assume that Countess Grosvenor is in a rural
setting) perhaps also from this picture or from
the portrait of Lord Vernon (cat.41) exhibited in
the same year.

Even as a fragment it is clear that cat.42
was a society portrait *par excellence*. Countess
Grosvenor wears a *sacque* (a French style of
dress with back drapery) in white silk, the
buttoned bodice ruched and decorated with soft
pink ribbon, as are the sleeves just above the
triple lace ruffles. Matching ribbon is tied in a
bow around the neck and in the hair. The hair is
smooth, unpowdered and worn in a high roll
covered at the back with a fashionable net hood.
In contrast with French custom, cosmetics,
especially rouge, were used occasionally and
with moderation in Britain, underlining the
national preference for a 'natural' (that is, paler)
complexion. Complexions that appeared to have
been 'made up' in a portrait, unlike Countess
Grosvenor's, were sometimes noted by
exhibition critics and occasionally lampooned,
given that such an appearance was more often
associated with *demi-mondaines*. Countess
Grosvenor appears to be out for a stroll, an
honest enough pursuit. Indeed Englishwomen
were noted for their enjoyment of exercise, and
this fondness is reflected in the number of
portraits set in the landscape, as opposed to
those of Frenchwomen who were more often
shown in an interior or formal garden setting.

What is remarkable in the present portrait is
the highly expressive turn of the head, as if
something has caught the sitter's attention, and
the almost mischievous look, accentuated by the
raised left eyebrow and the lips faintly pressed in
amusement (Gainsborough may also have been
responding to the acknowledged
coquettishness of the youthful sitter). This
greater spontaneity and sharper sense of
character is certainly a departure from Countess
Howe's cool, almost mask-like dignity. As Aileen
Ribeiro has observed, in general society
portraiture was expected to demonstrate the
restrained good breeding of the sitter even if this
resulted in a lack of expression. However, this
may explain why Gainsborough submitted this
particular portrait for public exhibition: firstly,
because it would stand out among most
conventional portraiture, and secondly, to
demonstrate to polite society that in the hands
of a highly skilled artist it was possible to have
both decorum and character. CR

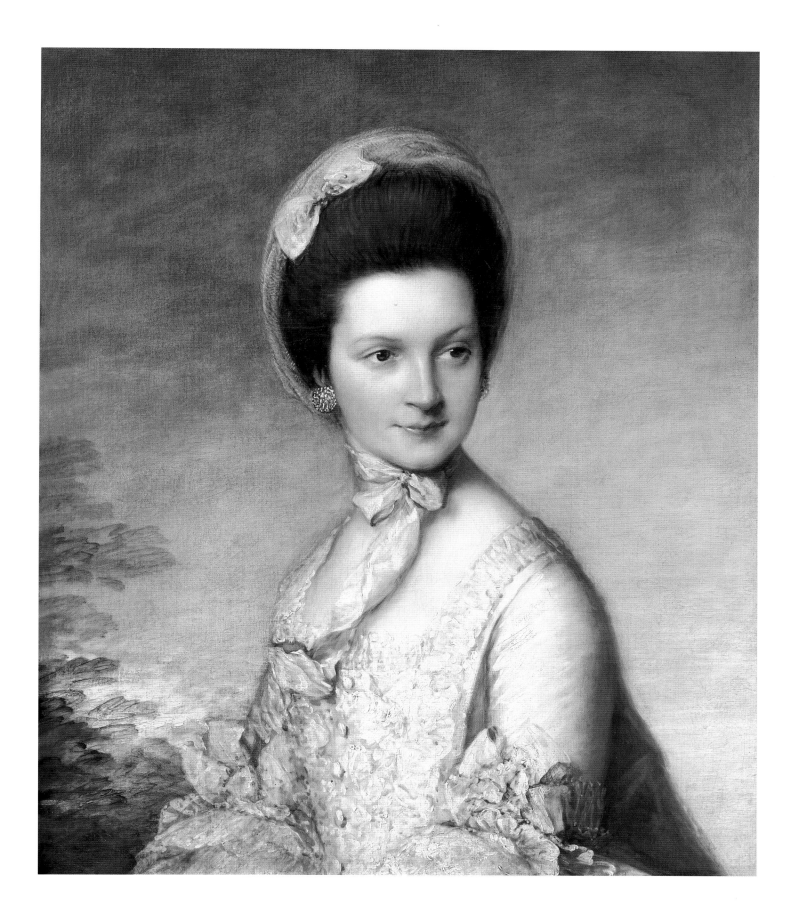

43

The Harvest Wagon

Exhibited at the Society of Artists in 1767,
no.61: 'A landskip with figures'
Oil on canvas, 120.7 × 144.8 (47½ × 57)
Trustees of the Barber Institute of Fine Arts,
The University of Birmingham

Hayes 1982, no.88

As with cat.38 and cat.40, this landscape was speculative rather than commissioned and was later given by Gainsborough to Walter Wiltshire, the Bath carrier, in 1774. According to tradition, it was painted at Wiltshire's home, Shockerwick Park, outside Bath, thus implying that over and above selective Old Master references and Gainsborough's own imagination this landscape was informed by the local scenery. It has also been suggested that Gainsborough's daughters Margaret and Mary modelled for the girl being helped into the wagon and the girl looking upwards respectively.

Gainsborough had previously used the subject of rustic merriment (as he had wagons and even a figure scratching his head). However, the pyramidal composition of figures on the wagon is more complex than any group hitherto executed by Gainsborough and has been linked to the study that he made from the early to mid-1760s of Rubens's *The Descent from the Cross* (fig.5), an oil sketch for which was then at Corsham (now Courtauld Gallery, London). This suggests a broadening of Old Master references in Gainsborough's landscapes to include history painting. But perhaps the most noteworthy aspect of this picture is that the rustic figures are not subservient to the landscape but rather the subject of the painting. In fact the landscapes discussed in this section form a progression: in cat.38 the viewer searches for the human figures; in cat.40, although more prominent, the figures and the narrative remain incidental; but here the human interaction is of prime concern.

The landscape also marks a turning point in Gainsborough's style. Gainsborough now employs a much lighter, luminous palette, and although certain areas are accentuated, none the less a more gentle light is diffused across the whole scene. This development, conceivably calculated to be broader in its appeal, may have been a response to the popular picturesque landscapes of George Barret (?1732–1784), who had moved to London from Dublin in 1763 and began exhibiting at the Society of Artists the following year.

This landscape appears to have received only one published review, by an anonymous writer, who tersely commented that 'The trees are hard, and the sky too blue'. Horace Walpole was more enthusiastic, stating: 'This landscape is very rich, the group of figures delightfully managed, and the horses well drawn, the distant hill is one tint too dark.' Gainsborough's rising status, at least in some quarters, was indicated by his inclusion, along with Barret and Wilson, in a commission made around 1767 by Lord Shelburne for a group of landscapes that 'were intended to lay the foundation of a school of British landscape'. CR

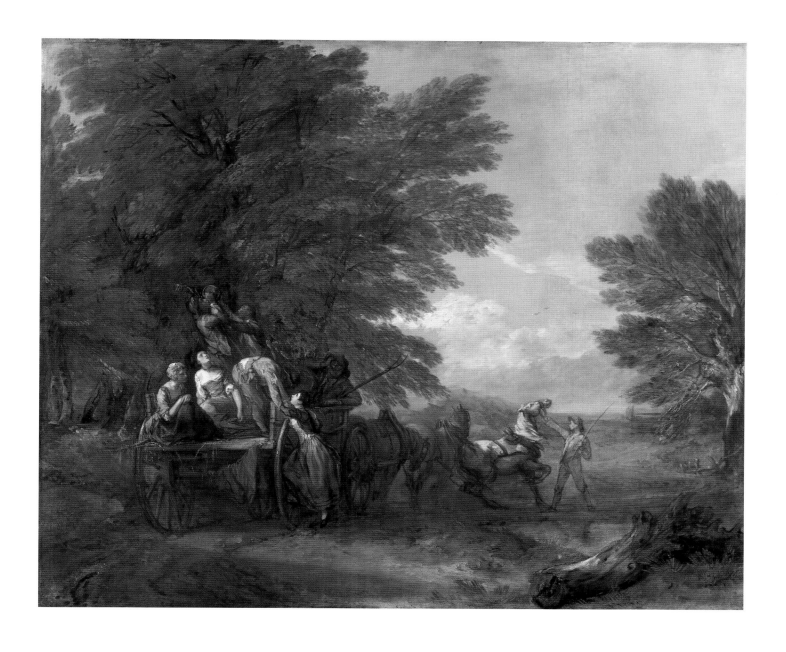

44

Isabella, Viscountess Molyneux
Exhibited at the Royal Academy in 1769,
no.35: 'Portrait of a lady; whole length'
Oil on canvas, 236.5 × 155.1 (93⅛ × 59½)
Board of Trustees of the National Museums
and Galleries on Merseyside (Walker Art
Gallery, Liverpool). Presented by HM
Government, 1975

Waterhouse, no.606

Gainsborough submitted four works to the first
exhibition at the Royal Academy in 1769: the
present full-length portrait of Lady Molyneux,
a full-length portrait of George Rivers (Cleveland
Museum of Art), a 'large landscape' (no.37) and 'A
boy's head' (no.38). Lady Molyneux (1748–1819)
was married at the end of 1768. This portrait was
most probably commissioned to mark the event.
Given the end result it is clear that Gainsborough
had set out to produce his grandest female
portrait to date for the inaugural exhibition.
Indeed cat.44 is arguably closer to seventeenth-
century courtly prototypes than any portrait he
had hitherto executed. The primary inspiration
was Van Dyck, and perhaps also Rubens. But,
instead of hinting at seventeenth-century
sources, as is generally the case with his portraits
of the 1760s, here Gainsborough is much more
explicit. The erect nobility of the pose and
remoteness of the expression are markedly
different from the ease and sense of individuality
of *Ann Ford* (cat.35) or *Countess Grosvenor*
(cat.42). Both the slender hand placed on the
breast (a characteristic of Van Dyck's portraits)
and the arm outstretched – as if in the process of
drawing the shawl around the body – are almost
theatrical. The figure silhouetted full-length
against the landscape is unusual in Van Dyck's
oeuvre and may have been taken from Rubens,
and in particular, the celebrated portrait of
'Rubens's wife' as it was then called (Gulbenkian
Museum, Lisbon). In the eighteenth century this
portrait, which was copied and engraved, was
often ascribed to Van Dyck.

The drama of this picture, however, comes
primarily from the costume worn by Lady
Molyneux. The open robe, bodice and underskirt
are of a matching white silk with stripes of blue-
grey and black. The triple lace ruffles, pearl
necklace and hair, which is dressed in a high roll,
lightly powdered and threaded with a string of
pearls, are set off against the intense blackness
of the shawl. The face is similarly powdered with
a hint of pink on the cheeks, to give the sitter a
refined pallor. In addition the warmer tones of the
generalised landscape accentuate the cooler,
contrasted tones of the central figure, a strategy
Gainsborough was to repeat the following year
with *The Blue Boy* (fig.45). Thus, through careful
manipulation of the figure, setting and palette
Gainsborough produced a Grand Manner portrait
with the resonance of an Old Master but without
resorting to the 'timeless' costume of classical
tradition.

That this portrait had the desired effect on
visitors is underlined by a short review published
in *Lloyd's Evening Post*, where it was listed as one
of the paintings 'that have this season chiefly
attracted the attention of the Connoisseurs at the
Royal Academy'. This review was repeated in the
Whitehall Evening Post, *Public Advertiser*,
St. James's Chronicle, *London Chronicle* and
Middlesex Journal. CR

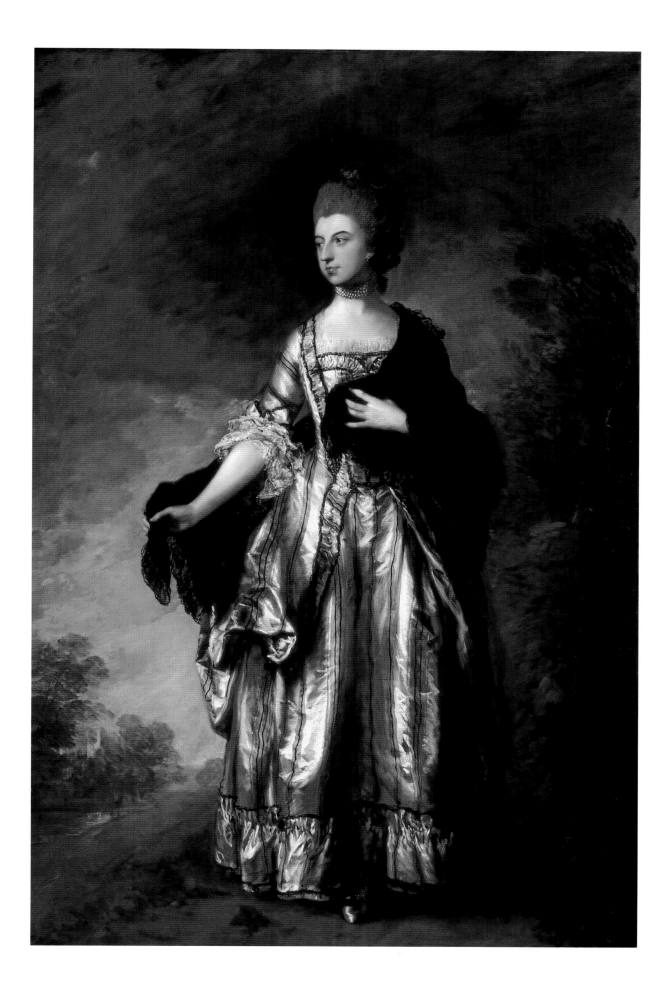

45

Hester, Countess of Sussex, and her Daughter, Lady Barbara Yelverton

Exhibited at the Royal Academy in 1771, no.74:
'Portraits of a lady and child; whole length'
Oil on canvas, 226.7 × 153 (89¼ × 60¼)
Toledo Museum of Art; Purchased with funds
from the Libbey Endowment, Gift of Edward
Drummond Libbey, and with funds from the
Florence Scott Libbey Bequest in Memory of
her Father, Maurice A. Scott

Waterhouse, no.644

Gainsborough submitted seven paintings to the third Royal Academy exhibition, the largest and most ambitious single group of works thus far. Four of the five portraits, all of which were full lengths, are included here: *Viscountess Ligonier* (cat.47), *Viscount Ligonier* (cat.46), *Captain William Wade* (cat.48) and the present double portrait. Hester (1728–1777), daughter of John Hall of Mansfield Woodhouse, married Henry Yelverton (1728–1799) in 1757. The following year he succeeded his brother to become 3rd Earl of Sussex. A soldier by career, he was given the role of Bearer of the Golden Spurs at the coronation of George III. Hester had previously served as Lady of the Bedchamber to the three eldest daughters of George II. Her daughter Barbara (1760–1781), shown here at the age of ten or eleven, later eloped with Edward Gould, for which she was disinherited.

This portrait can be seen as a transition from the imposing portrait of Lady Molyneux (cat.44), where the figure seems dislocated from the landscape, to one where the figures are shown at ease in a generalised, pastoral setting. Hester is seated at the foot of a tree, leaning on a grassy rise, while her daughter stands by, her hands crossed holding a sprig. However, unlike Gainsborough's portrait of the Linley sisters (cat.49), exhibited the following year, they cannot be described as 'children of nature', but clearly retain a society air. Like *Viscountess Molyneux*, much of the effect of this painting is achieved through the striking contrast of black and white tones, broken by the rich blue of the ribbons, against the softer greens and browns of the landscape.

The sparse newspaper coverage of the exhibition included the usual notices of opening times, the royal visit and so on. The *Craftsman* and the *Gazetteer* printed the longest notices concerning two Royal Academy exhibits: James Barry's (1741–1806) *The Temptation of Adam* (c.1767–70; National Gallery of Ireland, Dublin) and Benjamin West's (1738–1820) *Death of General Wolfe* (1770; National Gallery of Canada, Ontario), both of which were described as 'celebrated'. However Barry's work was thought to have too little drapery, 'a fault common to most young painters, immediately after their tour of Italy, on account of the difference in climate'. Albeit more like gossip than penetrating art criticism, the comment does demonstrate the emphasis newspapers often placed on subject paintings, whether history painting or historical reportage, over that of the 'lower' genres, perhaps because of their comparative rarity and novelty. Gainsborough's portraits and two landscapes appear not to have elicited any comment from newspaper critics. However, Robert Baker, in his *Observations on the Pictures now in exhibition at the Royal Academy* (1771), noted that 'After Joshua Reynolds, Gainsborough seems the best portrait-painter we have. His five full-lengths in the exhibition are very good … The two large landscapes (No.79 and No.80) by this painter are very good. They are executed with a masterly hand and with an excellent *gout* of colouring.' Horace Walpole, on the other hand, who did not annotate any comments on the portraits in his exhibition catalogue, described the landscapes as 'Very good, but too little finished'. CR

46
Edward, Second Viscount Ligonier

Exhibited at the Royal Academy in 1771, no.76:
'A portrait of a nobleman with a horse; whole
length'
Oil on canvas, 238.8 × 157.5 (94 × 62)
The Huntington Library, Art Collections and
Botanical Gardens

Waterhouse, no.443

Figure 38
After Joshua Reynolds
Lord Ligonier 1760
Oil on canvas, 279.4 × 238.8 (110 × 94)
Tate

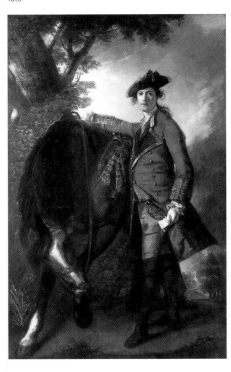

Figure 39
Joshua Reynolds
Captain Robert Orme 1756
Oil on canvas, 240 × 147.3 (94½ × 58)
National Gallery, London

The present picture and cat.47 were conceived
as pendant portraits. The commission was
made by the diplomat and courtier, George Pitt,
later first Lord Rivers, when his son-in-law
Edward Ligonier (1740–1782) succeeded as
second Viscount Ligonier of Clonmell.
Gainsborough described George Pitt as
a 'staunch Friend' and had previously sent a
full-length portrait of him to the first Royal
Academy exhibition of 1769. In July 1770 he
complained, though, that the present portrait
and cat.47 would 'take me prisoner for a
months work' (*Letters*, p.78).

The sitter's uncle, John, first Viscount
Ligonier, had served under Marlborough and
later succeeded the Duke of Cumberland as
Commander-in-Chief of the British Army.
Reynolds had painted him in 1760 in a large
equestrian portrait, that was copied (fig.38) and
engraved. Gainsborough had previously
exhibited a rejoinder to Reynolds's equestrian
portrait (exhibited in 1761) with his portrait of
General Honywood in 1765 (John and Mable
Ringling Museum of Art, Sarasota, Florida). In
the present work it is possible that the viewer
was invited to recall Reynolds's painting not
only to suggest the mutual qualities of the
uncle and nephew but also to invite artistic
comparisons. If that is the case, then the
contrast could not be more marked. Reynolds's
portrait, as with other examples of his military
portraiture, such as *Captain Robert Orme*
(fig.39), is a piece of high drama: a union of
portraiture, biography and national history. Set
in the midst of battle, Ligonier casts a heroic
figure, fearless and determined, seated on his
rearing charger. Gainsborough shows his
nephew leaning nonchalantly against his rather
more docile horse looking out of the painting
and towards where his wife's portrait was
conceived to be hanging. Admittedly, the more
domestic tone of this painting was inevitable
given its role as a pendant to a contemplative
female portrait. What is unusual about it is the
prominence that Gainsborough gives to the
horse itself, making the picture virtually a
double portrait, a point raised by Robert Baker
in his *Observations on the Pictures now in
Exhibition* (1771):

> The horse, being represented as near to the
> spectator as the gentleman, and being a
> large object, and a light colour, attracts the
> eye as much as the gentleman does. The
> eye is equally divided between them: and it
> is to be feared that such people as affect to
> be witty, will say the horse is as good a man
> as his master. CR

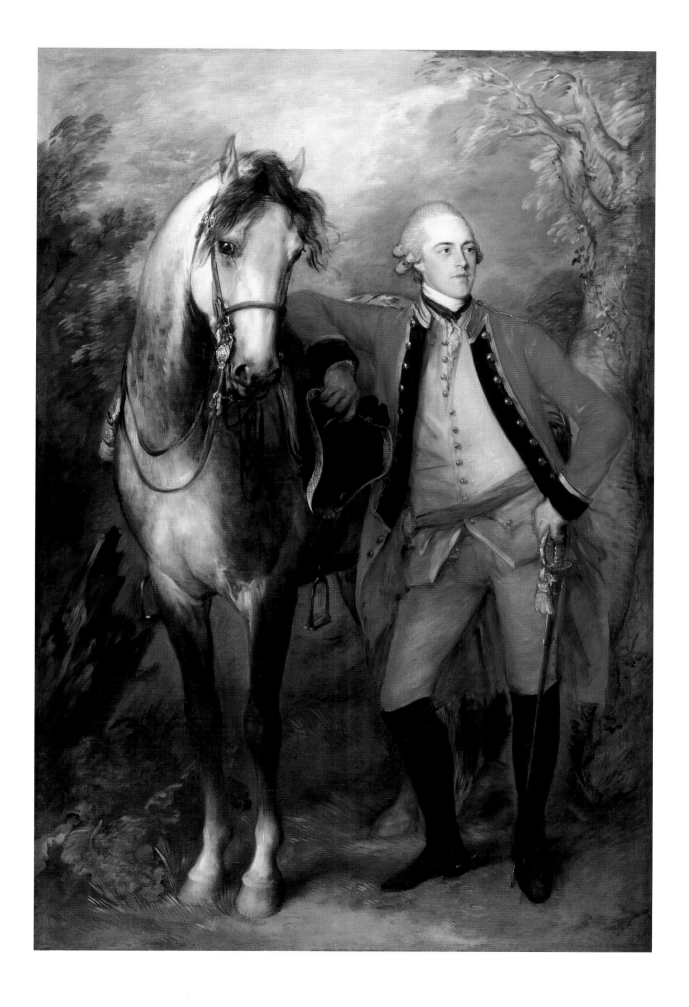

47
Penelope, Viscountess Ligonier
Exhibited at the Royal Academy in 1771, no.75: 'A portrait of a lady in a fancied dress; whole length'
Oil on canvas, 240 × 156.9 (94½ × 61¾)
The Huntington Library, Art Collections and Botanical Gardens

Waterhouse, no.444

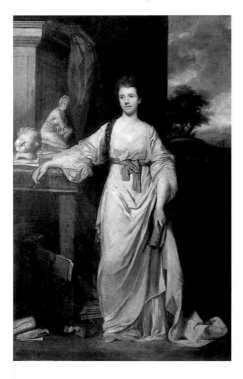

Figure 40
Joshua Reynolds
Lady Stanhope as Contemplation 1765
Oil on canvas, 236.3 × 146.1 (93 × 57½)
The Baltimore Museum of Art: The Mary Frick Jacobs Collection

Penelope Pitt, Viscountess Ligonier (1749–1827), was the eldest daughter of George Pitt, first Baron Rivers. She became acquainted with Edward Ligonier in Lyons and in December 1766 they were married in the chapel of the British Embassy in Paris. The marriage was not a happy one. Within months of sitting for her portrait she was embarking on an affair with Vittorio Amadeo, Count Alfieri. On 7 May 1771 Lord Ligonier and Alfieri fought a duel in Green Park. As the scandal unfolded Lady Ligonier fled to France and her husband sued for 'criminal conversation', the divorce being finalised in December that year. This would have added some piquancy to the exhibition of the portraits of both sitters during the Royal Academy exhibition from 24 April to 28 May.

Robert Baker was highly complimentary of this picture in his *Observations* stating that, amongst Gainsborough's portraits, 'That of the lady in the fancied dress is particularly graceful', 'the fancied dress' being a reference to her classicised costume. He continued, 'This lady, who has something of a French look, has a remarkably piercing eye and a sensible and polite countenance.' The allusion to 'a French look' could be in response to the sitter's highly fashionable hairstyle. However, in conjunction with her 'remarkably piercing eye' it is most likely to be a comment on national types. In 1755 André Rouquet noted that in England the ideal female type had eyes that were 'large and not so sparkling as melting'. In contrast, a bold look, such as Lady Ligonier's, was often characterised as French. Her intense expression is strikingly similar to that of William Poyntz (see cat.37). Given the sexual overtones of that portrait, as well as the presentation of a man at ease in nature, it is possible that Gainsborough is purposely portraying Lady Ligonier as a passionate woman, a 'child of nature', a suggestion that is reinforced by the witty inclusion of the statuette of a dancing female bacchante, as well as the prominent shell motif on the pedestal, a symbol of Venus.

Portraits of women as artists were fashionable in the eighteenth century, as exemplified by Reynolds's portrait of Lady Stanhope (fig.40). Lady Ligonier, who is shown holding a *porte-crayon*, was herself a talented amateur. An unusual feature of this portrait is that the sitter is wearing the 'timeless' dress expounded by Reynolds rather than the contemporary dress habitual in Gainsborough's work. It is possible that Gainsborough was paying lip service to a more academic aesthetic or, given the voguishness of classicised costume, responding to a specific request by Lady Ligonier. However, Gainsborough makes no further concessions. Indeed the generalised costume only serves to accentuate the

fundamental differences between Gainsborough and artists like Reynolds, Cotes and Romney in technique and approach. The flickering energy of the brushwork breaks up the blocks of colour on the robe, giving it at first glance the visual complexity of a contemporary dress, an effect in direct contrast to the smooth, sculptural quality considered appropriate by Reynolds. Equally the sway of Lady Ligonier's hips, which emphasises the boldness of the pose and gaze, contrasts with the demure, limpid figures characteristic of idealised female sitters. CR

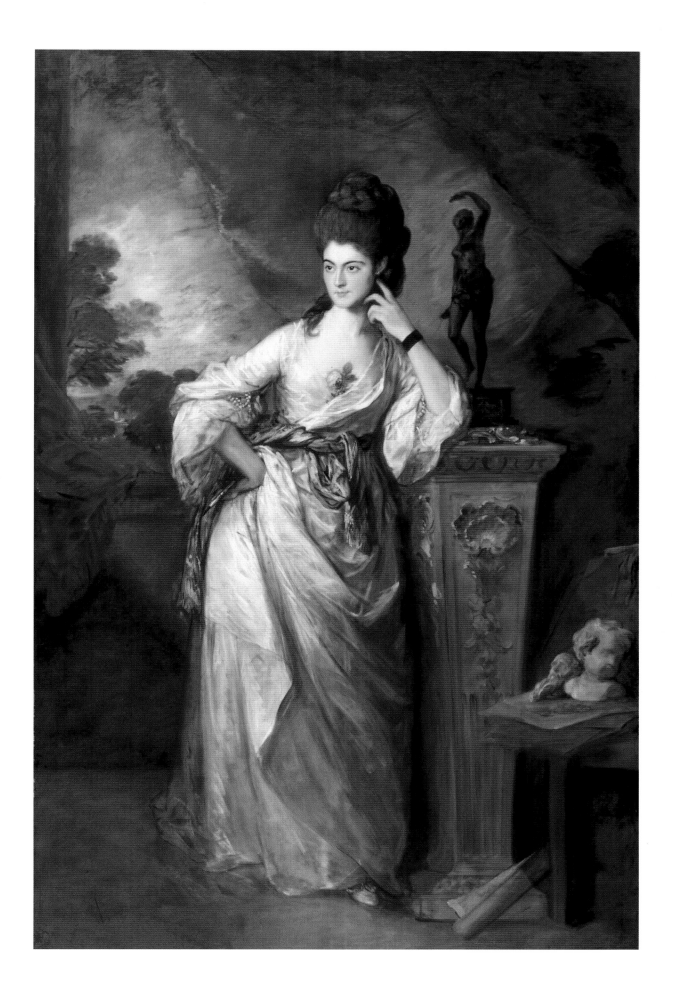

48

Captain William Wade

Exhibited at the Royal Academy in 1771, no.78:
'A portrait of Captain Wade, Master of
Ceremonies of Bath'
Oil on canvas, 231 × 149 (91 × 58⅝)
Victoria Art Gallery, Bath and North East
Somerset Council

Waterhouse, no.697

Captain William Wade (d.1809), illegitimate son
of Field Marshall George Wade, had been
Master of Ceremonies at the Assembly Rooms
in Bath since 1769. This portrait was
commissioned by the proprietors of the
Assembly Rooms shortly after his appointment.
Wade was in charge of protocol, overseeing the
dances and regulating the visitors' behaviour. It
was a role that demanded tact and diplomacy
and an in-depth knowledge of social etiquette.
Ironically, Wade, whose handsome figure
earned him constant female attention, resigned
in 1777, having been cited in a high-profile
divorce case.

This was only the second portrait exhibited
by Gainsborough where the sitter's name
appeared in the catalogue (the first was of the
actor James Quin, cat.39), most probably on
account of its being an official portrait.
However, given Wade's position, it must also
have served as a public advertisement for both
the Assembly Rooms and Wade himself.
Indeed, Gainsborough leaves us in no doubt
that we are in the presence of a man whose
business is fashionable society. Wade is shown
in formal dress, with a spectacular red silk suit,
gold satin embroidered waistcoat, white lace
stock with matching lace cuffs, and a powered
wig. He wears the ribbon and badge of his
office and sports a floral buttonhole. Wade's
decorous pose, based on Van Dyck, serves to
elongate his tall, slim figure, his left hand
resting nimbly on his hip as he walks forward,
his feet positioned as if in a dance step, his
expression cool and composed.

Although the portrait did not attract much
published criticism on its exhibition, it did
become the subject of some satirical verses
penned on its installation in the card room of
the New Upper Assembly Rooms:

> *All at once I was struck with the portrait of*
> *Wade,*
> *Which, tho' like him in features, is much too*
> *tall made,*
> *And looks, like its Master – ashamed of his*
> *trade.*
> *For it's drawn as if walking alone in the fields*
> *In a jauntee undress which the present mode*
> *yields,*
> *Uncovered – as though he intended to bow*
> *To an ox or an ass – to a heffer or cow;*
> *Thus to keep his hand in that he may not*
> *forget,*
> *When he hands out the ladies – to bow and*
> *retreat.* (quoted in Whitley, p.78)

Gainsborough's original composition, which
was devoid of architecture, would have
accentuated the sitter's height even further. As
Aileen Ribeiro has noted, formal dress such as
Wade's was not worn out of doors. Thus in the
original pastoral setting Wade's costume would
have contravened contemporary etiquette, a
sartorial *faux pas* one would not expect from the

Master of Ceremonies at Bath. Also, on the
issue of Wade's 'trade', which is by its nature
bound to urban spaces, the author above points
to the particular incongruity of Wade posturing
in a field. Gainsborough seems to have heeded
this and perhaps other similar criticisms and
painted in a stone floor and balustrade, thus
giving Wade his current appearance of stepping
out onto the terrace of a grand building. The
author, who had noted that the painting 'was
since taken down', was not satisfied with
Gainsborough's corrections, concluding:

> *Why draw him as if hurrying out of the room*
> *Down a steep flight of steps? Much like those*
> *by his home,*
> *Or why must the meadows retain a sly peep? –*
> *If the fields must be there why not give us*
> *some sheep?* CR

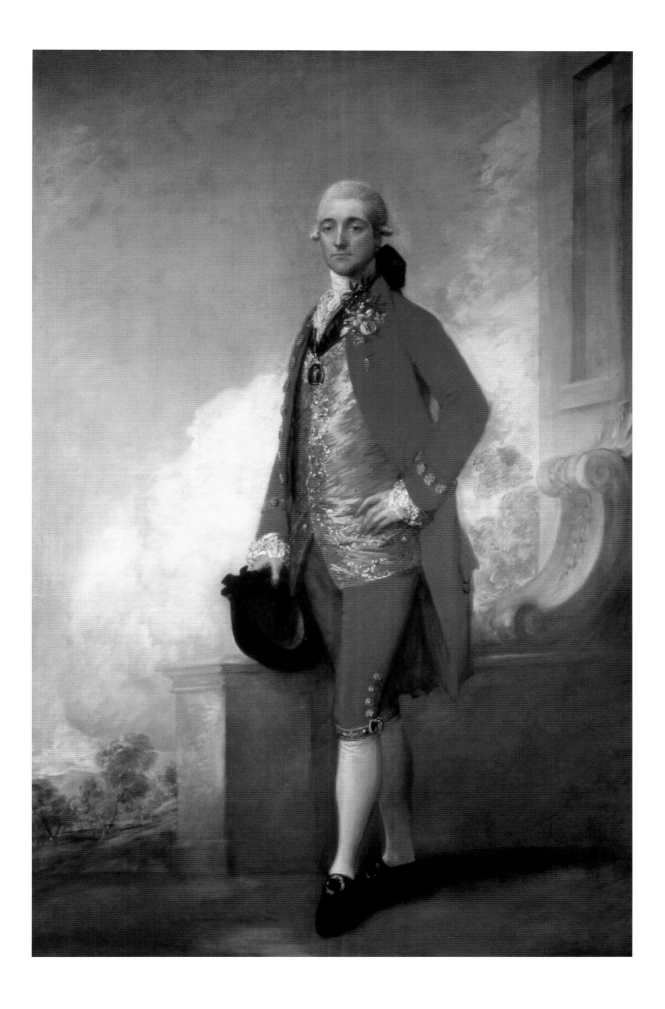

49
The Linley Sisters
Exhibited at the Royal Academy in 1772,
no.95: 'A portrait of two young ladies'
Oil on canvas, 199 × 153.1 (78¾ × 60¼)
The Trustees of Dulwich Picture Gallery,
London

Waterhouse, no.450

In 1772 Gainsborough submitted four oils, consisting of three full-length portraits, including this work, one three-quarter-length portrait, and ten landscape drawings 'in imitation of oil painting' (see cat.132). This portrait of Elizabeth and Mary Linley was painted for Gainsborough's close friend Thomas Linley, who was a music professor and director of concerts in Bath. Cat.49 was probably begun in early 1771, when Mary had joined her sister as a professional singer, and completed the following year, at the time of Elizabeth's elopement to France with Richard Brinsley Sheridan. As Gainsborough commented on March 31, 'Miss Linley is walkd off sure enough with young Sheridan' and continues 'I was just finishing her Picture for the Exhibition' (*Letters*, p.96). Mary Linley (1758–1787) was also a highly precocious singer, as well as an actress, but lived in the shadow of her celebrated elder sister.

In contrast to cat.44 where the figure and setting are contrasted, here they harmonise in a deliberately poetic manner, heralding the sensibility of Gainsborough's portraits in the 1780s, above all that of Elizabeth herself (see cat.166). In view of Gainsborough's passion for music, it is not surprising that in this portrait he should promote the interrelationship between painting, music and nature through composition, technique and use of colour. The sisters appear to have paused from their music. Mary sits with score sheets on her lap, 'engaging' the viewer with her gaze (the *London Chronicle* thought her face 'uncommonly expressive and lovely'). Elizabeth looks wistfully into the landscape, leaning on her sister's shoulder. The guitar has additional resonance in this pastoral context, as it featured in a number of *fêtes galantes* by Antoine Watteau and others.

The juxtaposition of warm and cool tones, of golden brown and pale blue, appears, too, in Van Dyck's portrait of Lords John and Bernard Stuart (*c*.1638; National Gallery, London) where similar colours are employed. Gainsborough knew this painting intimately having copied it, probably in the early 1760s (cat.85). The contrast in the direction of the gaze, one looking away, one looking directly at the viewer, seems also to relate to the Stuart portrait. Gainsborough's portrait of his daughters (cat.96) – painted at about the same time as the Van Dyck copy – in broad terms seems to pre-empt cat.49.

That Gainsborough's work was generally well received at the exhibition is underlined by a review in the *Middlesex Journal*, which affirmed 'Mr. Gainsborough's excellence in portrait painting' and that 'his performances of this year will lose him none of that fame which he has so justly acquired by his former productions'. The writer continues: 'He seems, however, to have one fault though a

fault on the side of excess; his colours are too glaring. It would be well for him if he would borrow a little of the modest colouring of Sir Joshua Reynolds.' This last comment appears to relate to the tendency among artists (noted by Gainsborough in 1766, see cat.40) to play up the colour of a painting for exhibition purposes. Because of the intense rivalry between the two artists, that the writer should focus on an 'error' of aesthetic judgement on the part of Gainsborough and offer Reynolds himself as the remedy smacks of partisanship, a suggestion borne out by subsequent reviews. As the 1770s progressed, newspapers dramatically increased in circulation and exhibition reviews became more comprehensive and influential. In such a competitive environment artists understood the necessity of getting an art critic on side. Indeed, when Gainsborough returned to the Royal Academy in 1777, he came fully prepared with the formidable support of Henry Bate. CR

Gainsborough in the Public Eye: The Exhibition Works

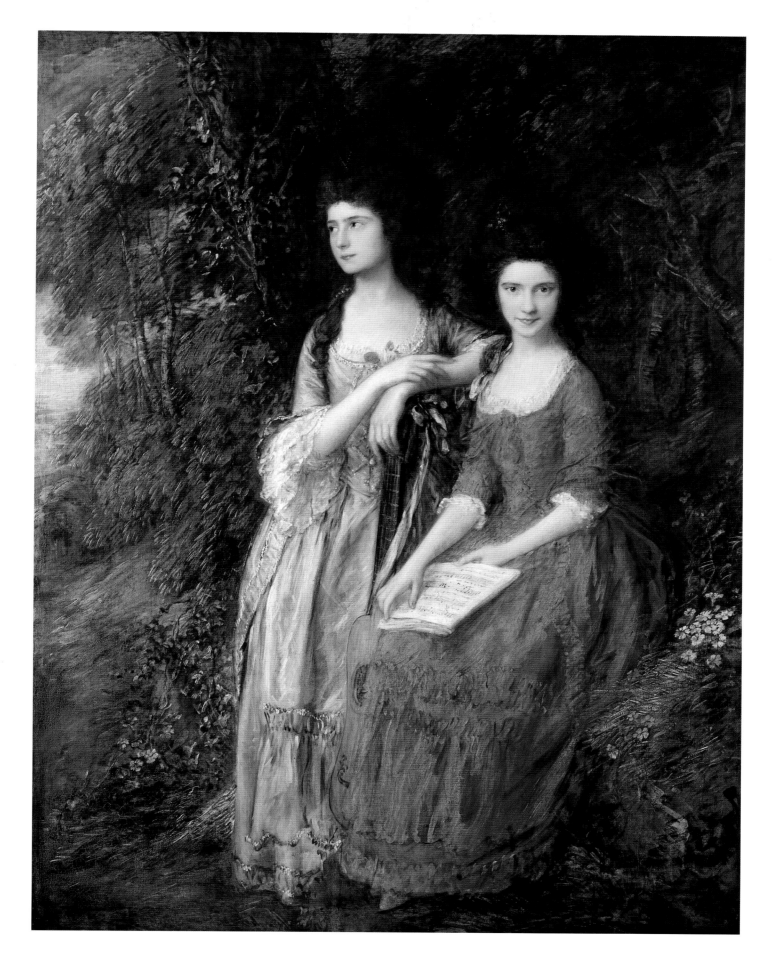

50

Carl Friedrich Abel

Exhibited at the Royal Academy in 1777,
no.135: 'Portrait of Mr Abel'
Oil on canvas, 225.4 × 151.1 (88¾ × 59½)
The Huntington Library, Art Collections and
Botanical Gardens

Waterhouse, no.1

In 1777 Gainsborough exhibited with the Royal Academy for the first time since 1772, stage-managing the event not only through the quality and range of the paintings he submitted but also by securing the support of Henry Bate, editor of the *Morning Post*. That the exhibition proved a triumph can be gauged from the almost unanimous approval of the critics. The *Public Advertiser* enthused, 'Tis hard to say in which Branch of the Art Mr. Gainsborough most excels, Landscape or Portrait Painting: Let the Connoisseurs carefully examine the Portrait of Mr. Abel, No.135, and the large Landscape, No.136 [cat.51], and determine – if they can.'

The rivalry between Gainsborough and Reynolds formed the subtext of a number of commentaries. The *Morning Chronicle* pointedly observed that Gainsborough's 'particular merit, as a portrait painter' was superior to all native artists except Reynolds, and that he 'in some instances … treads so close upon the heels of that chief of the Science, that it is not always evident Sir Joshua has a superiority.' Bate was deliberately provocative, stating in the *Morning Post*: 'As the pencil of this gentleman [Gainsborough] has evidently entitled him to the distinction, we have impartially placed him at the head of the artists, whose works we are about to review.' Reynolds was generally placed first as a courtesy to his position as President.

Abel (1725–1787) was a German composer who had settled in London in 1759. Gainsborough first met him in Bath in 1760 and the two became close friends. Gainsborough goes beyond presenting a grandee of the music world to produce an image that is itself colouristically harmonious and compositionally rhythmic, and so evocative of musical composition. The setting employs baroque conventions of a column with a swag of rich fabric. Abel wears formal dress, his brown frock suit enlivened with gold tassels, matching the waistcoat. The richness of the gold accessories, green curtains and red upholstery is accentuated by the flashes of blue silk lining the frock coat and the white lace ruffles.

Abel's pose is an essay in suspended motion. Instead of sitting upright, he leans forward in his chair, legs slightly splayed with the viola da gamba and bow resting at a steep angle on his left thigh, his right hand poised over the sheet of music. This momentary pause is contrasted with the agility of Abel's mind, his expressive gaze and gentle smile illustrating a moment of inspiration. Abel's music was characterised by its playfulness, which Gainsborough complements with the flickering brushwork and flashes of lively colour and, in so doing, makes artistic parallels between Abel's intellect and

virtuosity as a musician and his own as a painter.

This picture received by far the most effusive praise from the critics. The *St. James's Chronicle* described it as 'an exceedingly good Portrait' and 'a striking Likeness'. The *Morning Chronicle* opined, 'it is difficult to determine, whether the spirit of the figure, the clearly marked meaning of the face, or the correctness of the dog, and the richness of the chair cover … deserve the highest commendation', but thought Reynolds's portrait of the Duke of Cumberland 'somewhat superior'. As might be expected, the *Morning Post* waxed lyrical, describing it as 'the finest modern portrait we remember to have seen'. CR

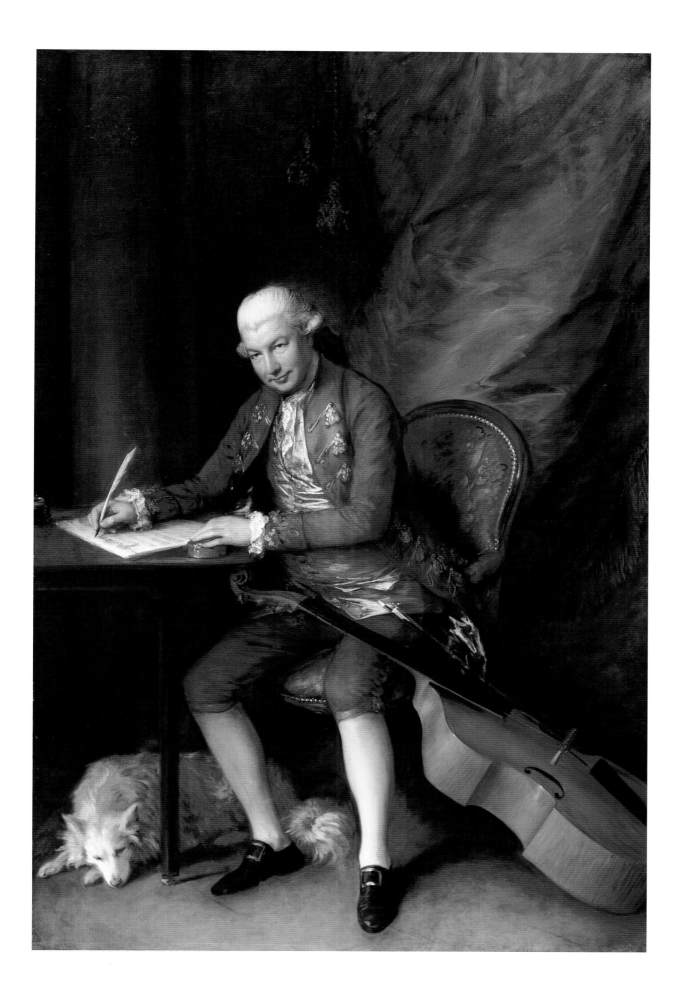

51
The Watering Place

Exhibited at the Royal Academy in 1777,
no.136: 'A large landscape'
Oil on canvas, 147.3 × 180.3 (58 × 71)
National Gallery, London

Hayes 1982, no.117

Figure 41
Peter Paul Rubens
Peasants with Cattle by a Stream in a Woody Landscape
('The Watering Place') *c.*1615–22
Oil on oak, 99.4 × 135 (39⅛ × 53⅛)
National Gallery, London

This was the one landscape Gainsborough showed at the Academy in 1777. The picture illustrates the broad but constant influence of Rubens on Gainsborough's landscapes, and has a specific relationship with the Rubens landscape that became known as *The Watering Place* soon after its arrival in England, between 1763 and 1768 (fig.41). Gainsborough's picture gained the present title only after entering the National Gallery collection in 1827. Although he had seen and admired Rubens's *The Watering Place* at Montagu House in 1768, Gainsborough is not so easily pinned down. Indeed, the massive trees and generalised background have been linked to 'the heroic manner of Titian' as well as Rubens. None the less, it was the Rubensian references that were noticed at the time: Horace Walpole noted that cat.51 was 'In the style of Rubens' and an Italian writer in the *St. James's Chronicle* thought that the work revived 'the Colouring of Rubens in that Line'.

Walpole also thought cat.51 'by far the finest Landscape ever painted in England, & equal to the great Masters'. This opinion was mirrored in the *Morning Chronicle*, which stated that Gainsborough 'as a landscape painter… is a formidable competitor with the ablest'. The *Morning Post* described it as 'a master-piece' that illustrated 'Gainsborough's superior taste and execution in the landscape way'. Henry Bate, who wrote this piece, focused on where the picture had been hung in the Great Room, concluding that the work 'is viewed to every possible disadvantage from the situation in which the directors have thought proper to place it'. Given Gainsborough's chagrin with the positioning of his works in the past, it is likely that Bate was acting as a mouthpiece for his opinions.

But perhaps the key to Gainsborough's ambitions lay in the comments in the *St. James's Chronicle*. After describing the scene as 'grand', the light 'striking' and the cattle 'natural', the writer seems lost for words:

> *But what shall I say of the Pencilling [brushwork]? I really do not know; it is so new, so very original, that I cannot find Words to convey an Idea of it. I do not know that any Artists, living or dead, have managed their Pencil in that Manner, and I am afraid that any Attempt to imitate it will be attended with Ill-success. Were you in London I could only tell you to go and see.*

Gainsborough may have learned from Old Masters or indeed other sources including nature itself, but *The Watering Place* was a singular and modern vision of the landscape that sought to equal, not imitate, the achievements of the past. CR

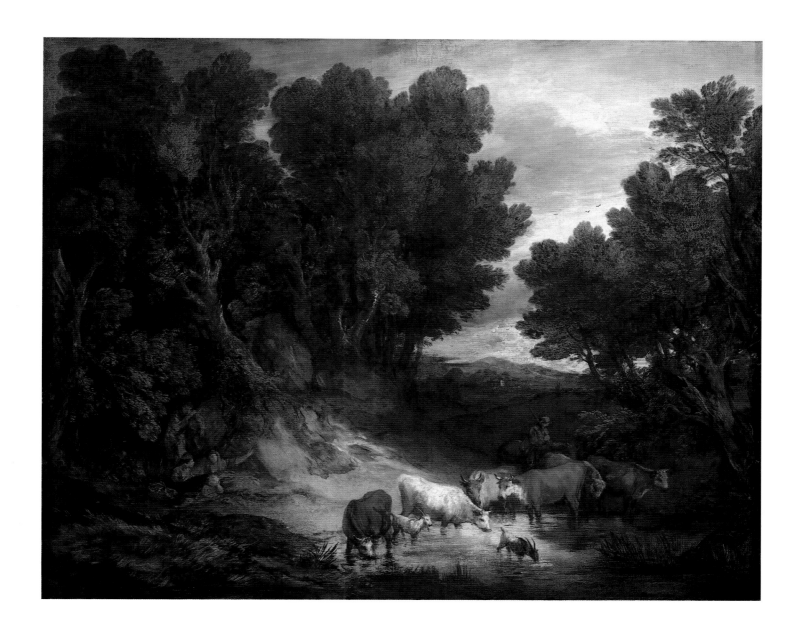

52

Grace Dalrymple, Mrs John Elliott

Exhibited at the Royal Academy in 1778,
no.114: 'Portrait of a lady; whole length'
Oil on canvas, 234.3 × 153.7 (92¼ × 60½)
Metropolitan Museum of Art, Bequest of
William K. Vanderbilt, 1920

Waterhouse, no.239

In 1778 Gainsborough submitted thirteen
paintings to the Royal Academy, the most thus
far to a single exhibition. These were eleven
portraits, including that of James Christie
(cat.54), Philippe Jacques de Loutherbourg
(cat.53), and the present full length, and two
landscapes. Gainsborough received mostly
favourable comments from the press.
However art criticism had changed significantly
by 1778 due primarily to the increasing
popularity of daily and thrice-weekly London
newspapers. David Brenneman has noted
how, with a broadening readership who held
'competing political and commercial interests',
art criticism itself became increasingly 'fraught
with factionalism'.

The *ad hoc* nature of earlier art criticism
ended in 1773 when Bate, the editor of the
newly formed *Morning Post*, introduced
regular reviews of both the Royal Academy
and Society of Artists exhibitions. Bate's
provocative and occasionally ribald comments
certainly stirred the situation up. In 1778, for
example, the *Morning Chronicle* asserted
that Reynolds 'is not only entitled to the first
notice, as President of the Academy, but on
account of the vast superiority of his skill'. Bate
countered this by declaring Gainsborough 'the
Apollo of the society' who 'is not excelled by
Sir Joshua Reynolds in the exact similitude
which his portraits bear to their originals,
nor in the elegant ease of attitudes, and
is infinitely superior in the brilliancy of
colouring'. Interestingly much of the adverse
criticism against Gainsborough in 1778 focused
on his 'misuse' of colour, particularly in his
female portraits.

In cat.52 Gainsborough presents a flattering,
broadly Van Dyckean image of the celebrated
courtesan, Grace Dalrymple (1748–1823). The
sitter is wearing a spectacular gold-yellow silk
dress. Her height, which earned her the
sobriquet 'Dolly the Tall', is accentuated by the
fashionably piled hairstyle and, it would seem,
by Gainsborough having elongated her limbs.
This, with the elegant turn of the head, makes
for a graceful, aristocratic figure. The general
air of seventeenth-century courtly portraiture is
heightened by the hand gathering the silk to
the breast forming a luxurious baroque swag,
the effect of which is reminiscent of Van Dyck
and, perhaps more poignantly, Sir Peter Lely
(1618–1680). Given the sitter, it is possible
that Gainsborough sought to evoke the
hedonism of the Restoration court, and in
particular the mistresses of Charles II. The
décolleté of the dress, more seventeenth
century than eighteenth century, also points
to this possibility.

In discussing this picture, the *General
Evening Post* opined that 'the inexpressible
sensibility that animates the whole figure' was
marred only by the 'blue tint' of the hair.
Another critic thought Gainsborough's use of
purple 'gives the face a foreign air, and reminds
the spectator of the Paris Ladies, whose
rubicundity of cheek is derived from art'. While
the writer in the *Morning Chronicle* eulogised
over Reynolds's 'superiority of skill', he cattily
described Gainsborough as clearly 'a favourite
among the demireps' concluding that:

> as the real faces of the ladies … have not
> been seen by the world for many a year …
> they were very fit subjects for Mr.
> Gainsborough's pencil, since he is
> rather apt to put that sort of complexion
> upon the countenance of his female
> portraits which is … described in the
> School for Scandal as coming in the
> morning, and going away at night. CR

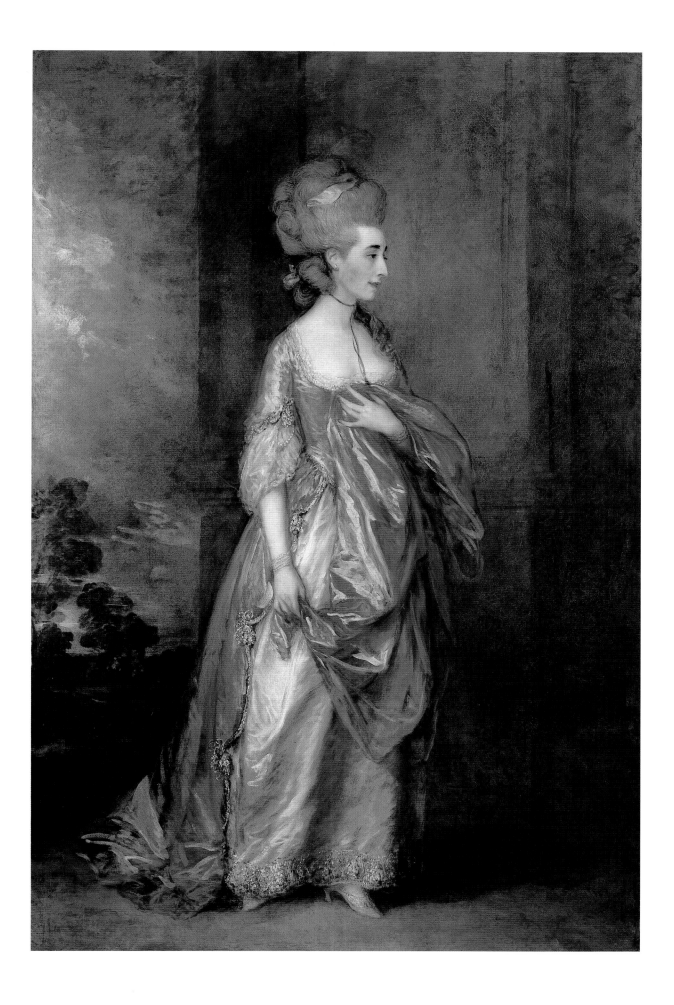

53
Philippe Jacques de Loutherbourg
Exhibited at the Royal Academy in 1778, no.408: 'Portrait of a gentleman; three-quarters'
Oil on canvas, 76.5 × 63.2 (30⅛ × 24⅞)
The Trustees of Dulwich Picture Gallery, London

Waterhouse, no.456

Philippe Jacques de Loutherbourg (1740–1812) was born in Strasbourg, trained in Paris and moved to England in 1771. He worked for David Garrick at Drury Lane as a scene designer. He also achieved a notable success at the Royal Academy with his dramatic landscapes and was elected an academician in 1780. The following year he exhibited for the first time the 'Eidophusikon', an early form of diorama that fascinated Gainsborough (see cat.152).

De Loutherbourg is shown looking up from a sketchbook in a moment of inspiration, signalled by the light falling on his face. Gainsborough had used a similar strategy to indicate intellect in his portraits of the actor James Quin (cat.39), and the composer Carl Friedrich Abel (cat.50). De Loutherbourg's face, however, has an open, far-away expression giving it an other-worldliness that seems wholly appropriate to a man who was to abandon painting briefly to take up faith healing. In response to cat.53 and Gainsborough's portraits in general, a number of commentators touched on key issues surrounding his technique. The writer in the *Morning Chronicle*, who had enthused over Reynolds's work (see cat.52), felt that most of Gainsborough's paintings 'appear as if the drapery and the subordinate parts were unfinished', the hands 'insubstantial and informal'. A commentator in the *General Advertiser*, in relation to the portrait of James Christie (cat.54), remarked on the 'unfinished stiffness' of the body. He continued:

> His stroke is very uncertain and fluctuating. After painting an excellent face, he joins a very bad body to it. There is not that strength in his execution, which gives life and motion to a figure. The brush is laid on, as it were, with a trembling hand, and it produces an unharmonious effect.

Gainsborough's 'uncertain and fluctuating' brushstrokes, applied with a 'trembling hand', are contrasted in the same article with Reynolds's technique, where 'a load of colour gives a manly vigour to his stroke' which at a distance produces 'a noble feature'. Uncomplimentary as these comments on Gainsborough were calculated to be, they should not be taken in isolation or indeed dismissed as purely partisan statements, but rather contextualised within a broader contemporary debate concerning different techniques in oil painting. This debate necessarily involved Reynolds, who, at the same time as instructing Academy students on 'best practice' generally in art, had been repeatedly criticised by the press for the fugitive nature of his colours. Indeed Henry Bate, in his exhibition review of 1777, noted that the 'critics have long found fault with his style of colouring, asserting, that its brilliancy must soon fly off'. Gainsborough's increasingly thin

and sketchy technique resulted in his paintings retaining their vibrancy; Reynolds's thick layering of paint did not. For Bate, the answer to Gainsborough's style was simple: hang the works in the correct position. His review of the present exhibition noted that Gainsborough 'has been reproached with negligence in finishing'. He continued, 'but if his pieces be viewed at a proper distance, which, as it is manifestly his design is the only just way of estimating their merit, this imputation will appear totally without a foundation'. The brusqueness of this comment-cum-statement suggests that it came straight from Gainsborough himself. CR

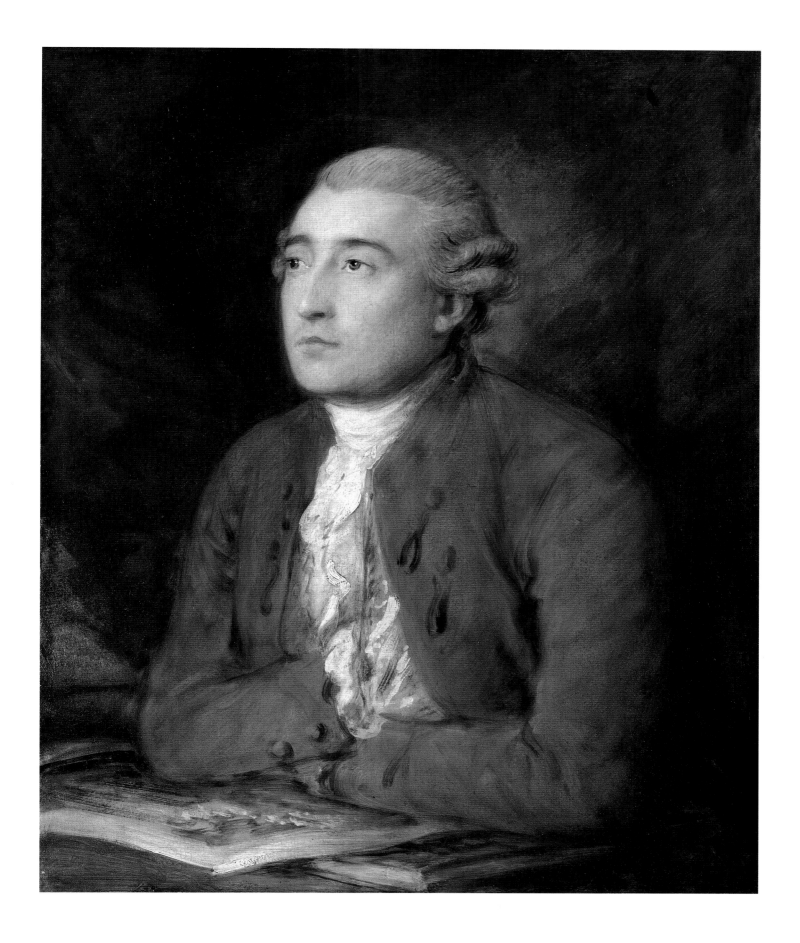

54
James Christie
Exhibited at the Royal Academy in 1778,
no.117: 'Mr Christie; half length'
Oil on canvas, 126 × 101.9 (49⅝ × 40⅛)
J. Paul Getty Museum, Los Angeles

Waterhouse, no.147

Although Gainsborough tended not to fraternise with the art world, he did have a friendly relationship with James Christie (1730–1803), who, after resigning his commission in the navy, had started a business in 1762 as an auctioneer in Pall Mall, London. By the time this portrait was painted, he had moved to premises adjacent to Gainsborough's residence at Schomberg House. In this portrait Christie leans, with gentlemanly ease, on the frame of a painting, apparently a landscape by Gainsborough. Since the artist found it hard to sell landscapes on the open market, this may have been an attempt to promote his work – rather deftly it must be said – through a portrait of an auctioneer. It is possible that Gainsborough also meant to infer that his landscapes were by association in the same league as the Old Masters that passed through Christie's saleroom.

Gainsborough's exceptional ability in capturing a likeness was regularly commented upon by critics throughout his exhibition career. The writer in the *General Advertiser* stated of this picture that the 'likeness, as indeed all his likenesses are, is very striking'. Even the commentator in the *Morning Chronicle*, who gave one of the most disparaging reviews Gainsborough ever received in print, admitted his skill in reproducing a sitter's face to the point whereby 'the name need not have been printed in the catalogue'. Indeed this writer opined that in his portraits Gainsborough 'seems solely to have taken pains with the heads' to the detriment of the figure itself, which was 'unfinished' and 'insubstantial'.

Gainsborough's increasingly thin, sketchy brushwork formed part of a wider debate on technique and in particular its effect on the durability of oil paintings. It is possible that Gainsborough sought to fuel this debate by submitting works for exhibition such as this and cat.53, which by contemporary standards appeared to be 'unfinished'. Gainsborough may also have been deliberately associating himself with those aspects of Van Dyck's working practice that were highly esteemed in the eighteenth century, that is, the application of thin layers of paint with broad, fluid brushstrokes. As David Brenneman has observed, there is a parallel between Van Dyck's almost legendary 'swift hand', reputedly spending – as recorded in Roger de Piles's well-known treatise *The Principles of Painting* (1708) – no more than an hour per sitting on his portraits, and the manner in which Gainsborough increasingly came to work. In his biography of the painter, Philip Thicknesse focused on his speed of execution, remarking that 'his best works' were 'finished ... at one sitting'. Thicknesse proceeded to adapt the Van Dyck anecdote mentioned above, by stating that Gainsborough's portrait of his nephew Gainsborough Dupont (cat.87) was completed in one hour. CR

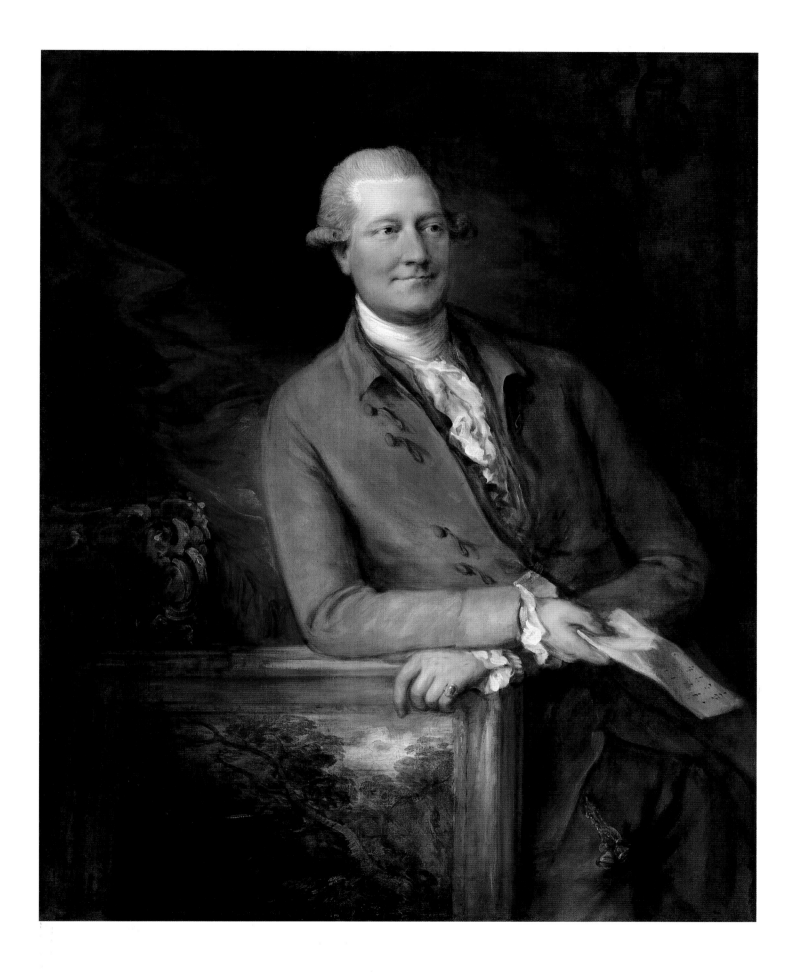

55
Reverend Henry Bate
Exhibited at the Royal Academy in 1780,
no.189: 'Portrait of a gentleman'
Oil on canvas, 223.5 × 149.9 (88 × 59)
Lord Burton, on loan to Tate since 1989

Waterhouse, no.45

The Reverend Henry Bate (1745–1824) was rector of St Thomas's, Bradwell, in Essex. He assumed the name Bate-Dudley in 1784 and was later made a baronet. By the time Gainsborough painted this portrait Bate is known to have had a cottage in Essex, which he used as a country retreat. It is possible that Gainsborough had this in mind when he placed Bate in a landscape. Rather than the sensibility that pervades many other pastoral portraits (see cat.41), Gainsborough underlines, with the confident tilt of the head and the arm outstretched holding a walking cane, the proud, resolute character of the 'Fighting Parson'.

As editor of the *Morning Post* and then the *Morning Herald*, Bate was Gainsborough's staunchest public supporter. In 1824 the *Morning Chronicle* published an obituary for Bate, stating that the nation was indebted to him 'for one of its ornaments – Gainsborough'. This, the writer opined, was as a result of his patronage of the artist in early life, which 'principally contributed to his subsequent success'. This is clearly untrue as Gainsborough was already one of the most successful artists in Britain at the time Bate became editor of the *Morning Post* in 1772. And it is possible that the two men became firmly acquainted only a short time before Gainsborough's decision to exhibit again in 1777. If so, the timing was surely no accident. Gainsborough would have been aware of this highly successful newspaper and of its editor, whose writings, as described by a contemporary journalist, had a 'sportive severity' that 'gave a new character to the public press, as the newspapers before the *Morning Post* appeared, were generally dull, heavy, and insipid'. Bate was also critical of the Royal Academy's directors, although his comments on Reynolds's exhibited works during the mid-1770s were generally favourable. This was to change dramatically in 1777. Indeed, comparing the reviews of Gainsborough and Reynolds respectively was, as Whitley so aptly states, 'like stepping suddenly from summer into winter'. Bate's praise of Gainsborough's works, his countering of previous criticisms and raising of issues close to Gainsborough's heart – primarily concerning the unsympathetic placing of his paintings by the Royal Academy Hanging Committee – set the tone for all subsequent reviews by him. Indeed, in 1780, albeit in one of the shortest reviews written by him on Gainsborough, Bate managed to point out the artist's 'superior excellence' and lament the positioning of his landscapes in the exhibition. Thus Gainsborough was one of only a handful of artists who were championed by a newspaper critic at this time.

To what extent Bate was a mouthpiece for Gainsborough's opinions and concerns is difficult to ascertain. Equally problematic is how much of the *Morning Post*'s contents were published with Bate's blessing, in that he was only one of a number of proprietors. Indeed, why would the man who supported Gainsborough so unconditionally at the same time allow the publication in 1777 of a poem lamenting Gainsborough's colouring and in 1778 a satirical comment on a 'cadaverous' female in one of his portraits? The issue of Bate's editorial independence was resolved soon after the Royal Academy exhibition closed, when he left the *Morning Post* to set up the *Morning Herald*, of which he was the editor and sole proprietor. The first issue came out in November 1780. CR

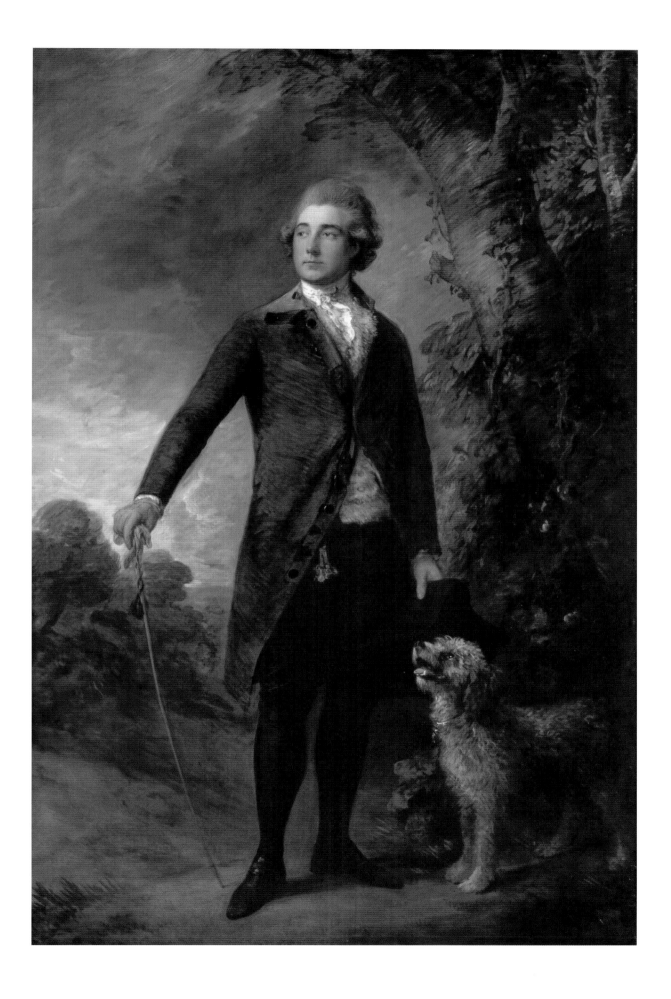

56
Coastal Scene
Exhibited at the Royal Academy in 1781, no.94:
'Landscape'
Oil on canvas, 100.3 × 127 (39½ × 50)
By kind permission of Her Grace,
Anne Duchess of Westminster on behalf
of herself and her Trustees

Hayes 1982, no.127

Gainsborough submitted seven paintings in 1781: three portraits, including the full lengths of George III and Queen Charlotte (Royal Collection); three landscapes, including the present coastal scene; and his first exhibited 'fancy picture', of a shepherd boy (see fig.49). Cat.56 and the accompanying coastal scene, now at Anglesey Abbey, were Gainsborough's 'first attempts in that line', as Henry Bate informs us in his exhibition review. As with his other landscapes, Gainsborough combined observation and his own imagination with references to Old Masters, in this case seventeenth-century Dutch landscapists such as Ruisdael and Jan van Goyen (1597–1656). It has also been observed that Gainsborough may have influenced by Claude Joseph Vernet (1714–1789). Vernet's landscapes and marine paintings were particularly admired by English patrons. In general terms Gainsborough's use of dramatic changes of light and shadow and the powerful effect of diagonals cutting across the canvas was clearly in response to de Loutherbourg's dramatic vision of landscape. Indeed, Earl Grosvenor, who purchased cat.56, commissioned a companion piece from de Loutherbourg.

Gainsborough's decision to submit seascapes certainly paid off in terms of critical response: the three landscapes exhibited in the present exhibition appear to have received more enthusiastic coverage collectively than any other landscapes of Gainsborough's exhibition career. A writer in the *Morning Chronicle*, who opined that the 'best paintings in the rooms, are those of Sir Joshua, and Gainsborough', thought the latter's landscapes 'beyond all compare excellent'. Three days later, another article appeared in the same newspaper, which described the two seascapes as 'full of the cheerfulness of the best Flemish painters, the elegance and grace of the first Italian artists, and have as much truth and correctness as has fallen to the share of any subjects of this sort'. An article in the *London Courant* focused on cat.56 for praise, stating: 'You cannot look at this sea, without being convinced of the universality of this gentleman's genius.' A writer in the *Public Advertiser* observed that 'the superior Merit' of Gainsborough's landscapes confirmed his opinion that the artist 'should entirely confine himself to Landscape Painting'. And so it goes on.

Henry Bate, of course, declared that Gainsborough was 'confessedly the principal support of the present exhibition' and that the two seascapes 'shew the universality of his genius'. He then launched into a vehement attack on the low hanging height of Gainsborough's work. 'Strange', he writes, 'that the fame of this artist, who is honoured with the most flattering marks of his Sovereign's favor [a reference to the royal

portraits in the exhibition], should here be sacrificed on the pitiful shrine of ignorance, or jealousy!' This was by no means the only charge of professional sabotage aimed at the Hanging Committee of the Royal Academy. Interestingly, other critics showed concern with the placing of Gainsborough's work. The writer in the *London Courant* noted that his paintings 'can never be seen to advantage when the [exhibition] room is filled with company, as they are hung too near the eye.' He concluded: 'If his pictures were hung the same height as Barret's, they would have a noble effect.' CR

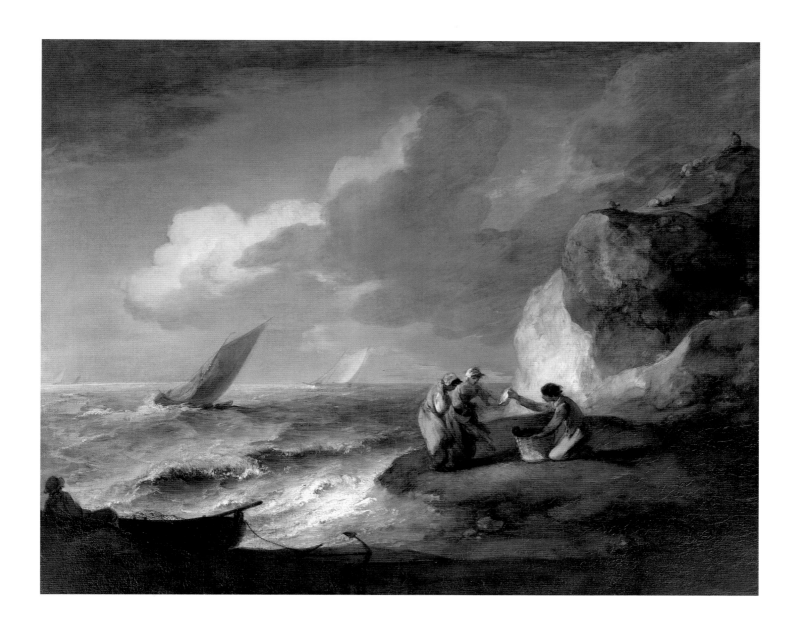

57
Giovanna Baccelli

Exhibited at the Royal Academy in 1782,
no.230: 'Madame Baccelli'
Oil on canvas, 226.7 × 148.6 (88½ × 57)
Tate; purchased 1975

Waterhouse, no.29

Gainsborough submitted eleven works to the
Royal Academy exhibition in 1782: nine portraits,
including the equestrian portraits of the Prince of
Wales and Major St Leger, the portrait of Master
Nicholls ('the pink boy') and the present portrait;
one landscape (cat.58); and one 'fancy picture',
Girl with Pigs (cat.59). The reaction of the press
was on the whole favourable. The *London
Chronicle*, for example, stated that the portraits of
the Prince of Wales and St Leger and the *Girl with
Pigs* were among those paintings in 'the large
room' of Somerset House 'that claim the loudest
praise'. The article also stated that there 'has
been, as usual, a proud rivalship between the
pencil of the President and that of Mr.
Gainsborough', which is a most explicit
acknowledgement in the newspapers of the
competitiveness between the two artists.

The celebrated Italian dancer, Giovanna
Baccelli (d.1801), was the principal ballerina at the
King's Theatre, Haymarket, where she first
appeared in 1774. She is shown in the role and
accompanying costume from the ballet *Les
Amans Surpris*, which had been one of the great
successes of the 1781–2 season. Baccelli was
equally well known as the mistress of John, 3rd
Duke of Dorset, who commissioned the present
portrait and had previously bought three of
Gainsborough's landscapes in 1778. Gainsborough
had intended showing a half length of the duke in
the same exhibition but the work was withdrawn,
presumably because of concerns about decorum.
Unlike other artists such as Zoffany and Reynolds,
Gainsborough very rarely showed his sitters from
the theatre world in role. It is possible then that
this portrait of Giovanna Baccelli dancing is the
only instance where Gainsborough presents his
sitter performing, albeit not on the stage but in an
idealised landscape. It should perhaps be viewed
in the context of Gainsborough's ambition in the
1780s to explore more complex poses in his
figurative work, above all in his 'fancy pictures'.
It may also signal Gainsborough's renewed
interest at this time in the work of Watteau, in
which dancing was a key theme.

Much press criticism focused on
Gainsborough's 'misuse' of colour in his portraits.
Interestingly a writer in the *Gazetteer* compared
the present painting with the artist's portrait of
Lord Camden (no.126), presenting the two
paintings as a contrast between what was
appropriate colouring for a gentleman as opposed
to a 'demirep'. He claimed that Gainsborough's
'early fault', which 'was said to be *too much glare
in his colouring*' had been 'long since corrected',
Lord Camden's portrait having 'all the *soberness
of colouring* which corresponds with the gravity of
the object'. However cat.57 being of a dancer (and
mistress) meant that 'the artist was not only
obliged to vivify and embellish … but to *lay on his*
colouring thickly … the face of this admirable
dancer is evidently *paint painted* '. CR

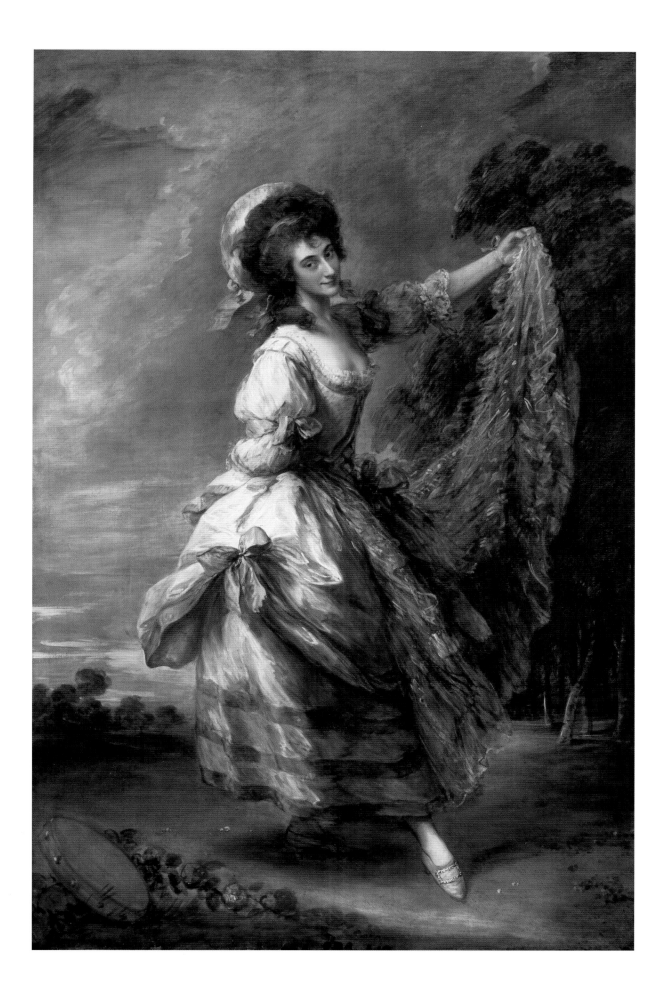

Wooded Landscape with Cattle by a Pool
Exhibited at the Royal Academy in 1782,
no.166: 'Landscape'
Oil on canvas, 120.4 × 147.6 (47⅜ × 58⅛)
Lent by the Trustees of Gainsborough's
House, Sudbury (purchased with many
contributions led by the National Heritage
Memorial Fund and the National Art
Collections Fund through Suffolk County
Council, 1987/88)

Hayes 1982, no.135

This was Gainsborough's only landscape in the exhibition of 1782. It relates to the landscapes featuring rural cottages that Gainsborough had been developing in various media since the late 1760s. However, rather than focus on a single rural vignette enclosed within an idealised setting, this painting unites a range of his landscape motifs in two figurative groups, one concentrated in the middle ground around the cottage itself and the other in the foreground beside the pool. Perhaps the most remarkable aspect of this painting is the use of light. The brilliant sunset sheds a warm glow across the pool and continues into the bottom right corner, the wooded areas either side cast into deep shadow. The luminosity of this work and the play of light and dark can perhaps be linked to Gainsborough's experiments with painted glass transparencies in a light box (see cat.152). The artist seems also to have been inspired by the example of Rubens, in particular a moonlight landscape (now in the Courtauld Gallery, London), which by 1778 was owned by Reynolds. This landscape employs a shimmering pool with a silhouetted horse, contrasted with a dense wood. The position of the pool and wood are reversed in Gainsborough's composition. Interestingly Reynolds had discussed Rubens's landscape in his eighth *Discourse* (1778), primarily in terms of the exaggeration of light in order to achieve 'a greater advantage'. He continued: 'Rubens has not only diffused more light over the picture than is in nature, but has bestowed on it those warm glowing colours by which his works are so much distinguished' (Wark, p.161).

In referring to this specific work, Gainsborough may have been presenting the Royal Academy with an object-lesson in Rubensian colour and light. If so, it is curious that Henry Bate did not mention Rubens in his exhibition review. The review itself contains the usual hyperbole, claiming the painting to be Gainsborough's '*chef d'oeuvre* in this line' and concluding that 'its aggregate beauties are too numerous to be pointed out in a news-paper review', and stating that aspects of the painting 'would have done honour to the most brilliant *Claude Lorain*'. Perhaps the motivation behind the mentioning of Claude was Gainsborough's concern at this time to introduce more elevated references and subject matter into his landscapes and pastoral scenes. Claude was admired because he did not imitate nature, but idealised its forms. In his fourth *Discourse* (1771) Reynolds opined that 'the practice of Claude Lorrain … is to be adopted by Landscape Painters, in opposition to that of the Flemish and Dutch schools … as its truth is founded upon the same principle as that by which the Historical Painter acquires perfect form' (Wark, p.70). It is quite possible that Bate was acting as a mouthpiece for Gainsborough's own ambitions. If so, then Gainsborough clearly sought to associate this painting with Claude and thus elevate his own position as a landscapist. CR

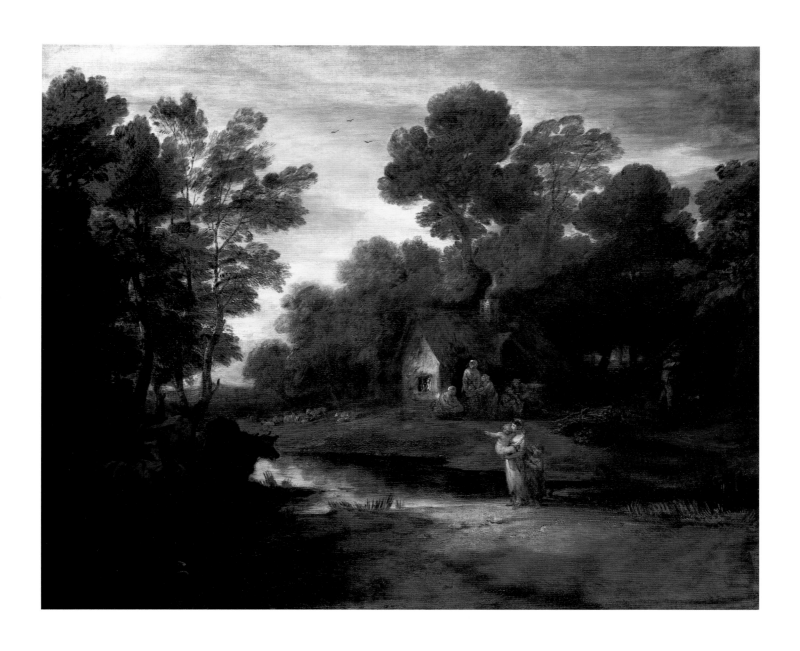

59
Girl with Pigs
Exhibited at the Royal Academy in 1782,
no.127: 'Girl with pigs'
Oil on canvas, 125.6 × 148.6 (49½ × 58½)
From the Castle Howard Collection

Waterhouse, no.799

In 1781 Gainsborough had shown his first exhibited 'fancy picture', *A Shepherd*, at the Royal Academy to great acclaim (see fig.49). The following year he submitted this painting, which was received with enthusiasm by press and public alike. A critic in the *General Advertiser* opined: 'His girl with pigs, if we may be suffered to deliver a free opinion, is the best picture in the present exhibition.' Significantly it was bought by Reynolds. The sale was reported by Bate in the *Morning Herald*, who clearly had intimate knowledge of the transaction (probably from Gainsborough himself), quoting the sum of money paid and also Gainsborough's written response, 'that it could not fail to afford him the highest satisfaction to think *that he had* brought his PIGS to so *fair a market*!'

During the early 1780s Gainsborough broadened his range of subjects to include so-called 'fancy pictures', a genre dealing with rural and urban low-life themes that had developed at mid-century. Gainsborough had introduced such motifs into his landscapes, and his chief departure in this period was the scale of the figures, which now dominated the composition. The idealisation and sentiment that imbue his pastoral scenes not only feature in these fancy pictures but are heightened by the greater legibility of the facial expressions and gestures afforded by the life-size format.

The figures in this composition were apparently based on life. He reputedly met the little girl on Richmond Hill, and was said to have introduced piglets into Schomberg House, which were seen 'gambolling about his painting room'. That Gainsborough intended the subject to appeal emotionally to his audience is made manifest here, not only through the prettified poverty of the young girl but also through the inclusion of the admittedly rather charming piglets. The *Morning Herald* reported that cat.59 was 'a great favorite with the public, and justly so: the little pigs are inimitably executed'. This ploy was utilised several years later in *Cottage Girl with Dog and Pitcher* (cat.122), where the girl (who may be the same sitter) is shown holding a puppy. As a portrait painter, Gainsborough often juxtaposed his sitters with animals in a pastoral setting. Clearly, part of the appeal of a work like *Girl with Pigs* was its ability to make such connections with fashionable portraits of sensibility. Gainsborough also incorporated Old Master references. The most obvious influence was the work of the Spanish artist Murillo, in particular his paintings of beggar children and infant saints. Gainsborough began studying Murillo in the late 1770s, making a copy of a version of the artist's *Good Shepherd* (fig.51). He also knew Murillo's *Invitation to the Game of Pelota* (1670; Dulwich Picture Gallery),

which was probably in the possession of Noel Desenfans, a London-based art dealer, from whom he purchased in 1787 *Saint John the Baptist in the Wilderness* (1660–70; National Gallery, London), then ascribed to Murillo. Interestingly this sale was reported at length in the *Morning Herald*, including the reputed purchase price of 500 guineas, a very large sum of money at the time. Given Gainsborough's relationship with Bate, it is possible that such details came from the artist himself with the intention, perhaps, of emphasising Murillo's position as a first-rate Old Master, and thus elevating his own paintings, which referred to Murillo's work, beyond mere sentimental genre into the realms of high art. CR

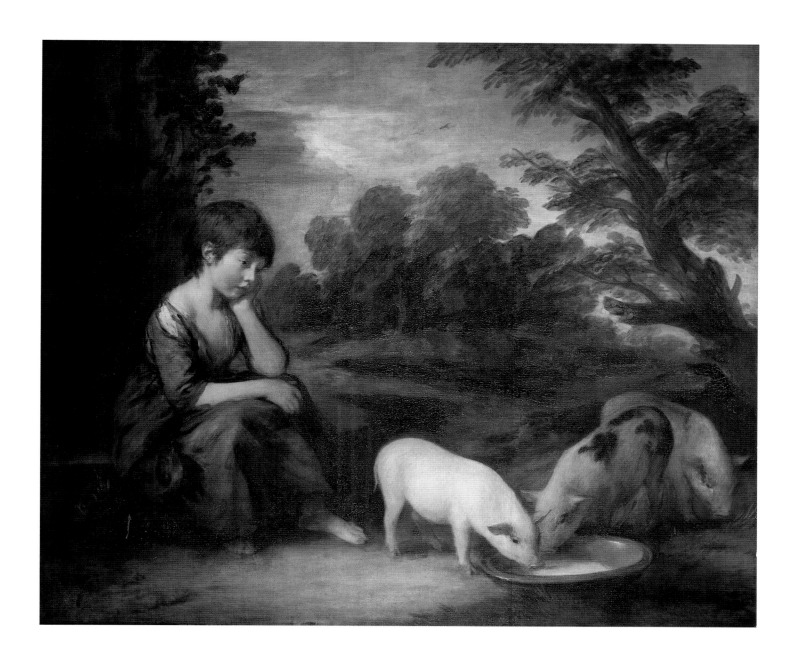

60

Shepherd Boys with Dogs Fighting
Exhibited at the Royal Academy in 1783,
no.35: 'Two shepherd boys, with dogs
fighting'
Oil on canvas, 222.5 × 155.1 (87⅝ × 61¹⁄₁₆)
English Heritage (Kenwood, The Iveagh
Bequest)

Waterhouse, no.800

Gainsborough submitted twelve works in what
was to be his last exhibition at the Royal
Academy in 1783. These were eight portraits
including a portrait of the Duchess of
Devonshire, a set of fifteen head-and-shoulder
portraits of the royal family, one landscape,
one seascape and the present 'fancy picture'.
As has been discussed, Gainsborough was
deeply concerned about the hanging of his
paintings not only at exhibition but in his
clients' houses. In 1783 Gainsborough sent a
letter to the Secretary of the Royal Academy
detailing how he wanted his paintings
positioned, in particular the royal portraits,
which he wanted 'hung with the Frames
touching each other'. He continued, 'Hang my
Dogs & my Landskips in the great Room. The
sea Piece you may fill the small Room with'
(*Letters*, p.148). This letter was followed by a
blistering note containing the threat that if the
royal family were 'hung above the line ... he
never more, whilst he breaths, will send
another Picture to the Exhibition' (*Letters*,
p.150). Clearly, the Hanging Committee
complied with his wishes, for the king was the
Academy's patron. However, the following
year, they would find Gainsborough to be as
good as his word. After withdrawing his works,
he never exhibited there again.

This extraordinary invention was one of the
hits of 1783. The artist has wittily adapted the
composition of Titian's *St Peter Martyr*, but
rather than tending their flocks, two shepherd
boys are themselves in contention while their
dogs fight. Gainsborough maintained the
Venetian reference in a more general way
through the matching of their red and green
waistcoats, which reprise the colours of the
costume worn by the small boy with a dog in
Titian's *Vendramin Family* (see cat.170). Within
this Renaissance-derived context he sets a
figure grouping that adapts the first two of
Hogarth's *Four Stages of Cruelty* (1751). This
picture might, then, be defined as a modern
moral subject and therefore an alternative to
the Grand Style histories being presented as
the most desirable form of modern art by
Reynolds. The basic sentiment of the picture,
that cruelty to animals will lead to brutality
towards humans, is in line with contemporary
sentimental thought, which led to early
concerns about vivisection and animal sports.
More speculatively, it might be claimed that
Gainsborough's perverted vision of the
pastoral as a scene of violence might refer to
conservative regrets about the fundamentally
fratricidal character of the American Wars of
Independence, which were drawn to a close
by a provisional peace late in 1782.

On its exhibition the painting was admired
for its invention and virtuosity. In the *Morning
Herald* Henry Bate greeted it with his usual
hyperbole, writing how this 'admirable
composition attracts universal notice, and is

deservedly commended by the science as a
performance of unrivalled excellence' and
calling Gainsborough an 'unrivalled painter
who has done, by his matchless
performances, so much honour to his country'.
Even the *Public Advertiser*, which often spoke
for the Reynolds camp, thought it the artist's
'Triumph', while the *Morning Chronicle* spotted
references to Frans Snyders (1579–1657) and
Murillo. Gainsborough himself was self-
effacing about the picture. Having managed
to get his other exhibits hung to his own
satisfaction by means of threats, he was
expansive in a letter to Sir William Chambers:

> *I sent my fighting dogs to divert you. I
> believe next exhibition I shall make the boys
> fighting & the dogs looking on – you know
> my cunning way of avoiding great subjects
> in painting & of concealing my ignorance by
> a flash in the pan.* (*Letters*, p.152)

The irony indeed suggests that it is not unlikely
he meant much more by this subject than
contemporaries were able to recognise. CR/MR

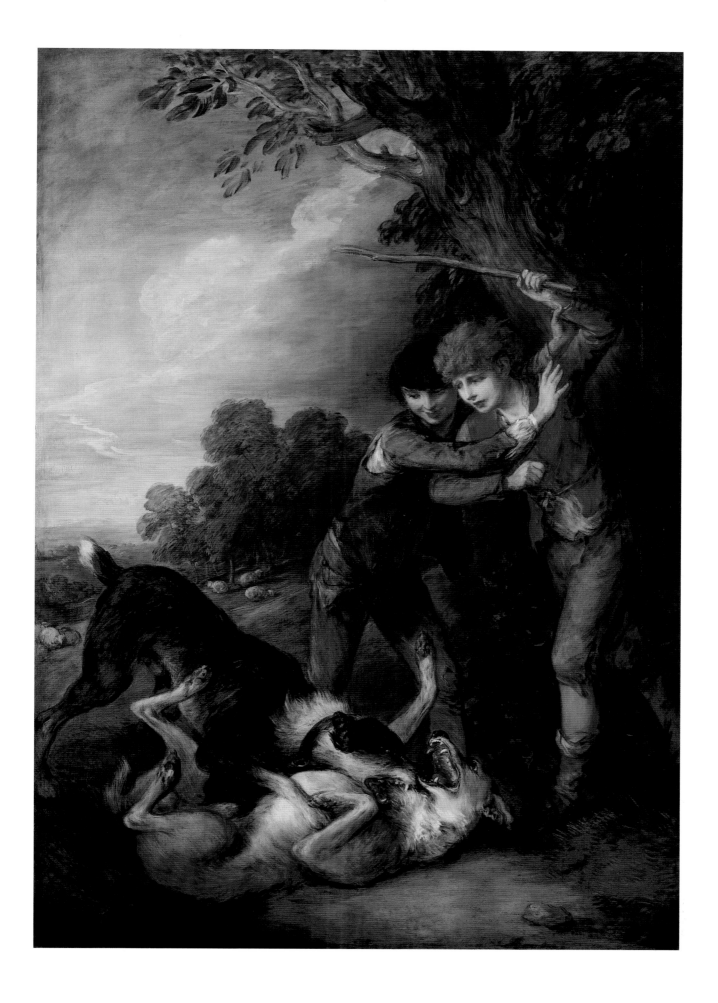

Portraiture and Fashion

The best way to make money through art was as a portraitist. Many commentators observed that, without much in the way of church or state patronage, portraiture was the only realistic way to make a living as an artist in Britain. Private patrons had little time for the literary and sacred scenes that artists were, according to high-minded art theory, meant to paint. They did, though, have time and money for the things they really loved: their estates, their horses and, most of all, themselves and their families. The British predilection for portraiture was seen as a national trait, reflecting the down-to-earth materialism of the populace and the narcissistic consequences of their ever-expanding wealth.

The market for portraits supported a great variety of professionals, in London and around the country: there were the miniaturists, the travelling cutters of silhouettes, caricaturists, makers of wax likenesses or portraits made of hair, and the artists who, like Thomas Gainsborough and Joshua Reynolds, aimed to supply the upper end of the market with a top quality product. These last works were exonerated from the stain of simply being a luxurious extravagance by being endowed with high aesthetic pretensions. But since the key factor was money, even here the artist would be confronted with the artistic equivalent of turning a sow's ear into a silk purse to keep the patron happy, as Henry Bunbury's caricature of the time suggests (fig.42). Portraiture was a complex and, in real respects, compromised area of artistic activity. However, Dr Johnson wrote that he 'should grieve to see Reynolds transfer to heroes and to goddesses, to empty splendour and airy fiction, that art which is now employed in diffusing friendship, in reviving tenderness, in quickening the affections of the absent and continuing the presence of the dead', pointing up the subtly totemic qualities of the genre, despite the fact that it was

commonly resorted to because only it would guarantee an income.

Thomas Gainsborough was acutely aware of this. He moved from Ipswich to Bath precisely because the latter town could supply a regular procession of wealthy clients. And, to judge from a letter he wrote to William Jackson in 1767, he took an appropriately world-weary view of his practice:

> Now damn Gentlemen, there is not such a set of Enemies, to a real Artist, in the World as they are, if not kept at a proper distance ... know that they have but one part worth looking at, and that is their Purse ... If any Gentleman comes to my House, my Man asks them if they want me (provided they don't seem satisfyed with seeing the Pictures and then he askes <u>what</u> they would please to want with me; if they say a Picture Sir please to walk this way and my Master will speak to you; but if they only want me to bow & compliment Sir my Master is walk'd out – and so my dear there I nick them. (Letters, p.42)

This disaffection appears confirmed in the *Reminiscences* of Henry Angelo, published in 1828–30, where he wrote of Gainsborough that if 'a portrait happened to be on the easel ... he was in the humour for a growl at the dispensation of all sublunary things. If, on the contrary, he was engaged in a landscape composition, then he was all gaiety – his imagination in the skies.' None the less, it is evident that the reality was less black and white. Portraiture could have real meaning and value to him. There is the instance in the Society of Arts exhibition of 1763 of his pitting a portrait of James Quin against that allegorical invention featuring David Garrick that Reynolds had shown the previous year (see cat.39). Or we may contemplate his letter of 1773 to the Revd Dr William Dodd, referring to his recently

Detail from **Mr and Mrs William Hallett ('The Morning Walk')** 1785 (cat.88)

Portraiture and Fashion

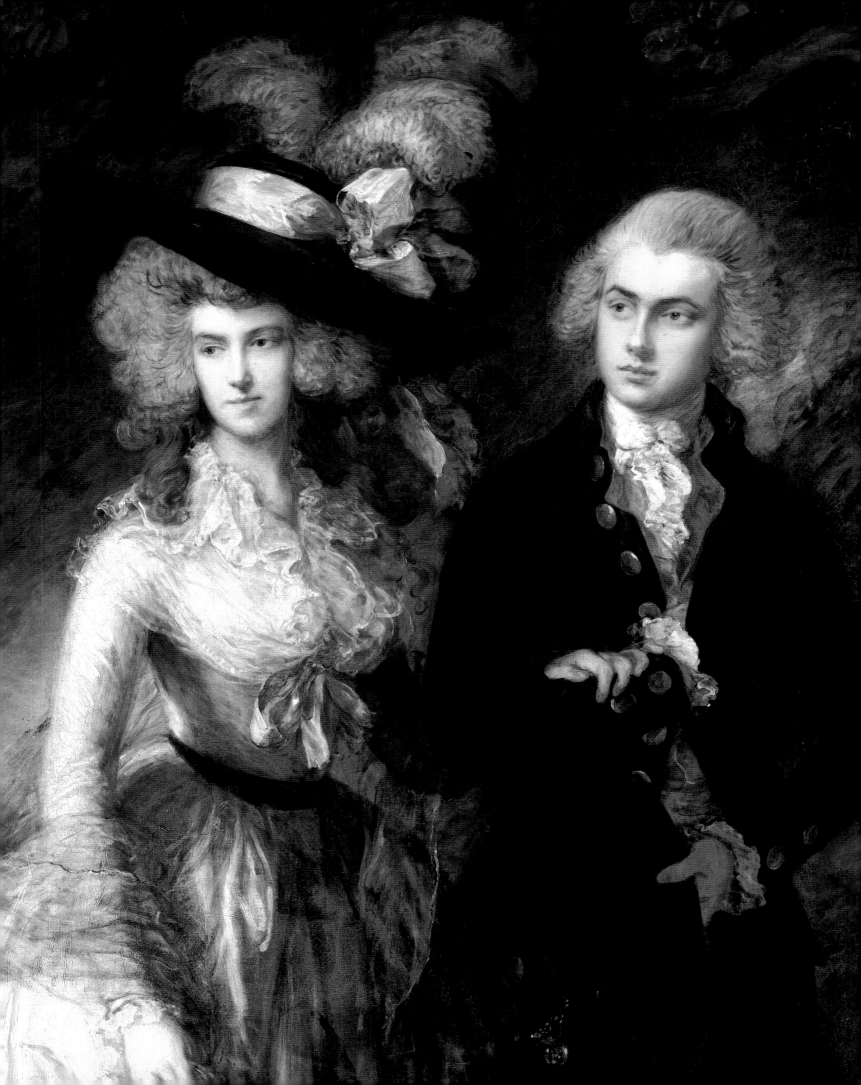

A FAMILY PIECE.

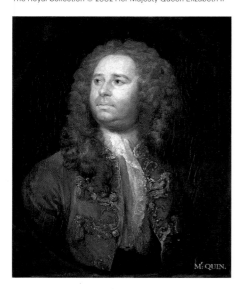

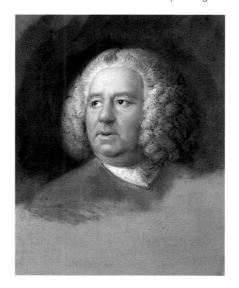

rooms were seeing Dodd's portrait as practically the person himself. This was an effect that we know he aimed at, and was noted by contemporaries: Ozias Humphry wrote of Dr Charleton's portrait that it 'absolutely seemed upon first entering the Room, like a living Person'. The artist aimed to achieve his likenesses through various means. From Allan Ramsay he had learned the benefits of deploying an 'unfixed' handling, which demanded real attention on the part of the spectator. As we can see with his portrait of William Wollaston (cat.34), he was aware, too, how slightly destabilising the symmetry of facial features encouraged the kind of active looking one might engage in when confronted by a living rather than a painted individual. Although the whole issue of physiognomic resemblance is horrifically tricky, to compare Gainsborough's portraits of the same sitters is often to be made sharply aware of how strongly they appear to represent the same person, and in basing a reputation on this gift the artist was working within a time-honoured tradition.

The question of naturalistic likeness was inherited by Gainsborough from St Martin's Lane, as comparison of his portrait of the actor Quin (fig.44) and Hogarth's earlier version of the same sitter (fig.43) makes evident. In his *Present State of the Arts in England* (1755), Hogarth's friend André Rouquet insisted that 'every attribute, which under pretence of completing the picture, diverts our ideas, and makes us mistake the likeness, is an error, a hasty mistrust of our capacity of allowing the principal intention of the work, namely resemblance.' In some respects this was a truism – the influential French theorist Roger de Piles (1635–1709) held likeness to be the 'essence' of portraiture – but it was also contentious. By 1759 Joshua Reynolds was amazing the public with such unprecedentedly elevated portraits as his *Elizabeth Gunning* (fig.13). This represented his sitter in full-length wearing classical robes, and established a fashion from which other artists could not be insulated. The vogue for classical guise, which could extend to the assumption of literary or divine roles by the sitter, prompted complaints. In 1772 the painter Ann Forbes, who was in London having recently returned from Italy and finding it hard to make a name for herself, lamented in a letter that 'here the Misses are not pleased without they be Flying in the Air, or Riding on a Cloud feeding Jupiter's Eagle'.

In arguing against the centrality of likeness in his *Discourses*, Reynolds might have pointed out that it was of negligible importance in communicating character, and that succeeding generations would have no model on which to judge the success of any painter in this department. He also used his position to belittle precisely that in which Thomas Gainsborough excelled. The issue was complex. Fashion was becoming a popular concern, with an upsurge

completed portrait of the cleric (who was to be hanged for forgery in 1777):

> *If … I thought it possible to make it ten times handsomer, I would give it a few touches in the warmth of my gratitude, though the ladies say that it is very handsome as it is; for I peep & listen through the keyhole of the door of the painting room on purpose to see how you touch them out of the pulpit as well as in it. Lord! Says one, what a lively eye that gentleman has! (Letters, pp.120–1)*

Gainsborough could be as subtle a writer as he was a painter, and it is worth pausing over this passage. Apart from the brilliantly witty pun on the verb 'to touch', for it displays a knowing awareness of the suspect side of excessive religious enthusiasm, Gainsborough reveals that at least female visitors to his painting

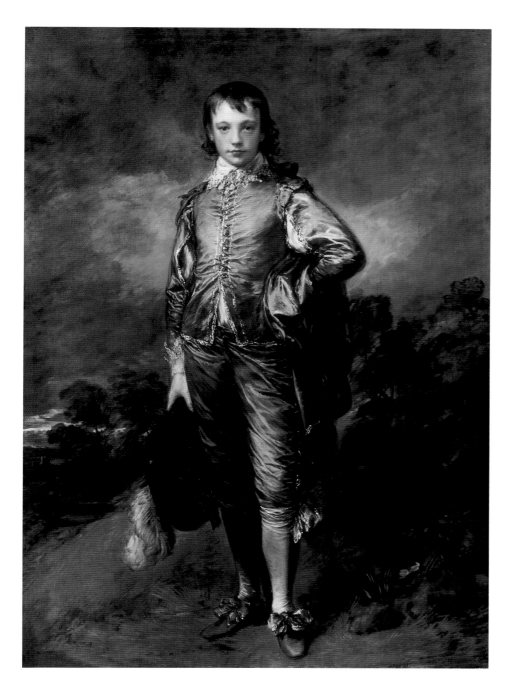

Figure 45
Jonathan Buttall: The Blue Boy *c.*1770
Oil on canvas, 179.4 × 123.8 (70⅝ × 48¼)
The Huntington Library, Art Collections and Botanical Gardens

There were, however, problems with this. Firstly, the excesses of fashion were meat and drink to the designers of satirical prints, which meant that portraits in which the fashions of the day were too closely rendered could be treading a thin line. Secondly, Ozias Humphry points out in his unpublished 'Memoir' how:

Altho' his pictures were exactly like, and to the parties for whom they were painted and their Families highly satisfactory at the time whilst the prevailing modes were daily seen, and the Friends approved and beloved in them; yet the satisfaction arising from their fixed resemblance was lessening daily, as the fleeting Fashions varied and were changing from time to time.

Aside from acting to warn us how careful we must be when applying twenty-first-century notions of likeness to work produced in the eighteenth century, Humphry's sentiments also suggest that clothing was a crucial factor in establishing individual identity. Reynolds elected to counter this problem by painting generalised portraits which, he could argue, elevated the sitter by associating them with the Great Style of history painting established in Florence and Rome in the early sixteenth century and the traditions of ambitious courtly portraiture. Gainsborough, who claimed that he painted landscapes for love and portraits for money, more pragmatically understood that his gift for capturing a likeness would serve him well with the majority of his clients; which it did, to the extent that his prices were second only to Reynolds's, and well ahead of any rivals'.

From the late 1750s Gainsborough developed a painterly technique that was peculiarly attuned to the fashions of the day in its ability to conjure the flickering, seductive surfaces of contemporary costume. With Van Dyck his guide, his portraits of the 1760s and 1770s, including the ironic portrait of the decidedly non-aristocratic Jonathan Buttall as the courtly *Blue Boy* (fig.45), provided a benchmark for fashionable portraiture. In the 1780s, with his paintings of *The Mall* (fig.14), *The Morning Walk* (cat.88) and the drawings for the 'Richmond Water-walk' (cats.90–1 and 94), we see something more profound: an artist whose ability to manipulate paint and chalk has reached such a high level of virtuosity that he is no longer simply representing fashionable ideals, his very manner of working his media embodies fashionability almost separately from the subject. Ultimately rooted in Hogarth's theories about the serpentine 'Line of Beauty' as constituting the archetypal form of sensual grace, Gainsborough's most acute visions of fashionable life from the 1780s see the academic distinctions between drawing and painting dissolved in a fluid evocation of a world of mutable values. MR/MM

in fashion images in the 1770s, and was both elaborate and constantly changing (not least because the lower orders were astonishingly adept at imitating the apparel of their betters). The artist had a background in the wool trade, and his sister was a milliner, established in Bath from 1762, which factors, as Susan Sloman has observed, would have trained his eye to noticing the materiality of stuffs, most evident in portraits like *Sir Edward Turner* (cat.79) and *Mrs Portman* (cat.65). Moreover, costumes could cost more than the paintings that commemorated them, so it would be unusual had sitters not wished a portraitist such as Gainsborough to deploy to full effect his extraordinary skill in rendering the appearances of fabrics.

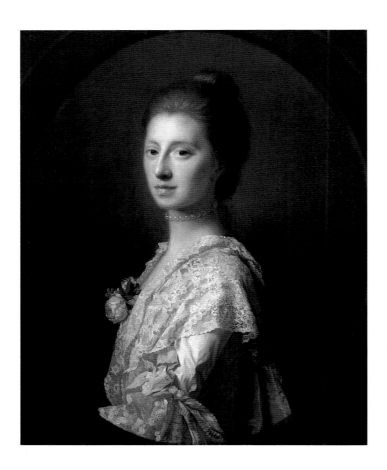

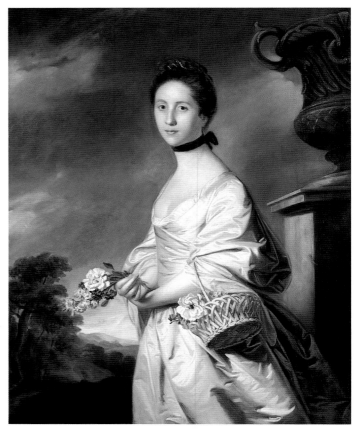

61
Allan Ramsay (1713–1784)
Mrs Bruce of Arnott
c.1766–8
Oil on canvas, 74.8 × 62 (29½ × 24¾)
National Gallery of Scotland

62
Sir Joshua Reynolds (1723–1792)
Lady Anstruther
1761
Oil on canvas, 126.4 × 99.1 (49¾ × 39)
Tate; Bequeathed by Viscountess D'Abernon
1954

63
Lady Elizabeth Montagu
c.1767
Oil on canvas, 76.5 × 64 (30¼ × 25¼)
In the collection of The Duke of Buccleuch &
Queensberry KT

Waterhouse, no.89

On returning from the Continent in 1757, the
Scottish artist Allan Ramsay demonstrated
that the finesse and delicacy that one
associated with the portraits of the French
pastel painters, such as Maurice-Quentin de la
Tour (1704–1788), could be adapted into an oil
painting that resulted in works of extreme
intimacy and immediacy. Gainsborough had
then taken Ramsay's hint and had developed
his hatched manner of painting. By the mid-
1760s this manner was refined into a subtle
and suggestive handling of paint, one that left
features sufficiently undefined to invite active
looking on the part of the beholder. Ramsay
himself, as can be seen here, in this famously
sensitive and fashionable work, was also
producing enormously delicate portraits, in
particular of women, in which there was, too,
an element of indistinctiveness, to suggest,
perhaps, some mutual awareness. What each
painter was creating was an alternative to the
linear, mask-like way of portraiture, suggesting
in the very great refinement and skill of their
handling comparable qualities both in their
sitters and the society they mutually
inhabited. By contrast, Reynolds, who could
demonstrate painterly finesse when he chose,
developed a far harder, 'licked' style of
painting, apparent in his fine portrait of Lady
Anstruther. The daughter of a merchant, she is
none the less represented by the artist as the
epitome of aristocratic grace. The costume, at

once contemporary and tending towards a
classical simplicity, the parkland setting
(suggestive of an estate) and the motif of
flowers are elements that recur in portraiture
of the period by Reynolds and contemporaries
like George Romney (1734–1802), Francis
Cotes (1726–1770) and Joseph Wright of
Derby (1734–1797). MR/MM

Portraiture and Fashion

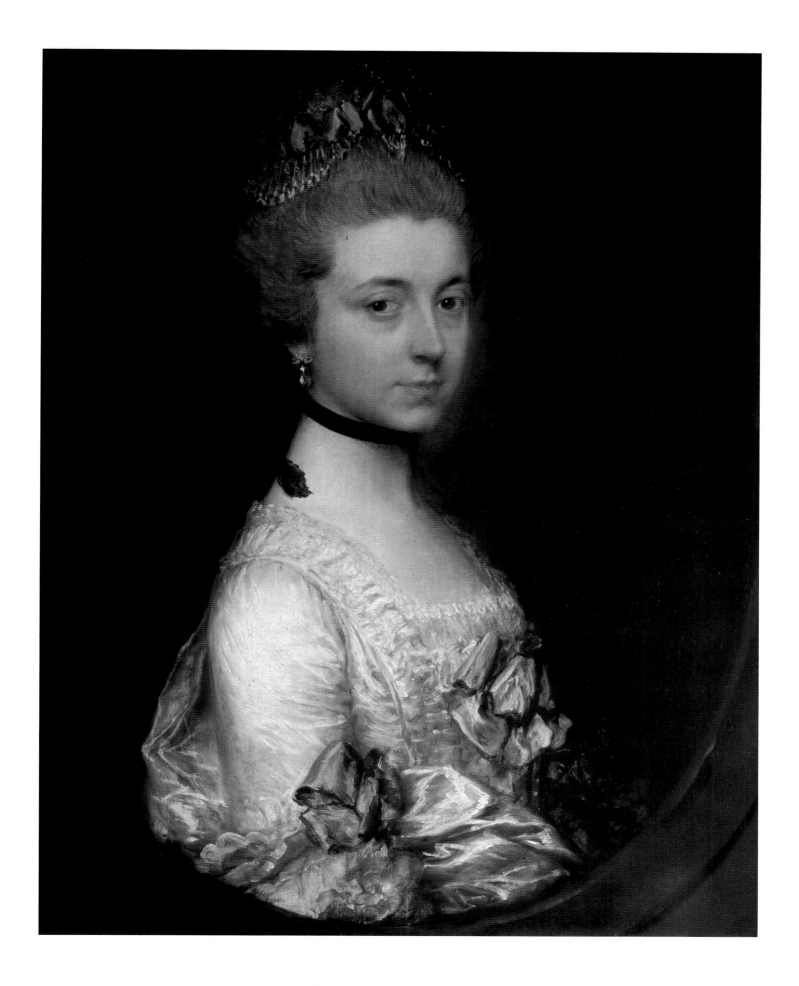

64

Mary, Countess Howe

*c.*1763–4
Oil on canvas, 224 x 152.4 (88³⁄₁₆ x 50)
English Heritage, London Region

Waterhouse, no.387

Richard, first Earl Howe (1726–1799) had
married Mary Hartopp (1732–1800) in 1758.
By the early 1760s he had gained a reputation
as a naval hero, and they had inherited
considerable wealth. It appears that
Gainsborough painted pendant portraits
of the pair in Bath in 1763–4.

The portrait of Lord Howe (Trustees of the
Howe settled Estates) represents him leaning
on a rocky outcrop in the familiar cross-legged
pose. A dark estuary stretches into the
distance, and the clouds overhead are darker
still, allowing a contrast with the steadfast
lack of expression on his face in a manner
which by then had become normal to
communicate ideas of martial courage.
In contrast Gainsborough represented the
countess in a light and fanciful deer park,
where thistles grow and the deer shelter by
a paling fence that seems arranged in almost
random disorder.

It has been frequently remarked that this is
one of those Bath portraits of women in which
the artist began to demonstrate the lessons
he had learned from a close study of Van Dyck
at Wilton and elsewhere, both in the posing of
the figure, which, as Anne French has
observed, has been adapted from the latter's
portrait of Elizabeth Howard, Countess of
Peterborough (1636–9; Private Collection), and
in the brilliance with which costume has been
painted. She is sporting a lightweight summer
dress of pink silk overlain by an apron, such as
would be normal for taking a walk, and the
folds, colouring and hang of this outfit have
been managed with consummate ease. In the
1750s, as Anne French has also pointed out,
Reynolds had adapted the same pose, with
one hand on hip and the other hanging to one
side in such portraits as that of Mrs Bonfoy
(1753–4; Trustees of the St Germans Estate),
and it may be that there is an element of
rivalry here, for in such portraits as *Mrs Riddell*
(1763; Laing Art Gallery, Newcastle upon Tyne)
or *Susanna Gale* (1763–4; Melbourne, National
Gallery of Victoria) Reynolds had shown he
could do fashionable ladies in outdoor
settings as well as women represented in the
Great Style. Gainsborough was evidently
intrigued with this format, for in a drawing
(cat.69) he shows a woman in the same pose
but from the side, and holding a rose, where
Lady Howe holds her right-hand glove in her
left hand. MR

Portraiture and Fashion

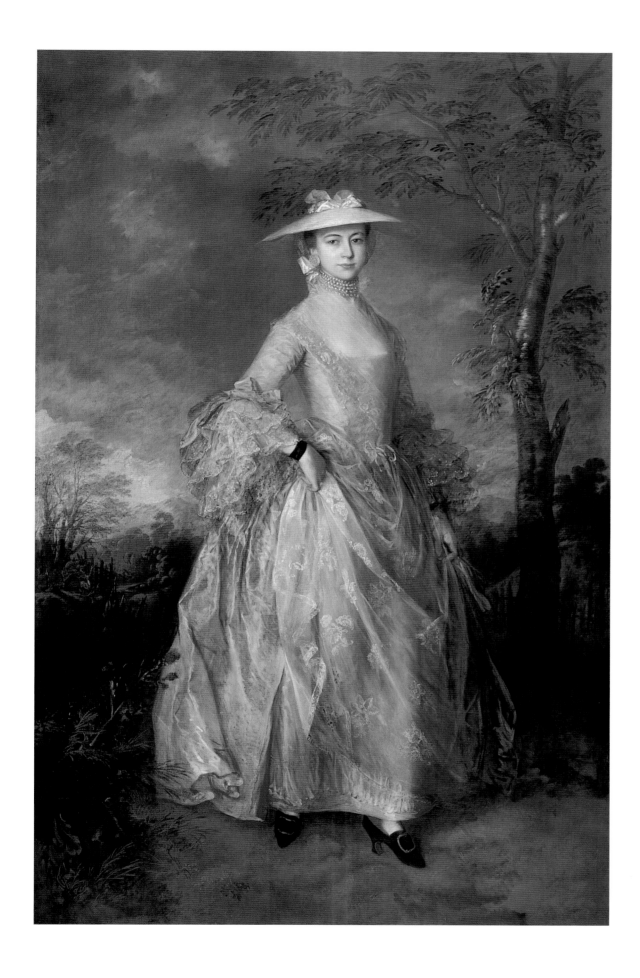

65

Mrs Henry William Berkeley Portman

*c.*1764–5

Oil on canvas, 213.7 × 152 (84⅛ × 59⅞)

By kind permission of the Trustees of the
Portman Settled Estates

Waterhouse, no.552

Gainsborough was a master of presenting his
sitters in the most dignified and flattering
light. He was particularly sensitive in the
depiction of older subjects, such as Sir
Edward Turner (cat.79), the Duke of
Northumberland (cat.168), or his own wife
(cat.172). Here, a more mature female sitter is
presented as the epitome of calm grace and
endowed with her own dignified beauty.
Known by tradition as 'The White Lady', the
picture shows Anne (1707–1781), the wife of
Henry William Berkeley Portman (*c.*1709–1761)
of Bryanston, Dorset, and Orchard Portman,
Somerset. He was heir to the extensive
Portman estates, and had been Tory Member
of Parliament for Taunton (1734–41) and then
Somerset (1741–7). He had died in January 1761,
so this is a depiction of the sitter as a mature
widow. Though presenting his sitter as calm
and serious, Gainsborough's portrait operates
to convey also a sense of persuasive feminine
charm. Mrs Portman's brilliantly conceived
and harmonised costume compares to the
dress worn by the contemporary doll, cat.76,
consisting of a sack dress and petticoat, and
stays, a chemise and stiffened hoops.
The flower held in her right hand was a stock
motif in female portraiture of this period.
Flowers appear as accessories throughout
Gainsborough's art, from the early depiction
of his wife in cat.17, through an anonymous
figure study (cat.69), and, rather more
suggestively positioned, in his portrait of
Lady Ligonier (cat.47). The Gainsborough-like
landscape painting on the wall is a device
from a number of his portraits, notably that
of Uvedale Tomkyns Price (cat.30), and serves
as a witty indication of good taste and culture.
These elements, in combination with her
averted gaze and her costume, contrive to
create an image of a woman of taste and
sober gentility. MM

Portraiture and Fashion

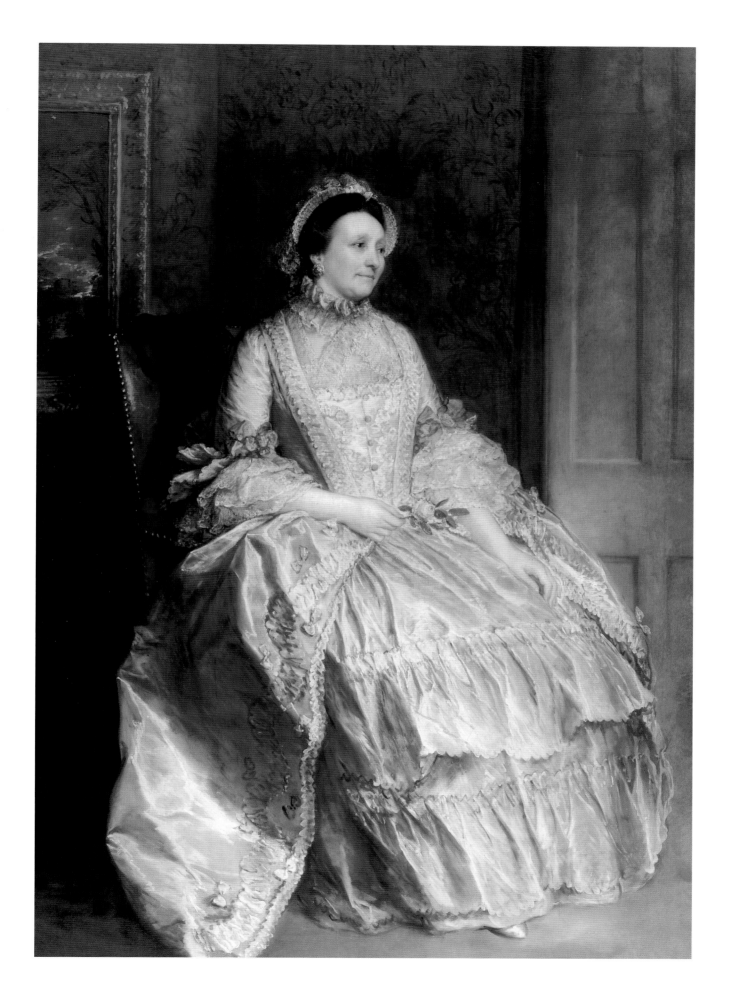

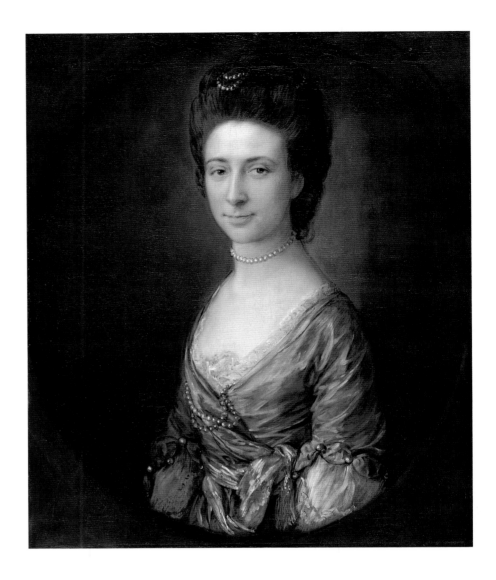

66

Mrs Elizabeth Tudway
1773
Oil on canvas, 76.5 × 63.8 (30⅛ × 25⅛)
Philadelphia Museum of Art: The George W.
Elkins Collection, 1924

Waterhouse, no.679

67

Miss Catherine Tatton
1786
Oil on canvas, 76 × 64 (29⅞ × 25¼)
National Gallery of Art, Washington, Andrew
W. Mellon Collection, 1937.1.99

Waterhouse, no.653

The sitter for cat.66 is Elizabeth Hill, the wife of Clement Tudway, Member of Parliament for Wells (only a few miles away from Bath). In the mid-1760s Gainsborough had painted his parents, Charles and Hannah, in full-length portraits (Baltimore Museum of Art and Courtauld Gallery, London). The present picture is the pendant to the artist's portrait of Clement Tudway (North Carolina Museum of Art, Raleigh) painted at the same time. They can be dated quite precisely, as the bill, dated 2 July 1773, exists for £70.16s for the two portraits together with frames.

The work typifies Gainsborough's elegant approach to female portraiture. The sitter was known for her modesty, and this is reflected in her portrait where her hair is shown as unpowdered. The modest format of the painting reinforces this impression. The picture thus neatly avoids the imputation of excess that was concurrently under so much satirical criticism in the 1760s and 1770s, as Britain seemed to be overrun with luxuries and fashion underwritten by the nation's imperial successes (see cat.75). We may,

though, note that her husband's status in society rested on his management of extensive slave plantations in Antigua. The veneer of fashionable elegance rested ultimately on the economic exploitation of men and women thousands of miles away.

Catherine Tatton (1768–1833) shown in cat.67 married James Drake-Brockman of Beechborough, Kent, in 1786. This portrait was paid for by her father, the Revd Dr Tatton, rector of Rotherfield, Sussex, in that year, and thus represents a commemoration of his daughter on the eve of her marriage. As the portrait passed into the hands of Catherine's son, the Revd William Drake-Brockman, it was presumably a gift to the newly weds. For his 30 guineas, the Revd Dr Tatton got a portrait showing Gainsborough at his most fluent, and his daughter at her most fashionable. Her stylish hat and free-flowing hair, whose bouncing curls recall Gainsborough's evocation of foliage, mark her out as a woman of sensibility, an effect explored by the artist on a much larger scale in *Mrs Sheridan* (cat.166). MM

Portraiture and Fashion

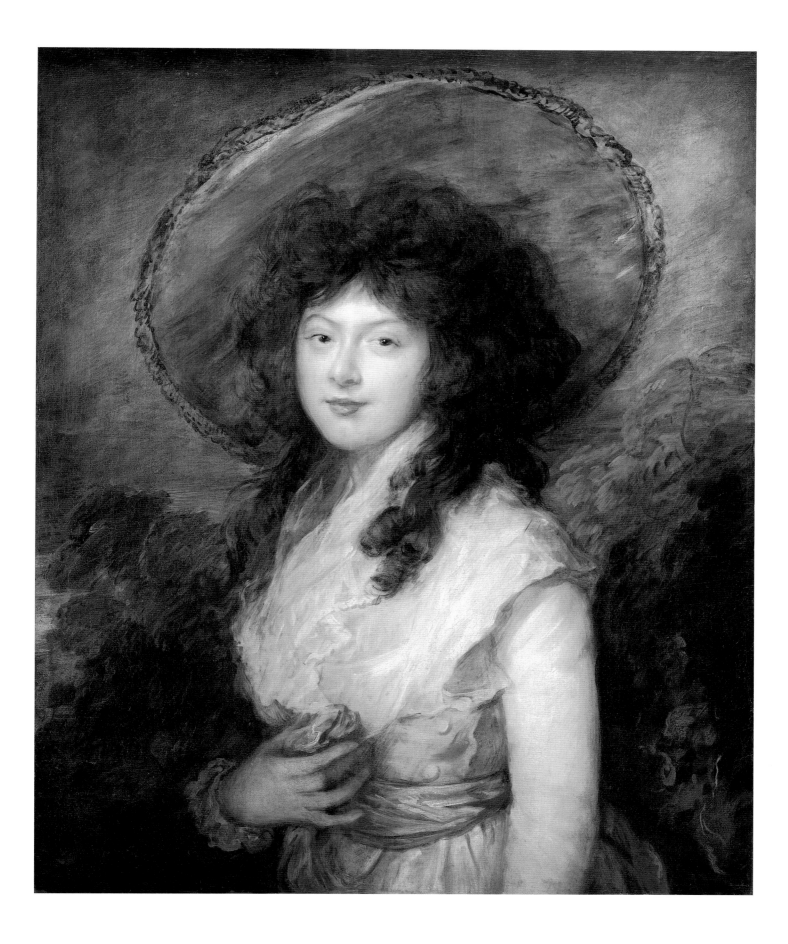

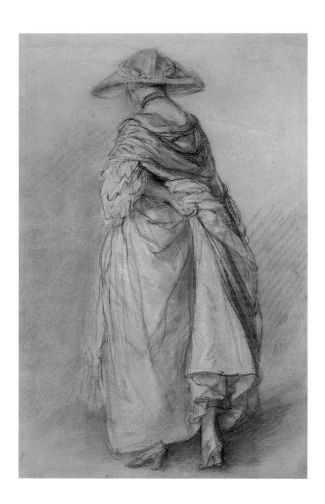

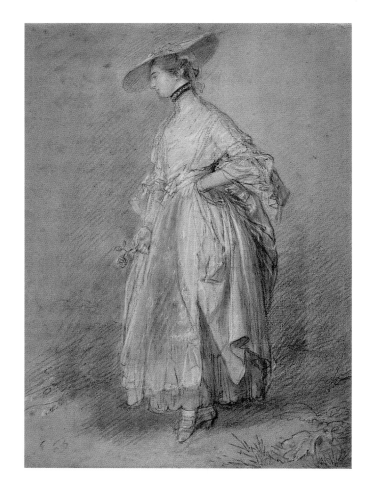

68

Study of a Woman Seen from Behind

*c.*1760–5

Black chalk and stump and white chalk,
24.9 × 19.4 (9¾ × 7⅝)

The Ashmolean Museum, Oxford. Presented
by Mrs Alice Jessie Mott, in memory of her
husband

Hayes 1970, no.30

69

A Woman with a Rose

*c.*1760–5

Black chalk and stump and white chalk,
46.4 × 33 (18¼ × 13)

The British Museum, London

Hayes 1970, no.29

70

Portrait of Mary Gainsborough

*c.*1765–70

Black chalk and stump and white chalk,
44.6 × 34.3 (17½ × 13½)

The British Museum, London

Hayes 1970, no.35

Gainsborough has drawn in cat.69 an
anonymous female in the same pose as
Countess Howe (cat.64), although holding a
rose, rather than a glove. Unlike in the
painting, he has not drawn in any background,
preferring to set off the figure with hatching,
and the general correspondence of the profile
with that of his daughter Margaret (see for
instance *The Artist's Daughter, Margaret* of
*c.*1772 at Tate) suggests that she might be the
subject. The calligraphy is characteristically
suggestive, with skeins of white chalk tellingly
communicating the appearance of her apron,
and indicating, with great economy of means,
both the weight and form of the body in
clothes which themselves would have had a
significant effect both on posture and motion.
Such drawings as these appear to exist in
parallel with comparable paintings, for
Gainsborough infrequently made preparatory
drawings for the latter, preferring instead,
as he had with *Countess Howe*, to work the
composition out directly on to canvas (see
above, p.35).

Gainsborough will have drawn his
daughters because they were easily available
as models: it is interesting in this instance that
both Mary's pose and the position of her
hands in cat.70 have a relationship with the
portrait of Lady Alston (*c.*1761–2; Louvre, Paris)

although the connection may merely extend
to this being a posture which at the period
was considered to be both proper and polite.
The artist has exploited his media to
maximum effect to suggest rather than detail
out the necklace, hair and bonnet, with the
white particularly enlivening his sitter's eyes.
This is another instance of Gainsborough
preferring to work from life, to repeat such
problems of portraiture as poses and
postures, much as he would reiterate the
themes of his painted landscapes in drawings
of various degrees of finish. MR

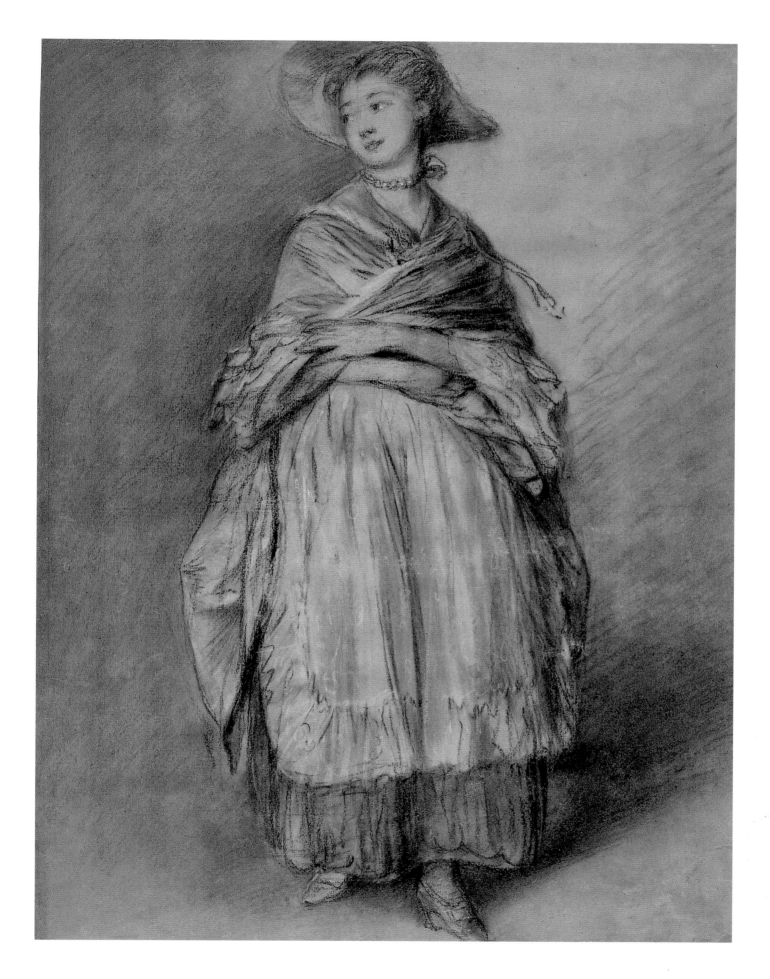

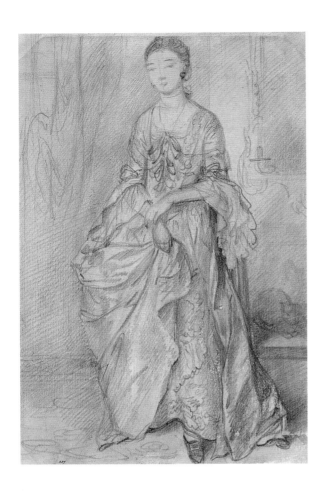

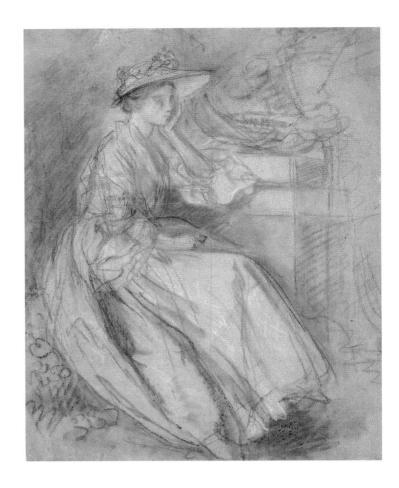

71

Study of a Woman

*c.*1760–5

Black chalk and white chalk and stump,
36.8 × 24.4 (14½ × 9⅝)
Victoria and Albert Museum

Hayes 1970, no.22

72

Woman Seated beside a Plinth

*c.*1765–70

Black and white chalk and stump, 44.8 × 35.6
(17⅝ × 14)
The Pierpont Morgan Library, New York

Hayes 1970, no.39

Cat.71 shows a more decorative style of dress of the early 1760s, cat.72 the casual style appropriate for outdoor settings. This was described in some detail by Pierre-Jean Grosley, who visited London in 1765. He made it clear that such informal costumes were meant to evoke the supposed innocence and purity of rural living – qualities that Gainsborough often explored in his idealised images of rustic lovers and milkmaids. Grosley saw these qualities, in combination with a certain ruddy good health, as typifying English women, as a contrast to the more cultivated, or even contrived, qualities of the French: 'The rustic life led by these ladies during great part of the year, and the freedom which accompanies that way of life' endowed them with an 'agreeable negligence in dress, which never gives disgust.' Grosley says that the flat hats, associated with the headwear of milkmaids, 'affords the ladies who wear it that arch and roguish air' bringing into play a sense of sexual teasing to go alongside the profession of rustic innocence. Instead of 'armour of whalebone' favoured by French women, English wear only 'a sort of whalebone waistcoat, which just reaches to the breast, and has no other effect but that of keeping the body in a slight compression'. In cat.72 that negligence helps underpin an image of sensibility; the woman is shown as in contemplation, leaning on a plinth, a pose the artist used later in his portrait of Lady Chesterfield (1778; Getty Museum, Los Angeles). MM

Portraiture and Fashion

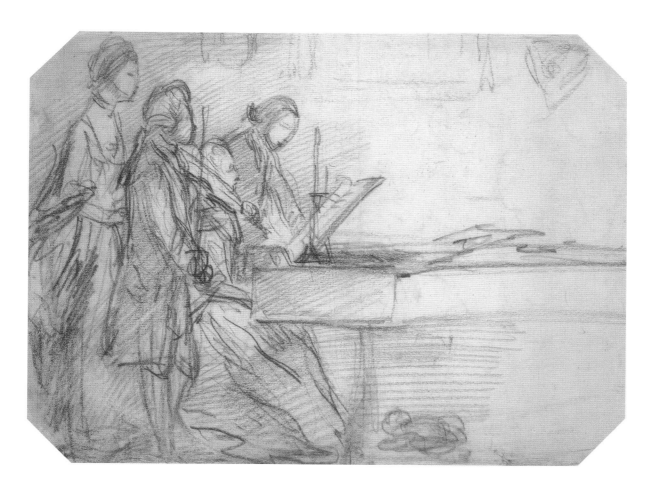

73
Study for a Music Party
*c.*1765–70
Red chalk and stump, 24.1 × 32.4 (9½ × 12¾)
The British Museum, London

Hayes 1970, no.47

This drawing is inscribed on the back: 'Portraits (of Himself, his two Daughters, and Abel) by Gainsborough' and 'To W. Mulready Esq. RA from his obliged servant Richd. Lane Provenance'. The 'Abel' would be the musician Carl Friedrich Abel, whose magnificent portrait Gainsborough exhibited at the Academy in 1777 (cat.50). However, Abel played the viola da gamba and one does not appear in this sketch, making this identification less likely. It has also been suggested that the scene shows Mrs Linley playing the piano with her children, Elizabeth Linley (later Elizabeth Sheridan) and Thomas Linley. Although Gainsborough certainly associated with the talented Linley family in Bath, this identification was based on a misreading of the inscription as referring to 'Linley' rather than Lane. Richard Lane was the artist's great nephew, to whom the drawing must have descended, before being passed on as a gift to the artist William Mulready. This may help confirm the autobiographical implications of the old inscription, though the precise identification of figures remains unresolved. On stylistic grounds the drawing is dated to the mid- or late 1760s, hence while Gainsborough was in Bath, and in its remarkably spontaneous style it conjures a vision of a genteel and fashionable domestic lifestyle.

Private music-making was an enormously popular activity among the 'polite classes' of the time. It was one of the primary ways in which the qualities of politeness were demonstrated, not least because such leisure activities could be expensive. The pianoforte depicted here would be a pricey instrument; ensuring that its possession alone would be a demonstration of social status. Although generally a private activity, amateur music-making was guided by quite a strict sense of decorum. The figure playing the piano is a woman. Pianos were seen as eminently suitable to be played by that sex, helping to confirm their domestic confinement. Richard Leppert notes that, by contrast, images of men playing keyboard instruments in the eighteenth century are rare. The violin, however, played by the foremost figure, was seen as among the most appropriate instruments for men in the same period. When in his portrait of Ann Ford Gainsborough came to depict a woman who specialised in public performance using one of these bowed 'male' instruments, the results were, in contrast to the sheer directness of this drawing, complex (see cat.35). MM

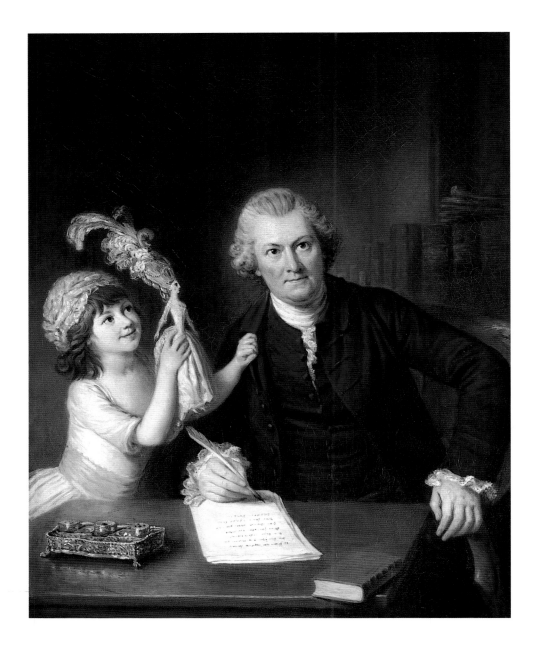

74
William Hoare (c.1707–1792)
Christopher Anstey with his Daughter
*c.*1776–8
Oil on canvas, 126 × 99.7 (49⅝ × 39¼)
National Portrait Gallery, London

The poet Christopher Anstey (1724–1805) scored his greatest popular success with *The New Guide to Bath* (first published in 1766), a collection of satirical poems about fashionable life in that city. Anstey spent time there in the 1760s for health reasons, and settled there permanently in 1770, hoping to ensure a superior education for his children. He was one of the first residents of the Crescent. His experience of Bath was therefore in many respects typical, combining his desire for a healthier lifestyle afforded by the famous spa and the rural setting, and the capacity of the city to provide a modern and gracious society. He was therefore well placed to turn a satirical eye towards Bath's inhabitants and visitors. Here he is shown with one of his four daughters, who teases him with an elaborately coiffured doll. The

sense of intimacy and playfulness expressed in their relationship is in tune with the ideals of sensibility, which encouraged a new emotional openness towards children.

The painter of this portrait, William Hoare, was based in Bath and appears to have enjoyed a cordial relationship with Gainsborough. Hoare specialised in pastel portraiture; the softness and grace of the medium enjoyed some vogue, and its qualities were transferred into oil paint with particular effect by Allan Ramsay and, after his example, Gainsborough himself. As an oil painter, Hoare could hardly rival the sheer technical fluency and glamour of Gainsborough, but none the less strove for a degree of informality suited to his patrons' needs. MM

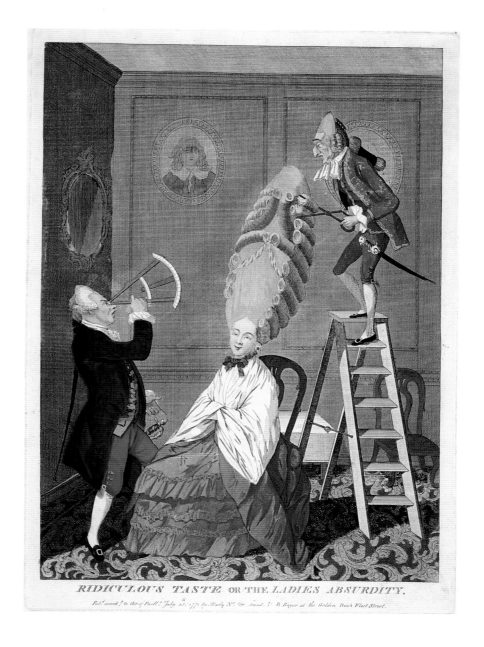

RIDICULOUS TASTE OR THE LADIES ABSURDITY.

Pub.d acord.g to Act of Parl.t July 15.th 1771 to Lady N.o 600 Strand & R Sayer at the Golden Buck Fleet Street.

75
British School
Ridiculous Taste, or the Ladies Absurdity
published 15 July 1771 by Matthew Darly and
Robert Sayer
Hand coloured engraving, 20.6 × 32.4
(8⅛ × 12¾)
The British Museum, London

This satire on female vanity depicts a woman with enormous hair being preened by a French, or at least Frenchified, hairdresser while an amazed male spectator looks on, a theme that recurs in a number of caricatures from the 1770s. This was when anxieties about contemporary fashion reached fever pitch, prompted by the expansion of public entertainments, the vogue for more elaborate costumes and hair-dos, and, more obliquely, the revelation of appalling levels of corruption among Britain's colonial bodies, whose activities underpinned the new wealth of the nation.

Although comic in intent, these commentaries on contemporary fashion reveal more serious worries: that modern dress could disrupt the 'natural' hierarchies of identity. The woman with an enormous headdress is both absurd, and faintly

threatening. The figure to the left, which must be the husband, can only look in amazement at the enormity of his wife's hair; he is an impotent bystander rather than an assertive head of the household. In these satires women, generally identified as the prime symbol of 'nature', are transformed by fashionable accessories into un-natural things. They are less like people, than dolls. Yet the satirical figure of the woman with enormous hair was itself supposedly brought to life at least once. Diana Donald has noted an article in the *Lady's Magazine* in 1773 which reported seeing a woman at a masquerade 'with an *enormous* head, and a ladder suspended from it'. MM

76 *right*
British, 18th century
Doll known as 'The Queen of Denmark'
*c.*1755–60
Painted wood, glass, hair, linen and silk,
55 (21⅝) high
Lent by the Museum of London

77 *far right*
British, 18th century
Large wooden doll
*c.*1765–70
Painted wood, glass, linen and silk,
52 (20½) high
Lent by the Museum of London

78 *below*
French, 18th century
Fashion doll
c. 1755–65
Wax, glass, linen and silk, 20 (7⅞) high
Lent by the Museum of London

These three dolls date from the 1750s and 1760s. Cat.78 is an example of a 'fashion doll', the figurines that would be distributed by dressmakers and designers to disseminate the latest fashions. She is dressed in a formal court costume of striped and brocaded silk. Cats.76 and 77 are children's dolls, although they are unusually elaborate and large. The former had a distinguished provenance, being created for one of the royal princesses, who gave it to Elizabeth Sampson, daughter of the chaplain of the Royal Hospital at Chelsea. Her jointed arms are an unusual feature in a doll of this period, and the level of detail bestowed on her costume is especially apparent in the multiple layers of her undergarments. More commonly, they would be on the scale of that which appears in Hoare's portrait, *Christopher Anstey with his Daughter* (cat.74). The enormous hair-do of the figurine there further demonstrates how children's dolls were finely attuned to contemporary taste. Here, cat.77 is dressed in a blue and white silk dress with a linen underskirt; cat.76 is wearing a sack dress with a matching petticoat of pink and yellow figured Spitalfield silk and pink stays, a linen chemise, three linen petticoats and a stiffened hoop.

Gainsborough, whose family worked in the textile trade, and whose neighbour in London from 1774 was a milliner, was well aware of fashionable costume and the use of dolls to exemplify, distribute and test out the latest fashion ideas. As well as the practical dolls such as cat.78, which served only as a template for the creation of actual costumes, milliners would advertise their trade by showing more elaborately dressed and finished dolls in their windows. Moreover, the use of dolls as models for painters was well established. A number of the artists associated with St Martin's Lane, including Gravelot and Hayman, are known to have painted from poseable dolls. Gainsborough, in turn, took up the practice, perhaps using dolls for his costume studies of the 1760s and quite definitely using figurines as models for *The Mall* and the 'Richmond Water-walk' (cats.68–72; fig.14; cats.91–2 and 94).

Dolls played a significant role in defining feminine identities in the eighteenth century. In his book, *Emile* (1762), the Swiss philosophical writer Jean-Jacques Rousseau recommended that girls play with dolls as they would, in turn, become like dolls themselves. Rousseau was widely read and appreciated in Britain, and his ideas helped shape the ideals of 'sensibility' that transformed attitudes towards children. In the later eighteenth century, as Hoare's portrait of Christopher Anstey (cat.74) alone indicates, the importance of play and laughter in a child's upbringing was emphasised. Dolls certainly had a role to play here, although as

the educationalists Maria and Richard Lovell Edgeworth noted in their *Practical Education* (1798), there were dangers too:

> *Dolls, beside the prescriptive right of ancient usage, can boast of such an able champion in Rousseau, that it requires no common share of temerity to attack them. As far as they are the means of inspiring girls with a taste for neatness in dress, and with a desire to make those things for themselves, for which women are usually dependent upon milliners, we must acknowledge their utility; but a watchful eye should be kept upon the child to mark the first symptoms of a love of finery and fashion.*

Conversely, women too concerned with fashion could be criticised as doll-like. Among the poems in Christopher Anstey's *New Guide to Bath* (1766) is one satirising contemporary female coiffure:

> *O cease, ye fair Virgins, such Pains to employ,*
> *The Beauties of Nature with Paint to destroy;*
> *See Venus lament, see the Loves and the Graces,*
> *How they pine at the Injury done your Faces!*
> *Ye have Eyes, Lips, and Nose, but your Heads are no more*
> *Than a Doll's that is plac'd at a Milliner's Door!* MM

Portraiture and Fashion

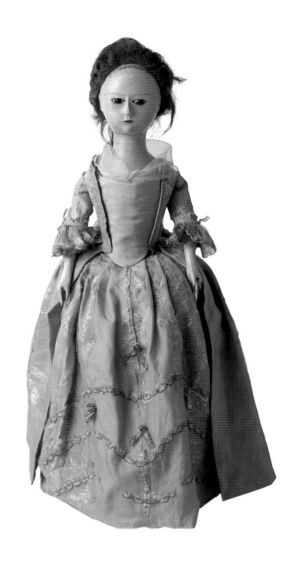

79

Sir Edward Turner, Bart
1762
Oil on canvas, 228.6 × 152.4 (90 × 60)
Wolverhampton Art Gallery

Waterhouse, no.684

Susan Sloman has demonstrated how a significant number of portraits from 1760 onwards were done in Gainsborough's painting room in his house in the Abbey Churchyard at Bath. We would recognise the window and the chair in the portrait of Matthew Hale (Birmingham City Art Gallery), while the wallpaper, which is missing here, appears both in that portrait and Gainsborough's *Robert Craggs* (cat.36). In all three we prospect a view into landscape rather than the city of Bath, which would in fact have been visible, not least to remind us that Gainsborough liked to associate his sitters with the natural world in various ways. In many respects *Sir Edward Turner* is an unexceptional portrait. The sitter stands in a pose of easy comportment, with his legs crossed as they are in so many contemporary pictures, to suggest through his posture that he is a gentleman of refinement. The face, upon which the artist appears to have taken some trouble, is also one that one can imagine as a good likeness of a middle-aged man of some prosperity. What is extraordinary is the suit. The historian of dress, Aileen Ribeiro, describes it as being made of grey French silk embellished with white, black and gold brocading, and points out how very unusual it is for such attire to feature in portraits. Gainsborough, who certainly had a sharp eye for fashion, clearly painted it with great care. However, in its extravagance it contrasts with the sobriety of costume one would expect in portraits of respectable gentlemen, and in this might hint at the kind of extravagances that were frequently noticed in the behaviour of visitors to the town. It also suggests that Gainsborough, though becoming established, could not afford to alienate patrons for full-length portraits, for Turner had recently come into a fortune, and both the painting and the mezzotint that McArdell scraped after it (cat.82) suggest that he wished to be commemorated in all his splendour. MR

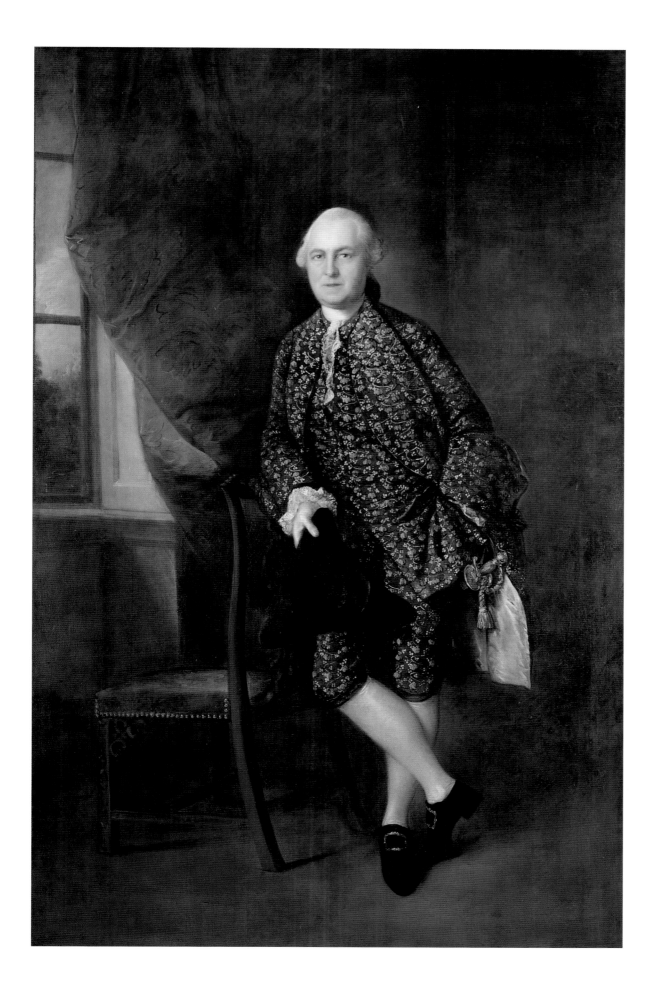

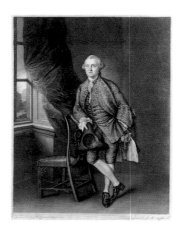

80

Valentine Green (1739–1813) after Gainsborough

David Garrick

published 2 April 1769 by J. Boydell
Mezzotint, 61 × 39.1 (24 × 15⅜)
Lent by the Trustees of Gainsborough's
House, Sudbury (purchased with
contributions from the MGC/V&A Purchase
Grant Fund, the Museums Association
[Beecroft Bequest] and the Scarfe Charitable
Trust, September 1987)

81

*Edward Fisher (1730–c.1785) after Joshua
Reynolds (1727–1792)*

Laurence Sterne

published 1761
Mezzotint, 34 × 27.9 (13⅜ × 11)
The British Museum, London

82

James McArdell (1729–1765) after Gainsborough

Sir Edward Turner, Bart

1762
Mezzotint, 49.2 × 37.4 (19⅜ × 14¾)
Lent by the Trustees of Gainsborough's
House, Sudbury

Reynolds was famously systematic in having
his portraits reproduced as prints. His portrait
of Laurence Sterne (1713–1768), painted
speculatively in 1760, was mezzotinted by
Edward Fisher, and the resulting print was
exhibited at the Society of Artists in 1761
(cat.81). Reynolds was capitalising on the
great popularity of the sitter – he and Fisher
producing the print to the mutual advantage
of each and, for that matter, Sterne, who thus
became even more prominent in the public
eye. Gainsborough, despite being an astute
businessman, appears to have been far less
organised in getting prints after his works
published – this fine mezzotint of David
Garrick, done by Valentine Green, one of the
top printmakers of the day, appears never to
have made it to the print shops (cat.80).
This apparent lack of interest in the
commercial advantages of publishing
his work suggests that the sitter instigated
the printing of his portrait.

David Garrick (1717–1779), the most famous
actor of the day, exploited the publicity he
could get from portraits of himself vigorously.
Gainsborough exhibited a portrait, now
destroyed, at the Society of Artists in 1766,
leading the *Public Advertiser* to observe:

*This Gentleman it seems is done for Mr.
Garrick, as he has his Arm about a Stone*

*Bust of Shakespear; and indeed he seems
as fond of it as if some benevolent God
had metamorphosed him into the same
substance. Mr. Gainsborough should have
been particularly careful how he had
drawn from an Original which a Reynolds
and a Zoffani hath so admirably pourtrayed.*

Garrick's wife, however, thought it one of the
best likenesses of her husband. In 1769
Garrick organised the Shakespeare Jubilee at
Stratford-on-Avon. A portrait of himself was
requested, and Gainsborough remodelled the
original full length, receiving 60 guineas. This
mezzotint – probably the result of both sitter
and publisher, the astute John Boydell
(1719–1804), wishing to capitalise on the
image's market potential – serves as an
invaluable record.

The print of Edward Turner (cat.82) was,
by contrast, a 'private plate', created at the
behest of the sitter. McArdell was the
leading mezzotint artist of the day. The
velvety tones of mezzotints, created by
covering the copperplate with tiny marks
using a 'rocker' and rubbing those marks flat
to create areas that would not pick up ink,
were singularly appropriate to the creation
of portrait images. MR

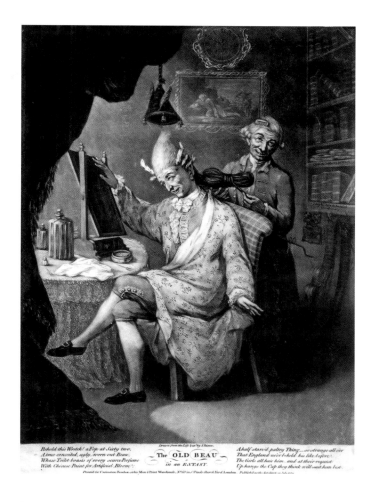

Behold this Wretch! a Fop at Sixty two.
A true conceited, ugly, worn out Beau,
Whose Toilet boasts of every scarce Perfume
With Chinese Paint for Artificial Bloom.

Drawn from the Life Yar by J Dixon

─ The OLD BEAU ─
in an EXTASY.

A half starv'd paltry Thing....so strange all over
That England ne'er behold has like before.
The Girls all have him, and at their request
Up hangs the Cap they think will suit him best.

Printed for Carrington Bowles at the Map & Print Warehouse, N.º 69 in S.t Paul's Church Yard London. Published as the Act directs 12 July 1773.

83
John Dixon (c.1720–1804)
The Old Beau in Extasy
published 13 July 1773 for Carrington Bowles
Mezzotint, 25.4 × 32.7 (10 × 12⅞)
The British Museum, London

In the late 1760s, and especially in the early 1770s, anxieties about male vanity and modern effeminacy reached hysterical levels, focusing on the figure of the Macaroni, the overdressed and effete man-about-town. The eighteenth century had seen a succession of new fashions in male couture and manners, but the Macaroni seemed to be of a new kind: 'It is the reverse of the *Mohawks* of the last age, and the *Bucks* and *Blonds* of this. *They* were rough and terrible. *It* is delicate and contemptible' (*London Magazine*, 1772). The effeminacy and self-absorption of the Macaronis appeared to many commentators to be a sign of the deep corruption and luxuriousness of a modern society fuelled by new wealth.

Here, an aged Macaroni is stationed at his toilette. Above his head is a fool's cap, as the poetic inscription explains, the form of headwear that the women who see him think most appropriate. The shelves are lined with books, but these are merely wooden fakes–a sham display of learning. His fashionable appearance is evidently entirely counterfeit– the product of make-up and costume rather than any truly genteel qualities.

In his flattering depictions of his sitters, his attention to current trends in dress and his playful approach to nature and artifice

Gainsborough was potentially subject to the same criticisms regarding the superficiality and transience of fashion. Such were the complaints about his execution and colouring that sometimes appeared in the press (see cats.53–4 and 57), though his greatest achievement as an artist was to create images that conformed to the desire of his sitters to appear absolutely modish, while also striving to transcend their historical circumstances, whether by force of likeness, the evocation of historical models (notably Van Dyck) or by sheer virtuosity of execution. MM

84
*Gainsborough after Anthony Van Dyck
(1599–1641)*
The Pembroke Family
*c.*1760–70
Oil on canvas, 95.3 × 125.7 (37½ × 49½)
The Marquess of Northampton

Waterhouse, no.1015

85
*Gainsborough after Anthony Van Dyck
(1599–1641)*
Lords John and Bernard Stuart
*c.*1760–70
Oil on canvas, 235 × 146.1 (92½ × 57½)
The Saint Louis Art Museum, Gift of Mrs.
Jackson Johnson in memory of Mr. Jackson
Johnson

Waterhouse, no.1017

In his fourteenth *Discourse* Reynolds recalled
of Gainsborough that:

*To satisfy himself as well as others, how well he
knew the mechanism and artifice which they
[the masters] employed to bring out that tone of
colour which we so much admire in their
works, he occasionally made copies from
Rubens, Teniers, and Vandyck, which it would
be no disgrace to the most accurate
connoisseur to mistake, at the first sight, for the
works of these masters. What he thus learned,
he applied to the originals of nature, which he
saw with his own eyes; and imitated, not in the
manner of those masters, but in his own.*
(Wark, p.253)

Copying the Old Masters was a cornerstone of
academic art training, yet Gainsborough,
whose artistic outlook clashed with that of the
Academy, certainly undertook numerous copies
as Reynolds indicates. We know of painted
reproductions after Rubens, Bartolomé Murillo
(1617/18–1682), Diego Velázquez (1599–1660),
David Teniers (1610–1690), and Titian (see
cat.170) but it was Van Dyck whom he copied
most frequently. Van Dyck was the key role
model for Gainsborough, both in his virtuoso
technique and in his successful management
of a role as an artist-courtier. His copying of the
seventeenth-century painter's work might
suggest that he was no less attentive to the
examples of the Old Masters than Reynolds,
though as the President suggests his
relationship with art history was practical,
rather than distanced and intellectual.

The copy of *The Pembroke Family* was,
tellingly, on display in Gainsborough's studio by
1770. It was priced at 150 guineas in the 1789

sale of Gainsborough's works, where it was
said to be 'Painted by Memory, after having
seen the original at Wilton'. Of the three
pictures believed to be original Van Dycks
owned by Gainsborough, the highest priced
was still only 80 guineas. The original painting,
still at Wilton House, is the largest Van Dyck
portrait in Britain, and shows the gathered
family members of Philip Herbert, 4th Earl of
Pembroke, disposed in the full range of elegant
postures characteristic of the artist. The copy
of the Stuart brothers was priced at 100
guineas in Gainsborough's sale. The original
painting by Van Dyck is now in the National
Gallery, London. Gainsborough's is an unusually
close copy of the original, suggesting it must
be based on direct study of the painting, rather
than a print or other reproduction. In that
respect, it may be significant that
Gainsborough painted a portrait of the owner,
the Earl of Darnley, in 1785 (National Gallery of
Art, Washington; Waterhouse, no.184). The
manner of this painting is so different from his
other works from this period that this late date
seems unlikely, but can certainly not be ruled
out entirely. We know that he undertook a copy
after Velázquez around the same date, and it
was Darnley who purchased the Van Dyck copy
from Gainsborough's sale. However, it is usually
considered that Gainsborough must have made
this painting in the 1760s. MM

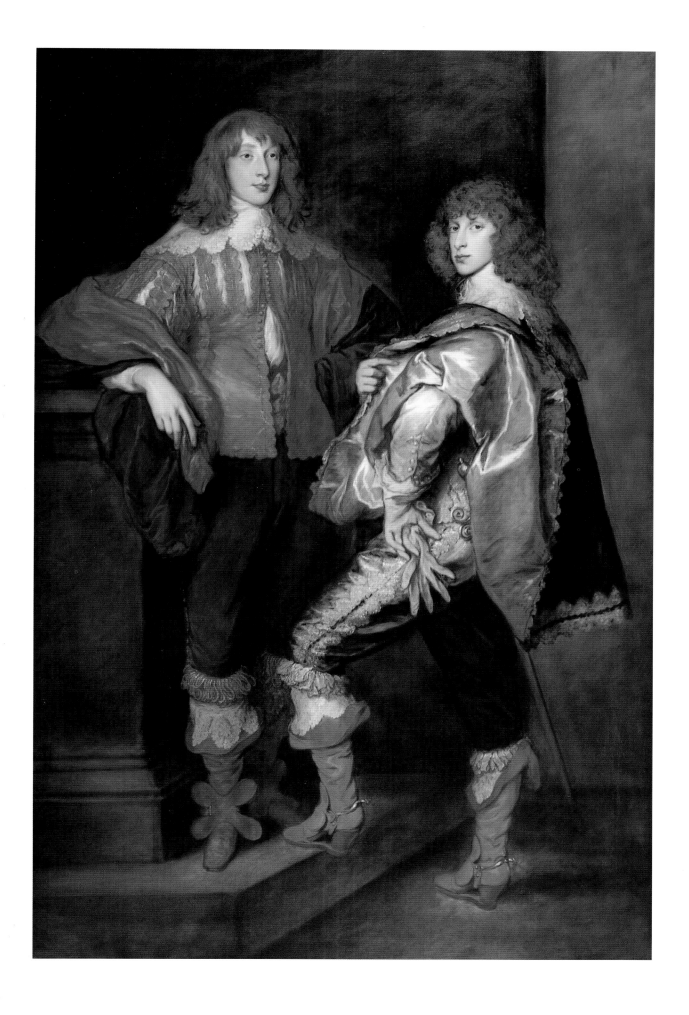

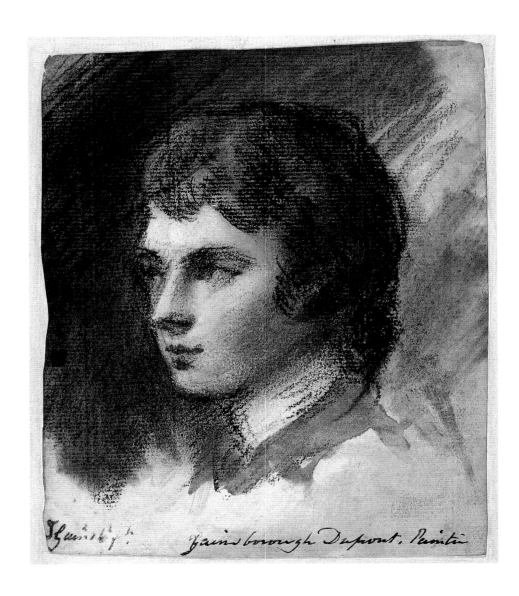

86
Gainsborough Dupont
c.1770
Black chalk and stump, coloured chalks and
watercolour, varnished, 16.5 × 14.1 (6½ × 5⁹⁄₁₆)
Victoria and Albert Museum

Hayes 1970, no.49

87
Gainsborough Dupont
c.1772
Oil on canvas, 44.5 × 36.2 (17½ × 14¼)
Tate; bequeathed by Lady d'Abernon 1954

Waterhouse, no.221

Gainsborough's nephew, Gainsborough
Dupont (1754–1797) joined him as his assistant
in 1772. He was the only assistant
Gainsborough appears to have employed;
unlike most of his contemporaries, his
paintings were not the products of studios
involving a team of specialists and assistants
contributing to the various aspects of the work
(most notably, draperies). Dupont helped the
artist in painting draperies, and after
Gainsborough's death he continued creating
pastiches of his uncle's work, although he
rarely displayed much of the technical aplomb
of his uncle. The senior artist appears to have
had his doubts about his protégé, referring to
him in one letter as a 'blockhead' who was
'too proud to carry a bundle under his arm'
(*Letters*, p.133).

An inscription in Dupont's hand on the
back of cat.86 states that it was executed
at Bath 'about the Year 1775'. From the
appearance of the sitter it is likely to date from
some years earlier. There are only a handful of
coloured portrait drawings of this kind by

Gainsborough, although pastel portraits were
an important and popular medium. Here, a
virtuoso splash of red wash suggests the
sitter's coat. Gainsborough was conscious of
the fragility of the medium, writing to the Hon.
Edward Stratford in March 1771: 'I'm sorry your
Chalk Drawings got Rubbed as they were
muzzy enough at first, as indeed all Chalk
Drawings of Portraits must be so Small and
the Chalk so soft—I shall very willingly retouch
them' (*Letters*, p.83). Cat.87, thought to be
produced a couple of years later in the more
conventional medium of oil paint, appears
hardly less spontaneous. The work is evidently
unfinished; Gainsborough very rarely
produced drawings in preparation of a portrait,
and these tended only to be compositional
sketches. The artist is here referencing Van
Dyck, both in the flowing hair and costume of
his nephew, and in the fluent virtuosity he
displays in his handling of paint. MM

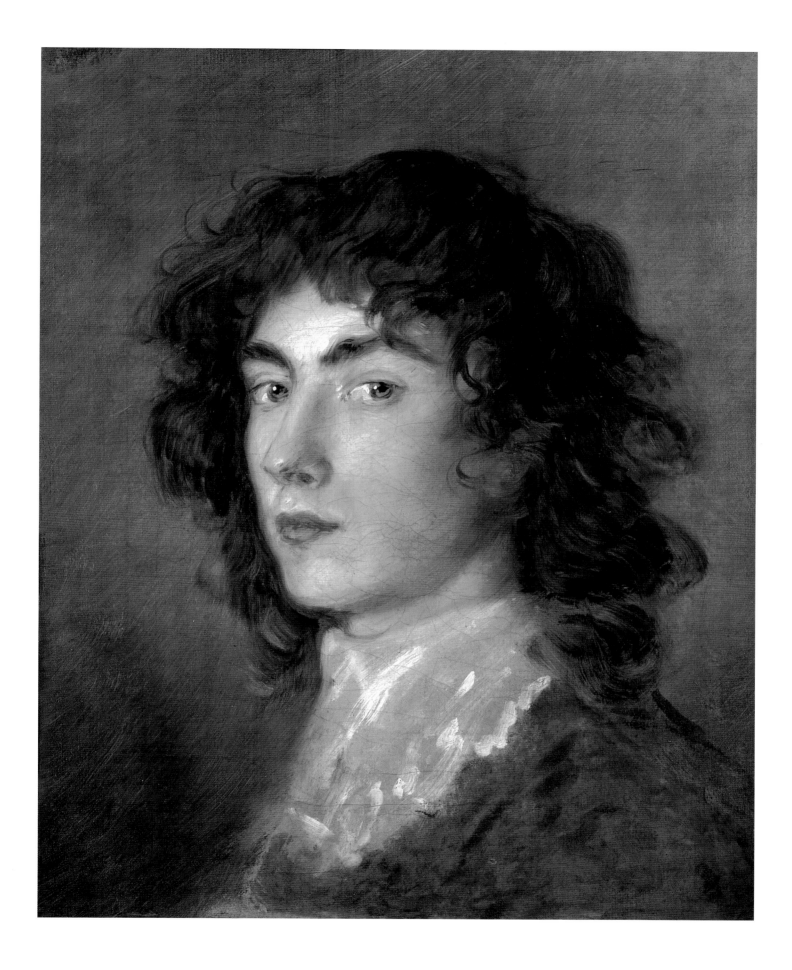

88

**Mr and Mrs William Hallet
('The Morning Walk')**

1785

Oil on canvas, 236.2 × 179.1 (93 × 70½)

National Gallery, London

Waterhouse, no.335

William Hallett married Elizabeth Stephen in July 1785; each had been born in 1764. Gainsborough's painting, for which he was paid 120 guineas, was delivered in March 1786. They form a highly fashionable pair, for each was dressed to impress, while taking a companionable walk in the country. Gainsborough has taken pains to incorporate them into their surroundings, for the modish black of William Hallett's suit merges into the shade to the right, while Elizabeth's frock picks up the blazing light in the background, and the Pomeranian that trots along beside them looks up to attract an attention it is, for the moment, denied, so lost in thought they appear to be. Their fitting so naturally into the landscape as well as the relationship with the hound signifies that this is a pair of high moral sensibility. When Joseph Wright painted Thomas and Mary Gisborne in 1786 (Paul Mellon Collection, Yale Center for British Art, New Haven) theirs was a comparable relationship: he sits with a portfolio of drawings, she leans on his shoulder and supports the parasol that shades both of them, and their greyhound rests its chin on his left hand. The idea communicated is that husband and wife are bound in a mutually supporting and supportive relationship (rather than she being inferior to him), where the domestic is as important to the husband as the public realm, which concept would have been extremely familiar to any reader of contemporary sentimental fiction or, indeed, connoisseur of portraits. In 1762–6 Thomas Gainsborough had shown George Byam, his wife Louisa and their daughter Selina enjoying such a promenade (fig.26), and Hugh Belsey has demonstrated how the artist was working within a well-established sub-genre of portraiture. Going for a walk was hardly an unselfconscious affair. Promenades around landscape parks allowed scenes to be presented to the gaze in an orderly sequence, and in his phenomenally popular poem, *The Seasons* (1726–30), James Thomson (1700–1748) wrote how, on such a walk

> nature all
> *Wears to the lover's eye a look of love;*
> *And all the tumult of a guilty world,*
> *Tost by ungenerous passions sinks away.*
> *The tender heart is animated peace;*
> *And, as it pours its copious treasures forth*
> *In varied converse, softening every theme,*
> *You, frequent pausing, turn, and from her*
> eyes,
> *Where meekened sense and amiable grace*
> *And lively sweetness dwell, enraptured drink*
> *That nameless spirit of ethereal joy,*
> *Inimitable hapiness!*

Desmond Shawe-Taylor linked these lines to Gainsborough's portraits to let us know that the moral virtue signified by the Halletts being at one with nature was also consequent upon a certain amount of role playing. MR

Portraiture and Fashion

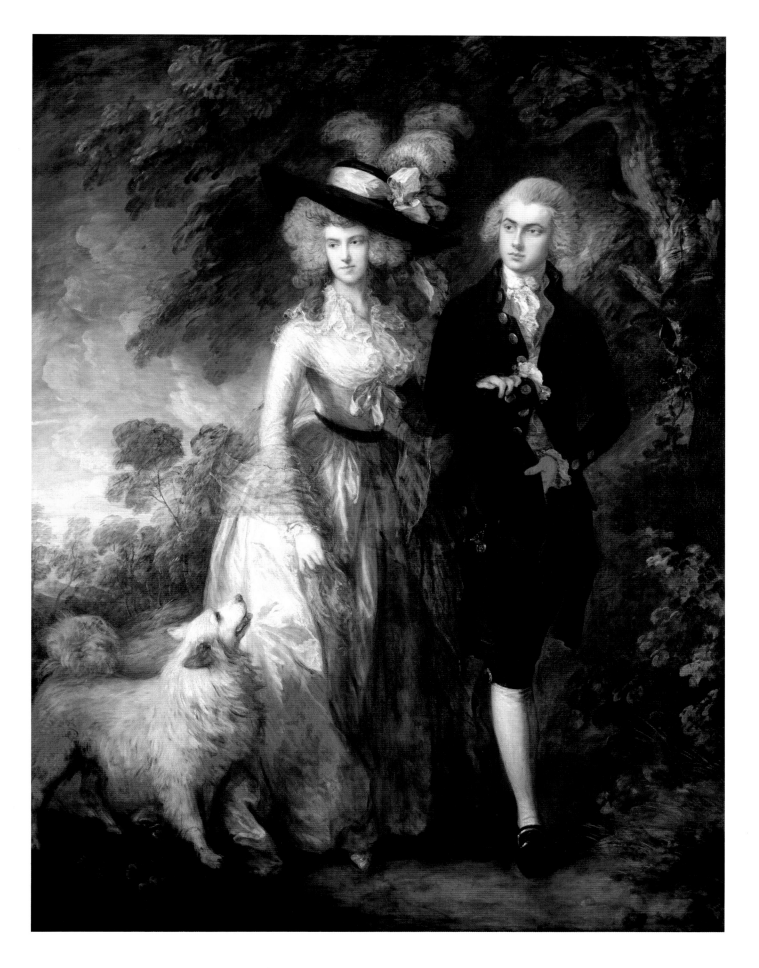

89

The Duke and Duchess of Cumberland, attended by Lady Elizabeth Luttrell

*c.*1783–5
Oil on canvas, 163.8 × 124.5 (64½ × 49)
Lent by Her Majesty Queen Elizabeth II

Waterhouse, no.178

This portrait was apparently painted 'at the Duke's insistence', and Gainsborough worked out the composition through two drawings (Royal Collection and British Museum) before painting it onto an oval canvas. His representation of a trio of fashionable personages and a lapdog enjoying the delights of Windsor Great Park connects in the size of figures and relationship with their environment to the near contemporary *The Mall* (fig.14). And, as that was initially said to be in the manner of Watteau (although Gainsborough later placed reports in the press to deny this) so too might we detect here the ultra-refined and elegant leisure that one would associate with a *fête galante*, in a setting suited to it, even down to the urn in the background. The Duchess's dress is painted with a finesse that seems to be mimicked in the elegant swathes of foliage that form its tonal complement, while behind them sits her sister, Elizabeth Luttrell, apparently herself making a drawing.

Apart from being an exquisite work of art, this portrait shows to what extent the fine arts might be involved in moulding a public reputation. Elizabeth Luttrell was famously immoral and an aficionado of gambling, while, back in 1770, the Duke of Cumberland (the king's brother) had starred in the public prints because of his affair with Lady Grosvenor. The press had revelled in his love letters, which revealed an unrivalled capacity to invent the spelling in which the most banal of sentiments were expressed. This was an affair that remained in the public mind, and the Cumberlands' public reputation hardly conformed to Gainsborough's painting them as exemplars of courtly virtue. MR

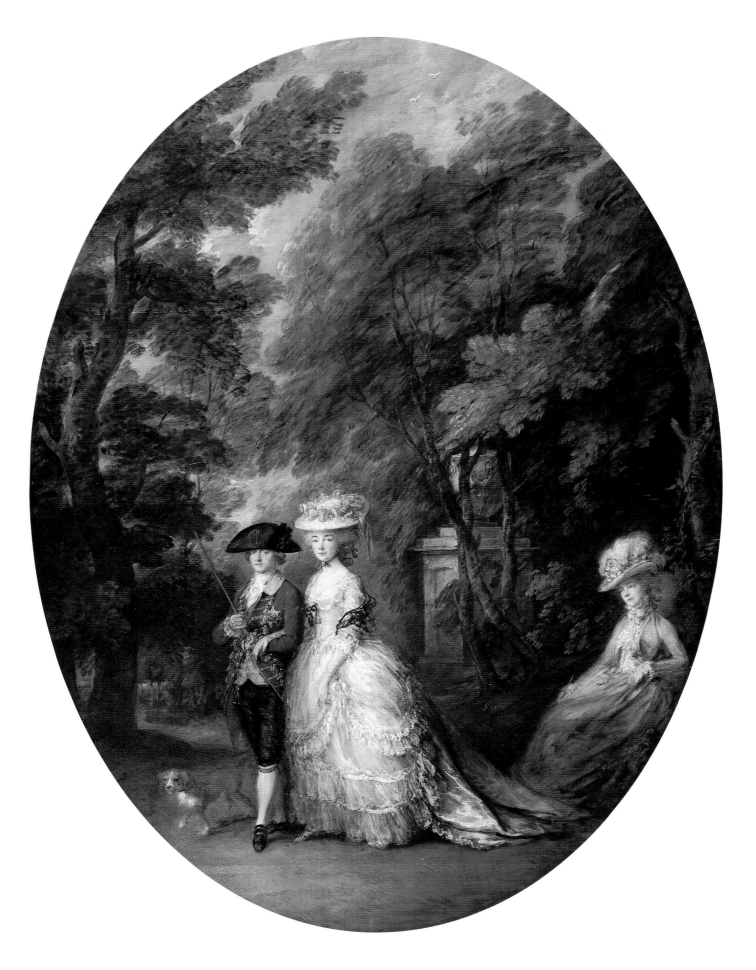

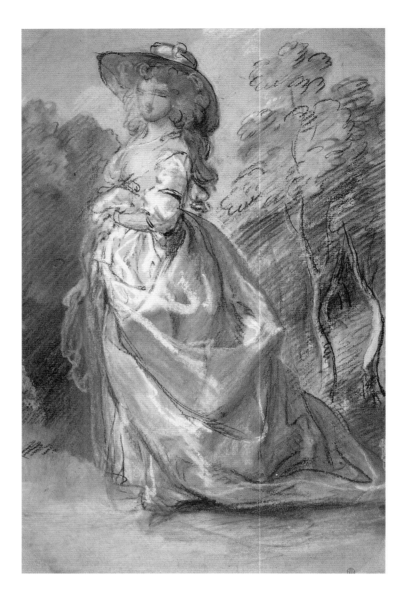

90
Study of a Lady
c.1783–5
Black chalk and stump and white chalk,
48.4 × 31.1 (19 × 12¼)
The British Museum, London

Hayes 1970, no.62

91
Study of a Lady
c.1783–5
Black chalk and stump and white chalk,
49.2 × 31.1 (19⅜ × 12¼)
The British Museum, London

Hayes 1970, no.59

In 1785 the *Morning Herald* reported that the artist 'is to be employed, as we hear, for Buckingham House on a companion to his beautiful Watteau-like picture of the Park-scene, the landscape, Richmond water-walk, or Windsor – the figures all portraits'. Like *The Mall* (the 'Park-scene' referred to here, see fig.14), the picture would have shown a multi-figure scene of contemporary fashionable life, with a range of figures parading themselves. John Hayes identified the present drawings as among the studies for this later picture, which has not survived or was never executed.

Cat.91 had an old label explaining that this drawing was given by the artist to Mr Pearce of the Admiralty, who supplied a written description to John Wilson Croker when he gave him the drawing in 1834, which explained that it was a study for a royal commission 'representing that part of St James's Park which is overlooked by the garden of the Palace', meaning *The Mall*. Although this is mistaken, the text provides a telling anecdote

regarding the appeal of such subject matter: 'While sketching one morning in the Park for this picture, he was much struck with what he called "the fascinating leer" of the Lady who is the subject of the drawing'. The fashionable women who frequented St James's and Richmond were certainly seen as predatory, and thus a challenge to more securely domesticated ideals of how modern women should behave. As the satirical *New London Spy* (1772) wrote of St James's Park: 'The brightest stars of the creation were moving here with such alluring mien and attracting grace, as could not but excite desire.' Gainsborough's extraordinary, even monumental, studies for the Richmond Water-walk provide a vision of contemporary femininity as alluring, and perhaps tinged with danger. As the *New London Spy* went on to explain, contemporary high-life was a world in which 'the order of things had been inverted, and the world turned topsy-turvy ... The ladies had the semblance of intrepid heroes ... while

Portraiture and Fashion

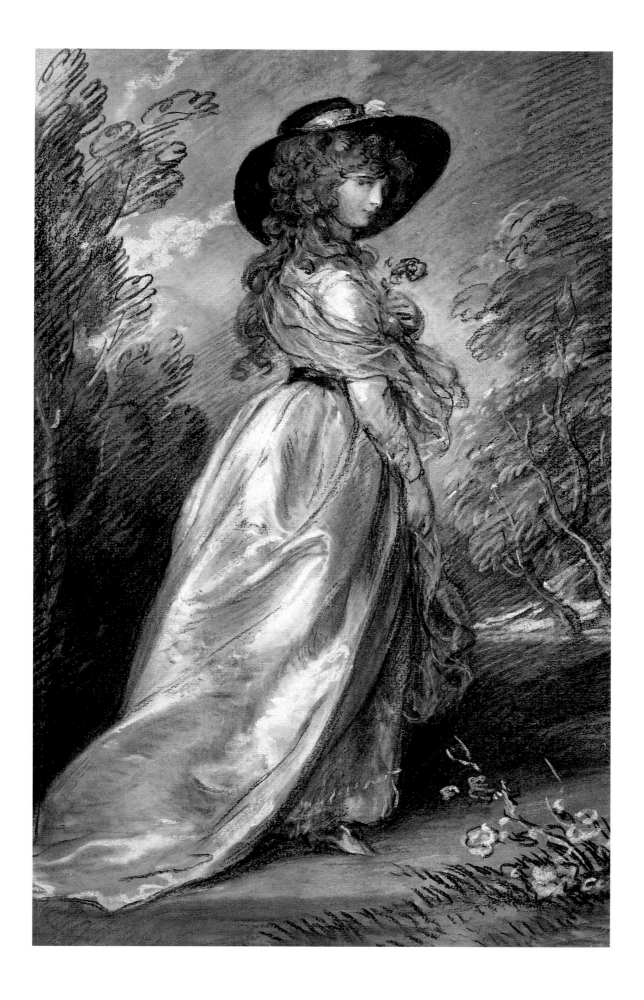

92
British School
Ladies in Fashionable Dresses
1788
Engraving, 11 x 7.7 (4⅜ x 3)
Lent by the Museum of London courtesy of
the Harry Matthews Collection

93
British School
The Dress of a Lady and Child of the Year 1785
1785
Engraving, 11 x 7.5 (4⅜ x 2⅞)
Lent by the Museum of London courtesy of
the Harry Matthews Collection

94
Lady Walking in a Garden with a Child
*c.*1783–5
Black and white chalk, 50.5 x 22.1 (19⅞ x 8⅝)
J. Paul Getty Museum, Los Angeles

Hayes 1970, no.63

Ladies in Fashionable Dresses.

The Dress of a Lady & Child of the Year 1785

our pallid, lank, and shallow apologies for virility, had all the appearance of mean, servile, pusillanimous, foppish coxcombs.'

Traditionally, various of these drawings have been identified as portraits of the Duchess of Devonshire (1757–1806), one of the most glamorous figures of the day and, with her support of Charles James Fox and his opposition Whig party, one of the most controversial. Gainsborough's portrait of the Duchess, which survives in cut-down form at Chatsworth House and is recorded in its full-length format in a nineteenth-century print, certainly shares these drawings' attention to contemporary costume, and something of its composition, as does his contemporary portrait of Lady Sheffield (Waddesdon Manor). But these drawings do not provide anything like conclusive likenesses, and the relationships between them indicate that they are more likely to be studies for a larger composition. In fact, there is evidence that the artist used dolls as models in creating these figures: William Jackson mentioned that this was the case in his memoir of the artist. Two such dolls were included in the artist's posthumous sale, and in the nineteenth century Wilkie Collins, the son of the painter William Collins, remembered his father owning one of them, dressed up by Gainsborough in contemporary costume.

Whether there was a commission from the court (as the *Herald* suggested) or not, the association of the picture with Richmond or Windsor would affirm Gainsborough's desire to be seen as something of a courtier. Windsor was, of course, home to the royal residence, Windsor Castle, while Richmond's courtly associations went back to the Middle Ages. The rural charms of the area provided inspiration for the poets Alexander Pope (1688–1744) and James Thomson, who helped consolidate its status in polite culture.

Long a centre for theatrical entertainment, the Theatre Royal, Richmond, opened in the 1760s, featuring regular performances from the best London actors, and the recently opened new bridge (1777) was reckoned an exemplary piece of modern architecture. By the time Gainsborough took a house in the area, in the early 1780s, it was reinvigorated as an elegant rural retreat. Richmond's associations with royalty and with refined retirement were especially pointed during the wars with America (1775–82), which resulted in the loss of the American colonies in 1783, an event particularly grievous to George III. Anne Bryton's *Richmond: A Pastoral* (1780) gave extended poetic tribute to the beauties of Richmond, the noble associations of the area and the power of the imagery of the Thames as a consoling symbol of Britain's maritime wealth. Gainsborough's near-visionary imagery of polite leisure might be interpreted in relation to such ideas.

If the basic motifs of women walking and turning in parks, sometimes accompanied by a child, were standard in contemporary fashion illustrations such as cats.92 and 93, it is with these drawings that Gainsborough's special achievement as a painter of fashionable life are brought to the fore. A Hogarthian aesthetic of serpentine beauty is still evident, in that the drawings do not simply document or describe fashionable ideals, but in the very gracefulness of their technique embody those ideals. The playfulness and visual confusion of these drawings may have been a challenge to academic ideals of drawings that emphasised firm, clear outlines as expressive of intellectual clarity, but it is in these qualities that we can detect a specifically modern way of looking. MM

Portraiture and Fashion

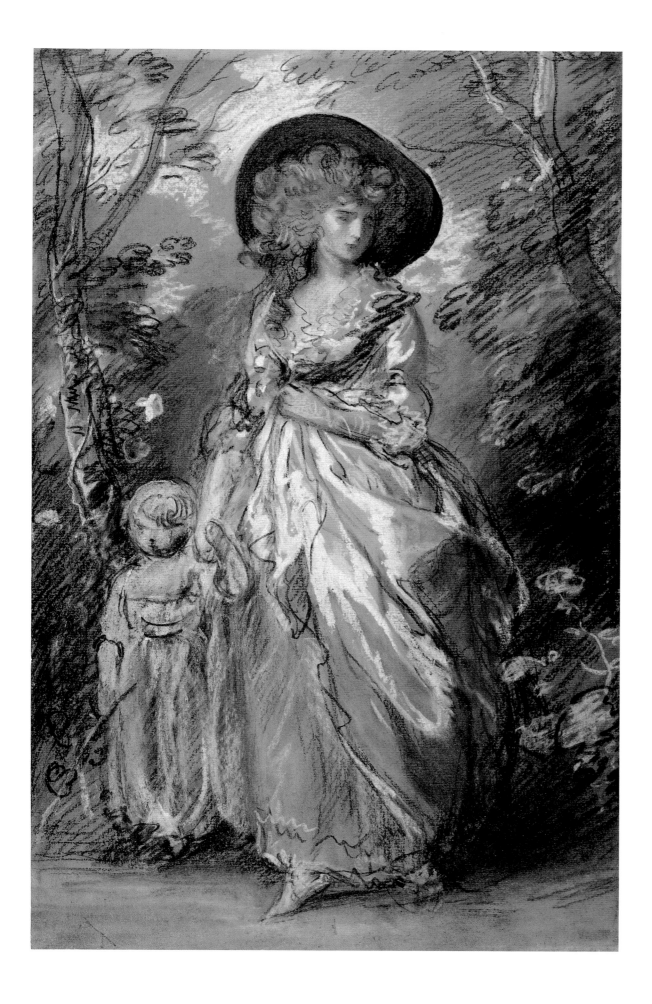

Sensibility

According to a newspaper of 1775, sensibility was 'a lively and delicate feeling, a quick sense of the right and wrong, in all human actions, and other objects considered in every view of morality and taste'. The fact that this statement was made in the popular press suggests that it was the articulation of what, by then, would be considered a truism. The idea that people were innately good and would respond instinctively to remedy scenes of distress had first been expressed – in terms taken from the seventeenth-century philosopher John Locke – by the 3rd Earl of Shaftesbury and was elaborated by his follower, Francis Hutcheson. This was further developed in *The Theory of Moral Sentiments* (1759) by Adam Smith, who maintained that such altruism was motivated by our innate desire that we should be similarly looked after, were we ourselves to fall upon hard times. By the 1760s the appeal of this philosophical stance had developed into a fashionable cult of sensibility, given expression in poetry and novels, essays and images. These provided a sense of morality peculiarly attuned to the contemporary world. Sensibility allowed for the moral regulation of a society requiring an ethical structure during a period when the speed of commercial and economic development was increasingly invalidating any idea that behaviour might be predicated on the dictates of authority. Just as commerce joined people through complex and reciprocal relationships, so a moral economy was supposed to be governed by a similar structure.

Appropriate to a society where seeing and being seen were essential aspects of social behaviour, sensibility could be activated by the sight of objects of distress. Thus the novelist Laurence Sterne imagined, in one of his sermons, the Good Samaritan to exclaim 'Good God! what a spectacle of misery do I behold!' Sterne, the high priest of sensibility, punctuates to let us know that the Samaritan's reaction is instinctive, spontaneous. The poor were, naturally, objects of particular attention to people of sensibility. Thus, in an essay they published in 1773, John Aiken and Anna Laetitia Aikin (later Barbauld) observed that:

Poverty, if truly represented, shocks our nicer feelings; therefore whenever it is made use of to awaken our compassion, the rags and dirt, the squalid appearance and mean employments incident to that state must be kept out of sight, and the distress must arise from the idea of depression, and the shock of falling from higher fortunes.

They noted, too, how the 'representation of distress' might be pleasing. This is what Gainsborough is appearing to present in his images of the rural poor. His is not the economically hard-headed view that we find, say, in the paintings of George Stubbs (1724–1806), and it is evident from his paintings and drawings that Gainsborough was alert to the decorum necessarily maintained if his works were to remain within the bounds of propriety. This was made more pressing an issue by the fact that, because he was also the quintessential portraitist of people of sensibility, his fictive universe had to accommodate both rich and poor within a harmoniously reciprocal relationship. At its crudest this meant that his landscapes could serve as a habitat both for the peasantry and for the aristocracy, and, in each case, serve to qualify the virtues of the figures. Thus, just as the *Cottage Girl with Dog and Pitcher* (cat.122) portrays the object of sensibility, so the extraordinary portrait of Mrs Sheridan (cat.166), whose hair follows the line of foliage and whose dress picks up the colour of the sunset, establishes her as so *sensible* as to be part of nature, which formed the standard of morality.

Detail from **An Officer of the 4th Regiment of Foot** *c.*1776–80 (cat.104)

Sensibility

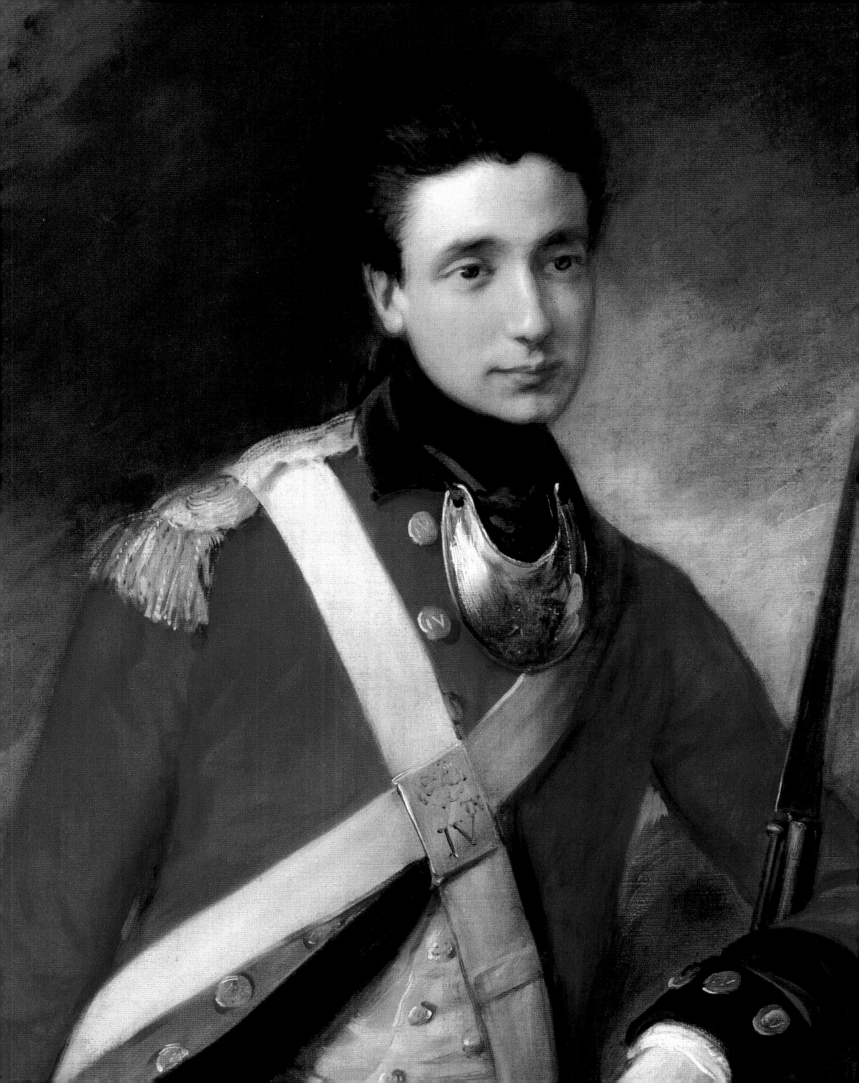

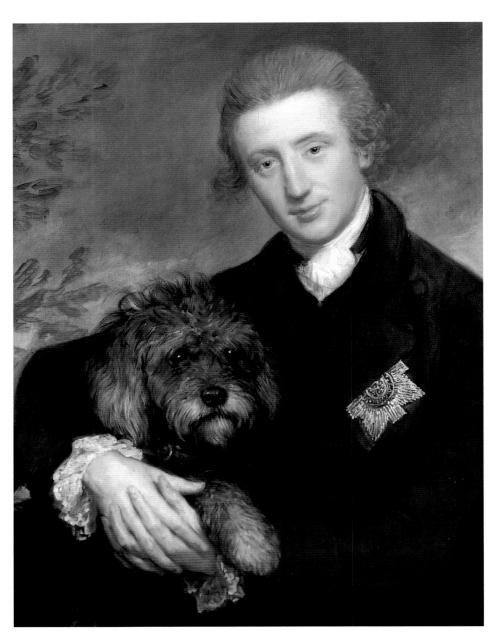

Figure 46
Detail from **Henry 3rd Duke of Buccleuch** 1770 (cat.110)

Refinement was a real issue here; the cultivation of one's social and cultural attainments in order to be able to represent personally the progress of culture away from the barbaric simplicity that, it was imagined, prevailed in former times. Eighteenth-century Britain was considered to have attained a degree of elegance and liberty unseen since ancient times. Sensibility was the means of expressing one's exquisite moral sense in this culture of refinement, re-affirming one's social status. It is evident from contemporary writing that perfect sensibility was normally to be found in those who were exceptional in all other respects too. In the socially aspirant it could be damned as affectation.

One of the hallmarks of the person of sensibility was an affinity with the natural world, as we witness with the superbly fashionable Halletts in *The Morning Walk*

(cat.88). Sensibility ideally did not differentiate between the responses of men and those of women when it came to the compassionate enjoyment of nature. Gainsborough showing their dog as an affectionate companion rather than a useful or working animal increases our admiration for this scene of conjugal harmony. Indeed, Gainsborough sometimes painted dogs as worthy subjects in their own right, as with the family pets *Tristram and Fox* (cat.107) where not only do we find a neatly Sternean joke in the naming of the dog as Tristram but, through the catchlights in its eyes, confirmation that it is seen as an individual that occupies its own universe. More often they were sympathetic companions, as in *Henry 3rd Duke of Buccleuch* (cat.110), and represented as the epitome of refined sensibility. The star of the Order of the Thistle may be half hidden but is, none the less, an effective reminder of

the duke's public role. He is dressed sombrely to indicate that his is a thoughtful sensibility, while the modelling of the composition on Titian's portrait of the Duke of Mantua (1523–9; Prado, Madrid) imbues his representation with an impressively elevated formal genealogy. In contrast, when Gainsborough pictured the notorious Duke and Duchess of Cumberland out walking in Windsor Great Park (cat.89), although he apparently offers us a compact version of *The Morning Walk* (cat.88), the fact that theirs is a lapdog adds a satirical touch that would be appreciatively noted by the observant.

This reminds us that there are pictorial subtleties that we must attempt to recover if we are to see Gainsborough's portraits historically. For example, *George, Lord Vernon* (cat.41) relaxes on a country walk with an affectionate dog and offers no hint of impropriety, while a comparison of the portraits *Lady Brisco* (cat.103) and *An Officer of the 4th Regiment of Foot* (cat.104) offers a useful reminder that one of the dangers of excessive sensibility was that it could cross the boundary into effeminacy. His unnamed officer is exemplary in his display of emotion, but also distinctly ineffectual-looking. The man of sensibility could, like the lead character in Henry Mackenzie's *The Man of Feeling* (1771), be comically impotent and unworldly. At one point the 'hero' of the novel, Harley, hangs around the prostitutes who gathered on the Strand, but only 'with ideas of pity suitable to the scene around him' rather than any lustful desire. When he is taken home by one of them, he only gets to listen to her mournful tale and is duped out of money and his watch. In real life sensibility had its dangers, too: Thomas Day, whose novel *Sandford and Merton* (1783–9) exemplified the new emotional ideals of childhood, died when he was thrown from a horse he was trying to tame by kindness, rather than the usual harsher means.

The ideals of sensibility meant that conventional forms of male and female identity could be threatened. Generally, Gainsborough negotiated the traps of sensibility with real dexterity. His men of sensibility, such as *Ignatius Sancho* (cat.112), *Carl Friedrich Abel* (cat.50) and the painter's brother, the clergyman *Humphry Gainsborough* (cat.113), are united in their acute alertness and receptivity to stimuli. His women partake of an intellectual life, developed by means of a sensual engagement with the world (rather than the formal acquisition of knowledge considered most properly the province of men). His *Mrs Drummond* (cat.102) and *Miss Indiana Talbot* (cat.100) are women shown in thought, contemplating the beauty of nature or art, without compromising the ideals of feminine fashionability. Such pictures are an illustration of the way in which sensibility might allow for a parity of attainment between men and women, as we see also in *Viscountess Ligonier* (cat.47). And Gainsborough paints children, not as the impish ciphers that Reynolds and others would sometimes present but as creatures of intellectual and emotional independence who none the less retain their charm.

Men, women, children and animals are thus united by their sensibility, as was the artist himself. Gainsborough's manner of painting, with hatchings and apparently random markings of paint on canvas, demands real perceptual engagement if it is to be understood as representational – the kind of engaged looking that one might grant the sitter or the subject were they to be encountered in real life. The artist's obituarist in the *Gentleman's Magazine* was taken by this and noted how:

> his likenesses are attained more by the indecision than by the precision of the outlines. He gives the feature and the shadow, so that it is sometimes not easy to say which is which; for the scumbling about the features sometimes looks like the feature itself; so that he shews the face in more points of view than one, and by that means it strikes every one who has seen the original as a resemblance.

Writing of the literature of sensibility, the scholar Janet Todd has noted how it was characterised by 'broken syntax and typographical exuberance', pretty much an equivalent to the way that Gainsborough handles his paint. But, as John Mullan also comments in reference to Mackenzie's *Man of Feeling*, sensibility produced a sense of virtue 'utterly stylized, specialised beyond the possibility of application'. So even if sensibility had the potential to regulate moral relations between people living in a changing social environment, how realistic it was, was another matter: for all the appearance of spontaneity and naturalness, it was a contrivance. The match of Gainsborough's painting to others' writing, or the homogeneity of the painted world in which he places both sitters and subjects, both reinforced the theoretical possibility of sensibility creating a new understanding of the social order and demonstrated that it could only be achieved through the creation of ideal fictions. MR/MM

95
The Painter's Daughters with a Cat
c.1760–1
Oil on canvas, 75.6 × 63 (29¾ × 24¾)
National Gallery, London

Waterhouse, no.286

This is one of a series of informal portraits of his young daughters painted by Gainsborough during the later 1750s and early 1760s. Gainsborough's elder daughter Mary was baptised in February 1750, his younger daughter Margaret in August 1751. At the time of the present portrait they would have been aged between nine and eleven years old. The earliest of these portraits, depicting his daughters chasing a butterfly (National Gallery, London), dates from about 1756. A second portrait, in which Mary adjusts her younger sister's hair (Victoria and Albert Museum, London), was painted around the same time as the daughters with a cat. A fourth painting, also of about 1760, depicted the daughters as peasant girls gleaning. It was cut in half during the nineteenth century, only the portrayal of Margaret having survived (Ashmolean Museum, Oxford).

The Painter's Daughters with a Cat is the most sketchy of these early double portraits, the presence of the snarling cat discernible only through a sketched outline. The unfinished nature of the picture reveals a good deal about Gainsborough's technique at this time. Having primed his canvas in brown, Gainsborough sketched the composition in white chalk or pastel, before working up the outlines of the figures in diluted brownish-black paint. The faces of the girls are built up through a series of short hatched brushstrokes. MP

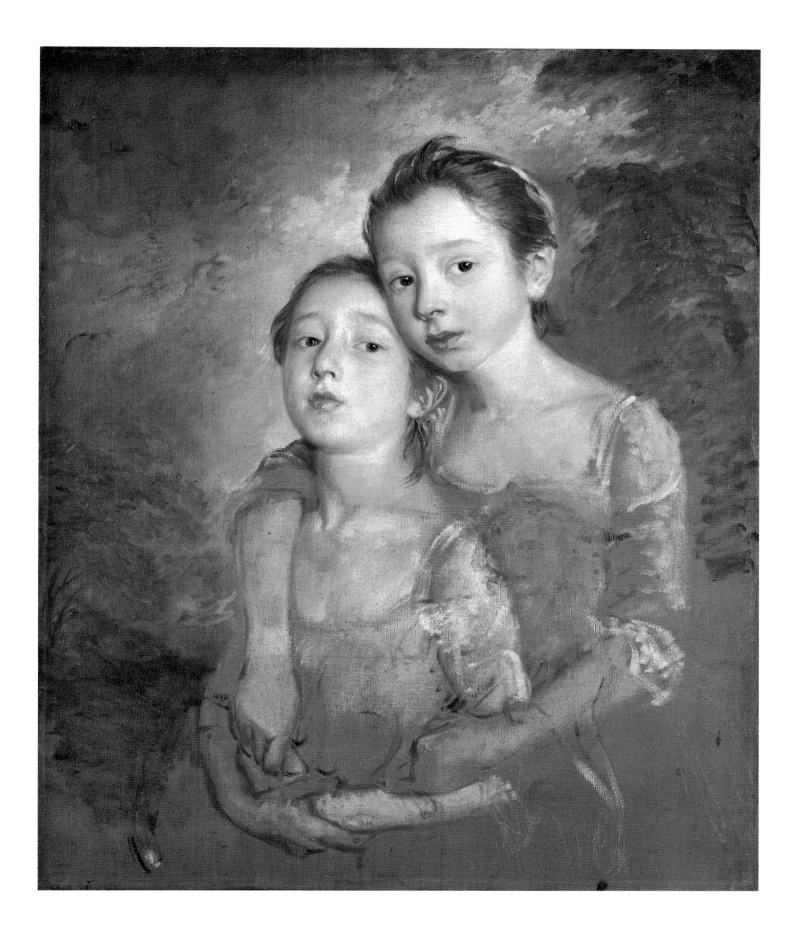

96
Portrait of the Artist's Daughters

*c.*1763–4
Oil on canvas, 127.3 × 101.7 (50⅛ × 40¹⁄₁₆)
Worcester Art Museum, Worcester,
Massachusetts, Museum Purchase

Waterhouse, no.287

In this portrait Gainsborough's daughters, Margaret and Mary, are aged between twelve and fourteen years old. They are depicted in a studio setting, possibly the artist's painting room in Bath. Mary, seated, holds in her right hand a double-ended drawing implement called a *porte-crayon*. On her lap rests a portfolio of her drawings. Margaret stands behind her, drawing in hand, looking at the plaster cast of a celebrated classical statue, the *Farnese Flora*. At that time drawing from the plaster cast was regarded as the basis of artistic training. Gainsborough was a loving and indulgent father, and took a keen interest in his daughters' education. In the autumn of 1764 both girls were sent to Blacklands School, Chelsea, partly to learn drawing. At that time Gainsborough wrote numerous letters to them (now lost), containing instructions for drawing. Before this, in March 1764, he had embarked upon a plan to teach his daughters landscape painting 'somewhat above the common Fan-mount stile'. As he told a friend, his intention was to provide them with skills to pursue art professionally, 'in case of an Accident that they may do something for Bread'. He was also concerned that they should have the means to survive without relying merely upon the lottery of the marriage market: 'I think (and indeed always did myself) that I had better do this than make fine trumpery of them, and let them be led away with Vanity, and ever subject to disapointment [sic] in the wild Goose chace' (*Letters*, p.26). Unfortunately, Gainsborough's plans appeared to have come to nothing: no paintings by his daughters survive, nor did they succeed in the marriage market. MP

Sensibility

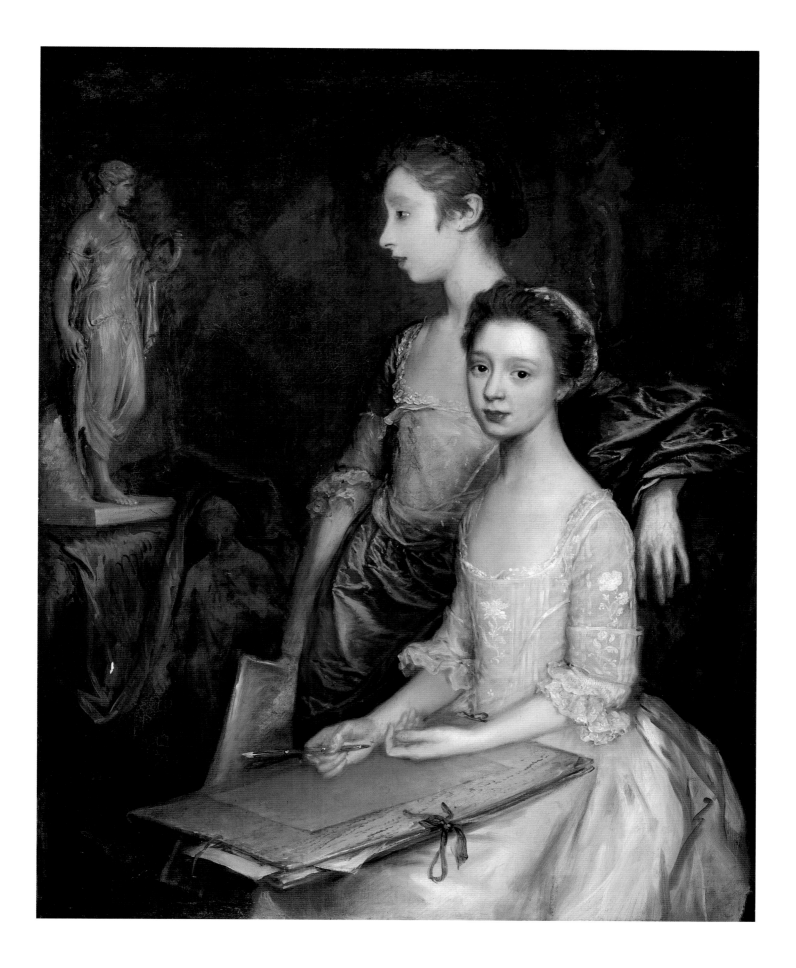

97
Lady Georgiana Spencer

1763
Oil on canvas, 72.4 × 61 (28½ × 24)
Althorp

Waterhouse, no.361

The sitter is Georgiana (1757–1806), daughter of Georgiana Poyntz, Countess Spencer, and John, first Earl Spencer, and thus niece to William Poyntz (whose portrait Gainsborough exhibited in 1762; cat.37). She had already been painted, with her mother, by Reynolds around 1760 (fig.47). But where he had provided her with an angelic innocence, Gainsborough now creates an image that suggests that there is a knowing intellect at work in this child. As the present Earl Spencer puts it in his history of the Spencer family, she seems 'an intuitive old soul trapped in a girl's body'. There may indeed be something a little disconcerting about Gainsborough's image of this girl, but the idea of a child having a nascent intellect and an emotional integrity that must be attended to in its upbringing was one of the cornerstones of sensibility. Countess Spencer was, besides being an enthusiastic sportswoman, greatly concerned with modern educational techniques that were in tune with these ideas, and Georgiana

was brought up in a liberal fashion in witty and cultured company. The old interests of dynasty and decorum won out in the end, however; she was married off at the age of seventeen to the Duke of Devonshire. The union was not initially happy, and as the Duchess of Devonshire she became one of the best-known women on the social circuit, famous for her glamour, and infamous for her love of gambling and her close association with the hard-living opposition politician Charles James Fox. MM

Sensibility

98
James Watson (?1739–1790) after Joshua Reynolds (1723–1797)
Miss Sarah Price
published 20 November 1770 by James Watson
Mezzotint proof, 34.3 × 27.9 (13½ × 11)
The British Museum, London

Reynolds's portrait of a little girl in the character of a shepherdess, on which Watson's mezzotint engraving is based, was exhibited at the Royal Academy in 1770 (Hatfield House). The author and aesthete, Horace Walpole, praised it lavishly in his copy of the exhibition catalogue: 'It is a little girl with her hands before her, amidst sheep, and under fine trees. Never was more nature and character than in this incomparable picture, which expresses at once simplicity, propriety, and fear of her cloaths being dirtied, with all the wise gravity of a poor little Innocent.' Reynolds's picture, as Walpole's commentary makes clear, corresponded closely to contemporary expressions of sensibility, in which the 'simple' virtues of the shepherdess were celebrated in literary and visual culture – as well as the more ephemeral realm of the masquerade. Sarah Price, the subject of the present portrait, was, needless to say, far removed from the realities of peasant life.

A daughter of Chase Price MP, she was three years old at the time of Reynolds's portrait, which cost her father 70 guineas. She married Bamber Gascoyne II (1758–1824), and her daughter went on to marry the 2nd Marquess of Salisbury. MP

99

Master John Truman-Villebois and his Brother Henry

*c.*1780

Oil on canvas, 154.9 × 129 (61 × 51)

Private Collection

Waterhouse, no.675

In this double portrait the Truman-Villebois children are depicted building a house of cards. The portrayal of children with playing-cards was a common motif in seventeenth-century Dutch art, where they exemplified the folly that results from indulging in games of chance. More generally, the presence of cards was symbolic of the mischievous nature of children, who are allowed to flout adult codes of conduct. In 1730 Hogarth had employed the motif of the house of cards in a conversation piece featuring young children. A decade later Francis Hayman used a similar device in one of his decorative paintings for Vauxhall Gardens – to which Gainsborough is thought to have contributed a figure. In the present picture Gainsborough uses the house of cards perhaps as a means of conveying a moral message concerning the fragile foundations of ambition and the fleeting pleasures of childhood. The composition is cleverly composed, Gainsborough repeating the triangular form assumed by the figures of the boys in the house of cards situated between them.

John and Henry Truman-Villebois were the sons of William Villebois and Frances Read, granddaughter of the brewer Sir Benjamin Truman. The portrait is one of four pictures Gainsborough painted of members of the Truman family, the earliest being the portrait of Sir Benjamin (Tate), which Gainsborough had painted during the early 1770s in Bath. The others were of the boys' mother and aunt, who were the children of Truman's only daughter. As Sir Benjamin's male heirs, it was expected that the young Truman-Villebois boys would carry on the family's brewing business. The picture was painted around 1783, the year after Sir Benjamin's death. MP

Sensibility

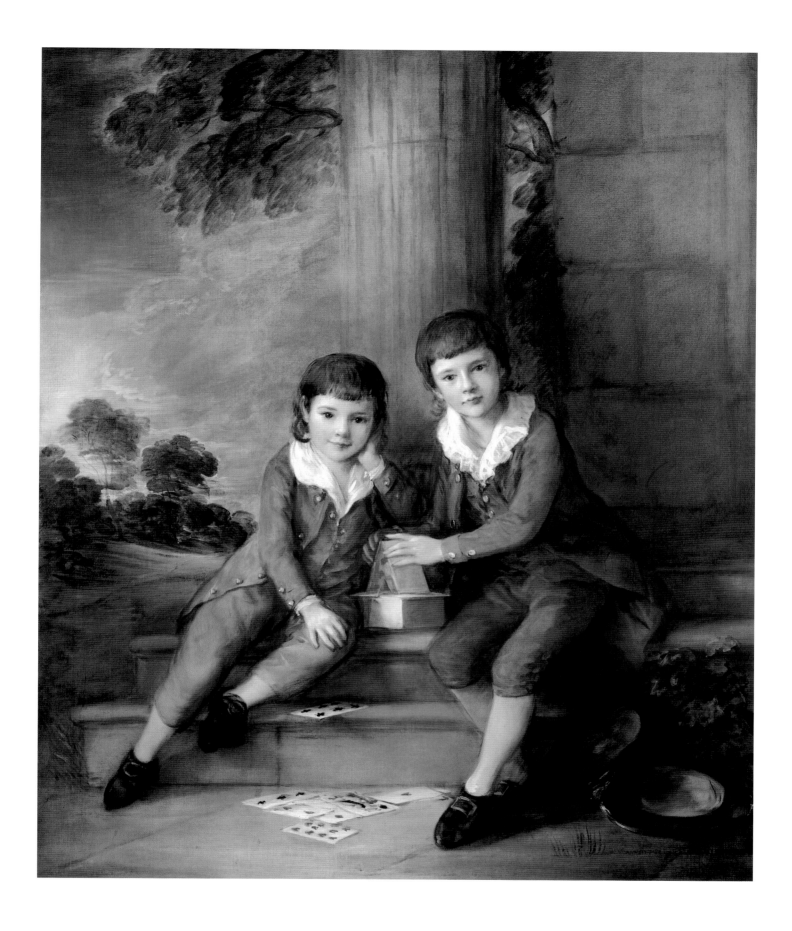

100

**Mrs Lewes Peak Garland,
formerly Miss Indiana Talbot**

c. 1775
Oil on canvas, 90.2 × 69.9 (35½ × 27½)
The Viscount Cowdray

Waterhouse, no.651

The contemplative pose adopted by
Gainsborough in this portrait of Mrs Garland is
to be found, with variations, in numerous
British society portraits from the seventeenth
century onwards. Sir Joshua Reynolds used it
regularly from the mid-1750s, most often in
portraits of younger married women. Indeed
the attitude of Mrs Garland, her right hand
resting upon her check and her left arm upon
her lap, closely resembles Reynolds's
Catherine, Countess of Egremont of 1755–6
(Marquess of Northampton, Castle Ashby). By
the 1770s this rather staid pose may have
appeared outmoded when compared to the
more dramatic repertory of gestures and facial
expressions presented by Reynolds and
George Romney in their female portraits.
According to Waterhouse the present portrait
remained unfinished. The only evidence of lack
of 'finish' is the sketchily painted floral area to
the left of the sitter. This, however, is an
indication of the increasing looseness of
Gainsborough's brushwork following his arrival
in London.

The portrait was probably painted a year or
so after the marriage of Indiana Talbot to Lewes
Peak Garland of Michaelstowe Hall, Harwich, in
1774. Indiana Talbot was born in 1751, the only
daughter of Major-General Sherington Talbot of
Stourton Castle, Staffordshire, and his wife,
Charlotte Freeman. Miss Talbot's family was
well connected socially and politically. Her
uncle, Charles Talbot (1685–1737), had been
Lord Chancellor under Sir Robert Walpole,
while her grandfather, William Talbot
(1659–1730), had been Bishop of Durham.
Mrs Garland died in 1780, following the birth
of her second son. MP

Sensibility

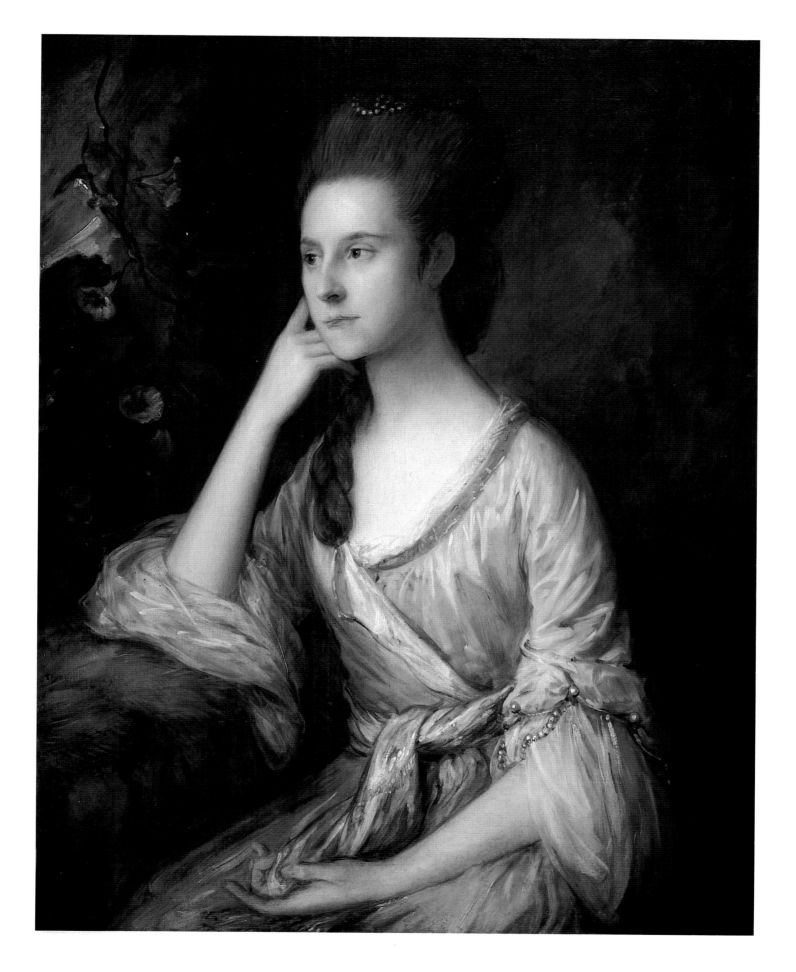

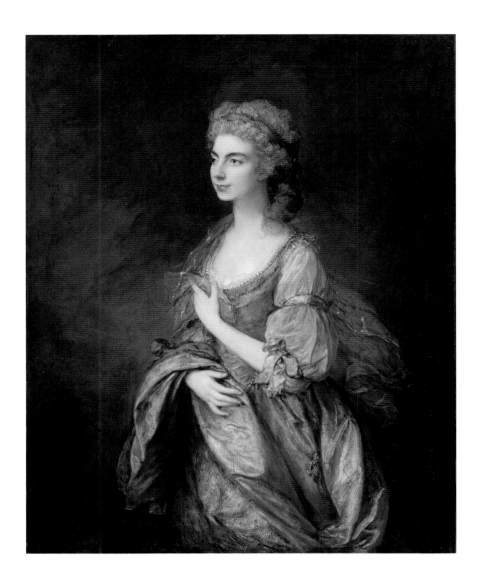

101

Portrait of Lady Rodney (née Anne Harley)
c.1778–9
Oil on canvas, 127.6 × 101.3 (50¼ × 39⅞)
Philadelphia Museum of Art: The John
Howard McFadden Collection, 1928

Waterhouse, no.584

102

Portrait of Mrs Drummond (née Martha Harley) Holding a Sketch in her Right Hand
c.1778–9
Oil on canvas, 126 × 100 (49⅝× 39⅜)
Private Collection

Waterhouse, no.212

The subject of cat.101 is Anne, second of five daughters of the Rt Hon. Thomas Harley (1730–1804), a former Lord Mayor of London and brother of the Earl of Oxford. Lady Anne was born in May 1758 and in April 1781 she married George, eldest son of the naval hero, Sir George Brydges Rodney, Lord Rodney. On her marriage her father presented her with Berrington Hall, Herefordshire. Cat.102 shows her older sister, Martha, born in 1757, who married the banker George Drummond on 30 November 1779.

The two portraits, together with a third of their sister Sarah, were begun in 1778, as a receipt of that date records the initial payment to the painter from Thomas Harley. In the two works, which can be regarded as pendants, the sisters Anne and Martha are dressed similarly in silk gowns trimmed with pearls, their chestnut hair worn beneath powdered grey wigs tied with a simple band of ribbon. Lady Anne's arms, gesturing towards breast and abdomen, are derived from classical statues of Venus, notably the Venus de'

Medici and possibly also the Venus Victrix (Uffizi, Florence) where the figure's lower arm, like the present portrait, is swathed in drapery. It is a pose found also in Van Dyck's portraiture. It has been suggested that the portrait was painted between 1779 and 1780, around the time of Martha's marriage and her depiction by Gainsborough. Alternatively, it has been argued that it was painted two years or so later, around the time of her own marriage, in which case the gesture of her right arm, placed over her belly, could possibly refer to the impending birth of her first child in June 1782.

The companion portrait of Martha Drummond conforms closely to the ideal of the woman of sensibility, at once graceful and feminine, and evidently cultured. She holds a drawing, and is posed with classical statues – devices connoting a cultured intellect that Gainsborough had earlier used in depicting his own daughters (cat.96) and Lady Ligonier (cat.47). MP

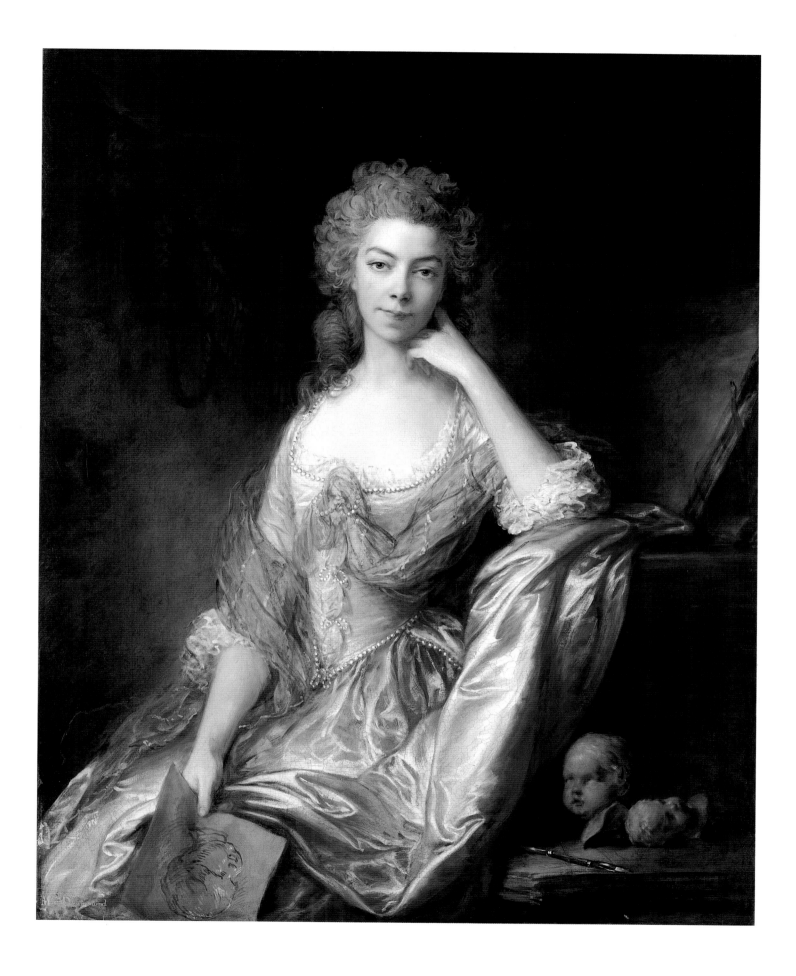

103
Lady Brisco
*c.*1776
Oil on canvas, 235.2 × 148.5 (92⅝ × 58½)
English Heritage (Kenwood, The Iveagh
Bequest)

Waterhouse, no.81

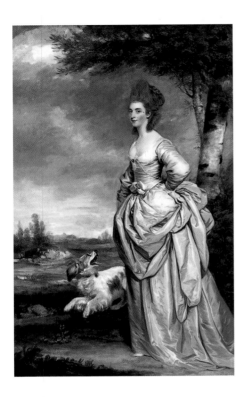

Figure 48
Joshua Reynolds
Mrs Elisha Mathew 1777
Oil on canvas, 237.5 × 146.4 (93½ × 57⅝)
The Museum of Fine Arts, Houston; Museum purchase with
funds provided by the Brown Foundation Accessions
Endowment Fund

This portrait of Caroline Alicia Fleming (died 1822) was painted in 1776, the year she was married to John Brisco. In 1782 Brisco was created a baronet, which indicates that the inscription on the back of the picture, 'Lady Brisco', was added later. The date given in the inscription (1776) is, however, presumably correct. Like many of Gainsborough's full-length portraits the figure appears to be elongated. This effect is increased by the figure's fashionable padded head-dress and the stretching form of the spaniel, a device used by Gainsborough in his 1767 portrait of George, Lord Vernon (cat.41), although here the animal is rather more restrained in its affection. The dog is a ubiquitous presence in later eighteenth-century portraits, an emblem of fidelity, but more particularly a signifier of the sitter's refined sensibility. This is amplified by Lady Brisco's relaxed yet dignified pose, her right elbow resting upon a conveniently positioned tussock, while her left hand beckons towards her dog. The 'natural' effect is further conveyed by the way in which the subject blends in with the surrounding landscape, her white dress absorbing the hues of her immediate environment, while the gold sash and trimmings reflect the colours of the setting sun.

At this time Gainsborough was not exhibiting at the Royal Academy. Even so, there are abiding similarities with Reynolds, notably his full-length portraits *Mrs Richard Lloyd* (Private Collection), exhibited at the Royal Academy in 1776, and *Mrs Elisha Mathew* of 1777 (fig.48), where the sitter is, like Lady Brisco, accompanied by an adoring spaniel. In both these works Reynolds eschewed the allegorical personae often used in previous portraits in favour of a more direct correspondence between his subject and nature. MP

Sensibility

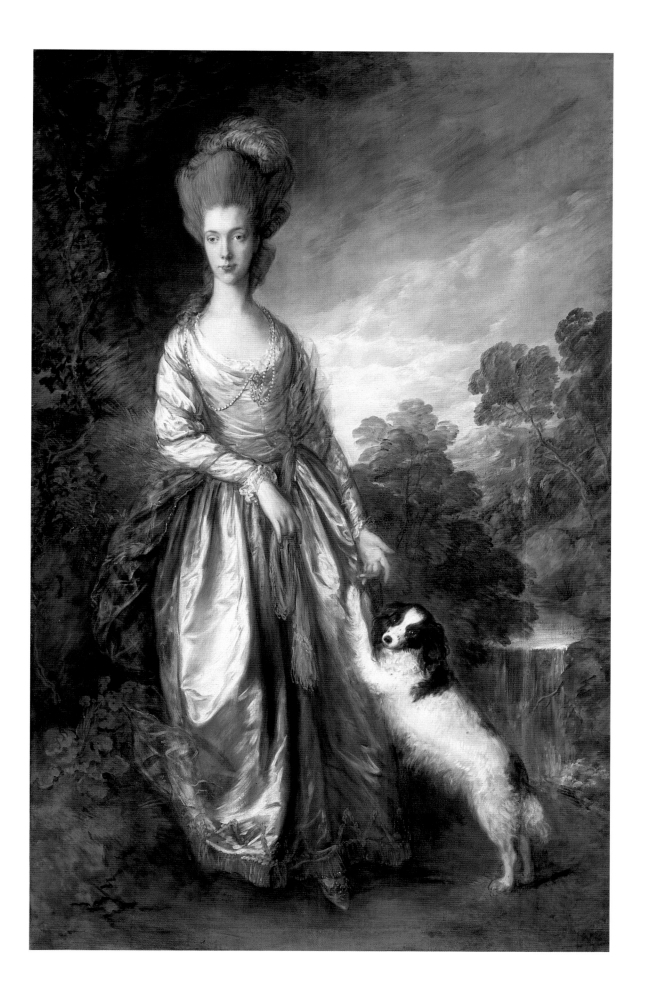

104

An Officer of the 4th Regiment of Foot
*c.*1776–80
Oil on canvas, 230.2 × 156.1 (90⅝ × 61½)
National Gallery of Victoria, Melbourne,
Australia. Felton Bequest 1922

Waterhouse, no.772

The officer shown here lost in thought is more sensitive in character than those in other military portraits by Gainsborough and thus appears less 'official'. The portrait has the air of being painted for a man who was perhaps not too enthralled with his military career and who preferred to project an image of himself that was more in keeping with the contemporary notions of sensibility and feeling. The underlying narrative here, regarding man's duty and how this conflicts with the instincts of the private individual, was a common theme in popular contemporary literature. He has been identified as an officer in the 4th Regiment of Foot. The regiment served in America in 1774–8, then in the West Indies, before being posted in Ireland from 1779 until 1786, and although it nowhere suffered heavy casualties, these postings put it in the front line of British imperialism. The conflict in America, with its fundamentally fratricidal character, was the source of tremendous concern, with British soldiers knowing they were fighting not a traditional, foreign enemy, but people who ostensibly shared the same religion, political values and language as theirs.

The portrayal of a military figure as a 'man of feeling' is far removed from most other such portraits of the period, for instance Reynolds's *Captain Robert Orme* (fig.39), who is displayed as an exaggerated military hero set against a dramatic battlefield. Gainsborough has not attempted, as Reynolds would have done, to capture a commanding figure. Rather, the languid pose and melancholic mood of the soldier here point to passivity rather than martial action, and the way his left arm is draped around the bayonet on his musket does not give one confidence in his ability to use such a weapon. The suggestion of the figure as a man of sensibility is enhanced by the inclusion of the faithful hound looking adoringly at his master. DP

Sensibility

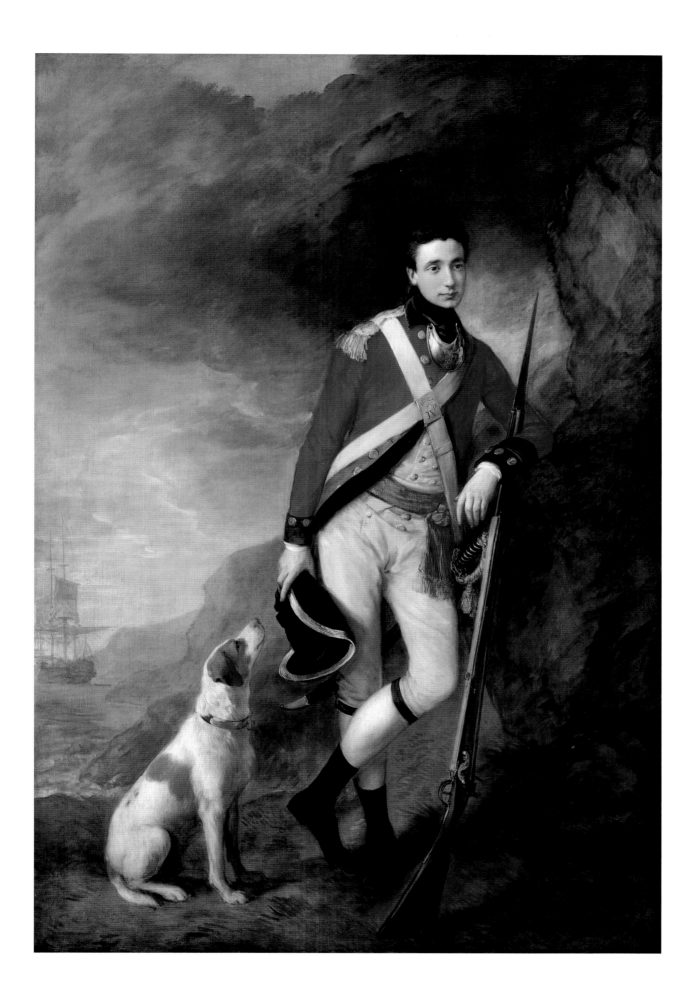

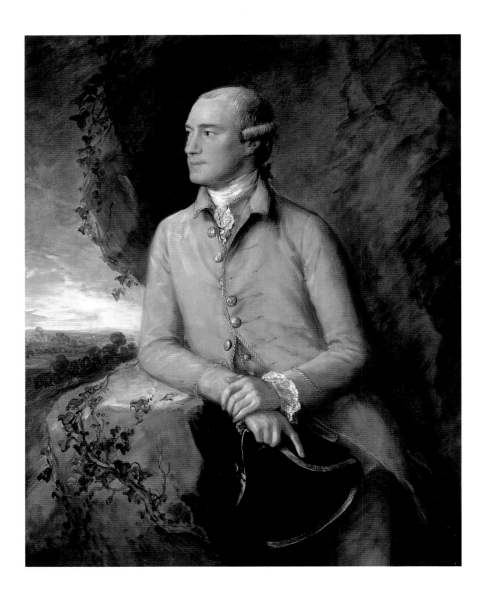

105
Joshua Grigby
c.1760–5
Oil on canvas, 127.5 × 102.2 (50¼ × 40¼)
Staatliche Museen zu Berlin, Gemäldegalerie

Waterhouse, no.331

Very little is known about the sitter. Several generations of Joshua Grigbys are recorded as living in Suffolk in the eighteenth century. This is probably Joshua Grigby III (1731–1798) who married Jane Bird in 1756. He was a man of law and his name is recorded in the Chancery records for 28 August 1772 concerning an enclosure of a highway in Beyton, near Bury St Edmunds. A man of the same name is documented in the 1780s as an anti-slavery campaigner (in letters in the Huntington collection). If this is indeed one and the same man it is interesting to note how a disproportionate number of portraits of 'men of feeling' were those of abolitionists, such as Ignatius Sancho (cat.112) and Thomas Day (cat.106). Although in stylistic terms the painting seems to date from Gainsborough's early Bath period, he presumably knew the sitter from his Suffolk days.

The portrait follows the model Gainsborough often adopted when painting male portraits that focused on the sitter's character as a 'man of sensibility', rather than on his profession or social standing. Joshua Grigby is shown as a pensive intellectual, alone in a landscape, emphasising his refinement by living in harmony with nature. His somewhat dishevelled appearance, with the buttons undone on his beige coat, also indicates his removal from worldly cares.

Gainsborough's male portraits of his Bath period relied for their appeal on extreme refinement, technical virtuosity and highly attractive colouring. These qualities lent his portraits an air of modernity that, combined with a melancholic expression, ideally suited gentlemen posing as men of feeling. They were also admired as being extraordinary likenesses, so we can assume that this elegant portrait bore a close resemblance to Joshua Grigby. DP

Sensibility

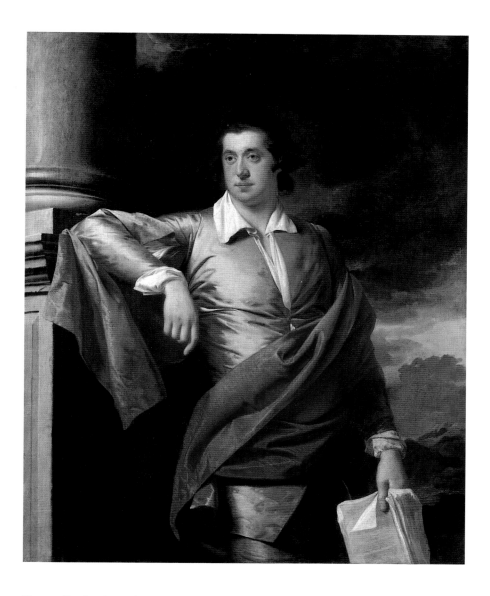

106
Joseph Wright of Derby (1734–1797)
Thomas Day
1770
Oil on canvas, 121.9 × 97.8 (48 × 38½)
National Portrait Gallery, London

Thomas Day (1748–1789) was the quintessential 'man of feeling'. His life was devoted to charity and the well-being of others and he aspired to an ascetic lifestyle, while occupying himself as a writer, philosopher and farmer. He is best-known for his children's book, *The History of Sandford and Merton*, published between 1783 and 1789, which tells the story of two boys, the rich Tommy Merton and the kindly farmer's son Harry Sandford. The book was a lesson in sensibility for the young reader, for it showed how moral behaviour is rewarded and how one can follow a path to virtuous manhood. It was one of the most influential and frequently reprinted early children's books. Day's other writings included pamphlets on social and philanthropic issues and *The Dying Negro* (1773), which aligned him with the anti-slavery movement.

The author put many of his ideas into practice and he was an ardent campaigner for moral and social reform. Much of his philosophy was based on Rousseau, whom he later met in Paris. The book he holds in his left hand is almost certainly a work by Rousseau, probably a copy of *Emile* (1762), which Day held in high esteem, and which clearly influenced *Sandford and Merton*.

Day must have been one of the least conventional of all Wright's sitters. In the portrait Wright has endeavoured to capture his qualities as a man of sensibility, showing him with a meditative and melancholy air, posed against a stormy background, no doubt emblematic of his radical opinions. Day's physical appearance would have presented problems for the artist for he was famously unkempt, refusing on principle to wash his hair. Wright's portrait is more formulaic and more closely based on artistic conventions than Gainsborough's treatment of similar men of feeling. It is one of two portraits Wright painted of Day and was commissioned by his lifelong friend Richard Lovell Edgeworth, who called Day 'the most virtuous human being he had ever known'. DP

107
Tristram and Fox
*c.*1770
Oil on canvas, 61 × 50.8 (24 × 20)
Tate; Presented by the family of Richard
J. Lane 1896

Waterhouse, no.822

Gainsborough had a love of dogs and included them in numerous portraits as well as landscapes. However, he painted only a handful of works where dogs were the central subject of the composition: these include *Bumper* (1745; Private Collection), one of his earliest known works, *Pomeranian Dogs* (1777; Tate) and this portrait of Tristram and Fox. While the exquisite white Pomeranians belonged to Gainsborough's friend Carl Friedrich Abel, this is a portrait of the artist's own pets.

Tristram and Fox were thought to have been named after the eponymous hero from Laurence Sterne's novel *The Life and Opinions of Tristram Shandy, Gentleman* (1759–67) and Charles James Fox, the Whig politician. The choice of names is indicative of Gainsborough's sense of humour and his awareness of contemporary literary and intellectual culture. The affectionate portrayal of the two dogs is in keeping with the cult of sensibility (in which Sterne's novel was a key text) which encompassed a kindness to animals and an understanding of their various natures. The handling and viewpoint here encourage us to see these as sentient beings in their own right, and as family companions rather than working or sporting animals.

The two dogs meant a great deal to Gainsborough and his wife. According to the artist's early biographer, G.W. Fulcher, Gainsborough sometimes represented himself as Fox in correspondence with his wife: 'Whenever Gainsborough spoke crossly to his wife he would write a note of repentance, sign it Fox, and address it to Margaret's spaniel, Tristram. Fox would take the note in her mouth and duly deliver it.' The painting is recorded as having hung over the chimneypiece in his London house. It probably had a more horizontal format then, for the unfinished figure of Tristram on the right appears to have been cut down. DP

Sensibility

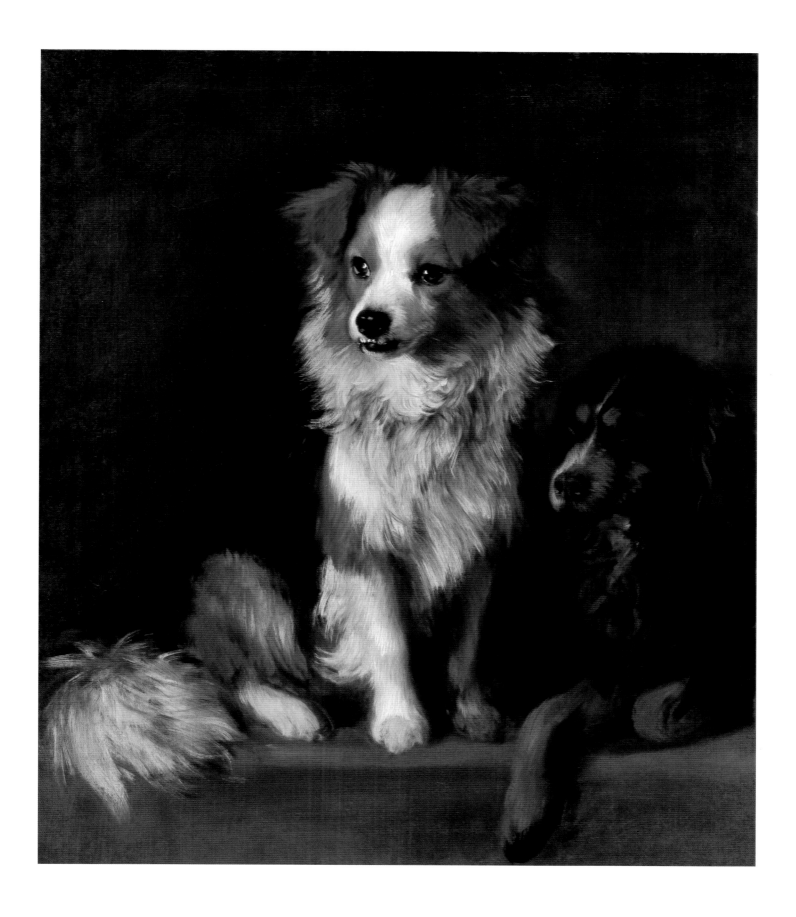

108

Study of a King Charles Spaniel

*c.*1765–70

Coloured chalks on brown paper, 23.5 × 31.7
(9¼× 12⁵⁄₁₆)

Collection of Cheryl Chase and Stuart Bear,
USA

Hayes 1970, no.873

109

Studies of a Cat

*c.*1765–70

Black chalk and stump and white chalk on
buff paper, 33.2 × 45.9 (13⅛ × 18⅛)

Rijksmuseum, Amsterdam

Hayes 1970, no.874

A hallmark of sensibility was a lively affection
for animals. The poet, William Cowper, wrote:

> *The heart is hard in nature, and unfit*
> *For human friendship, as being void*
> *Of sympathy, and therefore dead alike*
> *To love and friendship both, that is not*
> *pleas'd*
> *With sights of animals enjoying life,*
> *Nor feels their happiness augment his own.*

Gainsborough frequently displayed such a
feeling for animals in his art. He was evidently
highly attentive to the peculiarities of their
character and movement, and these two
drawings suggest the fascination he had for
individual creatures. They show Gainsborough
at his most fluent as a draughtsman,
communicating a sense of spontaneity that
was itself a sign of sensibility, as well as
conforming to long-standing ideas of artistic
virtuosity. On the basis of their technique, they
have been dated to the later 1760s. According
to tradition, cat.109 was executed at a country
house and given by the artist to the host. It
cannot be related to a specific painting and,
with the brilliant rendering of the cat's
progressive movements, seems complete as
a work of art (an impression added to by the
fact that it is signed in full by the artist—
something he rarely did). The pose of the
spaniel in cat.108 relates to that of the dog
in the *Study for the Haymaker and Sleeping
Girl* (cat.178), although it has a similarly
impromptu feeling. MM

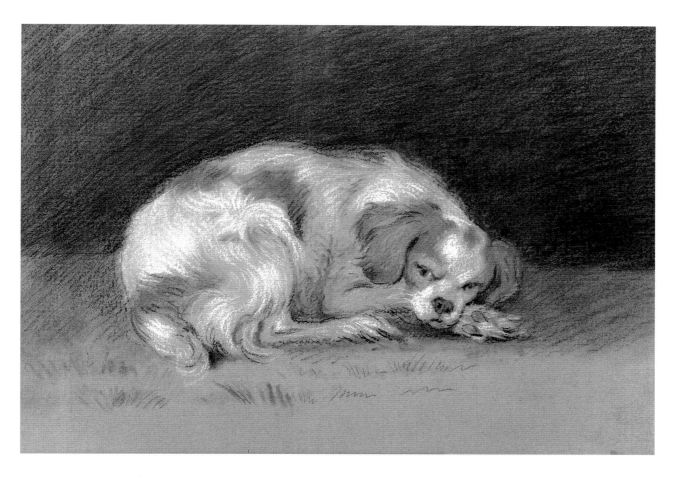

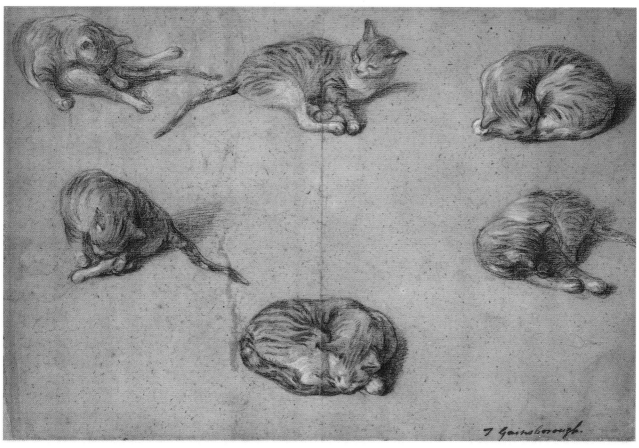

110
Henry 3rd Duke of Buccleuch
1770
Oil on canvas, 127.5 × 102 (50¼ × 40⅛)
In the collection of The Duke of Buccleuch
and Queensbury KT

Waterhouse, no.88

The young aristocrat Henry, 3rd Duke of Buccleuch (1746–1812), was known as a man of literary tastes and was a popular landlord. His friend Sir Walter Scott declared that 'his name was never mentioned without praises by the rich and benedictions by the poor'. With his kindly expression, gentle tilt of his head and affectionate embrace of his pet dog, the duke is presented not as a proud or powerful nobleman but as a 'man of feeling'. It is one of the earliest and most striking portraits of the period that set out to capture this notion of sensibility and predated by a year the publication of Henry Mackenzie's novel, *The Man of Feeling*, in 1771.

The pose of the duke, as he leans down towards the viewer with soft, enquiring eyes, shows him to be both modest and obliging, while graciously acknowledging our presence. Gainsborough has achieved a fascinating balancing act in communicating the idea that such refinement is incumbent on social status (signalled by the half-hidden star of the Order of the Thistle), and a low viewpoint ensures the spectator's deference. There is a fine line here between sensibility and effeminacy, and Gainsborough's conception was certainly unusual for a male portrait of the period: its formal parallels are more with contemporary portraits of motherly affection, such as those by Reynolds or Romney.

The manner in which the duke cuddles the dog suggests almost a child's love for his pet, but stresses the sitter's sensibility in his kindness to animals. The dog is an individual character in its own right, emphasised by it being an unusual breed, possibly a Dandie Dinmont terrier, later made famous by Walter Scott in his novel, *Guy Mannering* (1815). In this portrait Gainsborough could be said to have taken the idea of the dog as a portrait accessory to its ultimate conclusion. DP

Sensibility

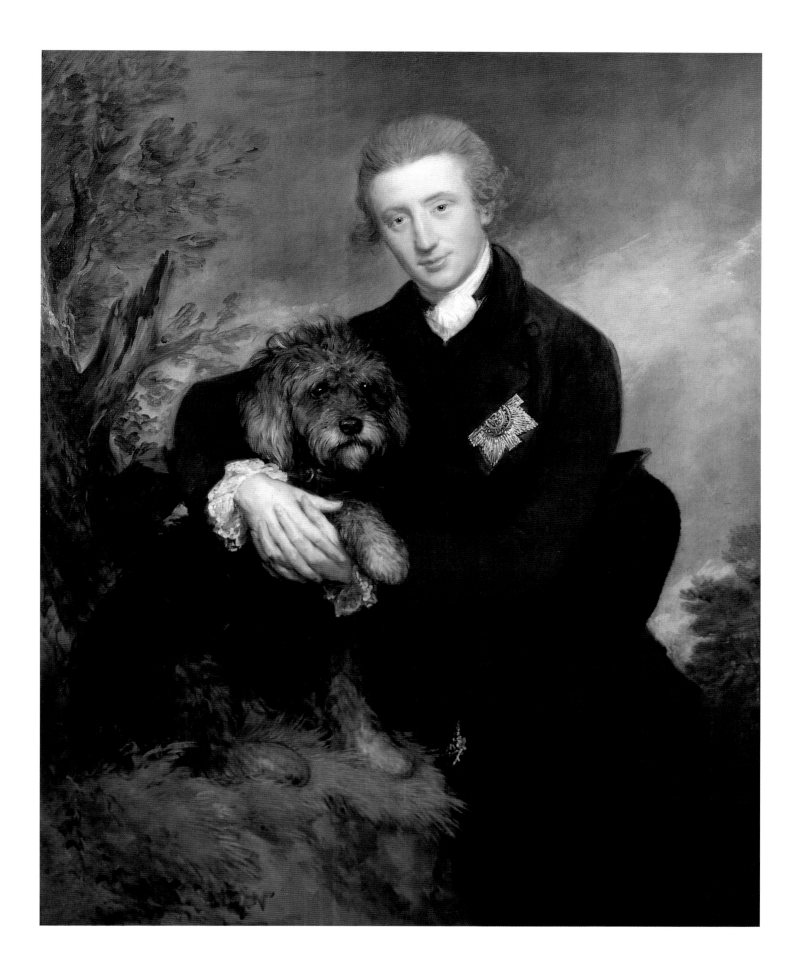

111
John Eld

*c.*1774–5
Oil on canvas, 238.6 × 153 (94 × 60¼)
Museum of Fine Arts, Boston, Special
Painting Fund 12.809

Waterhouse, no.237

The Elds of Seighford Hall were a long-established Staffordshire family. This formal portrait depicts John Eld (1704–1796) and marks his patronage of the Staffordshire General Infirmary. The hospital had been founded by subscription in Foregate, outside Stafford, in 1766. In 1769–72 a new building in a fashionable classical style had been created to the designs of Benjamin Wyatt, and Eld holds plans for the front elevation of the building in this portrait. An inscription on the base of the column states that the picture was created 'By the Command And at the Expence of the Subscribers', presumably to mark the opening of the new hospital in 1772.

Charity was an enormous concern in the eighteenth century. Drawing on established Christian principles, the ideals of sensibility encouraged charitable behaviour as a way of demonstrating personal gentility and helping to ensure social order. There were many new hospitals created in the eighteenth century, and portrait painters had a significant role to play in dignifying their benefactors. The full-length portraits of donors and founders at the Foundling Hospital, London, were important precedents for Gainsborough's picture, and included a depiction of that institution's architect, Theodore Jacobson, holding a plan of the building. More pertinently still, in 1761 Robert Edge Pine (before 1730–1788) had exhibited a full-length portrait of the Duke of Northumberland standing with the foundation stone of the Middlesex Hospital, which he had patronised.

The present portrait hung in the boardroom of the hospital, where it was forgotten until 1909. It was subsequently sold to benefit the institution, an appropriate fate for a work of art celebrating the role that charity can play in society. In common with formal portraits such as Gainsborough's of Captain William Wade (cat.48), the picture assumes that the viewer will look at it from below, so the figure is positioned relatively low within the composition, with quite an expanse of canvas above his head. With the amusing detail of the tricorne hat set atop the column's base and with the indication of a lush rural setting, the portrait shares something of the informality of Gainsborough's more modest portraits of men of sensibility. MM

Sensibility

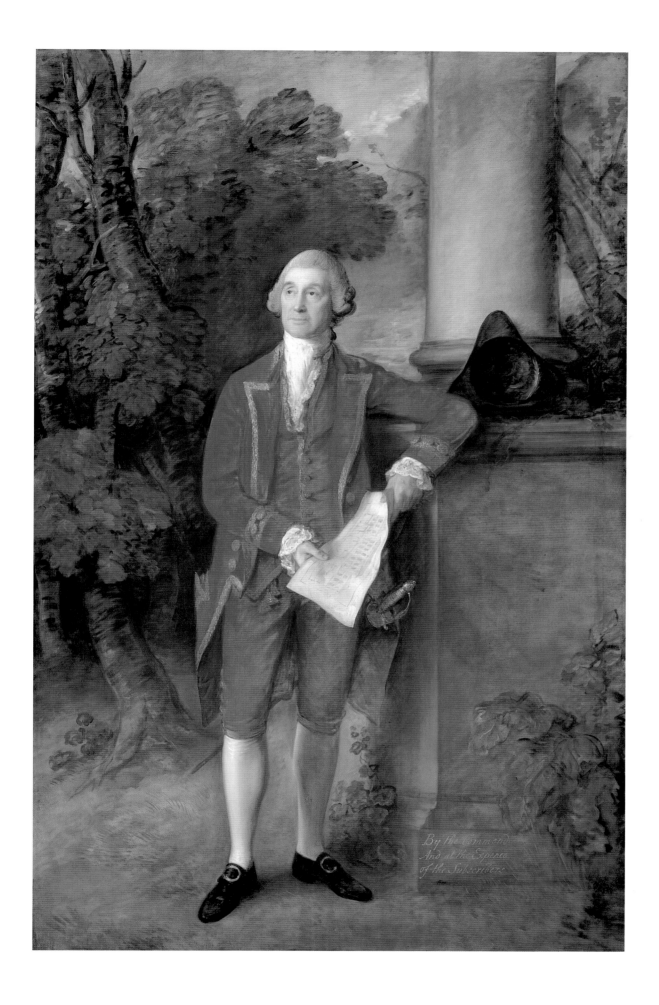

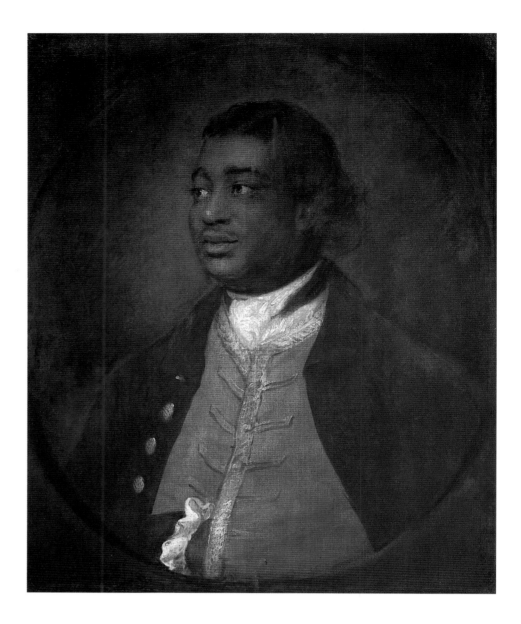

112

Ignatius Sancho

1768

Oil on canvas, 73.7 × 62.2 (29 × 24½)
National Gallery of Canada, Ottawa.
Purchased 1907

Waterhouse, no.598

Ignatius Sancho (1729–1780) was an extraordinary man. Born on a slave ship crossing the Atlantic, he became a servant in the household of the Duchess of Montagu in 1749. He remained with the family first as a butler, then as a valet to the 4th Earl of Cardigan (later Duke of Montagu) until 1773, when he set up as a grocer in Mayfair. His further contacts there with connoisseurs and aristocrats led to him becoming admired as a 'man of taste' amongst the artistic, literary and musical establishment in London. His friendship and correspondence with Laurence Sterne, which began in 1766, established his literary reputation, and much of his correspondence with Sterne and others was published in popular periodicals of the day, and in a posthumous edition in 1782. As well as his literary accomplishments, he was also a talented musician, composer and author of *A Theory of Music*. His correspondence and other writings reveal him to be a man of intellect, sensitivity and wit, indeed, a man of sensibility.

Gainsborough's portrait of Sancho was supposedly painted at Bath in 'one hour and forty minutes' on 29 November 1768. He may have visited the artist's studio with Mary, Duchess of Montagu, who was sitting for Gainsborough at that date. The painting belonged to Sancho, and was probably commissioned by the Duchess as a present for her faithful servant. While most images of black people during this period were of unidentified servants, portrayed as exotic accessories to their masters, Gainsborough has shown Sancho not as a servant, but as a gentleman, wearing fashionable clothes and with his hand tucked into his waistcoat in the standard pose used for portraits of gentlemen. DP

113

The Reverend Humphry Gainsborough

*c.*1770–4
Oil on canvas, 76.2 × 63.5 (30 × 25)
Mr Simon Jenkins

Waterhouse, no.273

This is one of two known portraits of Gainsborough's older brother Humphry Gainsborough (1718–1776); a smaller version is in the Yale Center for British Art.

Thomas Gainsborough was the youngest of nine children. Two of his older brothers shared his love of experimentation and invention. The eldest, known in Sudbury as 'Scheming Jack', was an inventor of useless curiosities, including a cradle that rocked itself. Humphry Gainsborough put his talents for mechanics to better use. He was a Dissenting minister at Henley-on-Thames, as well as an engineer. His inventions included a drill plough and tide-mill that were successful enough to be awarded premiums by the Society of Arts. A curious sundial of his contrivance is in the British Museum. His experiments with the steam engine must have been particularly innovative for it was said that he was cheated out of a patent for his condenser for the steam engine by the chicanery of James Watt.

Humphry Gainsborough is represented here as a man of sensibility, lost in thought, with his face highlighted, as if in the throes of receiving the 'light of inspiration'. Gainsborough was to use this device in other portraits of creative men, such as *Carl Friedrich Abel* (cat.50). DP

Landscape and the Poor

The aesthetician Uvedale Price noted of Gainsborough that, while he was 'at times severe and sarcastic … when we have come near to cottages and village scenes with groups of children and objects of rural life that struck his fancy, I have observed his countenance take on an expression of gentleness and complacency'. Henry Angelo, who had known Gainsborough, recalled how the artist, ill-tempered when confined to painting portraits, was cheerfulness incarnate when engaged on painting a landscape. And Gainsborough's letters reveal that, while charm itself when writing to one of the select whom he found sympathetic, he could be driven to exasperated sarcasm by those with whom he was less in tune. They suggest that the countryside was a kind of therapeutic refuge for him, and he evidently took as much pleasure in actual scenery as in painting landscapes. As the artist famously complained to his friend, the Exeter musician, William Jackson:

> I'm sick of Portraits and wish very much to take my Viol da Gam and walk off to some sweet Village where I can paint Landskips and enjoy the fag End of Life in quietness & ease
>
> But these fine Ladies & their Tea drinkings, Dancings, Husband huntings &c &c &c will fob me out of the last ten years, & I fear miss getting Husbands too – But we can say nothing to these things … we must Jogg on and be content with the jingling of the Bel[ls], only da-mn it I hate a dust, the kicking up a dust; and being confined in Harn[ess] to follow the track, whilst others ride in the Waggon, under cover, stretching their Legs in the straw at Ease, and gazing at Green Trees & Blue Skies without half my Taste That's d-mn'd hard. (Letters, p.68)

If we look past the irritated irony we see the artist likening his task to that of the carthorse confined to a particular job, an image that invests the motif of the figure (or figures) lounging in wagons that occur so frequently in his landscapes with a particular poignancy – even with a degree of autobiographical content.

Landscape was a constant throughout Gainsborough's working life. He is said to have started by drawing it on scraps of paper, and Angelo tells how in Bath he would occupy his evenings in making landscapes in various media. Despite appearances, Gainsborough always needed to work from at least a reminder of life, and is said to have made surrogate model landscapes from shards of mirror (serving for water), shoots of broccoli (acting as trees) and lumps of coal, which may still be discerned in some of his painted rocks. It is clear simply from looking at the results that he considered his landscapes as depicting an England refined through the imagination into a habitat appropriate for both rich and poor. His rural motifs were apparently as potent in slight wash drawings as they were in more portentous paintings.

While Gainsborough's earlier landscapes correspond closely to the appearances of the Suffolk terrain – to the extent that Constable would later observe that he fancied he saw the artist 'in every hedge and hollow tree' around Ipswich – and his painted scenery from the 1760s appears to demonstrate a response to the hillier and more wooded country he experienced on moving to Bath, by the later 1760s his compositions were more self-evidently inventions. Contemporaries were aware of these developments, and the writer J.H. Pott dwelt on them at some length in the *Essay on Landscape Painting* that he published in 1782. He noted how the first style was developed from such artists as Jan Wijnants

Landscape and the Poor

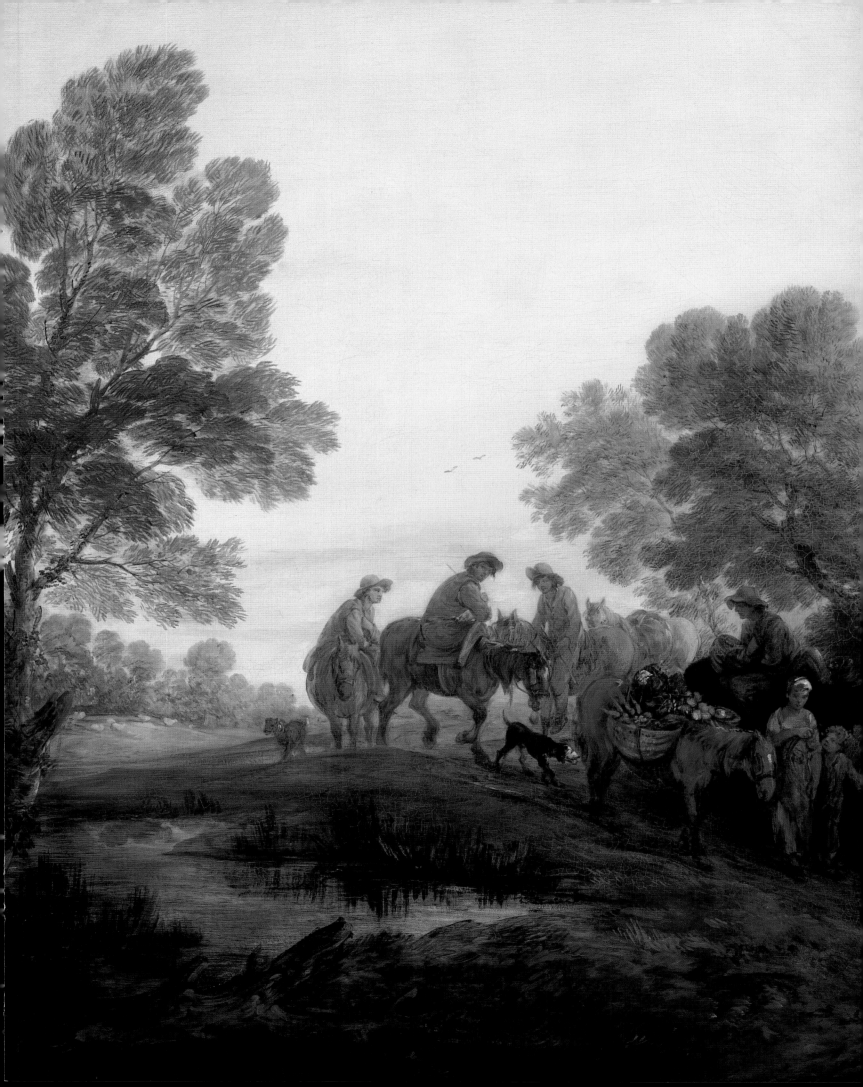

(active 1643–1684) to give 'a faithful representation of English nature'. From this he 'seems to have aimed at something more elevated … to neglect the minuter characteristics of nature, and to depend more upon the *chiaro oscuro*, and upon the beauty of his figures: yet he still continued to paint in the Flemish style, but it was in the broader manner'. In Pott's view while Gainsborough had neglected detail,

> *his works have encreased inconceivably in their merit and value … Nothing can be more charming, forcible, and harmonious than his colouring now is, his pencilling is broad and masterly, the light and shade wonderfully well managed, and the effect of his pictures not to be equalled by any master, antient or modern. His figures are admirable, and being beautifully adapted to landscape, afford a strong proof of how much this propriety assists the good effect of the whole.*

Pott, conceivably assisted by the artist himself, was alert to the stylistic changes in Gainsborough's landscapes, noticing how their relationships with the works of the Old Masters had become more complex and subtle as his career progressed. As explored below, in the 1770s Gainsborough was more self-consciously emulating Rubens and Claude, and referring to Salvator Rosa (1615–1673) and Filippo Lauri (1623–1694). Pott confirms that we are right in seeking to detect these formal connections, but also indicates that we should take special notice of the figures that populated Gainsborough's scenery.

The figures in Gainsborough's landscapes always had been integral to their content, and it is worth investigating how this was so. *Gainsborough's Forest* (cat.4) from the later 1740s had represented woodland, apparently near Sudbury, by adapting a composition developed from the study of Jacob van Ruisdael (see cat.3). The forest is shown as being used by the figures who inhabit it: each is rendered as independent. These are not labourers working for a wage, but autonomous figures taking their share of natural bounty. With the rapid spread of enclosure (of common land) and the associated phenomenon of engrossing (creating one large farm by purchasing many small ones) from the 1760s this kind of rural economy became contentious, for in the minds of the improvers it was economically inefficient. There was consequently a national debate over the relative merits of the cash against the moral economy, with agricultural capitalism pitched against a nostalgic vision of what was supposed to be the traditional way of country living. Perhaps the most significant cultural intervention in this debate was Oliver Goldsmith's enormously popular poem of 1770, *The Deserted Village*. This portrayed the socially catastrophic consequences of a village engulfed in the land-grabbing of an engrosser: as the village 'Auburn' loses its population to migration, it dies and a way of life disappears. On the evidence of his changing vision of the landscape from the late 1760s, this was a view to which Gainsborough was sympathetic.

In the *Evening Landscape* of c.1768–71 (cat.114) a procession of weary mounted figures winds out of a scene, in the left middle distance of which cottagers lounge in late sunshine. At the head of the procession is a couple of beasts with panniers laden with produce, perhaps to suggest that these people now have to buy what previously they might have grown, led by a girl and a young red-headed boy. He gestures to what we might not notice, for they are engulfed in deep shade: an old woman and a young girl,

Landscape and the Poor

Figure 50
Detail from **Cottage Door with Girl and Pigs** 1786 (cat.123)

slumped, and seeking alms. The girl turns her cheek, refuses charity. This harsh incident occurs in a landscape of exquisite beauty of painting and almost seems a figuring of Goldsmith's sad 'the rural virtues leave the land' as the population of Auburn migrates. Indeed, Gainsborough's landscapes in whichever media often featured processions of pedestrian or mounted poor moving into or out of space, and it is evident that such a painting as this, commissioned by John, 2nd Viscount Bateman (more usually his landscapes tended to be given to friends or to lie around unsold) corresponds in ethos to *The Deserted Village*. And in inviting our engaged sympathy, our active contemplation on the morality of this inversion of the theme of the Good Samaritan, the painting reveals that landscape itself had a potent charge when it came to investing figures with meaning.

That these figures who occupied Gainsborough's landscapes could equally be the patrician patrons of portraits or those impoverished urchins whom he brought into the studio to paint in the *Girl with Pigs* (cat.59) suggests a protracted and profound rumination on the interaction of figures with their natural surroundings. In *The Morning Walk* (cat.88) the colouristic harmonisation of the figures with their setting emphasises their virtuousness in enjoying so moral a pastime; a trope that would be used more ironically in the oval portrait of the Duke and Duchess of Cumberland (cat.89). In painting cottage scenes, or in inflating the figures of the poor on to a larger scale as with the late *Shepherd Boy* or *Woodman* (neither of which have survived, see fig.49 and cat.127), the artist may have been improvising on the kinds of pictorial themes so tellingly extrapolated in the *Shepherd Boys with Dogs Fighting* (cat.60). With these pictures, Gainsborough suggests, contrary to Reynolds, that a profound modern painting had to deal with modern subjects, and that from the Old Masters one needed to learn the practicalities of the pictorial, rather than a formal vocabulary that could express only some abstracted ideal. MR/MM

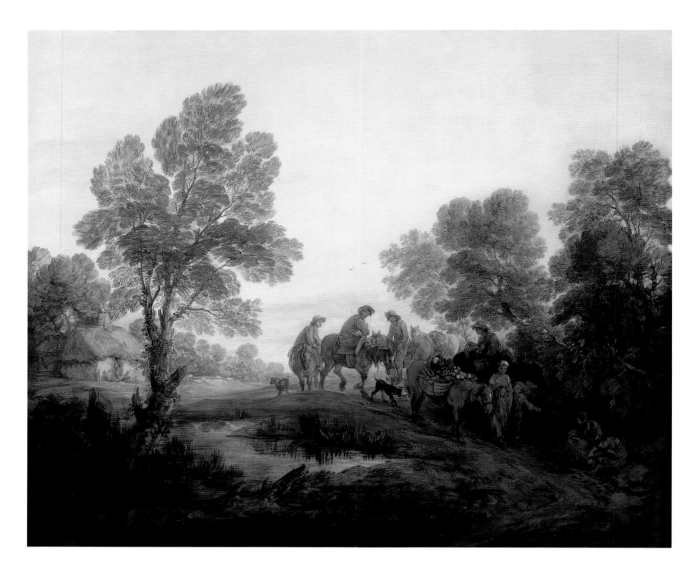

114

Evening Landscape with Peasants Returning from Market

*c.*1768–71

Oil on canvas, 122.3 × 150 (48⅛ × 59)

English Heritage (Kenwood, The Iveagh Bequest)

Hayes 1982, no.95

This serene evening landscape is one of a group of large-scale compositions that Gainsborough made around 1770. In these 'migration' pictures the well-established theme of peasants travelling to or from market took on a new direction, and centred on groups of rustic travellers and pack-horses following a woodland path in idyllic pastoral surroundings.

Like others in the group, *Evening Landscape* embodies a view of the countryside as a place of beauty and harmony, following in the tradition of the Arcadian visions of Claude. Nevertheless, Gainsborough's approach to landscape at around this time assumed a heightened poignancy and topicality in the face of the changes being effected in agrarian life. In this painting there is a sense of nostalgia for rural life, enhanced by the perfection of the lusciously green landscape bathed in a shimmering silvery light. There has been some debate about whether this is an evening or an early morning scene, but the wearisome poses and expressions of the travellers

would imply that they are returning after the labours of the day.

In earlier subjects in a similar vein, such as *Sunset: Carthorses Drinking at a Stream* (cat.33), the country people were included more as staffage, but the figures in this landscape, and in the other later migration subjects, took on a far greater significance. The group here, coming over the brow of the hill, consists of two peasant children leading a procession of horses heavily laden with panniers of vegetables, accompanied by four mounted riders. The presence of the children gives the impression of it being a family group although its make-up would suggest otherwise. The peasants approach beggars by the wayside, but while the young boy appeals to his older sister for charity, she resolutely ignores them. On the far left a distant cottage can be seen with a family outside the door, the first time that Gainsborough had included in a painting a motif that was to become the central focus in his 'cottage door' subjects of the 1770s and 1780s. DP

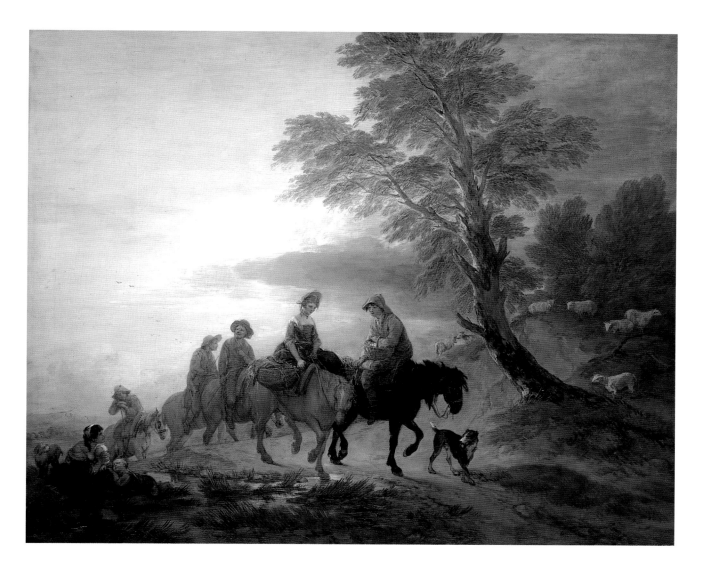

115
Peasants and Colliers Going to Market;
Early Morning
c.1773
Oil on canvas, 121.8 × 147.2 (48 × 58)
Private Collection

Hayes 1982, no.107

This idyllic landscape of peasants on their way to market is one of Gainsborough's most ravishing paintings. The impression of brilliant, early dawn light that pervades the scene gives a lyrical mood to the picture. While it may have been inspired by a similar effect of misty atmosphere in paintings by Rubens or Claude, its prevalence in one of Gainsborough's mature landscapes was essential to his vision.

In this and other migration pictures of around 1770 the rustic figures have assumed a dominance that has transformed the subject from being a landscape with incidental figures to one where they form the central narrative. The group of peasants ambling contentedly to market is led by a beautiful red-haired girl glancing down demurely, in the company of her admirer. The theme of rustic lovers had been taken up by Gainsborough in his earlier Suffolk works, such as the *Landscape with a View of a Distant Village* (cat.8), but here it forms the focus of the composition. The beggar-woman with her baby and sleeping child, who rests by the wayside, gazes up at

the courting couple, thus linking the theme of romance with that of motherly love. The figures are idealised and tinged by sentiment, and were not intended to display the harsh realities of life on the land.

The migration pictures were all bought or commissioned by important patrons in order to grace elegant country-house interiors, and it is not difficult to imagine how such luminous pastoral visions, steeped in tradition yet simultaneously 'modern', would have helped to advertise the civilised values of those who acquired them. This painting was purchased in 1773 soon after its execution by the artist's banker, Henry Hoare (d.1785) of Stourhead, for 80 guineas. It was hung as an overmantel in the celebrated Cabinet Room there and later added to the new picture gallery at Stourhead, alongside works by Nicolas Poussin (1594–1665), Carlo Dolci (1616–1686) and other Old Masters. DP

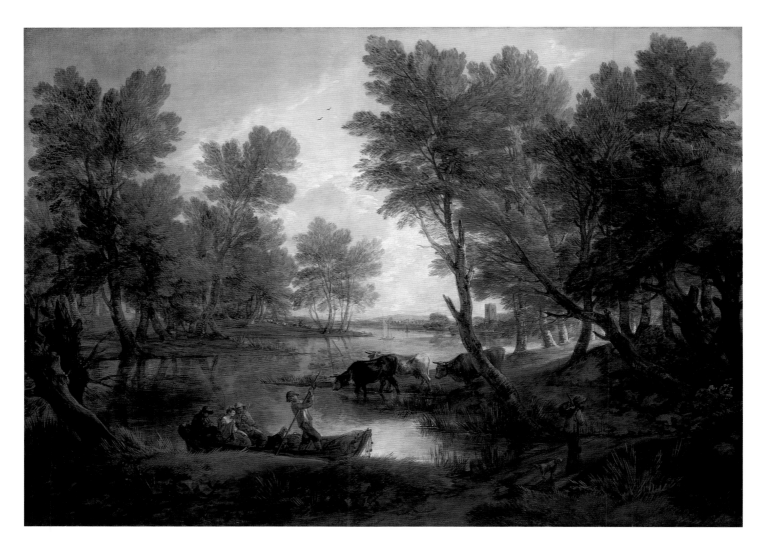

116

View near King's Bromley-on-Trent, Staffordshire

1769–70
Oil on canvas, 119.4 × 168 (47 × 66⅛)
Philadelphia Museum of Art: The William
L. Elkins Collection, 1924

Hayes 1982, no.94

Unusually for Gainsborough, this landscape has been identified with a specific location. It is a view near King's Bromley-on-Trent, in Staffordshire, the country seat of Samuel Newton (d.1783). Although the picture had been known by this title since its sale at Christie's in 1870, the description was not generally accepted, largely because of the general assumption of Gainsborough's aversion to painting topographical views (expressed by the artist in a letter of the early 1760s, see cat.7) and because of the common tendency in the past to attach fanciful titles to Gainsborough's landscape compositions.

However, it is now established that this does represent King's Bromley. The view is taken from about half a mile upstream, on the south side of the River Trent, the position of the north terrace of Samuel Newton's property. It is interesting that, although this is, in effect, Gainsborough's only known 'country-house view', he has chosen to paint what was seen looking out from the property, rather than the mansion itself. The tower of All Saints Church in the middle distance is recognisable, although Gainsborough has exaggerated

other details, such as the width of the river, and has probably added the footbridge in the foreground and the distant sailing vessels.

While the landscape is essentially topographical, the composition – with its winding river, distant church between trees and group of cattle drinking – contains many of the elements found in Gainsborough's more imaginary scenes. The carefree theme of the picnic party in the fishing boat was a new invention, and gives an idyllic focus that accords well with the beautiful effects of light and its reflections in the water. DP

Landscape and the Poor

117

Wooded Landscape with Family Grouped outside a Cottage Door (The Woodcutter's Return)

c. 1772–3
Oil on canvas, 147.3 × 123.2 (58 × 48½)
Duke of Rutland, Belvoir Castle, Leicestershire

Hayes 1982, no.105

Although the theme of a family group gathered around the door of a humble dwelling made its first appearance in the background of *Evening Landscape* (cat.114), this is the earliest of Gainsborough's 'cottage door' paintings. The subject was developed here on a large scale into a fantasy perfectly suited to express the artist's poetic vision and his feelings about the changing face of the countryside.

The family wait patiently for the return of the male provider, who approaches the cottage, laden with firewood. The figure of a woodman had been a familiar one in Gainsborough's landscapes since at least 1748 (see *Gainsborough's Forest*, cat.4). Here the figure is shown as stooped and anonymous. The way he carries his burden is reminiscent of Christ carrying the cross, and an element of religious symbolism is also apparent in the group of the mother surrounded by her family: the smaller children are described by John Hayes as looking 'like putti who have escaped from a Correggio altarpiece'. This figure was to become a more individual character in Gainsborough's later imagery, culminating in

the single figure subject of *The Woodman* (1787; destroyed; see cat.127), which was much admired at the time.

The painting was purchased from the artist by Charles Manners, later 4th Duke of Rutland (1754–1787). It is almost certainly the landscape with a cottage mentioned in an anonymous poem of 1773 as a 'scene of beauty, and domestic love'. The young aristocrat was both adventurous and determined in wanting to acquire such a picture by Gainsborough and reportedly 'laid about him, like a dragon to buy pictures'. He later bought two other fine landscapes by Gainsborough for the great art collection he was forming at Belvoir Castle. The subject clearly appealed to Gainsborough's contemporaries, for his friend Felice de Giardini (1716–1796) commissioned an exact replica of the picture, one of the rare instances in which the artist repeated one of his own designs. DP

118

Wooded Landscape with a Peasant Asleep in a Cart

*c.*1760–5
Watercolour, bodycolour and pencil on brown
paper, 28.1 × 38 (11¹/₁₆ × 15¹⁵/₁₆)
The Ashmolean Museum, Oxford. Presented
by Mrs W.F.R. Weldon, 1934

Hayes 1970, no.266

This delicate finished watercolour is one of
numerous drawings that Gainsborough made
from the 1750s onwards of figures riding in carts
or wagons along a country road. Others include
Drover with Calves in a Country Cart (cat.10), the
large *Wooded Landscape with a Country Cart*
(cat.163) and a drawing in the British Museum
(cat.119), the last of which shares the motif of
the boy languishing in the back of the cart.
Another version of the composition here is also
recorded (Hayes 1970, no.267).

The theme remained a dominant one in
Gainsborough's landscape compositions until
the end of his career and was explored not only
in drawings but also in soft-ground etchings,
such as *Wooded Landscape with Two Country
Carts and Figures* of *c.*1779–80 (cat.162). The
ideas explored in these graphic media were
absorbed into his paintings around the subject,
which culminated in *The Market Cart* (1786–7;
National Gallery, London).

This watercolour contains many of the
elements found in other compositions of
peasants in woodland carts. The large-wheeled
vehicle here is pulled by two horses and travels

along a winding rutted track through dense
woodland. In the foreground is a large log and
to the right a tumbledown fence, both of which
motifs can be found in *The Harvest Wagon*
(cat.43). The device of the cart pulling away
diagonally from the viewer helps to lead the eye
into the picture's space and to effect the
transition between foreground and distance.

The watercolour is executed with the
high degree of finish that characterises many
of Gainsborough's drawings of the 1760s.
It is among the most accomplished of his
landscape drawings on the subject and
succeeds in capturing a spirit of place and
time, as the cart carrying the sleeping boy
wends its way through the secluded wood
on a lazy afternoon. DP

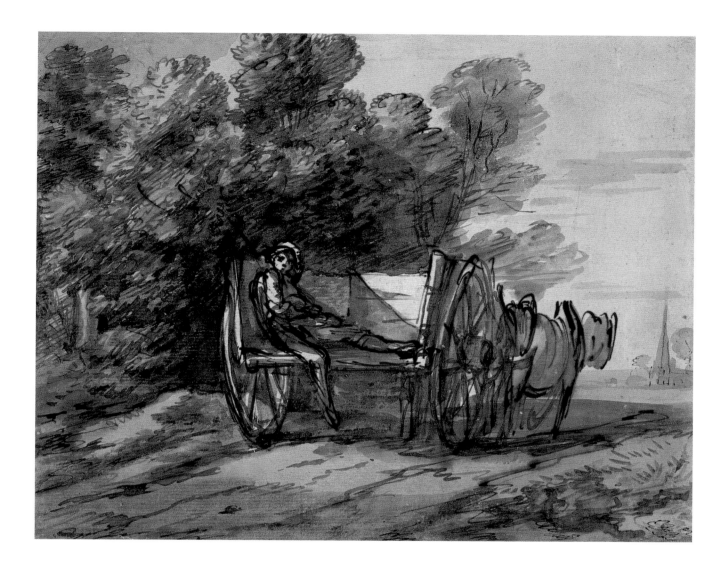

119

Wooded Landscape with a Boy Reclining in a Cart

*c.*1765–70
Pen and brown ink with wash, 17.6 × 22.1
(6¹⁵⁄₁₆ × 8¹¹⁄₁₆)
The British Museum, London

Hayes 1970, no.307

This is one of several drawings by Gainsborough showing figures and carts travelling along a country track. The subject was developed into *The Harvest Wagon* (cat.43), which was itself later modified into another oil of the same title (1784–5; Art Gallery of Ontario, Toronto). In composition, this drawing is quite close to the earlier painting, with the cart seen from behind moving away from the spectator past dense woodland on the left towards a distant church. However, the sketch is far less complex and shows only a single figure and one of the horses pulling the cart. The figure here is a peasant boy, slumped in the back of the cart, returning home after the labours of the day. His relaxed pose, dangling his right leg over the open back of the vehicle and apparently whistling merrily, gives him the carefree air of one who is engaged in the simple joy of just being alive. Since Gainsborough so often pictured figures resting in wagons or carts, one can speculate that it was an experience that the artist envied, though he felt himself to

be more like one of the hard-working horses (see p.212).

The handling in this lively sketch is much freer than in other drawings on the subject (such as cat.118). The penwork is unusually bold and sketchy, with the rapid squiggles delineating the track and the sweeping lines used to outline the horse and indicate its foreleg in movement. DP

A LADY and her CHILDREN relieving a COTTAGER.

120

John Raphael Smith (1751–1812) after William Redmore Bigg (1755–1828)

A Lady and her Children Relieving a Cottager

published 1 July 1782 by J.R. Smith and James Birchall, and 1 March 1784 by James Birchall

Mezzotint, 45.4 × 55.3 (17⅞ × 21¾)

The British Museum, London

The present print is one of two mezzotints engraved by John Raphael Smith after companion paintings by William Redmore Bigg. The other picture, engraved by Smith in 1781, was entitled *School Boys Giving Charity to a Blind Man*. Smith exhibited both prints at the Free Society of Artists in 1782. The print typifies the way in which the dispensation of charity by private individuals was presented in late eighteenth-century Britain. Here a fashionably attired lady shepherds her reluctant daughters towards the indigent peasant woman, who gratefully receives the coins proffered by the tearful younger child. The cottager's plight is underlined by the grotesque juxtaposition of her hovel and the polite family's landed estate, as well as the presence of the black servant and the yapping lapdog. Such prints would have been received less as illustrations of the privations endured by the rural poor than as reassuring reminders of benevolence of the moneyed classes, conscious of their Christian duty. By the time

he made the present print Smith was established in Oxford Street as an independent print publisher, enjoying a lucrative business partnership with the printseller James Birchall. In 1795 Birchall sold the copper plates for the present print and its companion, with 830 plain impressions, for £49 7s. MP

121

**Cottage with Peasant Family and
Woodcutter Returning Home**

*c.*1777–8
Pen, ink, grey and grey-black washes and
white chalk over pencil, 27 × 35 (10⅝ × 13¹¹⁄₁₆)
Birmingham Museums & Art Gallery.
Bequeathed by J. Leslie Wright, 1953

Hayes 1970, no.451

The theme of peasants grouped around a
cottage door was one that occupied
Gainsborough from around 1773 to the end of
his career. This drawing of a large family
gathered in front of a thatched cottage, with a
woodman returning home carrying a bundle of
faggots, is a horizontal adaptation of *The
Woodcutter's Return* (cat.117), the first of his
cottage door paintings. The concept was
more fully developed in the oil of *Peasant
Family at a Cottage Door* (*c.*1778; Cincinnati Art
Museum), and it was around this date–also
when this drawing was made–that the theme
became a particular concern of Gainsborough's.
In the Birmingham collection alone there are
six landscape drawings with figures in front of
rustic hovels.

Although Gainsborough's preoccupation
with the cottage door extended to both
drawings and oils, sketches such as this were
not necessarily preparatory compositional
studies for paintings. Rather their purpose
seems to have been as preliminary studies in
which to explore or evolve the theme, and to
formulate his ideas. An exception is *Wooded
Landscape with Figures outside a Cottage*
(*c.*1778; HRH Duchess of Kent), on which the
Cincinatti painting was closely based. The
drawing here obviously caused the artist
some concern as the diagonal tree on the left
was reduced in size, presumably in order to
balance it with the figure of the woodcutter on
the right. The loose handling and the use of
monochrome washes and chalk were the
drawing methods adopted for nearly all of the
later works on paper exploring the theme. It
was a technique that the artist must have felt
was well suited for quick sketches, which
were more concerned with ideas than with
capturing specific detail. DP

122

Cottage Girl with Dog and Pitcher

1785

Oil on canvas, 174 × 124.5 (68½ × 49)

National Gallery of Ireland

Waterhouse, no.803

Figure 51
Thomas Gainsborough after Bartolomé Esteban Murillo
The Good Shepherd *c.*1778–80
Oil on canvas, 175.9 × 132.6 (69¼ × 52¼)
Private Collection

Painted in the spring of 1785, *Cottage Girl with Dog and Pitcher* was regarded by the *Morning Herald* as 'a subject which promises to rival his *Shepherd Boy*' (see fig.49). It was purchased almost immediately for 200 guineas by Sir Francis Basset, later Lord de Dunstaneville. According to Henry Bate the child in the picture was a young peasant girl whom Gainsborough had met near Richmond Hill, where he then had a residence. She is supposed to have been the same girl who modelled for Gainsborough's *Girl with Pigs* of 1782 (cat.59), although this appears to have been a different, if physically similar child. Modern commentators have found the picture disturbing in its combination of rural indigence and sentiment, the child's attractiveness appearing to undermine the reality of her impoverished situation. There is no indication, however, that Gainsborough's contemporaries found the image other than 'natural and pleasing'. To this audience the cottage girl was perceived primarily as an aesthetic object rather than a real flesh-and-blood individual. Such an image, while eliciting sympathy, also reminded the public of its own capacity for carrying out good works, the existence of the poor being regarded as an enduring opportunity for philanthropy rather than a problem to be eradicated. Here the potential of the child to elicit sympathy is increased by the responsibilities she bears, in the form of the puppy and the pitcher. These emblems elevate the child to an iconic stature, as this secular image assumes the moral high ground of sacred art. In this respect she is reminiscent of images of the Christ Child as the Good Shepherd by the Spanish artist Murillo (1618–1682), a version of which Gainsborough had copied in the late 1770s (fig.51). The pitcher, in particular, has a connotation in Christian iconography relating to mortality. Its fragility is highlighted in Gainsborough's painting through its fractured surface, a reminder, perhaps, of the frailty of the child's innocence.

Although this is a 'fancy picture', the portrayal of a type rather than a specific individual, there are strong formal links with contemporary society portraiture where the depiction of polite young ladies with small dogs was commonplace. Indeed, the pose and demeanour of the girl in the present picture are strikingly similar to Pompeo Batoni's 1761 portrait of Louisa Grenville (Chevening, Kent), painted for her uncle Lord Temple. The similarity, however, may well be generic rather than specific, since it is questionable whether Gainsborough knew Batoni's picture. MP

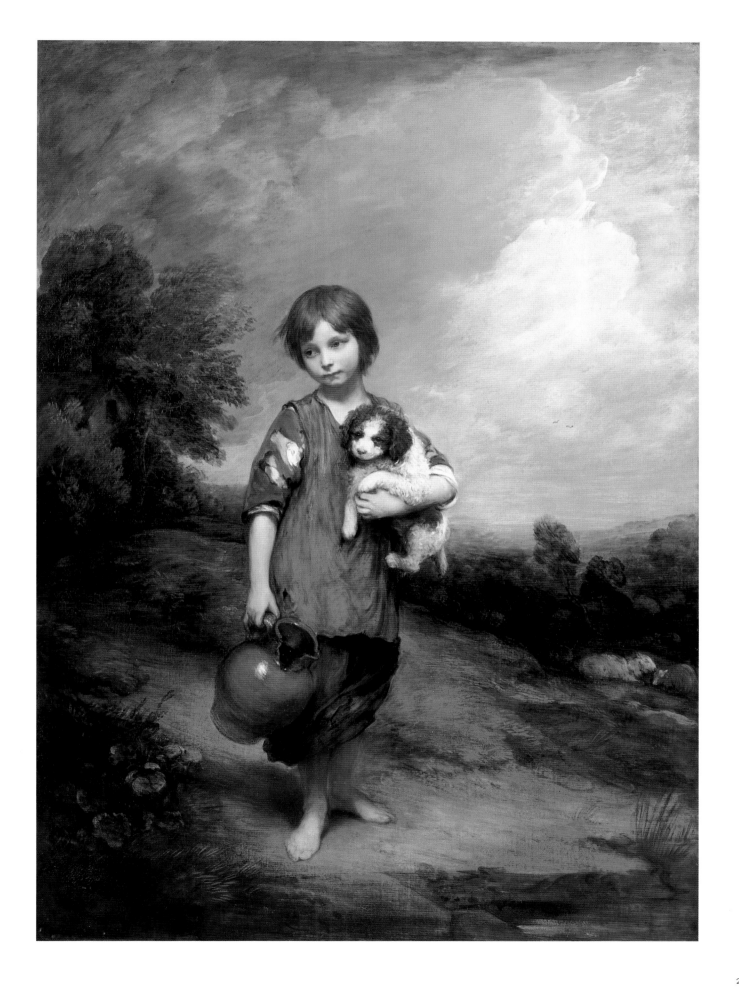

123
Cottage Door with Girl and Pigs
1786
Oil on canvas, 98 × 124 (38⅝ × 48⅞)
Ipswich Borough Council Museums and
Galleries, Acquired with the assistance of the
National Art Collections Fund, the Victoria and
Albert Museum Grant-in-Aid Fund and the
National Memorial Fund

Hayes 1982, no.174

On 24 May 1786 the *Morning Herald* noted:
'Mr. *Gainsborough* is, at this time, engaged
upon a beautiful landscape, in the foreground
of which the *trio* of pigs, that are so highly
celebrated by the connoisseurs, are
introduced; together with the little girl, and
several other rustic figures.' As the
correspondent (probably Henry Bate)
observed, the central motif of the little girl and
pigs was taken from Gainsborough's *Girl with
Pigs* (cat.59), which he had exhibited at the
Royal Academy in 1782. The figure of the
standing woman with the broom also appears
in another of Gainsborough's paintings, an
unfinished full-length fancy picture known as
The Housemaid (c.1782–6; Tate). Behind her is
a seated woman cradling a baby, a central
motif in a number of Gainsborough's earlier
'cottage doors'. To the right of the picture is a
shepherd, and in the foreground two cows are
grazing. Unlike these earlier cottage doors,
where the figures are clearly conceived as an
integrated family unit, the protagonists in the
present picture are curiously isolated, both
physically and emotionally, preventing the
formation of a coherent narrative structure.
In this way the composition takes on an
allegorical aspect, each figure representing a
distinct aspect of an idealised rural domestic
economy: motherhood, industry and
husbandry. Uniquely among Gainsborough's
cottage doors, the landscape composition is
influenced by Claude, notably through the
introduction of the framing tree to the right of
the cottage. This in turn underpins the
'classical' aspect of the picture and its
preference for symbolic representation over
sentiment. The picture was completed by
August 1786 when it was purchased by
Wilbraham Tollemache, later 6th Earl of
Dysart, who a few years earlier had purchased
Gainsborough's *Shepherd Boys with Dogs
Fighting* (cat.60). MP

Landscape and the Poor

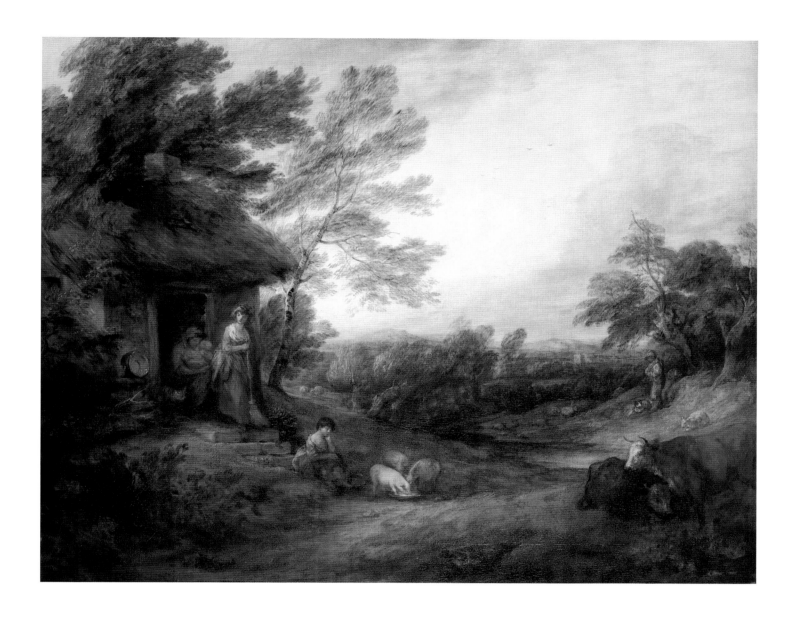

124
Woman Seated with Three Children
*c.*1780–5
Black chalk and stump, heightened with white
chalk on paper, 35.9 × 24.2 (14⅛ × 9⁹⁄₁₆)
The Pierpont Morgan Library, New York

Hayes 1970, no.845

125
Beggar Boy
*c.*1780–5
Black chalk and stump, heightened with white
on pale buff paper, 24.9 × 19.4 (9¾ × 7⅝)
The Ashmolean Museum, Oxford. Presented
by Mrs W.F.R. Weldon, 1934

Hayes 1970, no.832

126
Studies of Girls Carrying Faggots
*c.*1780–5
Black chalk and stump, heightened with white
on paper, 39.5 × 34.9 (15⁹⁄₁₆ × 13¾)
Yale Center for British Art, Paul Mellon
Collection

Hayes 1970, no.840

During the 1780s Gainsborough created a
number of extraordinarily fluent studies of rural
types. With these we sense the new
monumentality Gainsborough gave to his rustic
figures in his paintings of the period. His
draftsmanship is remarkably economical,
conveying an impression of substance and
movement through the most minimal means; the
interrelationships between black chalk and white
highlights, and the active use of the tone of the
paper, are almost musical in their muscular
subtlety. The motif of cat.124 can clearly be
related to the family groups found in his cottage
door and migration subjects, and to the compact
group of the impoverished mother and her
children in cat.123. In turn, the motif evokes the
tradition of Madonna and Child imagery, notably
Raphael's iconic depictions of the theme. A
simple rustic subject is thus endowed with a
greater degree of poignancy by this pictorial
context, and a certain emotional power from the
sheer daring of the manner of its depiction. The
figure of a poor girl carrying a faggot which
appears in cat.126 relates thematically to the
painting *Peasant Girl Gathering Sticks* (1782;
Manchester City Art Gallery; Waterhouse,
no.798), though deploying a different model. This
painting, like the *Cottage Girl with Dog and
Pitcher* (cat.122), raises a diminutive and
impoverished child to monumental status, in a
format evocative of society portraiture.

Cat.125 is one of several drawings made of
beggar children. The model is probably the
same boy who sat for Gainsborough's painting,
A Shepherd, exhibited at the Royal Academy in
1781 (see fig.49). Certainly, the pose and the
clothing of the boy in the present drawing are
reminiscent of the boy in the exhibited picture.
In making these sketches of beggar boys
Gainsborough was particularly influenced by
Murillo, a copy of whose *Christ Child as the
Good Shepherd* he had himself copied when it
was with the auctioneer, James Christie, in 1778
(fig.51). As *A Shepherd* indicates, it was also
Gainsborough's intention that his own paintings
of beggars should be viewed as secular icons.
MP/MM

Landscape and the Poor

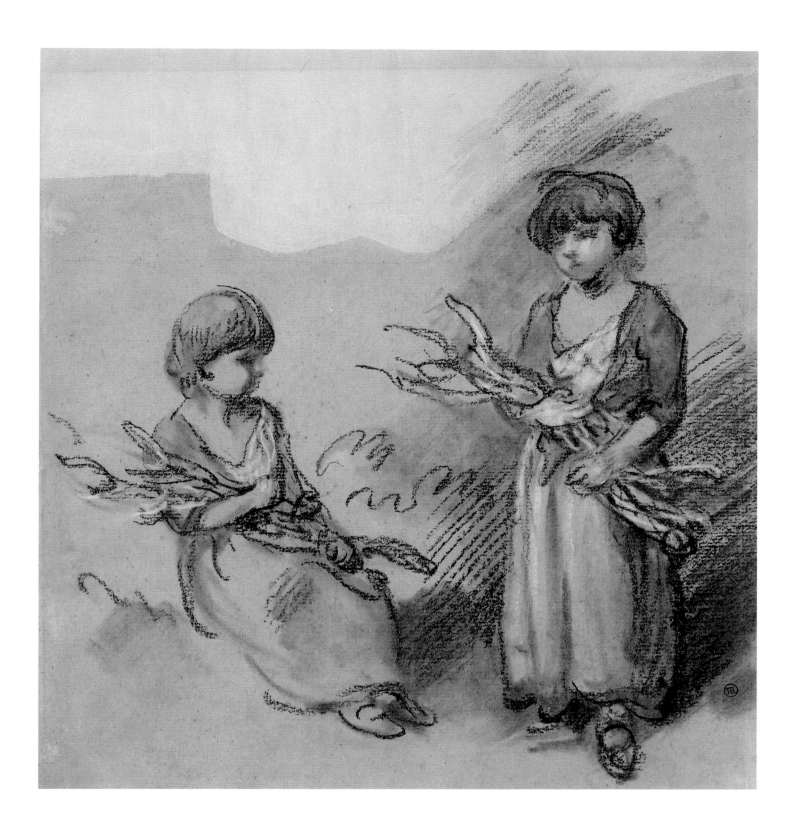

127
Peter Simon (c.1750–1810) after Gainsborough
The Woodman
published 4 June 1790 by John and
Josiah Boydell
Stipple, 64.3 × 43.2 (25⅜ × 17)
Lent by the Trustees of Gainsborough's
House, Sudbury (purchased with
contributions from the MGC/V&A Purchase
Grant Fund and the Museums Association
[Beecroft Bequest], May 1990)

This is the engraving made from
Gainsborough's celebrated picture,
The Woodman. The original painting
was destroyed by fire in 1810 at Exton Park,
Rutland. The painting, which measured
nearly eight feet by five feet (2.4 × 1.5 metres),
was painted in the summer of 1787.
Gainsborough's model was in reality
'a poor smith worn out by labour, and now a
pensioner upon accidental charity'. According
to Bate, Gainsborough was so impressed by
the man's 'careworn aspect' that he took him
home – although it is not clear for how long or
under what circumstances he remained under
the artist's roof. Gainsborough made several
sketches of the model, each in the character
of a woodman. However, none of these
correspond to the finished composition, in
which the figure stands in the manner of a
pilgrim, looking towards the skies.
Gainsborough regarded *The Woodman* as
among his best works, singling it out for the
attention of Reynolds, when he asked him to
visit him on his deathbed: 'my Woodman', he

said, 'you never saw' (*Letters*, p.176).
Recalling this meeting, Reynolds noted how
Gainsborough had told him that he was just
beginning to see his own shortcomings which
'he flattered himself in his last works were in
some measure supplied' (Wark, p.252).
The painting remained unsold during
Gainsborough's lifetime, being purchased
in 1789 by the Earl of Gainsborough for 500
guineas. He sold it to Sir Gerald Noel Noel, at
whose residence it subsequently perished.
John and Josiah Boydell, proprietors of the
Shakespeare Gallery, published the present
engraving. The print's inscription suggests
that the image was inspired by William
Cowper's poem, *The Task*, of 1785. While it is
possible that Gainsborough had this poem in
mind, the reference to it in the inscription was
probably intended to make the print more
saleable by providing a literary context. MP

Landscape and the Poor

128

Wooded Landscape with Country Mansion, Figures and Animals

*c.*1780–5
Grey and black washes, black and white chalks, 26 × 37.1 (10¼ × 14⅝)
The Whitworth Art Gallery, The University of Manchester

Hayes 1970, no.519

A number of drawings from the 1780s depict what appear to be largely imaginary country mansions. In the present drawing a gentrified family strolls about the terrace of their property. At the bottom of the steps sit a shepherd boy and dog, while to the left a drover herds cattle along a winding path towards the distance. None of these drawings relates directly to paintings by Gainsborough, although in certain details, notably the terrace and steps, the present work is reminiscent of the cut-down composition known as *Charity Relieving Distress* (cat.129). During his early career Gainsborough's interest in architecture had emerged fitfully in pictures of the later 1740s such as *The Charterhouse* (cat.6) and a *View of St Mary's Church, Hadleigh* (Private Collection). It was not, however, until the early 1770s that Gainsborough, influenced by the example of Gaspard Dughet (1615–1675), began to incorporate classical architecture into his drawings. Although he made frequent and repeated visits to the country seats of his aristocratic patrons he proclaimed that he had no interest in depicting their houses or estates. MP

129
Charity Relieving Distress
1784
Oil on canvas, 98 × 76.2 (38⁹⁄₁₆ × 30)
Private Collection

Waterhouse, no.988

Figure 52
Richard Banks Harradan after Thomas Gainsborough
Charity Sympathising with Distress 1801
Mezzotint, 59.6 × 42.8 (23½ × 16⅞)
Gainsborough's House, Sudbury

Gainsborough exhibited this painting at his inaugural exhibition at Schomberg House in the summer of 1784. It was described then by Henry Bate in the *Morning Herald*:

> *This picture consists of an elegant building, in one of the approaches to which is an ascent of steps, and at a distance an arch through which a loaded mule is passing. The principal objects are a beggar woman, who is receiving relief from a servant belonging to the house. The beggar has an infant in her arms and one on her back, and is also surrounded by others, some of whom appear terrified at a dog who will not suffer their approach to the house. Two children on the steps of the door are represented making observations on the circumstance. A very fine summer sky is introduced. A vine is represented against the side of the house; several pigeons, also, are descried fluttering about the building. The whole of which forms a beautiful assemblage of an interesting nature.*

Since that time the appearance of the picture has altered considerably. In 1787 Gainsborough reworked the composition, and perhaps then, or sometime later, it was cut down to its present size. An engraving of 1801 (fig.52) and a copy, perhaps by Gainsborough Dupont (Indianapolis Museum of Art), show the picture as it appeared before it was cut down.

The picture extols the Christian act of charity, exemplified by the actions of the servant girl. Gainsborough, however, adds an ironic twist to the narrative, since the beggar woman, loaded down with children, her breasts partially exposed, is herself recognisable as an allegorical figure of Charity. In presenting alms the wealthy provide for the poor. The emblematic figure of Charity, however, through providing an opportunity for benevolence, ultimately bestows the greater gift. The presence of the Holy Spirit, who hovers above the principal group in the form of a white dove, would appear to confirm the picture's spiritual dimension. It is also worth noting that Gainsborough's beggar woman is loosely modelled on a figure of Charity by Reynolds, one of a series of emblematic 'Virtues' then being installed in New College Chapel, Oxford.

Among those details present in the engraving by Richard Harradan, but removed from the original picture, are the two young women gossiping by a doorway, above which is a coat of arms, indicating the ennobled status of the house's owners. Perhaps the most significant loss is the figure of the mounted friar, who rides through the arch to the left of the large house, and the steeple of the church beyond. The omission of these details arguably reduces the impact of the picture's overall religious iconography, the presence of the monk – who effectively turns his back upon the scene – contributing to the poignancy of the beggar woman's situation. The engraving, published by Robert Bowyer some twelve years after Gainsborough's death, was dedicated to 'the Nobility & Gentry, whose humane exertions are employed in alleviating the distresses of the Poor'. MP

Landscape and the Poor

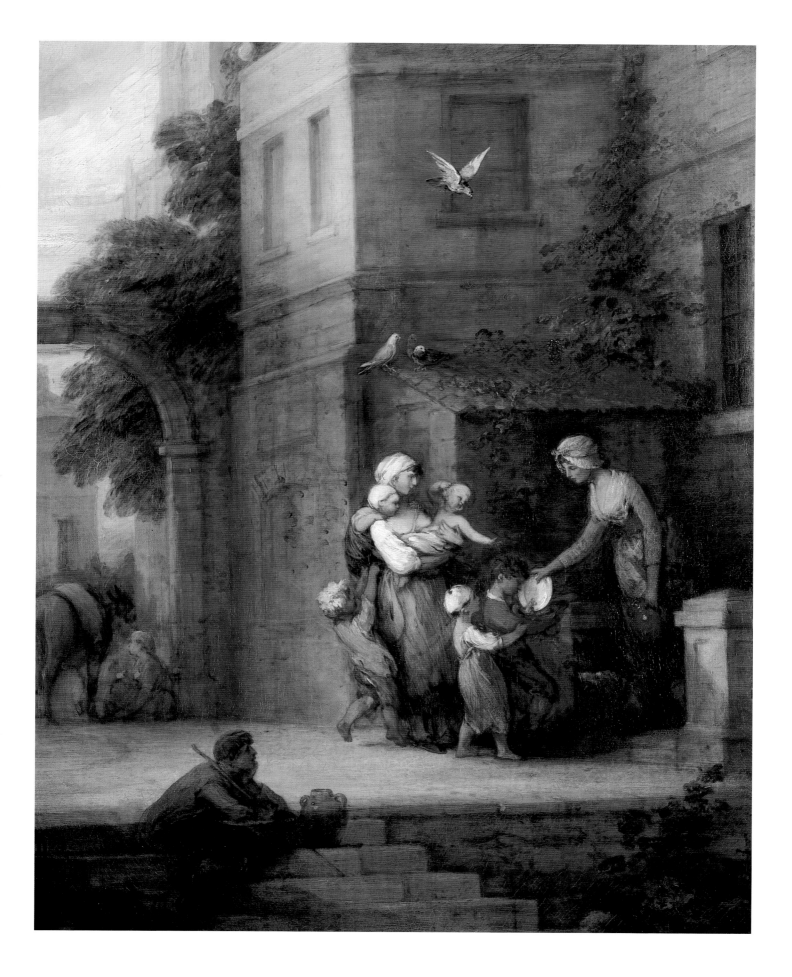

233

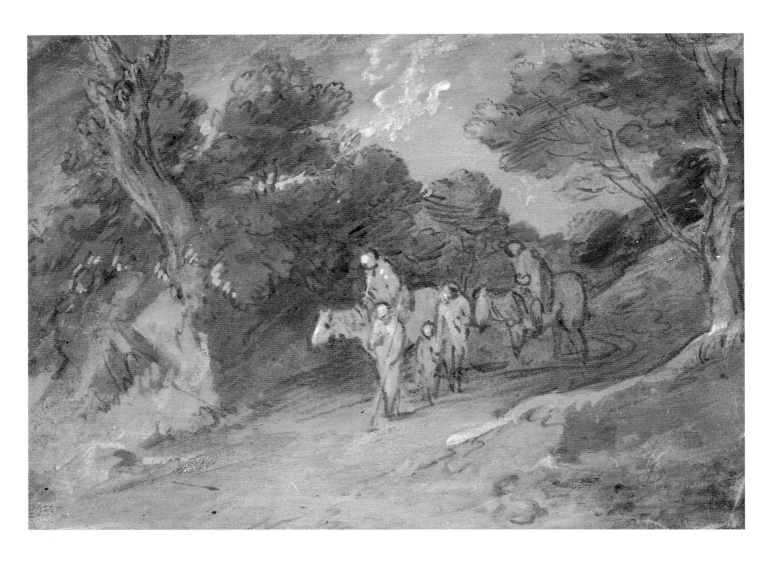

130

**Road through a Wood, with Figures on
Horseback and Foot**

*c.*1783
Pen and ink, oil, chalk and varnish on paper,
22.1 × 30.5 (8¼ × 12)
Courtauld Gallery, Courtauld Institute of Art

Hayes 1970, no.724

Gainsborough explored the theme of
migration intensively in paintings such as
cats.114 and 115, and in drawings. While the
oils are more obviously intended to show
peasants travelling to or from market, this
drawing lacks any specific details to indicate a
particular subject. The figures here – two on
horseback, accompanied by two others with a
child on foot – could be returning wearily from
market, but appear to represent a more
generalised group of rural poor, travelling
aimlessly along a country road.

Gainsborough adopted an unusual drawing
technique for this composition. In addition to
his commonplace use of black and brown
chalks and washes, oil pigments have been
used as highlights and the whole coated with
varnish. A radiograph suggests that the
effects in this drawing have been considerably
reduced by chemical changes over the course
of time. Gainsborough's experiments with
mixed media for drawings began in the late
1760s: in 1772 he exhibited 'two landscapes,
drawings, in imitation of oil painting', one of
which may be identified with cat.132. While
this later drawing incorporating oil and varnish

was not intended to delude the eye or appear
as a painting, the technique was nevertheless
one that segregated it from others and thus
seems to confer on it some special intent. The
composition is closely related to an aquatint,
Wooded Landscape with Riders, of the mid-
1780s, which was later published by Boydell
(Hayes 1971, no.14). DP

Landscape and the Poor

131
John Keyse Sherwin (1751–1790)
The Deserted Village
published 1 September 1787 by J. Kirby
Engraving, 47 × 59.5 (18½ × 23⅜)
The British Museum, London

If Gainsborough's landscape images of the late
1760s and 1770s can be interpreted as a concerned
commentary on the changes in the agricultural
economy and the rural life, he was far from alone in
his interests. The immense popularity of
Goldsmith's *Deserted Village* (1770) testifies to the
widespread appeal of that poet's nostalgic vision of
a lost world of rural innocence. Many artists took up
the theme of rural poverty, drawing on sentimental
literature for their sources. *The Deserted Village*
was illustrated in two prints by James Gillray from
1784, and again in this print by the promising young
draughtsman and engraver Sherwin. A second print
by Sherwin, the partner to this one, showed 'The
Happy Village'. Literally illustrating his source,
Sherwin depicts several generations of a family of
villagers moving out of their home as all around
them the work of agricultural modernisation goes
on. In his images, Gainsborough may have
endeavoured to create a more generalised vision of
the landscape, one that could evoke the Old
Masters and demonstrate his own technical and
formal ingenuity in an emphatically non-literary way,
but his works are none the less responses to the
same pressing social theme. MM

Ideal and Experimental Art: The Later Years

In May 1788 Gainsborough had written to a patron complaining of his 'Swelled Neck' but hoped that it 'is the near coming to a Cure' (*Letters*, p.174). He had, though, already signed his will, and his optimism would turn out to be misplaced. This was the cancer that was to take his life. As he lay dying from the disease in July 1788, he wrote a last letter to Sir Joshua Reynolds asking if he might come and look at his paintings, for 'my Woodman you never saw', and expressing his admiration and respect for his great rival (*Letters*, p.176). He died shortly afterwards, on 2 August. Reynolds recalled their last meeting in the fourteenth *Discourse*:

> If any little jealousies had subsisted between us, they were forgotten, in those moments of sincerity; and he turned towards me as one, who was engrossed by the same pursuits, and who deserved his good opinion, by being sensible of his excellence. Without entering into a detail of what passed at this last interview, the impression of it upon my mind was, that his regret at losing life, was principally the regret of leaving his art; and more especially as he now began, he said, to see what his deficiencies were; which, he said, he flattered himself in his last works were in some measure supplied. (Wark, p.252)

Evidently, in his last days Gainsborough reached some sort of rapprochement with Reynolds, who in turn by way of this *Discourse* was able, finally, to bring his rival into the academic fold. If Gainsborough's sensual, modernist art had necessarily to be allotted a secondary position within the academic hierarchy, Reynolds now at least recognised that it had a place in the nascent British School. What he testifies to, in the rather backhanded comment that Gainsborough in later years recognised the 'deficiencies' of his art, was the way that it had become varied and experimental, at least in part as a response to the agenda set by his great rival. While this gave licence to Reynolds's accommodation of Gainsborough within the Academy, it also had implications that went far beyond his prescribed strategies for British art.

In his last illness Gainsborough had written: ''tis odd how all the Childish passions hang about one in sickness, I feel such a fondness for my first imitations of little Dutch Landskips that I can't keep from working an hour or two of a Day, though with a great mixture of bodily Pain' (*Letters*, p.174). In this poignant expression of nostalgia Gainsborough was acknowledging both the constancy of his attachment to the rural scene, and how far his vision of the landscape and his means of expressing that vision had travelled and become transformed. The last decade or so of landscape production saw him testing out the limits of his techniques and expanding the imaginative range of his imagery. His first break with the Royal Academy was in a way heralded by his exhibition of drawings in imitations of paintings in 1772, works that challenged the institution's distinctions between what constituted finished and unfinished in a work of art (cat.132). From the mid-1770s he began experimenting with the latest printmaking techniques, such as aquatint and soft-ground etching, achieving completely novel effects and creating prints that had the fluidity and textural effects of drawing and could, even, be easily mistaken for drawings. It was a concern with managing every subtlety of his art that prompted the creation of his 'showbox', a device for viewing his own paintings on glass (see cats.152–6). Here he could intensify the effects of light and atmosphere that were such a concern in his landscapes created by more conventional means, contriving an experience of art far from

Detail from **Diana and Actaeon** c.1784–6 (cat.173)

the hurly-burly of the Academy's exhibitions but far also from the easy naturalism and open debt to the Dutch masters that characterised his earliest landscapes. In terms of his imagery, his 'schoolboy stile' was equally far behind him. Taking his lead from Claude and Dughet, his landscapes took on a new imaginative breadth: the conventional motifs of classical landscape painting were deployed within views of unprecedented painterly fluency. His meditation on the theme of peasants reading a tombstone, apparent in a now dismembered painting of 1780 (fig.53) and in one of the soft-ground etchings he planned to publish in that year (cat.159), compounds references to contemporary literature and high art in a complex and poignant way. Meanwhile, the rustic motifs that had originally occupied a minor role in his landscapes were taken up as monumental subjects in their own right. With both his landscapes and rustic figure subjects we can see the artist broadening his horizons, something he did quite literally in these years. In 1779 he took a trip to the Devon coast, and in 1783 travelled round the Lake District with

his old Suffolk friend, Samuel Kilderbee. It is also clear, from evidence presented by Amal Asfour and Paul Williamson, that Gainsborough travelled to the Low Countries later that same year, which, if previously undocumented, is also unlikely to have been the only time that the artist went abroad.

It is evident that in his final years Gainsborough was using painting to work out what art should do in modern society. The conclusion seems to have been that he should carry on painting the world in the way that pleased him. This much was implicit in the soft-ground etchings, or the portrait of Sarah Siddons (cat.165), and is confirmed in such portraits as the great *The Rt Hon. Charles Wolfran Cornwall* (cat.167). This is a brilliant essay on the use of black, which nods to Hogarth in its robust characterisation. It is contemporary with the artist's one attempt at a mythological subject, *Diana and Actaeon* (cat.173). In this deeply learned composition – for Gainsborough carried out meticulous pictorial research in its development – a fable was extracted from Ovid's *Metamorphoses* in order to explore what roles mythologies might

Figure 53
Maria Prestal after Thomas Gainsborough
The Country Churchyard 1790
Aquatint, 49.1 × 64.8 (19⁵⁄₁₆ × 25½)
Gainsborough's House, Sudbury

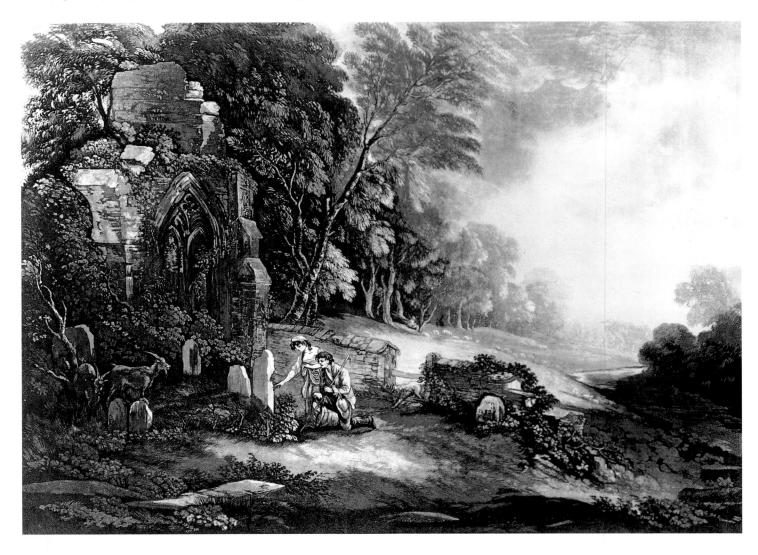

Ideal and Experimental Art: The Later Years

Figure 54
Detail from **Wooded Landscape with Herdsmen and Cattle**
*c.*1775 (cat.138)

now play. Slyly cocking a snook at the Earl of Shaftesbury, who had lambasted artists who committed the solecism of showing Actaeon's horns appearing at the moment the water hits his head, Gainsborough leached the subject of any narrative clarity. Instead, in playfully hinting at female form, his fragmented paint surface invites an engaged way of looking of a kind that would fill out these hints and thus involve spectators in a species of erotic voyeurism that mythological subjects and ideal nudes were claimed to neutralise. Moreover, in preparing his invention through at least three complex drawings, the artist once more raised the possibility that the drawing occupied the same status as the painting, and in this again produced an effective critique of academic theory. By the same token, when he came to paint the biblical subject, *Hagar and Ishmael* (cat.180), what he chose to depict was two figures trudging through forest: the theme is thus presented in the most prosaic form.

Reynolds told his audience in December 1788 that Thomas Gainsborough had been engaged in a prolonged contemplation on his art. This was of the greatest significance. It is evident, for instance, that he sometimes wished conspicuously to display his mastery of Old Master techniques in order to demonstrate a radical relationship with their art of rather a different nature from that advocated by Reynolds, for it appears that he understood the art of the past as supplying pictorial hints and solutions that would help in the realisation of such grand modern subjects as the late *Shepherd Boys with Dogs Fighting* (cat.60) and the *Haymaker and Sleeping Girl* (cat.179). Though each artist evidently remained to some degree in aesthetic opposition, their reconciliation and attempts at mutual understanding point up the extent to which each would have understood the fine arts as serving society in ways far more profound than the provision of luxury interior decorations. MR/MM

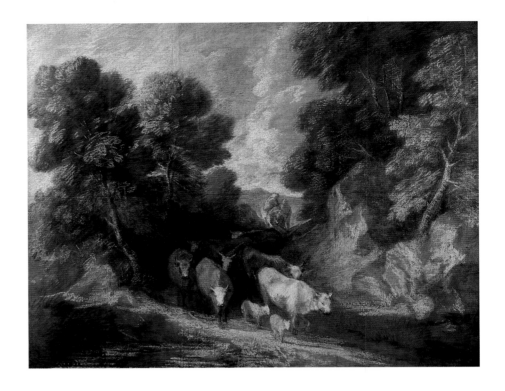

132

Rocky Wooded Landscape with Drovers and Cattle

c.1771–2

Mixed media on paper, mounted on board,
100 x 125 (39½ × 49)

The Faringdon Collection Trust

Hayes 1982, no.102

In February 1772 Gainsborough wrote that he had been 'trying a large Cartoon Landskip in the Way of Drawing ... & intend two spanking ones for the Exhibition' (*Letters*, p.94). This unusual work has been identified as one of the two resulting large landscape drawings 'in imitation of oil painting' exhibited at the Royal Academy in 1772 (as no.98), together with a group of eight smaller examples (no.99). The other large drawing is thought to be that in Indianapolis Art Museum (Hayes 1982, no.99). Although this work has been catalogued previously as an unfinished 'lay-in', that is, the initial sketch of a landscape composition that would be worked up into a finished state, it should be considered as a completed work of art since the artist was prepared to exhibit it. As such, it constitutes a challenge to the established hierarchies of artistic value promulgated by academic theory and compounded by the character of the art exhibitions. Drawings were meant to be only preparatory works for larger, finished paintings, representing initial thoughts or a more informal kind of art production that was marginal in theory, and were shown in the exhibitions away from the Great Room where most critics focused their attention. With the scale and the worked-through character of this work, Gainsborough confuses such distinctions.

Gainsborough described the technique he used to create such drawings in some detail in a letter to William Jackson of 1773, asking that he 'Swear now never to impart my secret to any one living' (*Letters*, p.111). It involved the application of dry white pigment, specifically the Bristol lead white that the artist had discovered to be superior to the more commonly used London variety, to specially prepared paper, dipping the drawing in skimmed milk to fix these whites, applying coloured pigments and finally, vitally, varnishing the paper on both sides 'to keep it flat'. Jonathan D. Derow's detailed analysis has confirmed the artist's use of these highly unconventional methods in numerous drawings, including the present example. MM

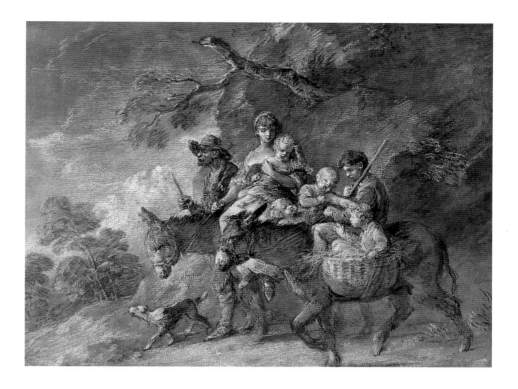

133
A Peasant Family Travelling to Market *c.*1770–4
Black chalk and stump, grey and brown wash
heightened with white chalk, on brown paper,
41 × 53.3 (16⅛ × 21)
Lent by the Trustees of Gainsborough's House,
Sudbury (purchased with the co-operation of
Timothy Clode Esq. and contributions from the
National Heritage Memorial Fund, the National Art
Collections Fund and other funds, January 1993)

Hayes 1970, no.826

134
Rembrandt van Rijn (1606–1669)
Flight into Egypt: A Night Piece 1651
Etching, 12.7 × 11 (5 × 4⁵⁄₁₆)
Lent by the Trustees of Gainsborough's House,
Sudbury

The motif of a peasant family travelling
through the landscape to market appears
frequently in Gainsborough's art, and formed
the focus of major canvases from the late
1760s and early 1770s (cats.114 and 115). In this
unusual drawing, which dates from this time,
Gainsborough imbues his travelling figures
with a sense of monumentality and grandeur,
casting them into a more compact
composition in which they dominate the
landscape. This format derives from
treatments of the theme of the 'Flight into
Egypt' found frequently in Dutch and German
art of the sixteenth and seventeenth
centuries. Writing to William Jackson in 1767,
Gainsborough made a typically satirical and
deflating reference to the theme: 'There is but
one <u>flight</u> I should like to paint,' he wrote, 'and
that's yours <u>out</u> of Exeter' (*Letters*, p.39). Hugh
Belsey has established that the present
drawing derives specifically from
Rembrandt's version of the subject in his
etching of 1651, as well as incorporating
references to Salvator Rosa and to the
sculpted putti heads of François Duquesnoy
(1594–1643). Gainsborough picks up on
something of Rembrandt's sonorous gloom in
his highly textural draughtsmanship and his
active use of the brown paper support as a
dominant tonal element. Rembrandt's prints
were well known and greatly admired in the
eighteenth century and his dramatic
management of light and shade was a model
for a number of artists. With the present
subject, Gainsborough takes a 'lowly' rural
theme and by reference to Rembrandt
endows it with a sense of greater

significance. What the precise content of this
image may be is, however, a moot point. The
family dynamic is not easy to interpret, with
the age difference between the man and the
young woman and the proliferation of
children, and the curious indifference they
display towards each other. And why a
woman travelling to market should be
compared to the mother of Christ is far from
self-evident. What is clear, though, is that
Gainsborough is here investing a rural subject
with some of the moral weight of biblical
narrative, and demonstrating that modern life
subjects are equally deserving of thoughtful
artistic treatment, even if what he was
thinking was not fully resolved. MM

135

Rocky Wooded Landscape with Rustic Lovers, Herdsmen and Cows

c.1773–5
Oil on canvas, 119.4 × 147.3 (47 × 58)
National Museums & Galleries of Wales.
Allocated by HM Government in Lieu of
Inheritance Tax 2000

Hayes 1982, no.113

Tradition has it that this landscape shares a history with *The Harvest Wagon* (cat.43), both having been painted at Shockerwick Park near Bath in 1774 and presented to its owner, Gainsborough's friend, Walter Wiltshire. This story is given some credence both by the paintings' provenance and their similarity in size. However, they differ significantly in subject and, if appearances are not deceptive, date, for this work manifests the easy and exceptional virtuosity the artist appears to have attained in the early 1770s. As John Hayes has remarked, this is manifestly an exercise in the Claudean mode – a good comparison would be with Claude's *Herdsman* of *c*.1635 (National Gallery of Art, Washington) – also noticeable in contemporary landscapes such as the painting in the Yale Center for British Art (Hayes 1982, no.108) and anticipated in earlier works such as *Wooded Landscape with Rustic Lovers* (1762–3; Philadelphia Museum of Art; Hayes 1982, no.79).

With a carefully-managed perspective into a golden and glowing distance we are invited to prospect a background which, in subtlety and depth of handling, brings to mind paintings of the Venetian Renaissance. The brushwork, as

John Hayes has noted, has become 'much bolder, rough slabs of encrusted white, yellow and pink impasto are laid on the sky with the palette knife and the rocks on the right are enlivened with tints of yellow, pink and violet'. Gainsborough's technical brilliance is also attested to by the exceptional soundness of the paint surface. It appears likely that at least parts of this invention had their origin in the landscape models he is reported as having made, for the rocks against which that youth so languorously leans have an obvious origin in lumps of coal. These, however, are successfully incorporated into a landscape that exploits the Arcadian associations of the Claudean to real effect. There is no rush in this terrain. The herdsman trudges unhurriedly behind his cows and goat, while the figures of the youth and girl – both attractive, perhaps to accord with pastoral convention – show no signs of urgency. In this there is a parallel with Gainsborough's contemporary essays on the theme of rural migration, in that both present a painted alternative to a world in which economic rationalism destroys the independence of a class; an alternative which we are persuasively invited to prefer. MR

Ideal and Experimental Art: The Later Years

136

Italianate Landscape with Travellers on a Winding Road

*c.*1774–6

Black chalk with watercolour and bodycolour, varnished, 22.5 × 30.9 (8⅞ × 12³⁄₁₆)

The Ashmolean Museum, Oxford. Presented by Mr Francis F. Madan

Hayes 1970, no.370

This landscape with its tall buildings, arched bridge and distant mountain is clearly not intended to represent a view in the English countryside. It appears to show an imaginary Italianate scene with travellers, one of whom is mounted, on a winding road. The seated figure by the wayside may be a beggar, similar to those found in the two migration paintings (cats.114 and 115). The composition with travellers harks back to the Old Masters and is reminiscent of Claude, particularly in the way the serpentine track, following the stream, leads the eye towards a sunlit distance.

The complex technique used for this drawing is experimental, combining black chalk with warmly coloured watercolour and oil, on grey-blue paper that has been varnished to achieve maximum effect. The broad treatment of wash and the sketchy outlining of the foliage give the drawing an unusual appearance but one that remains closer to the artist's other drawings, rather than oil sketches by him. The details of Gainsborough's extraordinary technique used in drawings such as this were communicated by the artist to William Jackson in 1773,

imploring him not to reveal the secret to anyone (see cat.132).

The purpose of such a drawing is not entirely clear. It is not a preparatory sketch for a painting nor one that formulated ideas on broad themes to be incorporated or worked up later into oils. Rather its subject and technique give the impression that it was made purely for the artist's own pleasure, perhaps the type of drawing that he created from models, when working at home in the evenings. It may have been made as a gift, for an inscription on the back reads: 'This Drawing was purchased at the Sale of the effects of the late Miss L Loscombe of the Bull Ring, Worcester, and was given by Thomas Gainsborough to her father an amateur and antiquarian.' DP

137 *top left*
**Mountain Landscape with Figures
and Buildings**
*c.*1775–80
Black chalk and white chalk on blue grey
paper, 26.2 × 40.5 (10⁵⁄₁₆ × 15¹⁵⁄₁₆)
Metropolitan Museum of Art, New York.
Rogers Fund, 1907

Hayes 1970, no.397

138 *top right*
**Wooded Landscape with Herdsmen
and Cattle**
*c.*1775
Pen and ink, wash and chalk, 26.7 × 35
(10½ × 13¾)
Lent by the Trustees of Gainsborough's
House, Sudbury (Gift of Miss Maud
Wethered, May 1988)

Hayes 1970, no.469

139 *bottom left*
Shepherd Tending Sheep in a Glade
*c.*1777
Black and white, heightened with yellow and
red chalks on blue laid paper, 30.2 × 41
(11⅞ × 16⅛)
Williamson Art Gallery and Museum,
Birkenhead, Wirral Museums Service

140 *bottom right*
**Mountain Landscape with Figures,
Sheep and Fountain**
*c.*1785–8
Grey and grey-black wash and oil with black
chalk on laid paper, varnished, and laid down
on wove paper, 21.6 × 30 (8½ × 11¹³⁄₁₆)
Yale Center for British Art, Paul Mellon
Collection

Hayes 1970, no.725

In his *Anecdotes of Painters* (1808) Edward
Edwards discussed Gainsborough's drawings
at some length. After noting his earliest
efforts, which exhibit 'a judicious attention to
the minutiae of nature' he distinguished a
'second class' of drawings:

> where he adopted a very different manner,
> both of style and execution, the subjects
> being more romantic in their composition,
> and their execution more indeterminate,
> and (if the expression may be allowed)
> more licentious than those of the former
> class. These last were executed by a
> process rather capricious, truly deserving
> the epithet bestowed upon them by a witty
> lady, who called them moppings.
> Many of these were in black and white,
> which colours were applied in the
> following manner: a small bit of sponge
> tied to a bit of stick, served as a pencil for
> the shadows, and a small lump of whiting,
> held by a pair of tea-tongs was the
> instrument by which the high lights were
> applied; beside these, there were others in
> black and white chalks, India ink, bister, and
> some in a slight tint of oil colours; with
> these various materials, he struck out a vast
> number of bold, free sketches of landscape
> and cattle, all of which have a most
> captivating effect to the eye of an artist, or
> connoisseur of real taste.

The improvised and innovative elements of
Gainsborough's approach to drawing the
landscape was recalled in comical terms by
another contemporary who saw him at work,
Henry Angelo, in his *Reminiscences*
(1828–30):

> Instead of using crayons, brushes or chalks,
> he adopted for painting tools his fingers
> and bits of sponge … one evening … he
> seized the sugar tongs, and found them so
> obviously designed by the genii of art for
> the express purpose, that sugar-tongs at
> Bath were soon raised two hundred per
> cent … Some of these moppings, and
> grubbings, and hatchings, wherein he had
> taken unusual pains, are such emanations
> of genius and picturesque feeling, as no
> artist perhaps ever conceived, and certainly
> such as no one surpassed.

It is easy to see why Gainsborough's drawings
were of such fascination from the four
examples illustrated here. With an established
repertoire of motifs – shepherds and
herdsmen, cattle, ruins, and occasionally
more explicitly classical features such as the
fountain in cat.140 – Gainsborough explored a
vast variety of effects, demonstrating that
drawing used so inventively was equal to oil
paint in the creation of engaging and resolved
works of art. MM

Ideal and Experimental Art: The Later Years

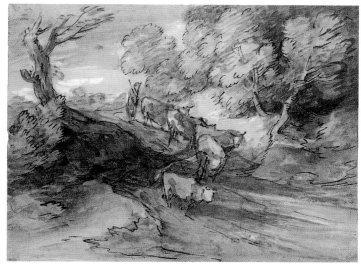

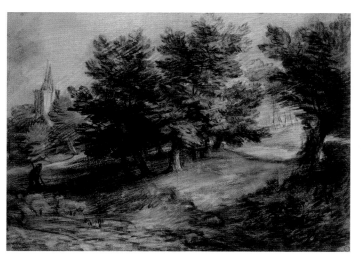

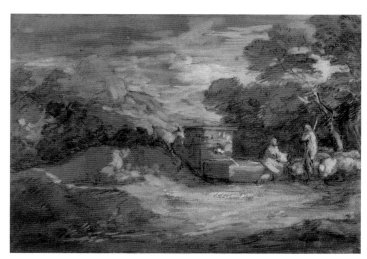

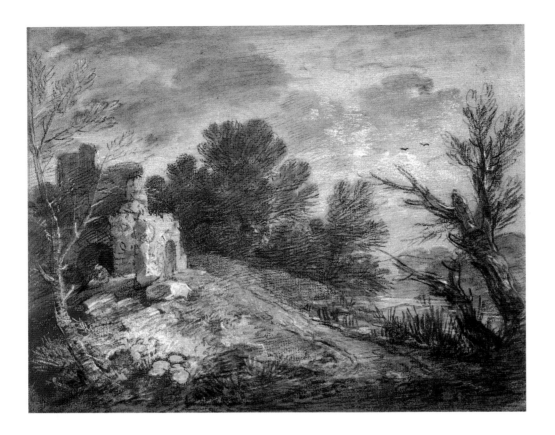

141

**Wooded Landscape with Figure
and Ruined Castle**

c.1772–4
Black chalk and stump and white chalk on
blue-grey paper, 24.6 × 30.8 (9¹¹⁄₁₆ × 12⅛)
Birmingham Museums & Art Gallery.
Bequeathed by J. Leslie Wright 1953

Hayes 1970, no.329

142

**Wooded Landscape with Shepherd
and Sheep**

c.1776–80
Black chalk, stump and white chalk on grey
paper, 23.5 × 32.4 (9¼ × 12¾)
Birmingham Museums & Art Gallery.
Bequeathed by J. Leslie Wright 1953

Hayes 1970, no.387

143

**Wooded Landscape with Horsemen and
Buildings**

c.1776–8
Black chalk and stump, white and coloured
chalks on blue paper, 31.3 × 40.3 (12⁵⁄₁₆ × 15⅞)
Birmingham Museums & Art Gallery.
Bequeathed by J. Leslie Wright 1953

Hayes 1970, no.446

Gainsborough worked through the same themes
in all media, although cat.141 is relatively unusual
in including a ruin. While all three drawings
exemplify his inventiveness, in cat.142 we again
recognise 'classical' elements, in the perspective,
the mountains and the buildings, combined in an
extemporisation on his own repertoire and
leavened with lessons learned from Dughet.
Although it appears very loose, the calligraphy is
exact and suggestive, communicating something
of the instinctive pleasure Gainsborough is
reported to have found in making these quite
complex drawings. He asks that we take him on
trust in recognising those globular forms as
sheep, for example. There is great technical
expertise in manipulating tones and in exploiting
the ground of the paper to harmonise effects.

Cat.143 is a fine, virtually abstracted drawing
reprising familiar themes: the track winding
through a wood, a mounted figure leading
another beast and progressing out of the picture
space. Within the closed setting is one of those
'box-like' buildings that are painted in closer focus
in works such as *Charity Relieving Distress* (cat.129).
The composition is organised to recall the wooded
and mountainous scenes of Gaspard Dughet, as
well as Gainsborough's own work, for the structure
of the foreground is quite similar to that of *The
Watering Place* (cat.51). The use of various
coloured chalks and the conspicuously suggestive
virtuosity of the drawing parallel the technical skill
of Gainsborough's painting, and remind us that in
each medium he deliberately erases the boundaries
between the public and the private. MR

Ideal and Experimental Art: The Later Years

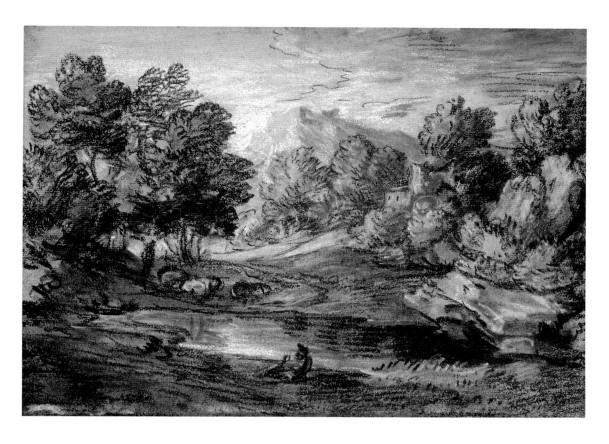

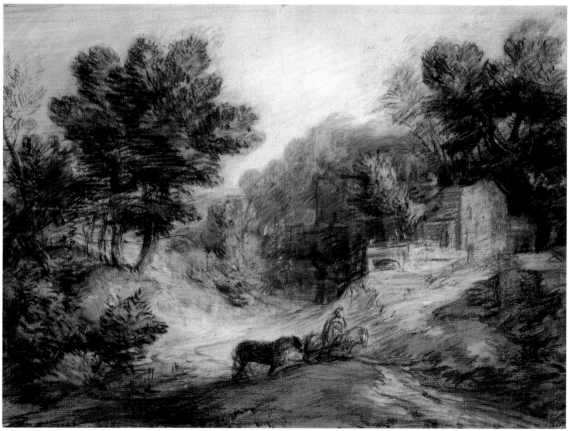

Romantic Landscape with Sheep at a Spring

*c.*1783
Oil on canvas, 153.7 × 186.7 (60½ × 73½)
Royal Academy of Arts, London

Hayes 1982, no.138

This is the largest of Gainsborough's ideal landscapes. The figure of a sleeping shepherd as a type is familiar from the artist's very earliest works, but is cast here into a monumental and fantastical landscape, first and foremost an artful contrivance clearly referring to Dughet and Claude in its style and motifs. The painting was included in the Schomberg House sale in 1789, but remained with the artist's daughter, Margaret, who presented it to the Academy in 1799. Although it is sometimes said to have been a belated 'Diploma Work' (the work Academicians were expected to give the institution on their election to its membership), as a founder member Gainsborough was under no obligation to provide one. He had, however, offered in 1787 to paint a picture as a gift to the Academy; the gift of this work may be a kind of posthumous fulfilment of that suggestion.

When it was exhibited at the British Institution in the important Gainsborough exhibition held there in 1814, it was tellingly given the title 'Romantic Landscape', which is still sometimes used. That exhibition had an important role to play in establishing Gainsborough's nineteenth-century reputation as a precursor of 'romanticism', in being an artist alienated from modern life who sought in ideal landscapes an emotional release from the labours of portraiture. While there is a grain of truth in this, these later landscapes need also to be appreciated as challenging artistic statements, a sensuous reinvigoration of the formal traditions of the Grand Style. MM

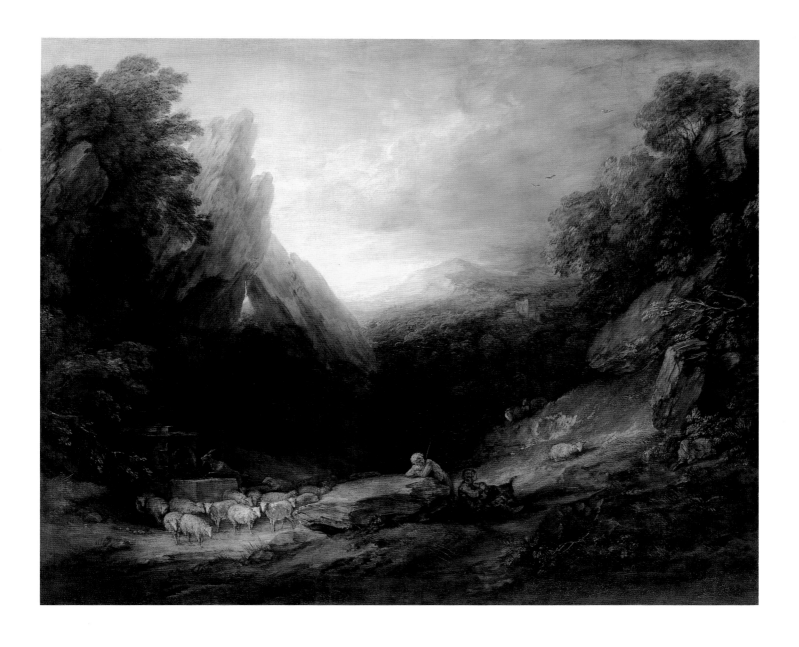

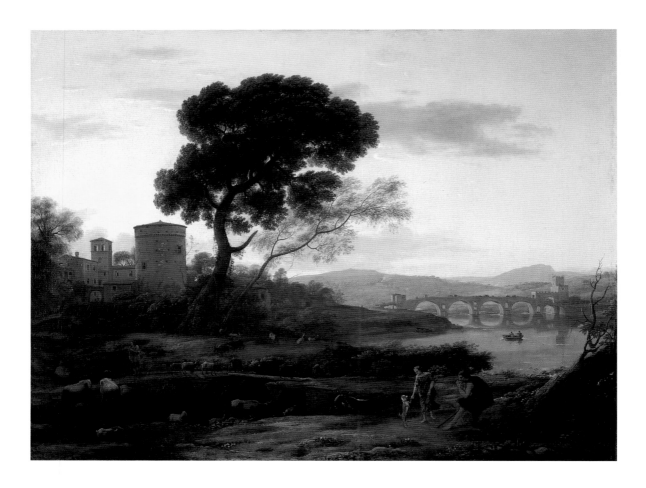

145

Claude Gellée, called Le Lorrain (1600–1682)

Pastoral Landscape with the Ponte Molle

1645

Oil on canvas, 73.7 × 96.5 (29 × 38)

Birmingham Museums & Art Gallery.
Bequeathed by E.E. Cook through the
National Art Collections Fund

The example of Claude was crucial to Gainsborough's landscapes of the 1770s and 1780s. A French artist based in Rome, Claude was generally considered the exemplary painter of ideal landscape in his creation of a vision of the world saturated by the values of Classical literature and thought. Many British collectors favoured Claude – this painting was in England by 1743, when it appeared at an art sale, and it was recorded at a further London sale in 1760 when it was bought by the Earl of Ashburnham. In 1753 it was engraved by Thomas Major (the printmaker who in the following year engraved Gainsborough's *Landguard Fort*). The painting provides a range of Claudean motifs (the open landscape, shepherds, castles and the bridge in the middle distance) and formal devices (notably the repoussoir of the tree, the secondary perspective to the left, and the banding of light and dark planes) that were considered typical and appeared in landscapes executed in a self-consciously classical mode, for instance in the work of Richard Wilson. But where the academic tradition was to advocate Claude's art as a model because of its narrative content and purported philosophical values, in Gainsborough's hands his example provided a springboard for fantasy and invention, in which the pleasures of paint and the evocation of atmosphere are foremost. MM

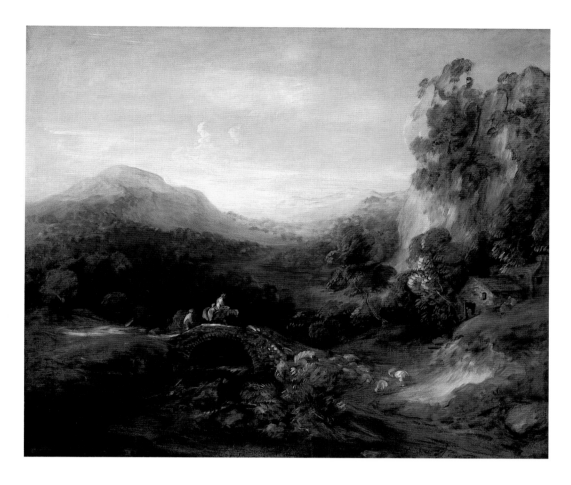

146
Mountain Landscape with Bridge
c.1783–4
Oil on canvas, 113 × 133.4 (44½ × 52½)
National Gallery of Art, Washington, Andrew
W. Mellon Collection 1937.1.107

Hayes 1982, no.151

Versions of this composition appear in a drawing in the collection at Althorp, Northamptonshire, and in a slightly earlier painting in the National Museum of Wales (Hayes 1982, no.153), suggesting that Gainsborough took some pains with it. This painting is unfinished, and in the commas and flicks of paint, particularly about the bridge, we can see the artist establishing by purely painterly means the formal structures that he would then refine through further applications of glazes and scumbles. At the present the picture is cool in hue, perhaps appropriate to a scene of declining light, and marries characteristic motifs – figures crossing the bridge, a cottage – with the imaginative representation of a mountainous terrain. Such countryside was nothing new with Gainsborough, and he enjoyed this kind of scenery in reality. In 1768 he wrote to his friend James Unwin in Derbyshire, 'I suppose your country is very woody – pray have you Rocks and Water-falls? for I am as fond of landskip as ever' (*Letters*, p.53); and in 1783 he went off on a tour of the Lake District with his old Suffolk friend, Samuel Kilderbee. He anticipated this in a letter to a William Pearce:

> I don't know if I told you that I'm going with a Suffolk Friend to visit the Lakes in Cumberland & Westmoreland and purpose when I come back to show you that your

> *Grays and Dr. Brownes were taudry fan-Painters. I purpose to mount all the Lakes at the next Exhibition, in the great Stile – and you know if the People don't like them, 'tis only jumping into one of the deepest of them from off a Wooded Island, and my reputation will be fixed for ever.* (*Letters*, p.153)

'Gray' was the poet Thomas Gray (1716–1771), and 'Dr. Browne' was John Brown (1715–1766), whose guide to the Lake District had been published posthumously in 1771. Their texts helped shape a new appreciation of the landscape and thus the growing enthusiasm for tourism into previously neglected areas of the country, including the Lakes. It is usually supposed that paintings such as this post-date the artist's trip in 1783, and if it is one of the landscapes he proposed to paint in the 'great Stile', that would support the idea that in such paintings Gainsborough was elaborating a serious alternative to more conventional academic art. MR

147 *top left*
**Wooded Landscape with Buildings,
Lake and Rowing Boat**
*c.*1784–6
Black chalk and stump and white chalk,
27.8 × 37 (10^{15}/$_{16}$ × 14^{9}/$_{16}$)
Lent by the Trustees of Gainsborough's
House, Sudbury (purchased with
contributions from the MGC/V&A Purchase
Grant Fund and the National Art Collections
Fund, November 1994)

Hayes 1970, no.627

148 *top right*
**Mountain Landscape with a Castle
and a Boatman**
*c.*1784–6
Black chalk, stump, heightened with white
chalk on blue paper,
26.8 × 33.3 (10^{9}/$_{16}$ × 13^{1}/$_{8}$)
Metropolitan Museum of Art, New York.
Rogers Fund, 1907

Hayes 1970, no.672

149 *bottom left*
**Extensive Wooded Landscape with a Bridge
over a Gorge, Distant Village and Hills**
*c.*1786
Black chalk and stump on blue paper,
25.9 x 34.8 (10^{3}/$_{16}$ x 13^{11}/$_{16}$)
Sir Edwin Manton

Hayes 1970, no.771

150 *bottom right*
**Rocky Wooded Landscape with Waterfall,
Castle and Mountain**
*c.*1785–8
Black chalk and stump, heightened with
white, 22.5 x 31.9 (8^{7}/$_{8}$ x 12^{1}/$_{2}$)
The British Museum, London

Hayes 1970, no.804

In his exploration of the idealised landscape,
across paintings and drawings, Gainsborough
returned to the same motifs and repeated
Claudean and Dughet-esque formats.
Something of the artificial, playful nature of his
practice is apparent in the selection of
drawings here, which together explore the
atmospheric and imaginative possibilities of
ideal landscape settings. The element of
game-playing was most evident in the artist's
reported use of real materials, which he would
rearrange to create models to draw from. So
even while the landscape drawings here are
very evidently far removed from the actualities
of the English countryside, and instead
represent an idealised and imaginative
amalgam of England and Italy that resembles
neither closely, Gainsborough still seems to
have required an initial, material stimulus. His
art, even when striving to achieve an ideal,
was experiential in its formation and
perceptual in its foundations. MM

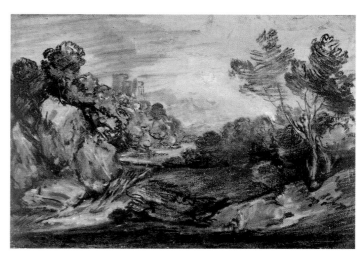

151
Seashore with Fishermen
c.1781–2
Oil on canvas, 101.9 × 127.6 (40⅛ × 50¼)
National Gallery of Art, Washington, Ailsa
Mellon Bruce Collection, 1970.17.121

Waterhouse, no.954

This is a further example of the small group of coastal scenes that Gainsborough created in the early 1780s. Like the similar painting exhibited at the Academy in 1781 (cat.56), it shows the artist endeavouring to broaden his subject matter, and thus demonstrate that his was an art of an inventiveness and variety that could rival Reynolds's or, more pertinently, de Loutherbourg's. Although Gainsborough had been on a sketching trip to the Devonshire coast in 1779, these coastal scenes are inventions. As in seventeenth-century Dutch and Flemish marine art, whose example Gainsborough is explicitly referring to here, and in the paintings of the French artist Claude-Joseph Vernet (1714–1789), which were much appreciated in England, the theme is the turbulence of nature, but the composition is finely balanced. The artist seeks to demonstrate that the effects of weather could in themselves form a theme worthy of dignified artistic treatment, without the addition of narrative or explicit literary associations.

Although not sold during his lifetime, this painting was well known in the nineteenth century, being exhibited several times at the British Institution. Indeed, the vision of the natural world on display here anticipates the 'romanticism' of early nineteenth-century art, and the creation of a powerful mythology of the British landscape. MM

Ideal and Experimental Art: The Later Years

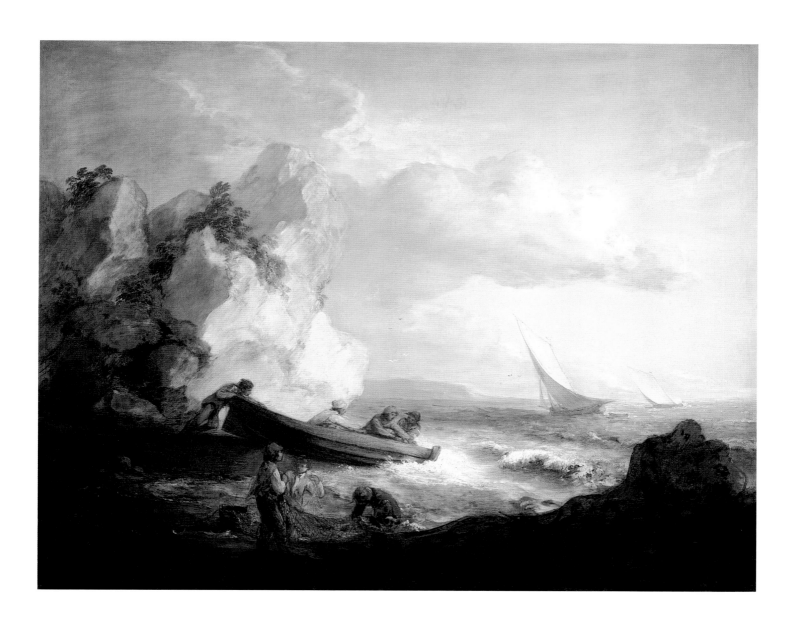

152
Gainsborough's 'showbox' *c.*1781–2
Victoria and Albert Museum

153 *top left*
Wooded Landscape with Herdsmen Driving Cattle past a Pool *c.*1781–2
Oil on glass, 27.9 × 33.7 (11 × 13¼)
Victoria and Albert Museum

Hayes 1982, no.132

154 *top right*
Coastal Scene with Sailing and Rowing Boats and Figures on the Shore *c.*1783
Oil on glass, 27.9 × 33.7 (11 × 13¼)
Victoria and Albert Museum

Hayes 1982, no.140

155 *bottom left*
Wooded Upland River Landscape with Figures Crossing a Bridge, Cottage, Sheep and Distant Mountains *c.*1783–4
Oil on glass, 27.9 × 33.7 (11 × 13¼)
Victoria and Albert Museum

Hayes 1982, no.154

156 *bottom right*
Open Landscape with Peasants, Cows, Sheep, Cottages and a Pool *c.*1786
Oil on glass, 27.9 × 33.7 (11 × 13¼)
Victoria and Albert Museum

Hayes 1982, no.177

Gainsborough created his 'showbox' in the early 1780s. It passed to his daughter Margaret and then to Dr Thomas Monro (1759–1833), whose drawing school was decisive in shaping a new generation of landscape artists (including Thomas Girtin, J.M.W. Turner and John Sell Cotman). It must have been while it was with Monro that the landscape artist Edward Edwards saw it. He described the showbox in his *Anecdotes of Painters* (1808):

The machine consists of a number of glass planes, which are moveable, and were painted by himself, of various subjects, chiefly landscapes. They are lighted by candles at the back, and are viewed through a magnifying lens, by which means the effect produced is truly captivating, especially in the moon-light pieces, which exhibit the most perfect resemblance of nature.

According to Edwards, Gainsborough's inspiration for this unique showbox came from an exhibition of painted glass by Thomas Jervais (d.1799). We also know that Gainsborough had experimented with painted transparencies used as decoration at the subscription concerts of Abel and Johann Christian Bach in 1775. A particularly interesting point of inspiration was Philippe Jacques de Loutherbourg's 'Eidophusikon', which had first opened in February 1781 and was re-exhibited in new versions in 1782 and 1786. Drawing on his experience as a theatrical designer and his interest (tinged with Masonic mysticism) in the effects of light, de Loutherbourg created a kind of small-scale theatre where the scenery was the focus of attention, rather than the backdrop for a performance. Part art exhibition, part theatrical event, the programme consisted of the presentation of a series of landscape scenes, showing different moods and times of day, and in some instances incorporating classical and literary imagery, with a musical accompaniment and even sound effects. A newspaper of the time described how 'His different views are all formed by detached pieces, from which he is enabled to manage his keeping, light and shade, &c. with the most critical exactness' and noted that the

foregrounds were formed of moss, lichens and cork for realistic effect. Thus we can identify several points of contact between Gainsborough's art and de Loutherbourg's: in the use of materials extracted from the natural world as components in landscape models; the process of composing from a repertoire of motifs; and in particular a concern with the exacting management of the effects of light and mood. Of course, the Eidophusikon and the present showbox were created on entirely different scales, de Loutherbourg inventing a form of entertainment that could be enjoyed by an audience who in effect inhabited the spectacle, Gainsborough something that only a single individual at a time could look into.

The essentially private nature of the viewer's experience of the showbox is critical. It is a magnifying device, with the moveable lens enlarging the image, but also making it appear more distant. Combined with the effects of the candles that originally illuminated the transparency, it thus intensifies the viewer's perception of the painted landscape. Reynolds noted that Gainsborough's use of composed models for his landscapes was connected to an interest in optics, saying: 'He even framed a kind of model of landskips, on his table; composed of broken stones, dried herbs, and pieces of looking glass, which he magnified and improved into rocks, trees and water' (Wark, p.250). With the showbox, this process of magnification and 'improvement' was further developed, with the significant effect of inverting the relationship between viewer and work of art that existed in the public exhibitions. There, the experience was essentially diffuse, with each individual painting contributing to a visual spectacle that the viewer physically inhabited and became part of. With the showbox, the relationship was one of intimacy and immediacy, of looking into a theatrically conceived closed space which the viewer could lose him or herself in. This concern with the precise quality of the aesthetic experience set Gainsborough against the developing public art scene of his day, and is a reminder of his seriousness of purpose as an artist. MM

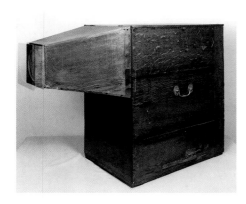

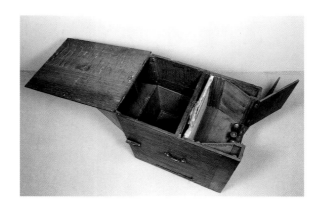

Ideal and Experimental Art: The Later Years

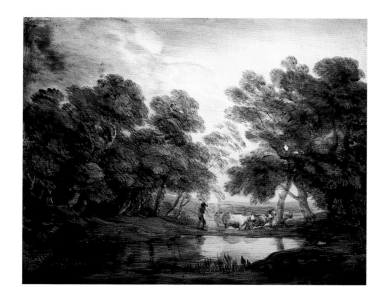

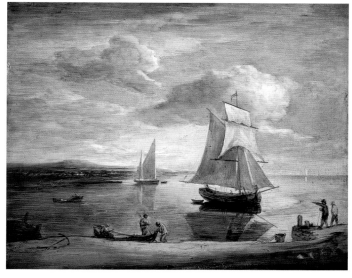

157

**Wooded Landscape with Figures and Cows
at a Watering Place (The Watering Place)**

*c.*1776–7
Copper plate, 27.9 × 34.9 (11 × 13¾)
Tate. Purchased 1971

158

**Wooded Landscape with Figures and Cows
at a Watering Place (The Watering Place)**

*c.*1776–7, reprinted 1797
Soft-ground etching and aquatint,
24.4 × 32.4 (9¹¹⁄₁₆ × 12¹³⁄₁₆)
Tate. Presented by A.E. Anderson 1907

Hayes 1971, no.7

John Hayes has argued that this print seems
to have preceded the famous painting
exhibited to such applause at the Academy in
1777 (cat.51). In the painted composition
Gainsborough added two goats and a
horseman which, arguably, creates a more
resolved composition, suggesting that the
artist was able to resolve in paint formal
problems discovered in the creation of a
copper plate for printing. None the less, the
print is a technical *tour de force*, incorporating
soft-ground etching, aquatint and 'sugar lift' to
create a variety of textural and tonal effects.
These were the newest printmaking
techniques of the time, involving the complex
use of different acid-resistant resins, mixtures
and varnishes and the repeated 'biting' of the
copper plate with acid. As with the drawings
of the latter part of his career, Gainsborough
tested the limits of technique with this print
and flew in the face of the proposed
hierarchies of art. These would insist that
printmaking was only suitable for reproducing
paintings and drawings rather than as a
creative medium in its own right.

Gainsborough prepared his copper plate in
1776–7 but never issued the resulting print. It
was eventually published as part of a set of
twelve Gainsborough prints by John and
Josiah Boydell in 1797. MM

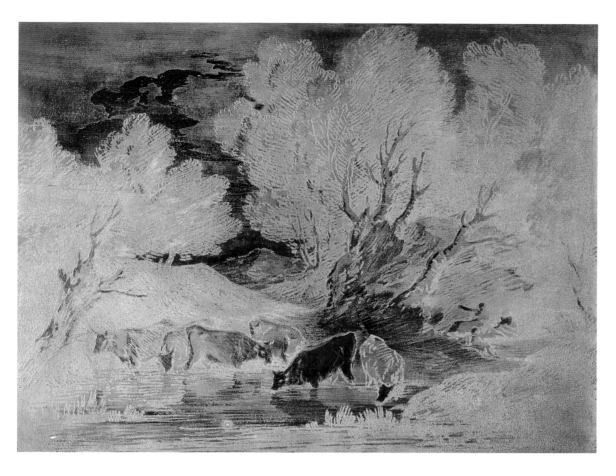

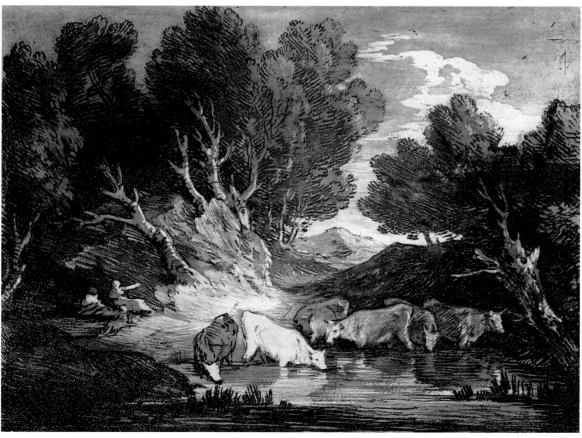

159

Wooded Landscape with a Peasant Reading a Tombstone, Rustic Lovers and Ruined Church

*c.*1779–80

Soft-ground etching, second state, 29.7 × 39.4 (11¹¹⁄₁₆ × 15½)

The Huntington Library, Art Collections and Botanical Gardens

Hayes 1971, no.10

Figure 55
Charles Grignion after Richard Bentley
Plate from **Designs by Mr R. Bentley, for Six Poems by Mr T. Gray** published London 1753
British Library

Figure 56
Richard Wilson
Ego Fui in Arcadia (I, too once lived in Arcadia) 1755
Oil on canvas, 109.2 × 135.9 (43 × 53½)
Private Collection

The subjects of the three soft-ground etchings Gainsborough intended to publish in 1780 are grounded in his own landscape practice, and, in generic terms, feature a scene with wagons that places itself within a landscape tradition originating in Rubens (cat.162), a view of a figure contemplating a tombstone in a churchyard set in mountainous country (cat.159), and a scene of cattle passing over a bridge that is within a more general seventeenth-century Italianate landscape tradition (cat.161).

While the subject of cat.159 connects with a drawing of some donkeys in a churchyard, it has a more significant linkage with a painting of two figures inspecting a gravestone. This was one of two landscapes shown by him in 1780, of which a critic noted: 'Each has some interesting Circumstance in it; such as Peasants viewing inscriptions on a Tombstone amidst the Ruins of a religious Building, &c. which are well calculated to captivate the heart.' The painting has been largely destroyed, but its appearance is preserved in an aquatint published in 1790 by Maria Prestal (see fig.53). The connection between this design and the painting is thematic rather than formal, for each composition is very different. The inscription on the aquatint quoted the first sixteen lines of Thomas Gray's *Elegy* (1751), and it is certain that the ethos of the poem pervades this soft-ground etching. Indeed, the reference may be pointed to by the figure's paraphrasing one of Richard Bentley's illustrations to the 1753 edition of Gray's poems (fig.55), or the reminiscence of the mountain range in the background with the profile of the Langdale Pikes in the Lake District, an area which was closely associated with Gray. While making these local references, the invention has a firm link to Poussin's famous painting *Et in Arcadia Ego* (1637–9; Louvre, Paris), perhaps by way of Richard Wilson's *Ego Fui in Arcadia*, in which

shepherds discover a tomb reminding them that death has a presence even in the apparent paradise they inhabit (fig.56). Although Gainsborough's creative use of soft-ground etching to resemble a drawing defies the distinctions between different media enforced by the Academy, this print reminds us that Gainsborough could be concerned with the most serious of artistic issues.

Gainsborough makes the point of domesticating the subject, pointing out that it loses none of its force or effect by being represented by a modern scene. Moreover, his doing this through a soft-ground etching demands notice. This technique, where the artist would draw onto paper laid onto a copper plate prepared with a soft ground that would lift with the lines, was new, having come into Britain some time around 1775. Gainsborough had learned it from Paul Sandby (*c.*1730–1809), who wrote how it saved 'all the trouble of Etching with a Needle, and will produce an outline like fine Indian chalk'. That is, the print actually (and, it is important to notice, deceptively) looks to be a chalk drawing, an element Gainsborough emphasised by printing onto coloured papers such as he habitually used for his own drawings, or using coloured inks. We might contrast this with reproduction through engravings, which translated the painterly into a linear idiom, and which collectively allowed one to imagine a history of art in which ranks or hierarchies of genres were feasible. Gainsborough starts with no original painting and makes a print that looks like a drawing. He thus implies that in the private society that Britain had now become the proper place for the contemplation of the serious lessons we might get from the fine arts is not through works in the Great Style in public buildings, but through paintings or works on paper at home: a pragmatic modernity opposed to the academic ethos.

Ideal and Experimental Art: The Later Years

Th.^s Gainsborough fecit

Published as the Act directs, Feb.^y 1.st 1780.

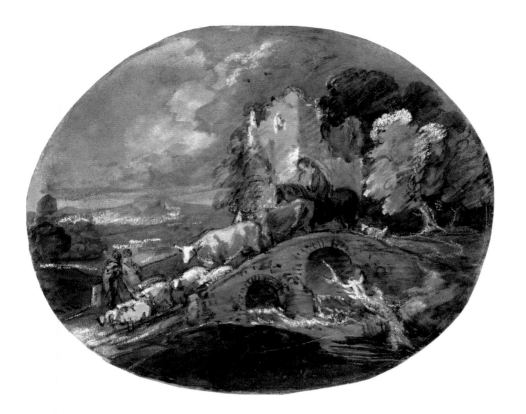

160

Wooded Landscape with Herdsmen Driving Cattle over a Bridge, and a Ruined Castle
c.1780
Black chalk and stump with white chalk and wash, 28.4 x 35.1 (11³/₁₆ x 13¹³/₁₆)
Courtauld Gallery, Courtauld Institute of Art

Hayes 1970, no.498

161

Wooded Landscape with Herdsman Driving Cattle over a Bridge, Rustic Lovers and Ruined Castle c.1779–80
Soft-ground etching, second state, 30.2 x 39.4 (11¹³/₁₄ x 15½)
The Huntington Library, Art Collections and Botanical Gardens

Hayes 1971, no.11

162

Wooded Landscape with Two Country Carts and Figures
c.1779–80
Soft-ground etching, first state, 29.9 x 39.4 (11¹¹/₁₄ x 15½)
The Huntington Library, Art Collections and Botanical Gardens

Hayes 1971, no.9

Cat.162 reprises a favourite theme of Gainsborough's – note in particular the figures lounging in the cart – which is set in a mountainous background, and treated with great finesse. The invention of this particular landscape type is thought to have been fired by the artist's encounter with Rubens's *Watering Place* (fig.41), and, therefore, this version of it establishes the subject again as one that has a highly respectable artistic genealogy, even if this appears to be at variance with the intimacy of the medium. In general terms the composition of cat.161 fits into the kind of Italianate landscape one might associate with Nicolaes Berchem (1620–1683) or Jan Both (c.1618–1652), while again incorporating a motif of pastoral felicity, for in very few of Gainsborough's landscapes do people ever have to labour very hard. The combination of bridge and ruin suggests some kind of Anglo-Italianate country of the artist's own imagining. He met with some interesting technical problems in working out the composition: in the first state the bridge has three arches, in the second, four, while the drawing in the Courtauld introduces some sheep, and has only a two-arched bridge (cat.160). This drawing formed the foundation on which the painting exhibited in 1781 at the Royal Academy was based. In this we have a notable inversion of the usual sequel, where the painting precedes the print, again to show Gainsborough working through conventions in his attempt to create a potent modern art. MR

Ideal and Experimental Art: The Later Years

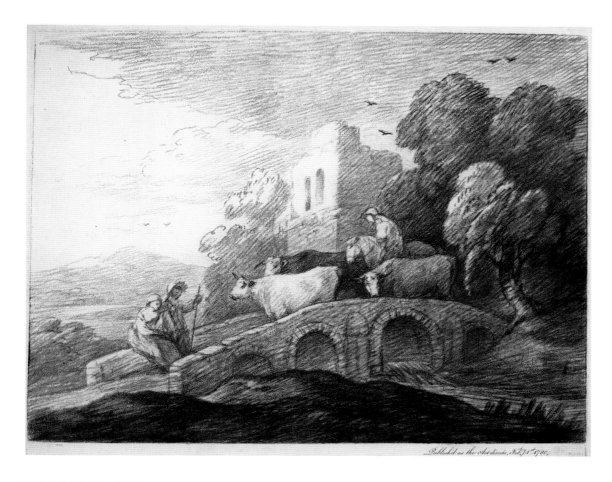

Published as the Act directs, Feb 1st 1780.

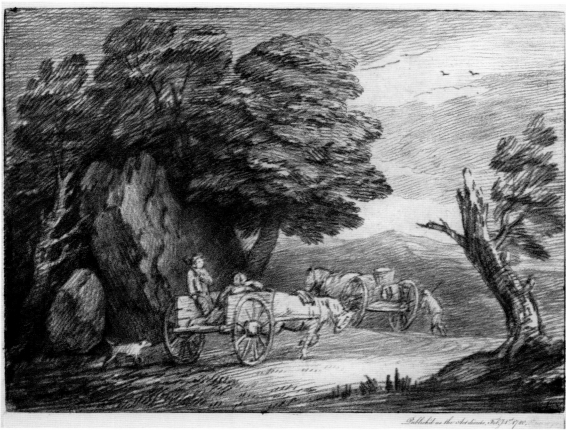

Published as the Act directs, Feb 1st 1780.

163
Wooded Landscape with a Country Cart
*c.*1785–8
Black chalk and stump and white chalk on
buff paper, 28.3 × 37.9 (11⅛ × 14¹⁵⁄₁₆)
Victoria and Albert Museum, Dyce Bequest

Hayes 1970, no.661

164
**Wooded Landscape with a
Country Cart and Figures**
*c.*1785–8
Black and white chalks with grey black
washes on off white wove paper prepared
with grey, 25.2 × 33 (9¹⁵⁄₁₆ × 13)
Yale Center for British Art, Paul Mellon
Collection

Hayes 1970, no.754

In his final years Gainsborough might return to themes that had been apparent in his art since his earliest years, but always with a sense of invention and novelty. Here, the basic subject of both drawings, that of the cart passing through woodland, can be discovered in works of Gainsborough's youth (for example, cat.10). But the sheer range of techniques the artist was able to deploy, and the extremely mannered character his designs could take on, are demonstrated through these two designs. These were qualities greatly admired in the years after Gainsborough's death, when the more personal, even idiosyncratic, qualities of drawing began to be ever more appreciated by connoisseurs and collectors. It was during these years that Gainsborough's drawings became well known through the publications of prints reproducing them. With cat.163 the textural qualities of chalk on paper are brought to the fore, and the graphic stylisation is such that John Hayes's comment that it is 'Van Gogh-like' seems wholly appropriate. This kind of stylisation was taken to almost parodic levels by Thomas Rowlandson (1756–1827), who created pastiches of Gainsborough drawings and included several reproductions of his drawings in his *Prints in Imitation of Drawing* published in 1789. Cat.164 combines washes and chalk drawing to dynamic effect. The design descends from that of one of the soft-ground etchings of 1780 (cat.162), and was reproduced, the same size but reversed, in an aquatint print by Gainsborough (Hayes 1971, no.18). This was not published by him, but was one of the twelve prints issued in 1797 by John and Josiah Boydell (see cat.158). MM

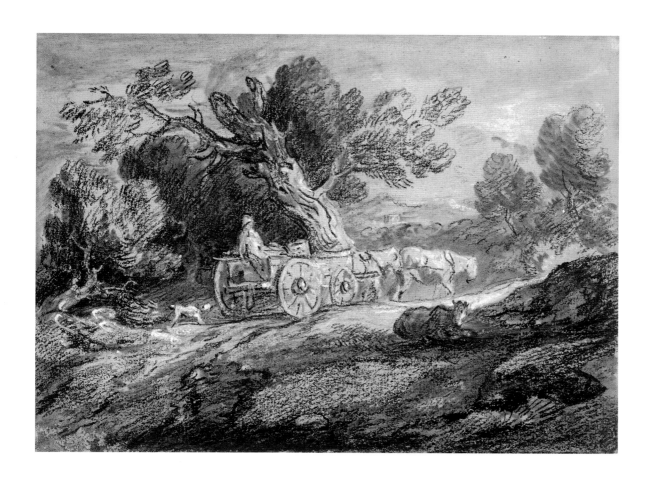

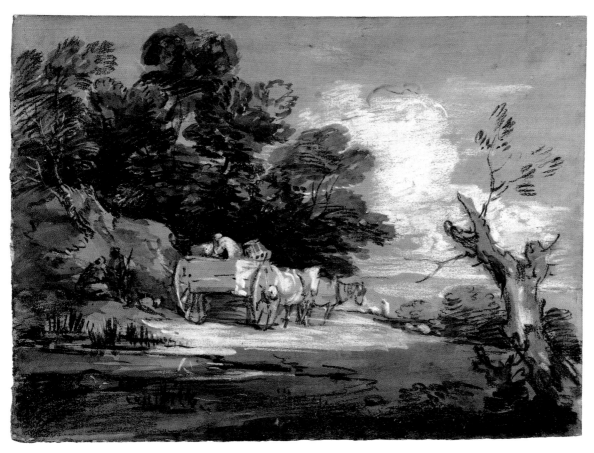

165
Mrs Siddons
c.1785
Oil on canvas, 126.4 × 99.7 (49¾ × 39¼)
National Gallery, London

Waterhouse, no.617

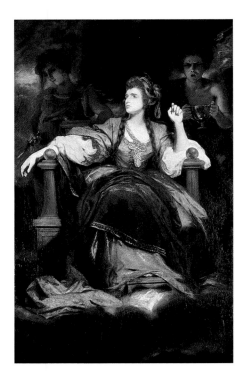

Figure 57
Joshua Reynolds
Mrs Siddons as the Tragic Muse c.1784
Oil on canvas, 237 × 146.1 (93⁵⁄₁₆ × 57½)
The Huntington Library, Art Collections and Botanical Gardens

This spectacular portrait was very probably painted as a riposte to Reynolds's rather more bombastic figuring of *Mrs Siddons as the Tragic Muse* (fig.57). In Reynolds's picture, exhibited at the Royal Academy in 1783, the sitter was cast in the form of a Michelangelo sibyl, the artist's ponderous palette of browns and golds intending to evoke the Old Master tradition. Gainsborough, by contrast, presents an emphatically contemporary image of her.

Sarah Siddons (1755–1831), one of the stars of the London stage of the later eighteenth century, inspired William Hazlitt later to write that: 'Power was seated on her brow, passion emanated from her breast as from a shrine. She was tragedy personified.' Moreover, she was scrupulous in negotiating the pitfalls inherent in being an actress, a profession that had strong contemporary associations with prostitution. She opted for tragic roles, and made a great public virtue of her domesticity, which may have a bearing on the circumstances under which Gainsborough elected to represent her. There is no indication of her calling. Siddons, instead, is shown as the epitome of high fashion within a neutral interior. Gainsborough's champion, Henry Bate, wrote how the

> resemblance is admirable, and the features are without the theatrical distortion which several painters have been fond of delineating. In addition to the great force and likeness … the new style of drapery might be mentioned. Mrs. Siddons's dress is particularly novelle, and the fur around her cloak and fox-skin muff are most happy imitations of nature.

The portrait has, indeed, been painted with a *bravura* appropriate to the reputation of the sitter, and it may have been to the mutual advantage of painter and sitter that it was not sold but rather occupied a prominent place in Gainsborough's painting room at Schomberg House. For Siddons thus to be represented helped to neutralise the negative associations of being an actress; for the painter, this grand portrait of one of the most famous women of the day would have served to enhance his reputation. MR

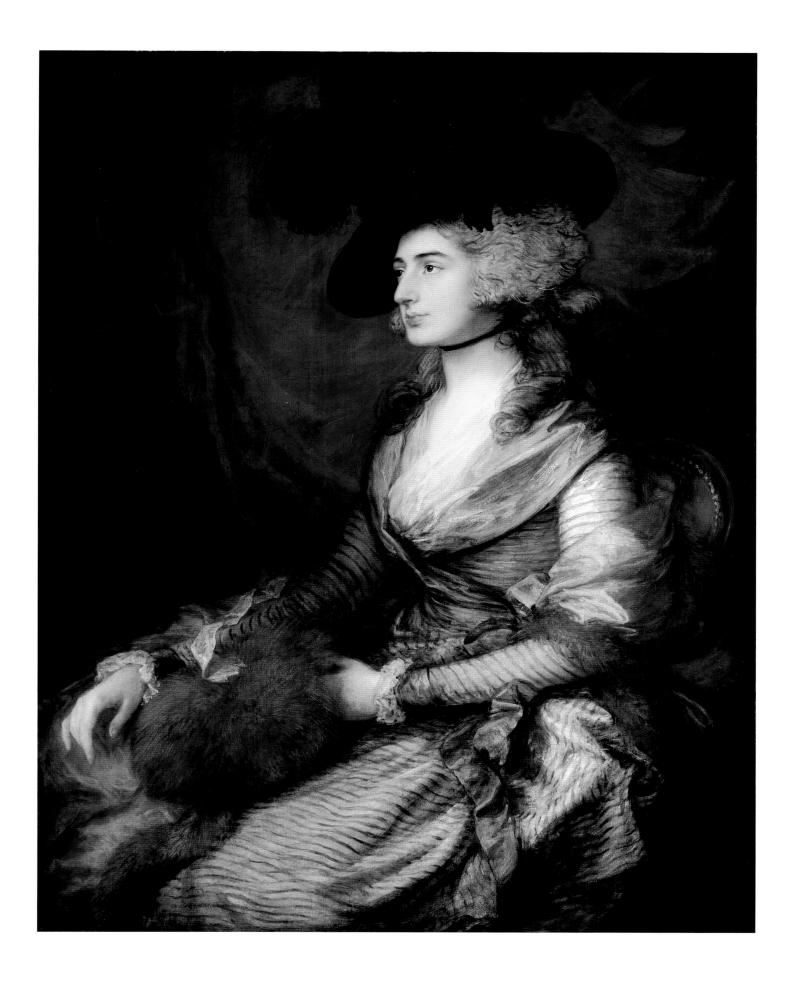

166
Mrs Richard Brinsley Sheridan
c.1785–7
Oil on canvas, 220 × 154 (86⅝ × 60⅝)
National Gallery of Art, Washington, Andrew
W. Mellon Collection 1937.1.92

Waterhouse, no.613

The sitter is Elizabeth Linley (1754–1792), a friend of Gainsborough whom the artist had known since she was a child. He had previously painted her in a double portrait with her sister Mary, exhibited at the Academy in 1772 (cat.49). Shortly after that picture had been painted, Elizabeth eloped to France with the playwright and theatrical entrepreneur Richard Brinsley Sheridan (1751–1816), also a friend of the painter. They married in 1773. Gainsborough was upset and angry at the elopement, suspecting that Elizabeth may have been mainly motivated by a desire to escape the sexual advances of a family friend, 'Captain' Mathews (see *Letters*, p.96).

Gainsborough may have begun a full-length portrait of this sitter as early as 1774, in the immediate aftermath of the elopement and marriage of his friends. He exhibited a large picture of her at the Academy in 1783, which has sometimes been identified with this work. Although the exhibited painting has not come to light, it is more likely that this is a completely new portrait, started by 1785. He exhibited it at Schomberg House in 1786 but continued to work on it in 1787. It remained in a state that is sometimes described as unfinished, although as with so many of these late works by the artist we can never be sure of what degree of 'finish' (in the conventional sense) Gainsborough intended for the picture. Given the long gestation of the painting, and Gainsborough's relationship with the sitter, it is tempting to interpret the picture in highly personalised terms. A talented singer, Elizabeth was banned from performing in public by her husband; her apathetic pose might convey some sense of beauty and talent left neglected. More particularly, her response to the tragic death of her brother Thomas Linley in 1778 was commemorated by the sentimental poet Samuel Jackson Pratt in 'Mrs Sheridan on her Brother's Lyre' (published in his *Miscellanies*, 1785), creating an image that chimes with this picture:

> Cecilia wept upon her Lycid's lyre,
> The pensive breeze then gave a sighing sound,
> And the strings seem'd to tremble and expire.

St Cecilia was the patron saint of music, and Lycid Milton's tragic shepherd, both references used frequently in commentaries on Elizabeth and Thomas. While Reynolds had painted Elizabeth as Cecilia in 1775 (Waddesdon Manor), Gainsborough, characteristically, avoids such direct references. He casts her as a woman of sensibility, of nature and feeling, rather than of the city and culture. The extraordinarily fluent brushwork and rhyming of forms, which meld the figure with the surrounding landscape, create an image of a woman so entirely in tune with nature that she seems almost to be absorbed by it. As Bate wrote of the picture when he saw it in Gainsborough's studio in 1785: 'She is painted under the umbrage of a romantic tree, and the accompanying effects are descriptive of retirement. The likeness is powerful, and informed by a characteristic which equals the animation of nature.' MM

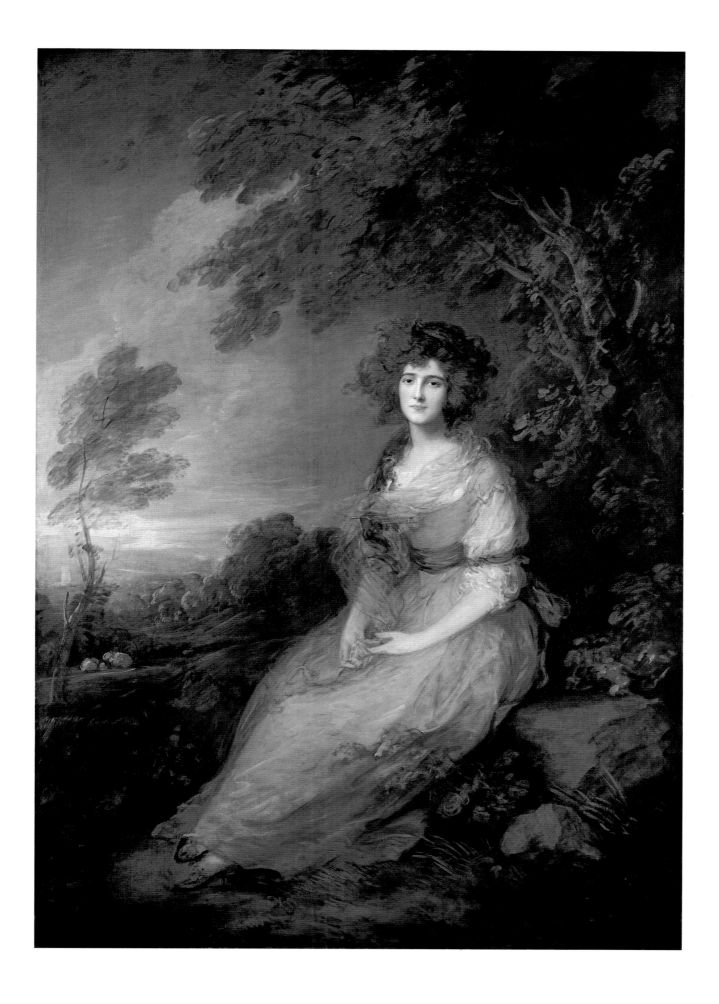

167
The Rt Hon. Charles Wolfran Cornwall
c.1785–6
Oil on canvas, 228 × 148.5 (89¾ × 58⁷⁄₁₆)
National Gallery of Victoria, Melbourne,
Australia. Everard Studley Miller Bequest 1962

Waterhouse, no.164

Charles Wolfran Cornwall (1735–1789), noted
for 'a sonorous voice … imposing figure and
a commanding deportment', became
Speaker of the House of Commons in 1780.
The Rolliad – a collection of political satires
published in 1784 – commiserated with his
being 'compelled by fate' to 'sit for ever
through the long debate', and expanded upon
his plight in mock-heroic terms:

> *Like sad Prometheus fastened to his rock,*
> *In vain he looks for pity to the clock;*
> *In vain the effects of strengthening porter*
> * tries.*

And, indeed, the reality appears to have been
that Cornwall could only survive sittings
through a copious intake of drink, and often
passed the time by falling asleep.

While the subject of parliamentarian as
dozy sot might have been meat and drink to a
caricaturist, Thomas Gainsborough evidently
felt strong enough a sympathy with his sitter
to present him in the most respectable terms.
Cornwall, clad in black robes with finely
painted gold brocading, displays a sensible
and alert countenance, and sits next to a table
on which a quill pen and sheaf of papers point
to his conscientiously carrying out his public
duties. Although the portrait type was
conventional – Reynolds, for example, had
used a version of this format in his picture of
Warren Hastings in 1766–8 (National Portrait
Gallery, London) – Gainsborough has deployed
it to articulate his position in the pictorial
debate in which he was engaging during his
final decade about the desirability or
otherwise of the Grand Style. There is a
deliberate articulation of Venetian colour
harmonies in the red of the curtain, green of
the table cloth, and gold of the brocading,
while the handling of the fabrics, in particular
the black robes, is consciously virtuoso.
Gainsborough has insisted that we appreciate
the pictorial and sensual qualities of oil paint
against its capacity to communicate
abstracted ideals in a self-effacing way. In
addition, Cornwall's posture pays a tribute to
the masters of St Martin's Lane and, in
particular, to two of the portraits with which
they had embellished the Foundling Hospital.
The general pose and the particular
positioning of the hands connect the work
with Hogarth's *Captain Coram* (fig.58), and the
crossed feet to Ramsay's riposte to that
portrait, *Dr Mead* (1747; Foundling Museum,
London). And, in general terms, the portrait
can be understood as a reiteration of the
power of that Hogarthian pattern also seen in
Archbishop Herring (1744–7; Tate). However, in
light of subsequent developments in British
portraiture, particularly those initiated by
Thomas Lawrence (1769–1830), *Cornwall*
terminates rather than continues a particular
eighteenth-century tradition. MR

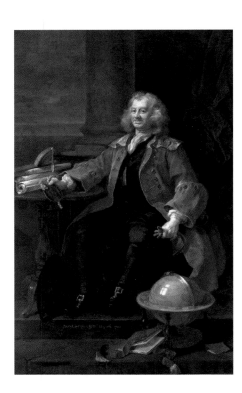

Figure 58
William Hogarth
Portrait of Captain Coram 1740
Oil on canvas, 239 × 147.5 (94 × 58)
Coram Foundation, Foundling Museum, London

Ideal and Experimental Art: The Later Years

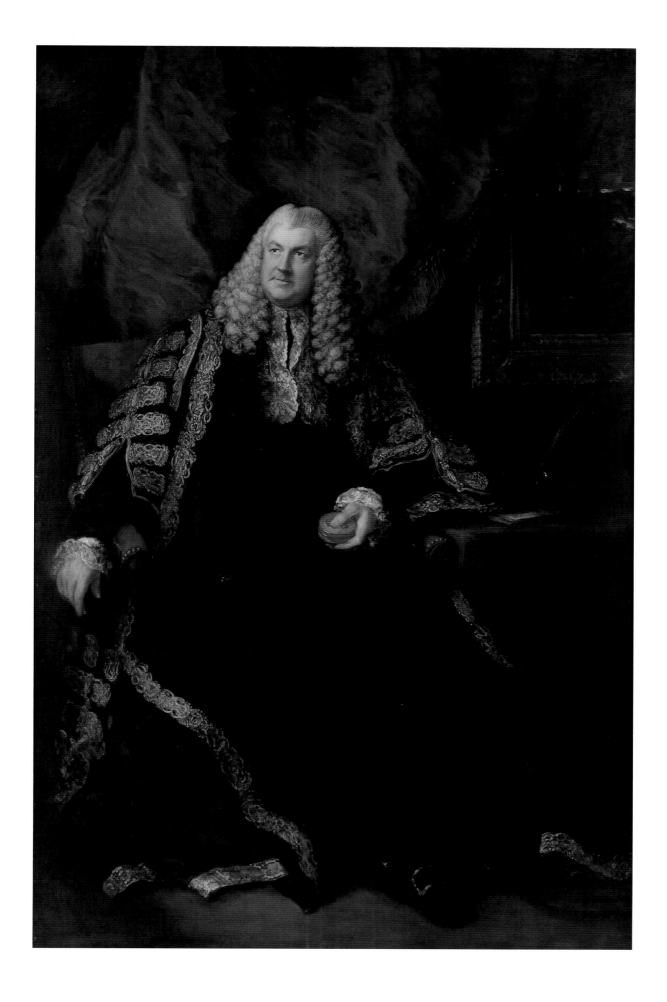

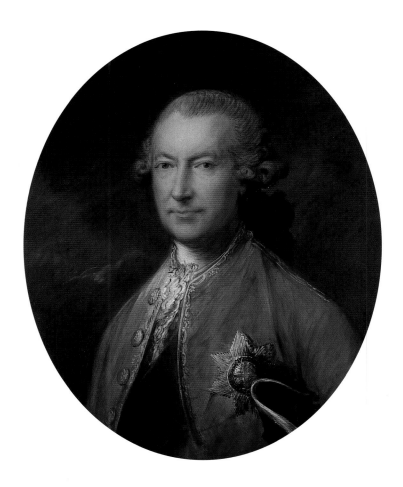

168

Hugh, First Duke of Northumberland

*c.*1783

Oil on canvas, 71 × 57.8 (28 × 22¾)

The Duke of Northumberland

Waterhouse, no.520

169

Edward Augustus, later Duke of Kent

*c.*1787

Oil on canvas, 91.25 × 71 (36 × 28)

Yale Center for British Art, Paul Mellon Collection

In the last years of his life, Gainsborough's art developed in personal and profound ways. But he was still a professional portraitist, and took on more prosaic kinds of commissioned work.

Cat.168 shows Hugh, first Duke of Northumberland (1715–1786). He was one of the most prominent public figures of the day, dedicating his energies to everything from the foundation of the Middlesex Hospital to the promotion of contemporary art and science. This portrait presumably originated with the full length of Northumberland by the artist, a grand public portrait showing the Duke in formal robes that was intended for the Sessions House of the County of Middlesex, and today hangs in the Middlesex Guildhall. Gainsborough exhibited this full length at the Royal Academy in 1783. It has also been noted, however, that the sitter looks slightly older here than in the full length, and that this painting may instead be by Gainsborough Dupont, who imitated his uncle's manner so closely that the authorship of many later Gainsborough portraits is disputed in this way. Whichever may be the case, we can see how Gainsborough's style, where the paint itself is alive with energy, was able to create a persuasive sense of a lively intellect and personality even in this modest yet relatively formal format.

Edward Augustus (1767–1820), shown in cat.169, was one of the royal princes, and had been included in the massed portrait of George III's children Gainsborough had exhibited at the Academy in 1783. This depiction dates from 1786 or 1787, when the sitter (still Prince Edward, being made Duke of Kent in 1799) was stationed in various military capacities on the Continent. What is most unusual is the format. Although a full length, it is painted on a canvas the size normally used for half-length portraits. It has been considered as a *modello* for a full-scale portrait, although as such it would be very unusual for Gainsborough, with whom even drawn studies for portraits are rare. It is possible that it was created on this scale so it could be more easily taken by the sitter abroad, although John Hayes has also proposed that it was meant to be part of the projected scheme of decoration of Carlton House, which had been allocated to Edward Augustus in 1783. Whatever the case, the portrait was never brought to a completed state, although to our eyes it may benefit from the technical fluency it demonstrates instead, a fluency that does much to enforce its thematic exploration of the relationship between the fashionable man of sensibility and his natural setting. MM

Ideal and Experimental Art: The Later Years

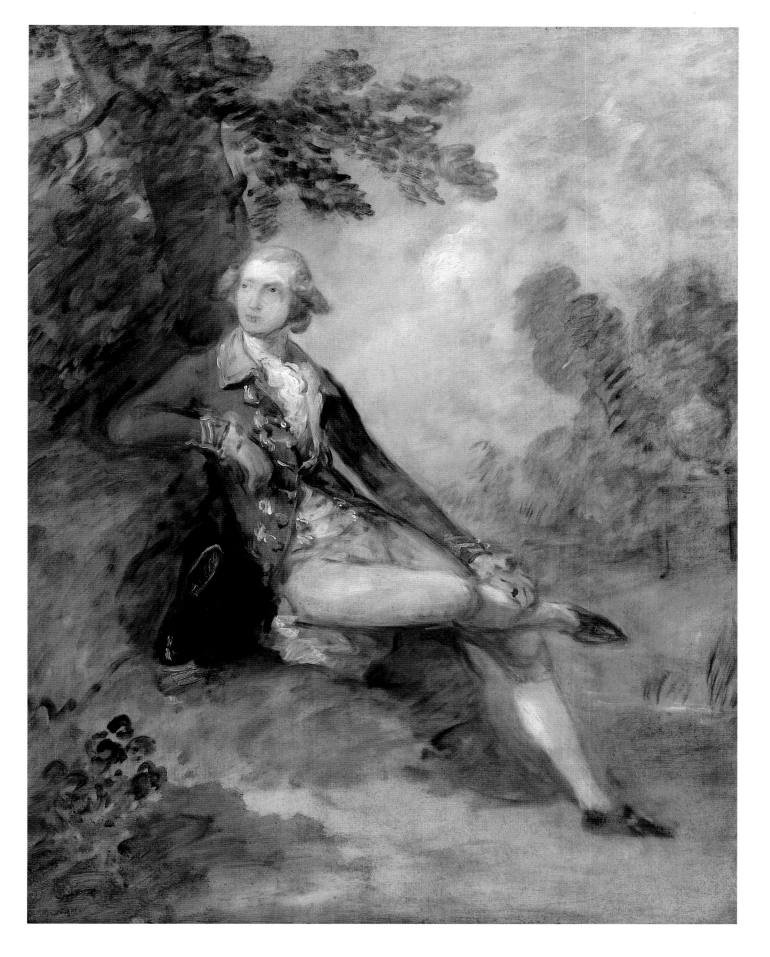

170
Gainsborough after Titian (c.1487–1576)
The Vendramin Family
Oil on canvas, 58.4 × 94 (23 × 37)
Mrs P. Gordon-Duff-Pennington

Waterhouse, no.1031

As with Gainsborough's other copies of Old Masters, it is hard to know when this painting was executed. Tradition has it that it was created as a bet, in an effort to match the colouring of the original from a pencil sketch by imaginative effort. Titian's original painting of 1534–7 was owned, pointedly, by Van Dyck, until it was purchased in 1645 by the Duke of Northumberland. It stayed with various Dukes of Somerset and of Northumberland until the twentieth century, when it entered the collection of the National Gallery, London. Originally thought to represent the Cornaro family, Titian's picture in fact shows the gathered male members of the Verdramin family of Venice, venerating a reliquary of the true cross presented to an ancestor. It is now thought that six of the children were painted by Titian's studio, rather than by the artist himself. In the late eighteenth century Reynolds and Benjamin West (1738–1820) linked the picture with Van Dyck's *Pembroke Family* (see cat.84) as being another major composition which had been subjected to insensitive restoration. None the less, the picture was one of the most important and impressive examples of Titian's art Gainsborough definitely could have seen in England.

Titian was greatly admired as a colourist in the eighteenth century but, as the leading figure of the Venetian School, was also considered with a degree of ambivalence. The sensuality and luxuriance of his colouring were much enjoyed, but also seen by some of the rather more high-minded critics as providing a distraction from the real purpose of art – which was to educate and enlighten as much as to please. Gainsborough would not, perhaps, have been troubled by such concerns. Titian's distinctive colour schemes of reds and rich golds, browns and greens was deliberately evoked by Gainsborough on a number of occasions, notably in his *Shepherd Boys with Dogs Fighting* (cat.60), a calculated effort to present a low-life subject of the most robust kind in an elevated pictorial form and demonstrate that serious art could be visually pleasing as well. MM

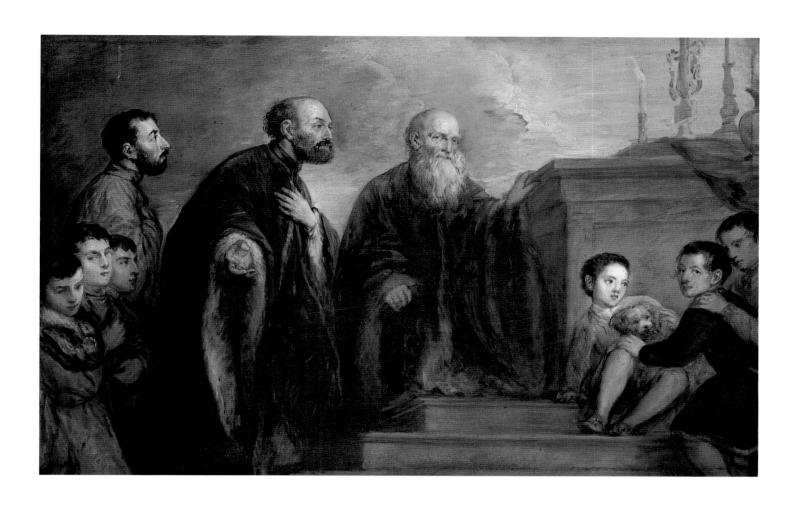

171
Self-Portrait
*c.*1787
Oil on canvas, 77 × 64.7 (30³⁄₁₆ × 25½)
Royal Academy of Arts, London

Waterhouse, no.292

Thomas Gainsborough produced a number of self-portraits, but this was not a regular part of his practice. He never sought to present himself with the formality or ostentation that characterised some artists' self-portraits of the era, notably Reynolds's picture of himself as Doctor of Laws, proudly wearing his gown, accompanied by the bust of Michelangelo (fig.12). This he had painted around 1780 to present to the Royal Academy. Befitting Gainsborough's own troubled relationship with the institution, his self-portrait was only presented to the Academy by his daughter in 1808, some twenty years after his death. The painting was originally meant as a gift for his friend, the composer and musician Carl Friedrich Abel (see cat.50). It appears, however, that it was by this image that he wished to be remembered. A memorandum reads:

It is my strict charge that after my decease no plaster cast, model, or likeness whatever be permitted to be taken: But, if Mr Sharp, who engraved Mr. Hunter's print, should chose to make a print from the ¾ sketch, which I intended for Mr. Abel, painted for myself, I give free consent. (Letters, p.175)

The painting was eventually engraved by Francesco Bartolozzi (1727–1815), and published by the Boydells in 1798. Although unfinished, this self-portrait communicates an impression of the quirky, intelligent and sharp character that was noted by contemporaries, and is manifest in his surviving letters. MR

Ideal and Experimental Art: The Later Years

172

**Mrs Thomas Gainsborough,
née Margaret Burr**

c.1778
Oil on canvas, 76.8 × 64.1 (30¼ × 25¼)
Courtauld Gallery, Courtauld Institute of Art

Waterhouse, no.299

Figure 59
Figure of **Juno Matrona**
from Joseph Spence *Polymetis* (1747)
3rd edition, London 1774
British Library

An old tradition – probably nothing more than sentiment – has it that Gainsborough would paint a portrait of his wife every year as a form of anniversary gift. There are certainly a number of portraits of her painted by the artist over the years, but these do not add up to a coherent sequence, and it is clear that their relationship was not always happy. From time to time Gainsborough himself dropped hints that the union had been made somewhere other than Heaven. In December 1775 he wrote to his sister Mary Gibbon: 'If I tell you my wife is weak but good, and never much formed to humour my Happiness, what can you do to alter her?' And the following year he complained of her 'disobedience Pride and insolence' (*Letters*, pp.130–1). The marriage none the less lasted, and Margaret Gainsborough was tolerant enough to bear with his philanderings and even to nurse him through the severe venereal infection he had contracted on a trip to London in 1763. Evidently they reached some kind of an accommodation moderated by real affection, as this fairly rapidly painted portrait itself suggests through the frank openness of Margaret Gainsborough's full gaze.

Hilary S. Brown has recently suggested that, although apparently spontaneous and frank, the painting may deploy a knowing reference to classical art. Margaret Gainsborough's pose appears to be taken from an engraving of an antique sculpture of *Juno Matrona* that appeared in Joseph Spence's *Polymetis* of 1747 (fig.59), a book we know Gainsborough owned (and referred to when painting *Diana and Actaeon* – see cat.173). The accompanying text discussed the two sides of Juno, as both virtuous wife and haughty scold. Given Gainsborough's ambivalent relationship with Margaret, the reference seems entirely apposite. MR/MM

173
Diana and Actaeon
c.1784–6
Oil on canvas, 158.1 × 188 (62¼ × 74)
Lent by Her Majesty Queen Elizabeth II

Waterhouse, no.1012

174
William Woollett (1735–1785) after Filippo Lauri
(1623–1694)
Diana and Actaeon
published 1764 by John Boydell
Engraving, 40.3 ×51.4 (15⅜ × 20¼)
The British Museum, London

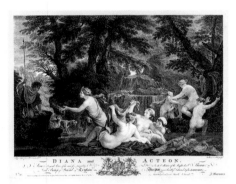

Thomas Gainsborough's only exercise in mythological painting is an extraordinary work. At once viscerally engaging in the virtuoso fluency of its brushwork and daring in its lack of finish, it is also deliberately learned. Ronald Paulson suggests that he took the subject from Addison's translation of Ovid which relates the fate of the hapless Actaeon who, hunting in the sacred Vale of Gargaphe, happened on Diana and her Nymphs bathing. To punish the crime of violating the divine flesh with the worldly gaze, Diana turned Actaeon into a stag, which was then hunted down and torn to pieces by his own hounds. The subject had strong associations with Titian, whose *Death of Actaeon* Benjamin West was reported to have rediscovered in 1785. Gainsborough had adapted the dogs from this painting into *Lurchers Coursing a Fox* (c.1784–5; Iveagh Bequest, Kenwood). The artist was shy of painting naked women – the only other example is *Musidora* (c.1780–8; Tate) – and appears here to have taken his figures mainly from prints. The group of Diana and her nymphs came from a plate from Spence's *Polymetis* (1747), the woman clutching her foot potentially from various places but perhaps the print after Watteau's *Diana Resting*; while the reclining figure to the right originated in Baron's engraving after Titian's *Jupiter and Antiope*, appropriately a subject about voyeurism and violation. These were incorporated into a setting adapted out of Filippo Lauri's *Diana and Actaeon* (cat.174) from which also came a further group of figures.

We may again understand Gainsborough's selection and handling of this subject in terms of that silent debate he was carrying on with Reynolds, which originated in sixteenth-century arguments over the relative merits of *disegno* against *colore*, the intellectual over the sensual, initiated by Vasari. In his eleventh *Discourse* of 1782 Reynolds himself quoted Vasari on Titian and went on to commend his 'excellence with regard to colour, and light and shade, in the highest degree … By a few strokes he knew how to mark the general image and character of whatever object he attempted' (Wark, p.195). Gainsborough managed precisely this, and it may be that in the patches of red and blue, the only chromatically assertive areas of the painting, he was referring back to the Venetians. While Reynolds was adamant that sketches might inspire the imagination to complete their subjects, no such ambiguity was permissible in a finished work. Gainsborough, who had once called histories 'tragi-comic' pictures, appears to discard the iconographic possibilities of the subject which could, for instance, be about such serious ideas as the randomness of fate, to reveal it essentially as being at best about imaginative, even erotic looking, and at worst about voyeurism, for it is the spectator who completes the naked female forms: with some irony, considering that they were based on art and not life. MR

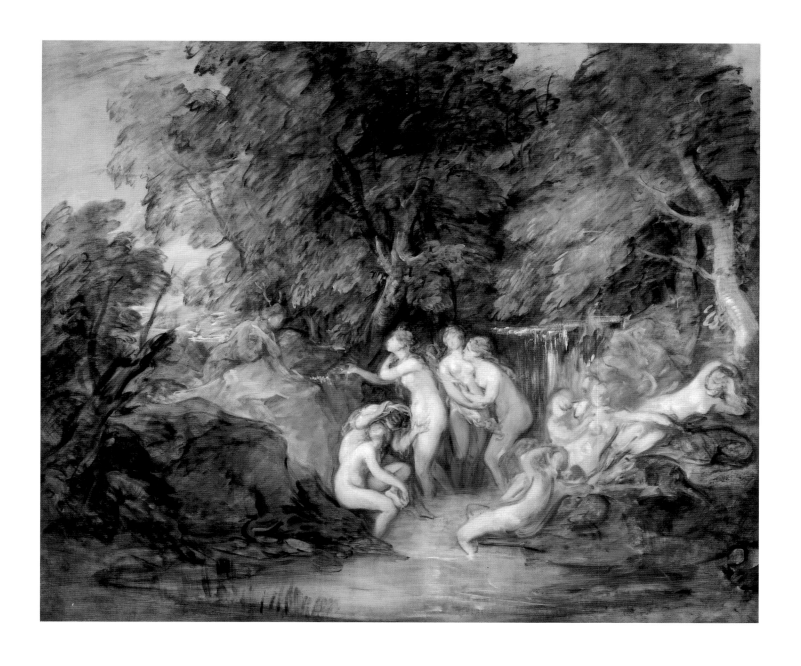

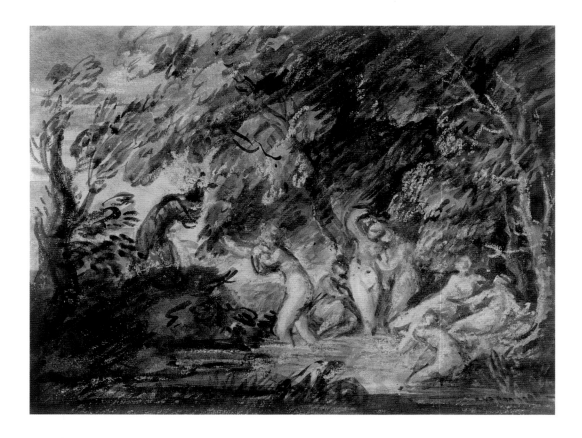

175

First Study for Diana and Actaeon *c.*1784–6
Black chalk with grey and grey-black washes
heightened with white chalk, 25.6 × 33.3
(10¹⁄₁₆ × 13⅛)
Lent by the Trustees of Gainsborough's House,
Sudbury (purchased with contributions from
the National Heritage Memorial Fund, the
MGC/V&A Purchase Grant Fund and the
National Art Collections Fund through Suffolk
County Council, March 1996)

Hayes 1983, no.983

176

Second Study for Diana and Actaeon *c.*1784–6
Wash heightened with white on buff paper,
27.9 × 36.8 (11 × 14½)
The Huntington Library, Art Collections and
Botanical Gardens

Hayes 1970, no.811.

177

Third Study for Diana and Actaeon *c.*1784–6
Black chalk and grey-black and yellowish-brown
washes heightened with white bodycolour on
white paper, 27.5 × 35.4 (11¹³⁄₁₆ × 14)
The Trustees of the Cecil Higgins Art Gallery,
Bedford

Hayes 1970, no.812

John Hayes has proposed that these drawings
evolve in a sequence that logically has the
main figure groupings of the painting of *Diana
and Actaeon* (cat.173) as its conclusion. This
has interesting consequences. Working
virtually in monochrome and incorporating
figures into a setting with an almost violent
tonal blending, Gainsborough allows the
painting to continue the sequence and, as it
were, to function on a par with the drawings in
terms of its capacity to articulate the subject
(and in this demonstrates a consistency with
his landscapes in particular). While preparatory
drawings suggest a real concern with the
subject, again we are permitted enlightenment
as to Gainsborough's position regarding the
theories Reynolds was articulating. In his
eighth *Discourse* (1778) he had conceded that
the necessity to complete what is lacking in
sketches can give 'more than the painter
himself, probably, could produce', but that one
could not 'on this occasion, nor indeed on any
other, recommend an undeterminate manner,
or vague ideas of any kind, in a complete and
finished picture' (Wark, p.164), for such works
had to be unambiguous, to state the ideas
common in any definable public.
Gainsborough appears to have been following
the ideas of the French critic, Roger de Piles,
who had maintained in his *Art of Painting*
(1690) that 'Designs that are just touch'd, and
not finish'd, have more spirit and please more,
than those that are perfected', and that the
'designs of excellent masters, who join solidity

to a fine genius, lose nothing by being
finished'. That is, the qualities of the finished
picture are inherent in sketches for it and they
can be seen, therefore, as enjoying parity.

None of the preparatory work for *Diana and
Actaeon* features the waterfall, which, as
Anthea Callen observed, was painted wet over
dry, and was therefore a late addition to the
painting, so it appears that Gainsborough
found cat.174 while he was working through
the composition. It gave him a landscape
structure and a figure group. Lauri was a
painter of Flemish origins who had worked in
Rome during the seventeenth century, and this
print after his composition appeared in a series
that Boydell published in 1764. MR

Ideal and Experimental Art: The Later Years

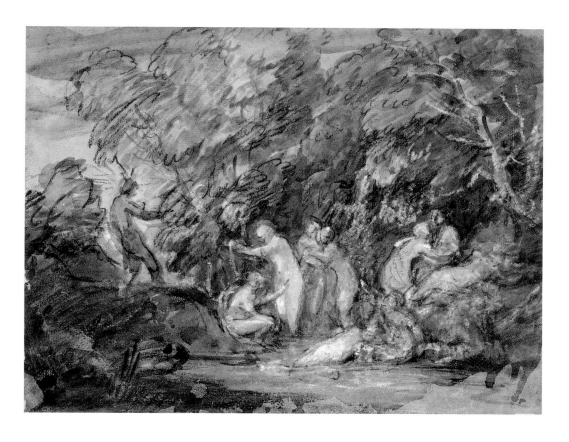

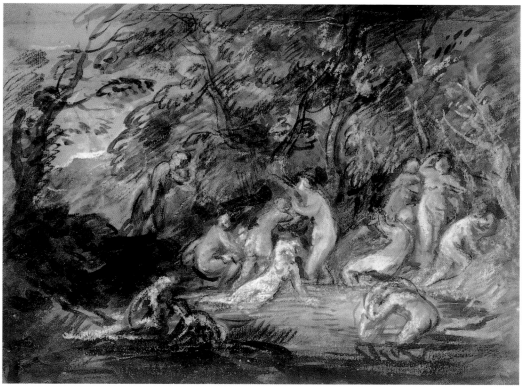

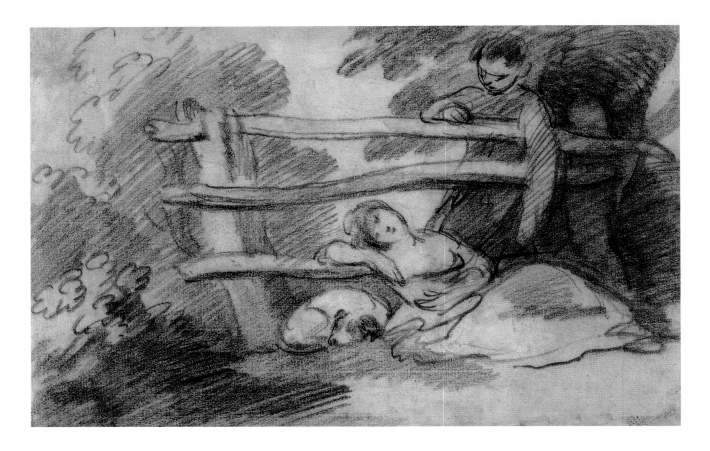

178
Study for the Haymaker and Sleeping Girl
*c.*1785
Black chalk and stump, 22.5 × 35.2 (8⅞ × 13⅞)
The British Museum, London

Hayes 1970, no.847

179
Haymaker and Sleeping Girl
*c.*1785
Oil on canvas, 227.3 × 149.9 (89½ × 59)
The Museum of Fine Arts, Boston, M. Theresa
B. Hopkins Fund and Seth K. Sweetser Fund
53.2553

Waterhouse, no.815

As with the *Shepherd Boys with Dogs Fighting* (cat.60), which he had exhibited in 1783, Gainsborough here elevates what would before have been an incidental element of a landscape composition into a monumental subject in its own right. The canvas is the size and format of that used for grand full-length portraits, indicating the importance this work must have had for the artist. The theme of rustic lovers was a stock one in the arts, appearing in popular song and as a motif on decorative wares as much as in landscape painting. In Gainsborough's art it appears with some frequency, for instance in the idyllic landscapes of the early 1770s such as cat.135, but never before with this absolute focus on the figures. Unusually for Gainsborough, we have a drawn study that relates quite closely to the finished work (although on a different format), indicating that, as with the contemporary *Diana and Actaeon* (cat.173), he must have taken some pains with the composition. Gainsborough Dupont certainly thought highly of this work, choosing it for himself when his uncle offered him any picture from his studio.

Despite the apparent simplicity of the theme, Old Master references have been detected in this composition, with the sleeping girl cast as a Correggio goddess and the haymaker as a voyeuristic satyr. The figure of the girl, bathed in light and with her hat acting as a kind of makeshift halo, is certainly

supplied with divine qualities, and the presence of freshly-collected mushrooms in her basket serves further to associate her with the dawn, and thus youth, new life and light. Amal Asfour and Paul Williamson have identified a precise reference to a device from an earlier eighteenth-century Dutch emblem book, representing the motto 'He that loveth not *his* brother abideth in death' and thus the theme of innocent, spiritual love. There is certainly something in this, although how innocent the haymaker's love for the dishevelled sleeping girl is may be in doubt and Gainsborough's self-confessed enthusiasm for 'petticoats' is fully confirmed by the young woman's tenderly conceived décolletage. If Gainsborough is acknowledging the emblem tradition here, his celebration of the sensuous appeal of women, and of the power of art to convey that appeal, may undermine the moral seriousness of the emblem (which was, in the original, represented through distinctly asexual putti figures). Whether we can elaborate a precise symbolic content for this painting or not, Gainsborough's effort to create a monumental image out of a lowly rustic theme has its own importance in relation to the aesthetic theory of his time, and the variety of allusions that can be traced in the image demonstrates the potential complexity of his kind of modern art. MM

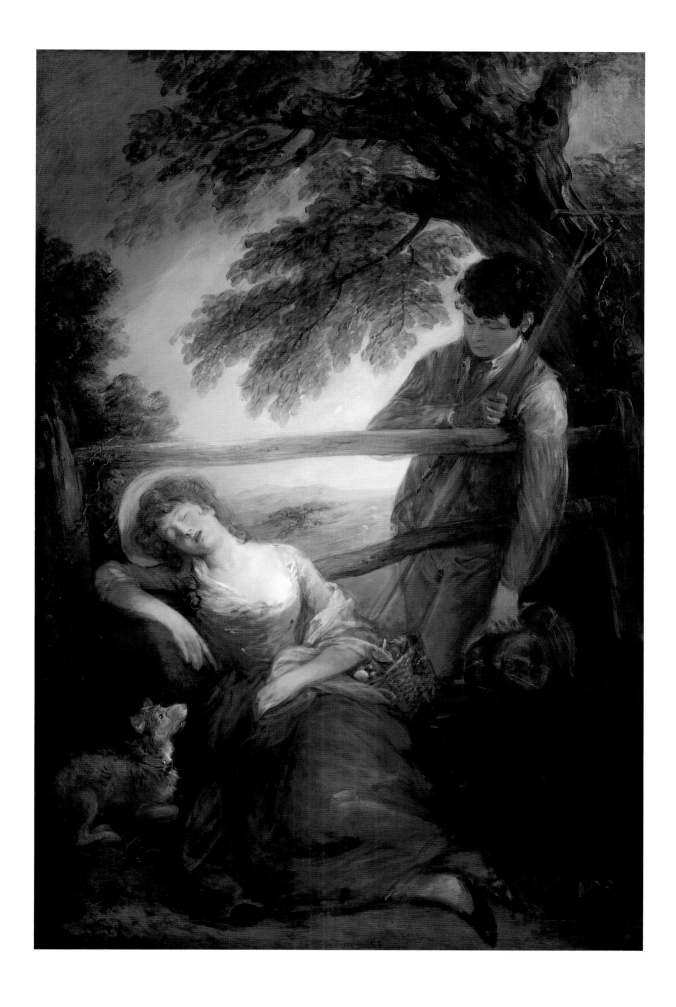

180
Rocky Landscape with Hagar and Ishmael
*c.*1785
Oil on canvas, 78.1 × 94.6 (30¾ × 37¼)
National Museums and Galleries of Wales

Hayes 1982, no.186

Although Gainsborough copied religious subjects by the Masters, this was his only explicitly religious work. As a devout Christian and regular church-goer the artist knew his Bible, and here took his subject from Genesis 21:14. Abraham's wife Sarah insisted that he banish Hagar, and Ishmael, the child Hagar had had by Abraham. Consequently, 'Abraham rose up early in the morning, and took bread, and a bottle of water, and gave *it* unto Hagar, putting *it* on her shoulder, and sent her away: and she departed and wandered in the wilderness of Beer-sheba.' In time she abandons Ishmael to starvation, but is saved by God, who supplies water. It is evident from the painting that Gainsborough was being literal in his representation of the banishment, with Hagar and Ishmael trudging through a brown and confined landscape of a type recognisable from others of his works, save for the distance being less open than is usually the case. These connections, along with the familiarity of the motif of travelling figures, suggest that we might review some of Gainsborough's more ostensibly secular subjects in the light of his faith. MR

Chronology

1727 Born in Sudbury, Suffolk, the fifth son of John Gainsborough and Mary Burroughs; baptised on 14 May.

c.1740 Apprenticeship with Hubert-François Gravelot in London.

Joins the artistic community of St Martin's Lane with William Hogarth, Charles Grignion, Francis Hayman and Louis-François Roubiliac.

Paints his first self-portrait at the age of thirteen (cat.1).

1741–2 Works with Francis Hayman and possibly collaborates on decoration of the pleasure gardens at Vauxhall.

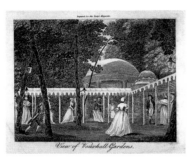

Figure 60
Anonymous
View of Vauxhall Gardens *c.*1750
Engraving on paper, 11 × 13 (4¾ × 5⅛)
Guildhall Library, Corporation of London

1743–4 Establishes an independent studio in Hatton Gardens, at no.2 Little Kirby Street.

1746 Marries Margaret Burr, daughter of Henry, Duke of Beaufort, on 15 July at St George's Chapel, Curzon Street, London.

1746/7 Moves to no.67 Hatton Garden.

1747/8 Birth of his first daughter, Mary, who died in infancy and was buried on 1 March at St Andrew's Church, Holborn.

1748 Works with Hogarth, Gravelot and Hayman decorating the Foundling

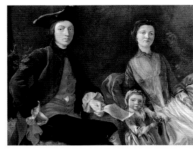

Figure 61
Detail from **Portrait of the Artist with his Wife and Daughter** *c.*1748 (cat.17)

Hospital and presents his painting *The Charterhouse* (cat.6).

1749 The Gainsboroughs return to Sudbury.

1750 Birth of his second daughter Mary, who was baptised at All Saints' Church, Sudbury, on 3 February.

Paints the portrait of Mr and Mrs Andrews (cat.18).

1751 Birth of his third daughter, Margaret, who was baptised at St Gregory's Church, Sudbury, on 22 August.

Publication of Thomas Gray's *Elegy in a Country Churchyard*.

1752 The Gainsboroughs move to Ipswich.

Introduction of the Gregorian calendar.

1753 Gainsborough is introduced to Philip Thicknesse.

Reynolds settles in London.

Hogarth publishes *The Analysis of Beauty*.

1754 Establishment of the Society for the Encouragement of Arts, Manufacture and Commerce.

1755 Samuel Johnson publishes his *Dictionary of the English Language*.

1756 Outbreak of the Seven Years' War (1756–63).

1757 Publication of Edmund Burke's *A Philosophical Enquiry into the Origin of our Ideas of the Sublime and Beautiful*.

1758 Paints the Colchester attorney William Mayhew (see p.18).

Makes a six-month trip to Bath.

1759 Moves to Bath.

Reynolds publishes his essays on art in Samuel Johnson's *Idler*.

1760 Accession of George III.

Paints the amateur musician Miss Ann Ford, later to become Mrs Philip Thicknesse (cat.35).

Establishment of the Society of Artists in London.

1761 Exhibits *Robert Craggs* (cat.36) at the Society of Artists at Spring Gardens.

1762 James Christie opens his auctioneering business.

1763 Shows portrait of actor James Quin (cat.39) at annual Society of Artists exhibition.

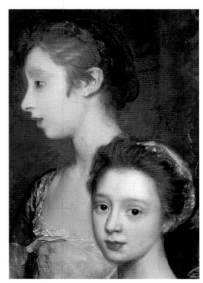

Figure 62
Detail of Mary and Margaret Gainsborough from
Portrait of the Artist's Daughters *c.*1763–4 (cat.96)

Moves to a house outside Bath in Lansdown Road.

Victorious end of Seven Years' War.

1764 Death of Hogarth

1766 Moves to a house at no.17 Circus, Bath.

Christopher Anstey publishes *The New Guide to Bath*.

1768 Foundation of the Royal Academy in December; Gainsborough invited to become a founder member.

1769 Inaugural exhibition at the Royal Academy; Gainsborough exhibits *Isabella, Viscountess Molyneux* (cat.44).

Reynolds delivers the first of the *Discourses* on the nature of art which he gave annually until 1771 and biennially thereafter.

1770 Oliver Goldsmith publishes his poem, *The Deserted Village*.

1771 Gainsborough exhibits the full-length portraits of Lord and Lady Ligonier (cats.46 and 47) at the Royal Academy.

Opening of the Pantheon on Oxford Street, London.

Publication of Tobias Smollett's *Humphrey Clinker* and Henry Mackenzie's *The Man of Feeling*.

1772 Takes on his nephew Gainsborough Dupont as an apprentice.

Exhibits at the Royal Academy and includes drawings in imitation of paintings (see cat.132).

Revd Henry Bate becomes editor of the *Morning Post*.

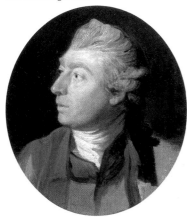

Figure 63
Johan Zoffany **Thomas Gainsborough** *c.*1772
Oil on canvas, 19.7 × 17.1 (7¾ × 6¾)
Tate

1773 Abstains from the Royal Academy exhibition after quarrelling over the hanging of his paintings. Does not exhibit again until 1777.

Publication of Richard Graves's *The Spiritual Quixote*.

1774 Settles in London and rents the west wing of Schomberg House, Pall Mall.

1775 American Wars of Independence (1775–82).

1776 American Declaration of Independence (4 July)

1777 Gainsborough returns to the Royal Academy exhibition after an absence of four years; exhibits four portraits including *Carl Friedrich Abel* (cat.50) and *Mrs Graham* (fig.11), and the landscape, *The Watering Place* (cat.51).

Revd Henry Bate leaves the *Morning Post* to found the *Morning Herald*.

1778 Submits thirteen paintings to the RA exhibition, including portraits of the auctioneer James Christie (cat.54), Philippe Jacques de Loutherbourg (cat.53) and Grace Dalrymple (cat.52), while Reynolds shows *The Marlborough Family* (Blenheim Palace, Oxfordshire).

1779 Visits Devon coast.

1780 Exhibits at the Royal Academy and includes the portraits *Reverend Henry Bate* (cat.55) and *Johann Christian Fischer* (Royal Collection).

Royal Academy moves to new premises in Somerset House on the Strand.

1781 Exhibits at the Royal Academy include portraits of King George III and Queen Charlotte (both Royal Collection), and *Coastal Scene* (cat.56).

Phillippe Jacques de Loutherbourg exhibits his 'Eidophusikon' for the first time.

Publication of William Gilpin's *Observations on the River Wye and Several Parts of South Wales Relative Chiefly to Picturesque Beauty*.

1782 Tours the West Country with Gainsborough Dupont.

Exhibits at the Royal Academy; includes the portrait of Giovanna Baccelli (cat.57), *Wooded Landscape with Cattle by a Pool* (cat.58) and *Girl with Pigs* (cat.59), which Reynolds buys later in the year.

J.H. Pott publishes his *Essay on Landscape Painting*.

1783 Gainsborough's final exhibition at the Royal Academy; exhibits include composite portrait of fifteen oval heads of the monarchs and their offspring (Royal Collection), and *Shepherd Boys with Dogs Fighting* (cat.60).

Tours the Lake District with Samuel Kilderbee and may have visited Flanders later in the year.

Constructs his showbox and paints landscape transparencies.

1784 Quarrels with the Royal Academy; withdraws his paintings from the exhibition and never exhibits there again.

Inaugural annual exhibition of his work at his studio in Schomberg House, which runs concurrently with the Royal Academy show.

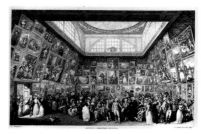

Figure 64
J.H. Ramberg, engraved by *Pietro Martini*
Family of George III at The Royal Academy Exhibition at Somerset House, 1787, 1788
Engraving, 36.3 × 50.2 (14¼ × 19¾)
The Museum of London

Following the death of Allan Ramsay, Reynolds is appointed Principal Painter to the King in August.

1785 Paints *Diana and Actaeon* (cat.173).

1788 2 August dies at home; buried at Kew Churchyard.

Philip Thicknesse publishes his biography of Gainsborough's life.

Reynolds writes of his last encounter with Gainsborough in the fourteenth Discourse delivered in December at the Royal Academy.

1789 Private sale of Gainsborough's drawings and paintings held at Schomberg House.

1792 Death of Reynolds.

1794 Publication of Sir Uvedale Price's *An Essay on the Picturesque, as Compared with the Sublime and the Beautiful*.

1797 Death of Gainsborough Dupont.

1799 Death of Mrs Margaret Gainsborough.

Selected Bibliography

This is not intended to be a comprehensive bibliography of writings on Gainsborough, but rather a selection of both standard works of reference and of books and articles which have been decisive in shaping the thinking represented in this catalogue. The list also includes a few modern editions of the most pertinent and interesting original eighteenth-century texts.

Abbreviations

Farington Diary
 Kenneth Garlick, Angus Macintyre and Kathryn Cave (eds.), *The Diary of Joseph Farington*, 16 vols., New Haven and London 1978–84; Evelyn Newby (ed.), Index, vol.17, New Haven and London 1998
Hayes 1970
 John Hayes, *The Drawings of Thomas Gainsborough*, 2 vols., London 1970
Hayes 1971
 John Hayes, *Gainsborough as Printmaker*, London 1971
Hayes 1982
 John Hayes, *The Landscape Paintings of Thomas Gainsborough*, 2 vols., London 1982
Hayes 1983
 John Hayes, 'Gainsborough Drawings: A Supplement to the Catalogue Raisonné', *Master Drawings*, vol.21, 1983, pp.367–91
Letters
 John Hayes (ed.), *The Letters of Thomas Gainsborough*, New Haven and London 2001
Wark
 Robert R. Wark (ed.), *Sir Joshua Reynolds: Discourses on Art*, New Haven and London 1975
Waterhouse
 Ellis Waterhouse, *Gainsborough*, London 1958
Whitley
 William T. Whitley, *Thomas Gainsborough*, London 1915

Thomas Gainsborough: Life and Art

Amal Asfour and Paul Williamson, *Gainsborough's Vision*, Liverpool 1999
Hugh Belsey, *Gainsborough the Printmaker*, Aldeburgh 1988
— *Gainsborough's Family*, exh. cat., Gainsborough's House, Sudbury 1988
Adrienne Corri, *The Search for Gainsborough*, London 1984
Malcolm Cormack, *The Paintings of Thomas Gainsborough*, Cambridge 1991
Dulwich Picture Gallery, *A Nest of Nightingales: Thomas Gainsborough 'The Linley Sisters'*, exh. cat., 1988
Gainsborough's House Review, ed. Hugh Belsey, published annually 1990 on
John Hayes, *The Drawings of Thomas Gainsborough*, 2 vols., London 1970
— *Gainsborough as Printmaker*, London 1971
— *Gainsborough: Paintings and Drawings*, London 1975
— *Thomas Gainsborough*, exh. cat., Tate, London 1980
— *The Landscape Paintings of Thomas Gainsborough*, 2 vols., London 1982
— *Thomas Gainsborough*, exh. cat., Palazzo dei Diamanti, Ferrara 1998
John Hayes (ed.), *The Letters of Thomas Gainsborough*, New Haven and London 2001
Jack Lindsay, *Thomas Gainsborough: His Life and Art*, London 1981
Martin Postle, *Thomas Gainsborough*, London 2002
Michael Rosenthal, *The Art of Thomas Gainsborough: 'a little business for the Eye'*, New Haven and London 1999
Susan Sloman, *Gainsborough in Bath*, New Haven and London 2002
William Vaughan, *Gainsborough*, London 2002
Ellis Waterhouse, *Gainsborough*, London 1958
William T. Whitley, *Thomas Gainsborough*, London 1915

The Techniques of Painting

M.K. Talley, *Portrait Painting in England: Studies in the Technical Literature before 1700*, London 1981
Leslie Carlyle, *The Artist's Assistant: Oil Painting Instruction Manuals and Handbooks in Britain 1800–1900 With Reference to Selected Eighteenth-Century Sources*, London 2001

Cultural and Political Contexts

John Brewer, *The Pleasures of the Imagination: English Culture in the Eighteenth Century*, London 1997
John Brewer and Ann Bermingham, *The Consumption of Culture, 1600–1800: Image, Object, Text*, London 1995
Linda Colley, *Britons: Forging the Nation 1708–1837*, New Haven and London 1992
Paul Langford, *A Polite and Commercial People: England 1727–1783*, Oxford 1989
Paul Langford, *Englishness Identified: Manners and Character 1650–1850*, Oxford 2000
Richard Leppert, *Music and Image: Domesticity, Ideology and Socio-Cultural Formation in Eighteenth-Century England*, Cambridge 1988
Neil McKendrick, John Brewer and J.H. Plumb, *The Birth of a Consumer Society: The Commercialisation of Leisure in Eighteenth-Century England*, London 1983
Simon McVeigh, *Concert Life in London from Mozart to Haydn*, Cambridge 1993
Iain Pears, *The Discovery of Painting: The Growth of Interest in the Arts in England 1680–1768*, New Haven and London 1988
David Solkin, *Painting for Money: The Visual Arts and the Public Sphere in Eighteenth-Century England*, New Haven and London 1992

Beginnings: The Early Years

Ilaria Bignamini and Martin Postle, *The Artist's Model: Its Role in British Art from Lely to Etty*, exh. cat., Nottingham University Art Gallery 1991

Elizabeth Einberg (ed.), *Manners and Morals: Hogarth and British Painting 1700–1760*, exh. cat., Tate, London 1987

Susan Foister, Rica Jones and Olivier Meslay, *Young Gainsborough*, exh. cat., National Gallery, London 1997

William Hogarth, *The Analysis of Beauty* (1753), ed. Ronald Paulson, New Haven and London 1999

Michael Rosenthal, 'Thomas Gainsborough's *Ann Ford*', *Art Bulletin*, vol.80, 1998, pp.649–65

Gainsborough in the Public Eye: The Exhibition Works

Richard D. Altick, *The Shows of London*, Cambridge, Mass., and London 1978

David Brenneman, *The Critical Response to Thomas Gainsborough's Painting: A Study of the Contemporary Perception and Materiality of Gainsborough's Art*, Ph.D. Brown University, published Ann Arbor 1995

David Solkin (ed.), *Art on the Line: The Royal Academy Exhibitions at Somerset House, 1780–1836*, New Haven and London 2001

Richard Wendorf, *Sir Joshua Reynolds: The Painter in Society*, Cambridge, Mass., and London 1996

Portraiture and Fashion

Diana Donald, *The Age of Caricature: Satirical Prints in the Reign of George III*, New Haven and London 1996

Anne French (ed.), *The Earl and Countess Howe by Gainsborough: a bicentenary exhibition*, exh. cat., Iveagh Bequest, Kenwood, London 1988

Marcia Pointon, *Hanging the Head: Portraiture and Social Formation in Eighteenth-Century England*, New Haven and London 1993

Aileen Ribeiro, *The Art of Dress: Fashion in England and France 1750 to 1820*, New Haven and London 1995

Desmond Shawe-Taylor, *The Georgians: Eighteenth-Century Portraiture and Society*, London 1990

Sensibility

G.J. Barker-Benfield, *The Culture of Sensibility: Sex and Society in Eighteenth-Century Britain*, Chicago and London 1992

Henry Mackenzie, *The Man of Feeling* (1771), ed. Brian Vickers, Oxford 1987

John Mullan, *Sentiment and Sociability: The Language of Feeling in the Eighteenth Century*, Oxford 1988

Janet Todd, *Sensibility: An Introduction*, London and New York 1986

Landscape and the Poor

Malcolm Andrews (ed.), *The Picturesque: Literary Sources and Documents*, 3 vols., Robertsbridge 1994

John Barrell, *The Dark Side of the Landscape: The Rural Poor in English Painting 1730–1840*, Cambridge 1980

Ann Bermingham, *Landscape and Ideology: The English Rustic Tradition, 1740–1860*, London 1987

Kay Dian Kriz, *The Idea of the English Landscape Painter: Genius as Alibi in the Early Nineteenth Century*, New Haven and London 1997

J.M. Neeson, *Commoners: Common Right, Enclosure and Social Change in England, 1700–1820*, Cambridge 1993

Ideal and Experimental Art: The Later Years

Hilary S. Brown, 'Gainsborough's Classically Ambivalent Wife', *The British Art Journal*, vol.3, 2002, p.78

Jonathan D. Derow, 'Gainsborough's Varnished Watercolor Technique', *Master Drawings*, vol.26, no.3, Autumn 1988, pp.259–71

Jonathan Mayne, 'Thomas Gainsborough's Exhibition Box', *Victoria and Albert Museum Bulletin*, vol.1, no.3. July 1965, pp.17–24

Ronald Paulson, *Emblem and Expression: Meaning in English Art of the Eighteenth Century*, London 1975

Joshua Reynolds, *Sir Joshua Reynolds: Discourses on Art*, ed. Robert R. Wark, New Haven and London 1975

Michael Rosenthal, 'Gainsborough's *Diana and Actaeon*', in John Barrell (ed.), *Painting and the Politics of Culture: New Essays on British Art 1700–1850*, Oxford and New York 1992

List of works – London, Washington, Boston

#		London	Washington	Boston
1	Self-Portrait	•	•	•
2	Open Landscape with Cottage at the Edge of a Wood	•		
3	Copy after Ruisdael's 'La Forêt'	•	•	•
4	Gainsborough's Forest ('Cornard Wood')		•	•
5	Wooded Landscape with Peasant Resting	•	•	•
6	The Charterhouse	•		
7	Holywells Park, Ipswich	•	•	•
8	Landscape with a View of a Distant Village	•	•	•
9	Landscape with a Decayed Willow over a Pool	•		
10	Drover with Calves in a Country Cart		•	•
11	The Suffolk Plough	•		
12	Study of a Standing Youth (Boy with a Book and Spade)	•		
13	Study of Mallows	•	•	•
14	Self-Portrait Sketching	•		
15	*Hubert-François Gravelot* **A Young Woman Seated on a Chair**	•		
16	Study of a Young Girl Walking	•		
17	Portrait of the Artist with his Wife and Daughter	•	•	•
18	Mr and Mrs Andrews	•		
19	*Francis Hayman* **Jonathan Tyers with his daughter Elizabeth, and her husband John Wood**	•		
20	The Gravenor Family			•
21	Peter Darnell Muilman, Charles Crokatt and William Keable	•		•
22	The Revd John Chafy Playing the Violoncello in a Landscape	•	•	•
23	Heneage Lloyd and his Sister	•	•	•
24	Portrait of a Woman	•	•	
25	Admiral Vernon	•		
26	Self-Portrait	•		
27	Wooded Landscape with Peasants, Donkey and Cottage	•		
28	*Thomas Gainsborough and Joseph Wood* **Wooded Landscape with Gypsies round a Camp Fire (The Gypsies)**	•		
29	Beech Trees in the Woods at Foxley	•	•	•
30	Uvedale Tomkyns Price	•	•	•
31	Landscape with Cows	•	•	•
32	Woody Landscape	•	•	•
33	Sunset: Carthorses Drinking at a Stream	•		
34	William Wollaston	•	•	•
35	Ann Ford, Later Mrs Philip Thicknesse	•	•	•
36	Robert Craggs	•	•	•
37	William Poyntz	•		
38	A Grand Landscape	•	•	•
39	James Quin	•		
40	Wooded Landscape with Country Wagon, Milkmaid and Drover	•	•	
41	George, Lord Vernon	•	•	
42	Henrietta Vernon, Countess Grosvenor	•		
43	The Harvest Wagon	•	•	•
44	Isabella, Viscountess Molyneux	•		
45	Hester, Countess of Sussex, and her Daughter, Lady Barbara Yelverton			•
46	Edward, Second Viscount Ligonier	•	•	•
47	Penelope, Viscountess Ligonier	•	•	•
48	Captain William Wade	•		
49	The Linley Sisters	•	•	•
50	Carl Friedrich Abel	•	•	•
51	The Watering Place	•		•
52	Grace Dalrymple, Mrs John Elliott		•	•
53	Philippe Jacques de Loutherbourg	•	•	•
54	James Christie	•	•	•
55	Reverend Henry Bate	•		
56	Coastal Scene	•		
57	Giovanna Baccelli	•	•	•
58	Wooded Landscape with Cattle by a Pool	•		•
59	Girl with Pigs	•		
60	Shepherd Boys with Dogs Fighting	•	•	•
61	*Allan Ramsay* **Mrs Bruce of Arnott**	•		
62	*Sir Joshua Reynolds* **Lady Anstruther**	•		
63	Lady Elizabeth Montagu	•		
64	Mary, Countess Howe	•		
65	Mrs Henry William Berkeley Portman	•	•	•
66	Mrs Elizabeth Tudway	•	•	•
67	Miss Catherine Tatton	•	•	
68	Study of a Woman Seen from Behind	•		
69	A Woman with a Rose	•		
70	Portrait of Mary Gainsborough		•	•
71	Study of a Woman	•	•	•
72	Woman Seated beside a Plinth	•		
73	Study for a Music Party		•	•
74	*William Hoare* **Christopher Anstey with his Daughter**	•		
75	*British School* **Ridiculous Taste, or the Ladies Absurdity**	•		
76	*British, 18th century* **Doll known as 'The Queen of Denmark'**	•		
77	*British, 18th century* **Large wooden doll**	•		
78	*French, 18th century* **Fashion doll**	•		
79	Sir Edward Turner, Bart	•		
80	*Valentine Green after Gainsborough* **David Garrick**	•		
81	*Edward Fisher after Joshua Reynolds* **Laurence Sterne**	•		
82	*James McArdell after Gainsborough* **Sir Edward Turner, Bart**	•		
83	*John Dixon* **The Old Beau in Extasy**	•		
84	*Gainsborough after Anthony Van Dyck* **The Pembroke Family**	•		
85	*Gainsborough after Anthony Van Dyck* **Lords John and Bernard Stuart**	•		

#		London	Washington	Boston
86	Gainsborough Dupont	•	•	
87	Gainsborough Dupont	•	•	•
88	Mr and Mrs William Hallett ('The Morning Walk')		•	•
89	The Duke and Duchess of Cumberland	•	•	•
90	Study of a Lady		•	
91	Study of a Lady	•		
92	*British School* **Ladies in Fashionable Dresses**	•		
93	*British School* **The Dress of a Lady and Child of the Year 1785**	•		
94	Lady Walking in a Garden with a Child			•
95	The Painter's Daughters with a Cat	•	•	
96	Portrait of the Artist's Daughters			•
97	Lady Georgiana Spencer	•		
98	*James Watson after Joshua Reynolds* **Miss Sarah Price**	•		
99	Master John Truman-Villebois and his Brother Henry	•	•	•
100	Mrs Lewes Peak Garland, formerly Miss Indiana Talbot	•	•	•
101	Portrait of Lady Rodney (née Anne Harley)	•	•	
102	Portrait of Mrs Drummond (née Matha Harley)	•		
103	Lady Brisco	•	•	•
104	An Officer of the 4th Regiment of Foot	•	•	
105	Joshua Grigby	•	•	•
106	*Joseph Wright of Derby* **Thomas Day**	•		
107	Tristram and Fox	•	•	•
108	Study of a King Charles Spaniel	•	•	•
109	Studies of a Cat	•		
110	Henry 3rd Duke of Buccleuch	•		
111	John Eld			•
112	Ignatius Sancho	•	•	•
113	The Reverend Humphry Gainsborough	•	•	•
114	Evening Landscape with Peasants Returning from Market	•	•	•
115	Peasants and Colliers Going to Market; Early Morning	•	•	•
116	View near King's Bromley-on-Trent, Staffordshire		•	•
117	Wooded Landscape with Family Grouped outside a Cottage Door	•		
118	Wooded Landscape with a Peasant Asleep in a Cart	•	•	
119	Wooded Landscape with a Boy Reclining in a Cart	•		
120	*John Raphael Smith after William Redmore Bigg* **A Lady and her Children Relieving a Cottager**			
121	Cottage with Peasant Family and Woodcutter Returning Home	•	•	•
122	Cottage Girl with Dog and Pitcher	•		
123	Cottage Door with Girl and Pigs	•		
124	Woman Seated with Three Children	•		
125	Beggar Boy	•	•	
126	Studies of Girls Carrying Faggots		•	
127	*Peter Simon after Gainsborough* **The Woodman**	•		
128	Wooded Landscape with Country Mansion, Figures and Animals	•	•	•
129	Charity Relieving Distress	•	•	
130	Road through a Wood, with Figures on Horseback and Foot	•		
131	*John Keyse Sherwin* **The Deserted Village**	•		
132	Rocky Wooded Landscape with Drovers and Cattle	•		
133	A Peasant Family Travelling to Market	•		•
134	*Rembrandt van Rijn* **Flight into Egypt: A Night Piece**	•		
135	Rocky Wooded Landscape with Rustic Lovers, Herdsmen and Cows	•		
136	Italianate Landscape with Travellers on a Winding Road	•	•	
137	Mountain Landscape with Figures and Buildings			•
138	Wooded Landscape with Herdsmen and Cattle	•		•
139	Shepherd Tending Sheep in a Glade	•	•	•
140	Mountain Landscape with Figures, Sheep and Fountain	•	•	
141	Wooded Landscape with Figure and Ruined Castle	•	•	•
142	Wooded Landscape with Shepherd and Sheep	•	•	•
143	Wooded Landscape with Horsemen and Buildings	•	•	•
144	Romantic Landscape with Sheep at a Spring		•	•
145	*Claude Gellée, called Le Lorrain* **Pastoral Landscape with the Ponte Molle**	•		
146	Mountain Landscape with Bridge	•	•	•
147	Wooded Landscape with Buildings, Lake and Rowing Boat	•		•
148	Mountain Landscape with a Castle and a Boatman		•	
149	Extensive Wooded Landscape with a Bridge over a Gorge	•	•	•
150	Rocky Wooded Landscape with Waterfall, Castle and Mountain	•		
151	Seashore with Fishermen	•		
152	Gainsborough's 'showbox'	•		
153	Wooded Landscape with Herdsmen Driving Cattle past a Pool	•		
154	Coastal Scene with Sailing and Rowing Boats	•		
155	Wooded Upland River Landscape with Figures Crossing a Bridge, Cottage, Sheep and Distant Mountains	•		
156	Open Landscape with Peasants, Cows, Sheep, Cottages and a Pool	•		
157	Wooded Landscape with Figures and Cows at a Watering Place	•		
158	Wooded Landscape with Figures and Cows at a Watering Place	•		
159	Wooded Landscape with a Peasant Reading a Tombstone, Rustic Lovers and Ruined Church	•		
160	Wooded Landscape with Herdsmen Driving Cattle over a Bridge, and a Ruined Castle	•		
161	Wooded Landscape with Herdsman Driving Cattle over a Bridge, Rustic Lovers and Ruined Castle	•		
162	Wooded Landscape with Two Country Carts and Figures	•		
163	Wooded Landscape with a Country Cart	•	•	•
164	Wooded Landscape with a Country Cart and Figures	•	•	
165	Mrs Siddons		•	•
166	Mrs Richard Brinsley Sheridan	•	•	•
167	The Rt Hon. Charles Wolfran Cornwall	•		•

Lenders and Credits

	London	Washington	Boston
168 **Hugh, First Duke of Northumberland**	•		
169 **Edward Augustus, later Duke of Kent**	•	•	•
170 *Gainsborough after Titian* **The Vendramin Family**	•		
171 **Self-Portrait**	•	•	•
172 **Mrs Thomas Gainsborough, née Margaret Burr**	•	•	•
173 **Diana and Actaeon**	•	•	•
174 *William Woollett after Filippo Lauri* **Diana and Actaeon**	•		
175 **First Study for Diana and Actaeon**	•		•
176 **Second Study for Diana and Actaeon**	•	•	•
177 **Third Study for Diana and Actaeon**	•	•	
178 **Study for the Haymaker and Sleeping Girl**		•	•
179 **Haymaker and Sleeping Girl**		•	•
180 **Rocky Landscape with Hagar and Ishmael**	•	•	•

Lenders

Private Collections

Althorp
Duke of Buccleuch & Queensberry KT
Cheryl Chase and Stuart Bear
The Castle Howard Collection
The Right Hon. Viscount Cowdray
The Faringdon Collection Trust
Simon Jenkins
Sir Edwin Manton
Duke of Northumberland
Marquess of Northampton
Trustees of the Portman Settled Estates
Private Collection
Phyllida Gordon-Duff-Pennington
Robert Stephen Holdings plc
Duke of Rutland
Lord de Saumarez
His Grace the Duke of Westminster
Her Grace the Duchess of Westminster

Public Collections

Amsterdam, Rijksmuseum
Bath, Victoria Art Gallery
Bedford, Cecil Higgins Art Gallery
Berlin, Gemäldegalerie
Birkenhead, Williamson Art Gallery and Museum
Birmingham, Barber Institute of Fine Arts
Birmingham, Birmingham Museums and Art Gallery
Boston, Museum of Fine Arts
Brighton, Brighton Museums and Art Gallery
Cambridge, Fitzwilliam Museum
Cardiff, National Museums & Galleries of Wales
Cincinnati, Cincinnati Museum
Dublin, National Gallery of Ireland
Edinburgh, National Gallery of Scotland
Ipswich, Ipswich Borough Council
Liverpool, Walker Art Gallery
London, British Museum
London, Coram Family in the care of the Foundling Museum
London, Courtauld Institute of Art, Courtauld Gallery
London, Dulwich Picture Gallery
London, English Heritage, Kenwood House
London, Museum of London
London, National Gallery
London, National Portrait Gallery
London, Royal Academy of the Arts
London, Royal Collection Trust
London, Tate Gallery
London, Victoria and Albert Museum
Los Angeles, J. Paul Getty Museum
Manchester, Whitworth Art Gallery
Melbourne, National Gallery of Victoria
Munich, Neue Pinakothek
New Haven, Yale Center for British Art
New York, Metropolitan Museum of Art
New York, Pierpont Morgan Library
Ottawa, National Gallery of Canada
Oxford, Ashmolean Museum
Philadelphia, Philadelphia Museum of Art
Saint Louis, Saint Louis Art Museum
San Marino, Huntington Library, Art Collections and Botanical Gardens
Southampton, Southampton City Art Gallery
Sudbury, Gainsborough's House
Toledo, Toledo Museum of Art
Washington, National Gallery of Art
Wolverhampton, Wolverhampton Metropolitan Borough Council
Worcester, Worcester Art Museum

Photographic Credits

Catalogue Illustrations

AIC Photographic Services
Althorp
© Rijksmuseum, Amsterdam
Mark Asher Photography
David Bamber
The Trustees of the Holburne Museum of Art, Bath
Victoria Art Gallery, Bath and North East Somerset Council/Bridgeman Art Library
Cecil Higgins Art Gallery, Castle Lane, Bedford
Staaliche Museen zu Berlin - Preußisher Kulturbesitz Gemäldegalerie/Jörg P. Anders
The Williamson Art Gallery and Museum, Slatey Road, Birkenhead, Wirral, United Kingdom
The Barber Institute of Fine Arts, University of Birmingham/Bridgeman Art Library
Birmingham Museums & Art Gallery
Photograph © Joachim Blauel - ARTOTHEK
Courtesy, Museum of Fine Arts, Boston. Reproduced with permission, © 2002 Museum of Fine Arts, Boston. All Rights Reserved.
Royal Pavilion, Libraries and Museums, Brighton & Hove
By kind permission of His Grace The Duke of Buccleuch & Queensberry KT
Reproduction by permission of the Syndics of the Fitzwilliam Museum, Cambridge
National Museums & Galleries of Wales, Cardiff
From the Castle Howard Collection
Michael Chevis

Cincinnati Art Museum
Richard Clive
© Penny Davies Photography 2002
© Courtesy of The National Gallery of Ireland, Dublin
© National Gallery of Scotland, Edinburgh
Courtesy of David Edmond
© English Heritage Photo Library
Faringdon Collection Trust
R. Derek George
Ipswich Borough Council Museums and Galleries
Courtesy of Mr Simon Jenkins
© Copyright The British Museum, London
Coram Foundation, Foundling Museum, London, UK/Bridgeman Art Library
Courtauld Institute Gallery, Somerset House, London
By Permission of the Trustees of Dulwich Picture Gallery, London
© Museum of London
© The National Gallery, London
By courtesy of the National Portrait Gallery, London
Paul Mellon Centre for British Art, London
Pym's Gallery, London
Photograph courtesy of Richard Green Gallery, London
Private Collection of Robert Stephen Holdings plc, London/Photograph courtesy of Richard Green Galleries
© Royal Academy of Arts, London
© The J. Paul Getty Museum, Los Angeles
The Whitworth Art Gallery, University of Manchester
National Gallery of Victoria, Melbourne, Australia
Board of Trustees of the National Museums and Galleries on Merseyside (Walker Art Gallery)
Yale Center for British Art, New Haven/Richard Caspole
Photograph © 1983 The Metropolitan Museum of Art, New York
Photograph © 1992 The Metropolitan Museum of Art, New York
Photograph © 1998 The Metropolitan Museum of Art, New York
The Pierpont Morgan Library New York
The Pierpont Morgan Library New York/Joseph Zehavi
© Duke of Northumberland
Norwich Castle Museum and Art Gallery
Photograph © National Gallery of Canada, Ottawa
The Ashmolean Museum, Oxford
Philadelphia Museum of Art/Graydon Wood
The Portman Estate/ Christie's
The Royal Collection © 2002, Her Majesty Queen Elizabeth II
The Saint Louis Art Museum
The Huntington Library, Art Collection, and Botanical Gardens, San Marino, California/Powerstock
Southampton City Art Gallery, Hampshire, UK/Bridgeman Art Library
Photography courtesy of Gainsborough's House, Sudbury
Tate Picture Library
Tate Photography/Andrew Dunkley/David Lambert/Marcus Leith/Rodney Tidnam
The Toledo Museum of Art
V&A Picture Library
Photograph © 2002 Board of Trustees, National Gallery of Art, Washington
By kind permission of Her Grace Anne, Duchess of Westminster on behalf of herself and her Trustees
By kind permission of His Grace, the Duke of Westminster on behalf of himself and his Trustees
Wolverhampton Art Gallery
Worcester Art Museum, Worcester, Massachusetts

Figure Illustrations

Althorp 47
The Baltimore Museum of Art 40
By permission of the British Library 55,59
Musée de Douai (Photo C. Theriez) 33
Photograph © English Heritage Photo Library 31
© The National Gallery of Scotland, Edinburgh 11
Photo Scala, Florence 4
Museum of Fine Arts, Houston 48
Ipswich Borough Council Museums & Galleries 22
Photograph © Rica Jones 17, 18, 19
© Copyright The British Museum, London 32, 42
Coram Foundation, Foundling Museum, London, UK/Bridgeman Art Library 58
Guildhall Library, Corporation of London 1, 2, 8, 10, 35, 60
London Metropolitan Archives 30
Photograph © Museum of London 64
National Gallery, London. Photograph © National Gallery, London. All Rights Reserved 39, 41
Photograph © Ashok Roy, Scientific Department, National Gallery, London 20 21
Courtesy of the National Portrait Gallery, London 7
Photograph © National Maritime Museum, London 34
Photograph © Royal Academy of Arts, London 12,15
Photographic Survey, Courtauld Institute of Art, London 51
Witt Library, Courtauld Institute, London 36
Board of Trustees of the National Museums and Galleries on Merseyside (Lady Lever Art Gallery, Port Sunlight) 13
Photograph © The Frick Collection, New York 14
The Royal Collection © 2002, Her Majesty Queen Elizabeth II 44
Photograph © Royal Institute of British Architects 24, 25
The Huntington Library, Art Collection and Botanical Gardens, San Marino, California/Powerstock 45, 57
Photograph courtesy of Sotheby's 28
Photography courtesy of Gainsborough's House, Sudbury 49, 52, 53
Tate Photography 3, 23, 63
Tate Picture Library 29, 38, 43
Waddesdon, The Rothschild Collection/Mike Fear

Index